Contents

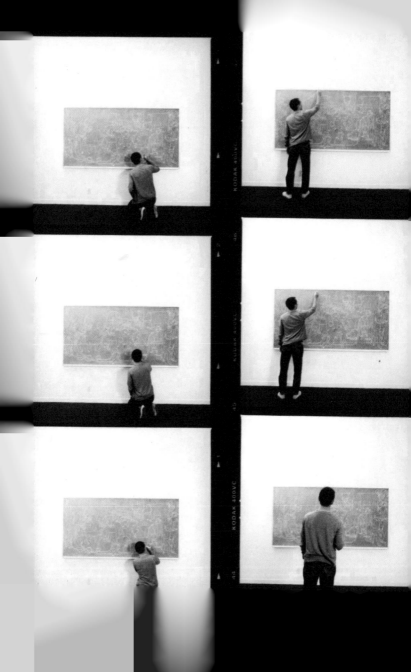

Do Photo

Observe. Compose. Capture.
Stand out.

Andrew Paynter

Preface by Geoff McFetridge

For my children and my grandfather, Bertram Couch Payne

Published by
The Do Book Company 2020
Works in Progress Publishing Ltd
thedobook.co

Preface © Geoff McFetridge 2020
Text and photographs
© Andrew Paynter 2020
p15 © Eric Coleman, Dockers
p120 © Michael Blumenfeld

The right of Andrew Paynter to be
identified as author of this work has
been asserted by him in accordance
with the Copyright, Designs and
Patents Act 1988

To find out more about our company,
books and authors, please visit
thedobook.co or follow us **@dobookco**

5% of our proceeds from the sale of
this book is given to The Do Lectures
to help it achieve its aim of making
positive change: **thedolectures.com**

Cover designed by James Victore
Book designed and set by Ratiotype

Printed and bound by OZGraf Print on
Munken, an FSC-certified paper

A CIP catalogue record for this book is
available from the British Library

ISBN 978-1-907974-84-7

10 9 8 7 6 5 4 3 2 1

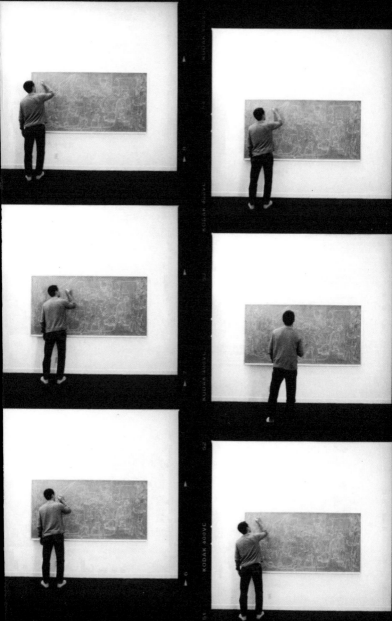

Preface

I first worked with Andrew over ten years ago. I was preparing for an art show that was a fairly involved installation. The lead up to the shows, the process, was always interesting and I wanted to capture some of that. I sought out Andrew after he had come by the studio to shoot my portrait. I knew he shot bands, and he seemed easy to get along with. Working with Andrew has become the deepest and longest collaboration of my career. Spending time with him, and seeing how he works, has informed my understanding of photography, and the alchemy of what makes a photo great.

One thing I know about photography is that I am not good at it. I know that If I am taking a photo and the person next to me is taking a photo, most likely, their photo will be better than mine. Even if they are nine years old.

As a visual artist I have often thought, shouldn't I be good at this? However, I have come to understand that what is most valuable in photography is more than visual.

This is the quality that Andrew has in spades.

Many people make images and use cameras to do it. Scanners are cameras. Photocopiers are cameras. Cars (backing up) have cameras. Phones are cameras... so what is a photographer?

When working with Andrew, I am aware of his sense of observation. It is palpable. Often, he has flown across the country, or the world, leaving his kids and projects behind. There is a high-wire aspect to his work, a skateboarder's level of commitment, that hinges on his sense of observation.

On the other hand, the most noticeable thing about working with Andrew is that he never seems to be taking any photos. When Andrew and I are working together, I am often in a bit of a stressed-out state, or at best, busy. Yet observing Andrew, it seems that he is too: talking to the gallery assistants, playing with dogs, riding bikes with the kids, having a coffee, talking to strangers, or going to the bakery for croissants... again.

When I was working on that large installation, we were in Eindhoven. We were there for a while. It was fun. He was super helpful and easy to get along with, yet, he was not shooting any photos. At the end of the trip, I remember thinking that since nothing very interesting was going on, we could do the photos another time. I said something about it in an, 'oh well' sort of way, and was shocked when he told me he had shot 40 rolls of film or something. Basically, all the film he brought.

Photography of the sort Andrew Paynter does feels like it comes out of a sensitivity to the world — a deep social intelligence. His work is not the band; it is the hum of an amp in between songs. It is not a lecture; it is mediation. You never feel that his photos need a caption. You don't wish they were video. You are glad they are still.

Geoff McFetridge
Los Angeles, July 2020

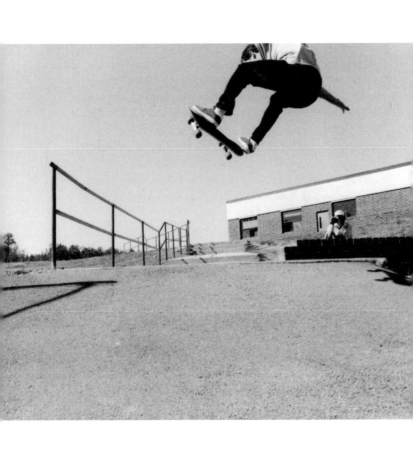

Prologue

I suppose photography became a part of my life the moment I discovered I had a reason to make pictures.

At a relatively young age, I learned that the camera gave me the ability to approach people of all types without hesitation and capture something compelling — the feeling of a particular time and place.

I started by documenting my friends, who shared a mutual love of skateboarding. Our boards transported us to new places daily and gave us the freedom to imagine, build, and play. It was equal parts athleticism and escapism, and the camera extended the fantasy of it all.

But the tangible side of photography was also part of its allure. While I loved the act of capturing, I craved its palpable continuation, which inevitably led me to the darkroom. On weeknights, I'd spend hours experimenting in the dim, red light. The ritualistic components and habitual quiet that came with the practice became my personal Zen.

Seeing the images I'd made come to life on paper stirred something in me that I still can't quite put into words. I'd found my secret chaotic classroom, the ideal setting for me to learn how to observe and document meaning in life's passing moments.

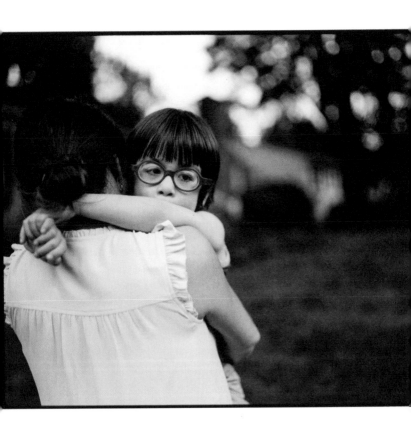

Introduction

I grew up in a family affected by dementia. I saw my grandmother's memory slowly fade from her grip as her mind lost touch with time. It was difficult to see the disease take root in our lives, but it taught me that memory is one of life's most treasured things. And because of it, I also got to witness the magic that photography offers.

Through my grandfather's collection of handmade photo albums, my family discovered a way to engage my grandmother's memory. Together we would flip through the prints and Polaroids of family gatherings, holidays, and daily life; they seemed to transport her to a time and place she could not only remember, but find a piece of herself in.

I say this because photography is many things — it is an integral part of so much of what I do and am drawn to, and it shapes the way that I both see and experience the world — but at its core, it is a medium of connection. It has the unique ability to bring us back to specific moments in time and reawaken our senses. It preserves details, tells stories and prompts visceral recollection.

Because of this, I have always looked at photography with reverence.

When I started making pictures, I realized that just as photography has the ability to connect us to intimate points in the past, the *act* of photographing has the ability to connect us to the present.

As a medium, photography has enabled me to interact with people in a totally new way. It has granted me entry into people's private lives and gifted me quality time with individuals I hadn't known before — a notion that's still remarkable to me.

For this reason, I have always been drawn to making photographs of people rather than things, and that's why this particular type of photography has become the primary focus of my work — and, subsequently, the book you're holding.

Since I started documenting life from behind the lens, I've learned that photography begins before you even put film in the camera. It is just as much about observation and what I call 'disarming' (more on that later) as it is about the technical aspects of taking a photo.

Whether working on personal projects, like my *Working Artists* series, or professional commissions, my approach is the same: I take an interest in the person I'm photographing and spend time talking to them. I practically interview them with a parade of questions and do my best to soak up every bit of who they are so that I can document it honestly. Because when you're able to capture someone as they are, fully, in the precise moment that they're in, the result is rather special.

In the pages that follow, I'll walk through the 10 practices I've honed over my years of camera-wielding and share some stories along the way. Don't worry, I'll also cover a few technical tips and the prompts I find most meaningful. These sections can be found at the end of each chapter, marked with a camera symbol. But through it all, you'll get an idea of how beautiful photography can be — how it can teach you, push you, and help reconnect you to your surroundings.

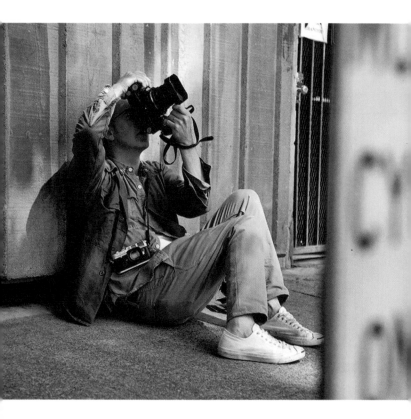

THE 10 PRACTICES

PRACTICE 1

BE PRESENT

When I was a boy, one of the most important things my parents instilled in me was manners. They taught me to look people in the eye, carry conversation with confidence and show interest by asking questions. But it wasn't until adulthood that I realized these common acts of politeness are simply ways to stay present while in the company of others — a skill I've found is not only applicable to everyday life but integral to photography.

For me, being present just means engaging with whatever's in front of you. It requires that you disconnect from your internal dialogue and tune in to the nuances of your environment. No distractions, no impatience, no wandering thoughts — just earnest awareness. It may sound like somewhat of a no-brainer, but it's often harder than it seems.

When I first started taking commissions, I was so fixated on whether or not I was loading my film correctly, metering the light effectively, and shooting the right speed and F-stop on my camera that I'd take myself out of the moment completely. Even though I knew I needed to slow down and engage with my subject, I couldn't disconnect from all of the variables moving through my head. Trying to stay present while juggling the technical aspects of each shoot

was challenging — and it took years for me to strike the right balance. But one day, I remembered my manners, and the rest just clicked.

No matter how nervous I got or what scenarios surfaced, I'd just keep putting myself in a space where I was actively engaged with my subject. And once I started, it was easier than I thought. As I consciously slowed my pace, settled into the shoot, and initiated conversation, I discovered that the person I was photographing was actually interesting, which made the act of photographing even more exciting. Plus, I couldn't believe how much better the images turned out.

All I needed to do was stay present in the interaction. Because that's all a shoot is, really — an interaction with whoever or whatever you're shooting. Through staying present, I realized that making photographs for commissions doesn't have to be all that different from making photographs for personal projects. In fact, the process can be rather similar.

Whenever you're photographing people, be it on a set or in your backyard, you owe it to your subject and yourself to be there fully. Only then can you begin to take in the scene in front of you and capture it honestly. But the act of being physically and mentally present has a personal payoff as well — it allows you to reconnect with your intuition and the reasons you love making pictures in the first place. When you take time to understand and appreciate everything around you, each shot becomes incredibly fulfilling — and it often leads to interesting and provoking images.

This is true of landscape and still-life photography as well — but since you don't have to think about interacting with another human or engaging in conversation, remaining present can actually be a lot easier. Sometimes shooting things that are still or constant can naturally encourage you to follow suit, and if you do so, you're given ample time to

become more aware of the space you occupy and the reason you're there documenting it with your camera. That's when you're able to visually articulate what an environment truly feels like.

So the next time you find yourself becoming overly conscious of your role and approach, remind yourself that having your feet firmly planted on the ground and your mind actively tuned in to the moment is just as important as the technical stuff. As a photographer, you have a unique opportunity to connect with people, places, and things, and to document them in a refreshingly intimate way. But that first requires that you become present in the interaction and not get swept up in your settings.

And if you need a little extra help, one of my favourite tricks is to not read up on my subject before going into a shoot. It gives me the opportunity to get to know them naturally, in a way that doesn't feel superficial for either of us. But, above all, remember to trust yourself — because when you exhaust energy on second-guessing your instincts, it makes it a hell of a lot tougher to stay present.

Don't overthink it.

Make the camera disappear

While I love many different formats of cameras, I see each one as having its own role and strength, depending on how I use it. I've found that sometimes less invasive cameras — like Leica rangefinders — are best when trying to help both you and your subject stay present in a shoot, as they're compact and quiet and allow for more of-the-moment photographs that don't feel forced or static.

I once did a shoot solely with my Leica M6, and when it was over, my subject was completely unaware I'd even been taking photographs. I think that's one of the best compliments you can receive as a photographer. There's a sense of freedom in almost making the camera disappear.

BE PRESENT

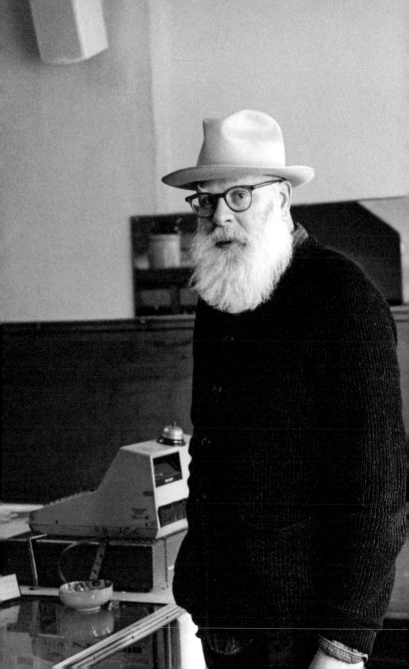

PRACTICE 2

OBSERVE

I've always been a daydreamer. Growing up, I spent the majority of my school days fixating on scenes outside the window and wandering about in my own head. Needless to say, I wasn't exactly the ideal student. But in my musings, I found a way to escape and observe life's smallest details.

In the simplest terms, observation is the ability to see in the present — but I believe its meaning is twofold. It is a way to both survey a scene and hone in on its magic, the minute elements that catch your eye. As a photographer, this type of observation is what allows you to understand the beauty of a space, explore it, and, ultimately, expose it for what it is.

When you become more aware of and in tune with your surroundings, they begin to take on different shapes. You can walk down a street a hundred times and still find something new. You can stare at a painting for five minutes and watch its composition change as new shapes, colours, and tones come into focus. There is always something more to be seen, and it is up to us as photographers to constantly redefine how we view a setting and challenge the perspective we had at first glance.

This is something my grandfather Bertram did quite well. No matter where he angled his lens, his photographs seemed to highlight the aspects of life that no one else noticed — even those of us who were there, in the same spaces, living beside him. He observed in quiet reverie and captured the things that he appreciated in his everyday. For this reason, I always enjoyed watching him make pictures, and his images still resonate with me today.

I discovered the importance of this type of observation in my own photography when I started touring with bands. I was around the age of 25 when I was commissioned to document my first summer music tour across the States. The idea was that I would shoot the initial leg of the tour and another photographer would pick up and continue where I had ended. It was unlike anything I'd ever done before, but being with the same people for days on end gave me the opportunity to slow down and really observe what was happening around me — all while experimenting with which cameras and formats best suited certain moments.

After the first month, which was supposed to be the end of my time on the road, I was told by the label manager that the bands had decided to keep me on board for the entire tour. Because I'd set my focus on observing rather than inserting myself into scenes to 'get the shot', my presence was minimal and not overwhelming — which benefitted my work, as well as the bands' overall experience. To this day, I refer to that time as my crash-course in documentary photography.

Because of this, I believe observation is one of the greatest teachers. It's what allows you to dissolve into a scene, tune in to the light, mood, and environment of a particular space, and capture the moments when people let their guards down. Once you learn to blend in and adjust your eyes, you have an advantage — a new perspective on

making photographs, where everyone and everything feels genuine, because it is. That's when you know it's time to make a picture.

I'm certainly not saying that I always know when to pull the trigger, but good old-fashioned trial and error has taught me what to look for. Masters like Henri Cartier-Bresson call this the 'decisive moment', something that occurs when the visual and psychological elements of a scene spontaneously come together in perfect resonance to express the essence of that situation. And it makes sense — photography is a sliver of time recorded on film, so if you learn to focus your attention on the nuances of a scene, you will be far more likely to capture meaningful moments within that space.

This is why, whenever you're photographing people, keen observation becomes all the more important. In addition to observing someone's appearance and relation to their surroundings, you must be aware of their demeanour as well. You have to be able to gauge how people feel around you, understand their body language, and mirror and/or complement their energy with your own in order to establish a certain level of comfort and respect. If this step is overlooked, you can push too fast and create an entirely different rapport, which leads to rigid, impersonal photographs. But if you do this correctly, that's when the real stuff happens.

Observation is what allows you to make judgements on when is the best time to make a picture. But it takes practice — each scene is different, and its distinct elements are what lead to its unique visual fabric. So don't be afraid to sit back, watch, and experiment with the technical side of things. When it comes to observation, time is your biggest ally.

TIP

Focus on the light

If you're unsure of where to begin your observations, start by focusing on the light. For me, light is everything — I find it absolutely fascinating, as it's what defines objects and has the ability to consistently influence how things appear to our eyes. It also happens to be one of the more important factors in making photographs, so it's a good idea to train yourself to look at how lighting affects space, structures, and the areas around you. Taking the time to observe light in this way will not only help you appreciate how beautiful it is, but also how powerful it can be in your photographs.

To do this, simply spend time in a place you like — it could even be an area you've shot before or want to shoot in. Just spend hours there, watching how the natural light changes throughout the day. Look for areas where it juxtaposes surrounding textures, and study how it alters the tones and shapes in and around the space. And if you really want to see how light correlates with colour, start at dawn and end at dusk so that you can observe both the blue and golden hours.

Once you have a sense of where you are and what the light will be like in various situations, pick up your camera and start experimenting with different shots. If you're craving more of a challenge, try shooting with a Hasselblad 6×6 square camera. This will force you to practise a more intimate level of observation by looking down into the camera and shooting through a waist-level finder. It's a unique way to look at a subject or an environment, as it only lets you see a small area at once. It also has a square format, which I personally like the constraint of because it encourages you to get creative and observe essential details that may suggest the best composition to create.

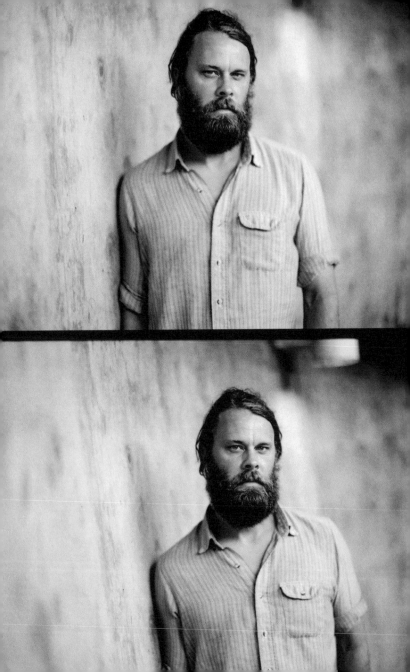

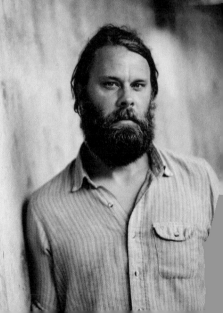

One of my favourite phenomena is coincidence. It has influenced so much of my work and decision-making, and it's what has ultimately enabled me to establish connections in my career. Even back in my teenage years, when I was first seeking out musicians to photograph, I was introduced to a whole group of interesting people I wouldn't have normally interacted with — all because of a shared admiration of sound. And several of those individuals ended up influencing the way I approached my life and my work.

Since then, I have photographed many different people — including those I would have never guessed shared a single commonality with me. But as I got to know them and collaborate with them, the coincidences that connected us as humans came to light. Through similar upbringings, mutual friends, and common interests or beliefs, we found a meeting point, and I was granted entry into their lives.

This type of connectivity is critical when making photographs of people because it is what allows for organic experiences. As picture-makers, we have a unique opportunity to document individuals in an extremely personal way, but in order to do so authentically, and non-

intrusively, we must first establish a base-level respect for one another. And the simplest way to do this is by talking.

When photographing, whether you have 15 minutes or a full day, forming this mutual bond is crucial. Taking the time to get to know your subject and building a sense of rapport with them not only helps them to relax and settle in to the shoot, but it allows you to get a better understanding of who they are so that you can capture them honestly, without disruption or offence. Some of my favourite shoots have felt like days spent hanging out, chatting for so long that my subjects forgot they were the focus of the camera. For me, that's the best possible scenario for capturing genuine photographs.

This reminds me of a time I photographed Kyle Field, the artist behind the band Little Wings, in San Francisco. Neither of us were in a time crunch, so we decided to walk around (almost) the entire city. Over the span of six hours, we aimlessly walked, talking about life, art, music, food, and our respective childhoods in the South while I photographed him. By falling into deep conversation with one another, we both let our guards down and completely let go. At times, I even forgot that I was there to make pictures. It was a really inspiring day for me personally, and even though I only made 46 photographs in all, it felt easy, and they captured the moments perfectly. The interaction and the corresponding images were impactful, and you could tell that both of us had enjoyed the shoot. Having a nice, long conversation like this sounds simple, but I've found it can be stimulating enough for both parties to forget that photographs are being taken (in the best way possible).

When it comes to learning how to connect the dots of coincidence and craft natural conversation, I recommend watching old talk shows. I'm not kidding — I've watched loads of interviews over the years, and each one has taught

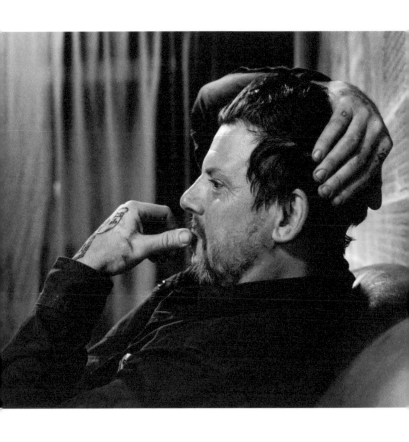

me something new. They've helped me understand how to listen between the lines, ask questions in a way that is inquisitive but never critical in tone, and open up about my own experiences, even when it seems that I may have nothing in common with the person I'm talking to. But what I've also discovered is that these techniques translate to the art of picture-making.

Just as there is a rhythm in good conversation, there's a rhythm in good photography. In photography, however, the 'rhythm' is the synchronicity between you and your subject and/or environment. So it's important that you continue to read the room and keep your connection engaged even after that initial meeting point, as it allows for a sense of ease that gives subjects the freedom to be themselves without fear of over-awareness. The more your presence aligns with the rhythm of the scene, the more likely you are to make photographs at the right time.

Practising this with intention can also lead to lasting relationships — I've been photographing some of my subjects for years now, all because of connections built off of single coincidences. I am continually humbled by the network of friends and mentors that photography has gifted me, and it's influenced the type of work I gravitate toward as well. It's why I prefer longer-term projects — whether editorial, commercial or personal in nature.

Establishing connection is equally important when photographing places as well. Underlying commonalities are what give meaning to pictures, regardless of what the subject is. So even if it takes more patience and research to get to know an environment and understand how it connects to you personally, it's well worth it. Landscapes reveal their secrets in time, and if you put in the work, those learnings will give greater context to the stories you choose to tell with your pictures.

Take your time

I was once told that you should always arrive at a shoot with a loaded camera ready to go, in the event that stuff starts happening immediately. While I understand this notion, I completely disagree. I think that one of the most detrimental things you can do on set is pull out the camera too quickly without establishing some kind of connection that allows your subject to feel comfortable and collaborative. So take your time. If you're shooting film, chat with your subject as you load it. And if you're shooting digital, get your gear in order slowly. As an added bonus, it will familiarize them with your camera and make it seem less formal and scary.

CONNECT

DISARM YOUR SUBJECT

There's a famous photograph that the late Richard Avedon shot of Marilyn Monroe on his Rollei square-format camera. In it, she's looking slightly off-camera in a state of contemplation. It's an image that people have talked about for decades, but I believe what makes it beautiful has little to do with who it highlights or how it was shot. It's striking because it captures someone in their natural, relaxed state — and the fact that that someone is a public icon who had only ever been seen 'on' makes it all the more interesting. I've always loved the image for this reason: It embodies something refreshingly real, an ordinary viewpoint that isn't contrived.

Helping people to relax while being photographed is the secret sauce of picture-making. In fact, you could argue that it's the single deciding factor of whether you're going to get the right or wrong picture. Aptly, it's one of the more difficult things to do, and it often takes practice. But once you grasp it, it becomes second nature, and everything falls into place.

I like to refer to this notion as 'disarming your subject'. Basically, it's everything a photographer does to make the person in front of their camera feel comfortable enough to

lower their guard. As with anything, disarming can come easily to some, and not so easily to others — but it has a lot to do with how you interact with people in your everyday life. That doesn't mean you have to be some charismatic being that strangers gravitate toward, though; it's about making people feel at ease around you, even if you only have a matter of minutes.

Simple things like making eye contact and greeting people with your full attention are great first steps to breaking down barriers, as are getting to know your subjects and establishing where your commonalities lie, but disarming takes it a step further. It builds trust.

I've found that an effective way to begin to do this is by talking to your subject about your work. It not only helps them to relax, but it allows them to gain a greater understanding of what you're both there to do, and it invites them to be a part of your process. By sharing a sense of what you plan to make and how you plan to make it — whether it's a simple of-the-moment portrait or something more complex that requires a greater collaboration — you allow your subject to feel more involved. Similarly, sometimes bringing in visual examples or books when you need to be more literal in regards to your creative plan can be helpful as well.

That said, one of my favourite tricks is to make a Polaroid of my subject before we start shooting and share it with them. That way, they can understand the general feeling of the shoot, what I'm hoping to capture, and how they best appear in the light I've put them in. More times than not, this gives your subject a greater understanding of your ability and a sense of what you're creating together, which can help them feel like they're a part of the process rather than just the focus of your lens. (I wouldn't overdo this, though — especially with digital. If you make sharing frames the norm, you'll end up showing them every other picture,

which will disrupt the flow between you and take away from the time you have to make photographs.)

Likewise, it's important not to get overly focused on making photographs that flatter your subject. While that's certainly a part of the process, if you only concentrate on how a scene looks, your subject can begin to feel self-conscious. But if you're also attuned to how they're feeling on set, you can reflect a complementary energy back to them as you shoot, which will help you to build a sense of trust that will ultimately allow you to make photographs that flatter. Once that natural ebb and flow is established, the door remains open.

Yet, some situations aren't always so simple. When dealing with multiple subjects, the act of disarming can become slightly more complex. Once, when I was commissioned to photograph a band that was working on a record, I was asked to document an entire group's creative process. While I was intrigued by the idea of photographing the band's dynamic and various personalities, I also understood that time in the studio is a delicate and intimate thing, as the band is there to write, make music, and record. So, as a photographer, I was challenged to make my added presence and sound (i.e., camera clicking) feel natural and welcome — all while capturing moments that felt impactful.

After my initial interaction with the band, my presence didn't seem to be a big deal for most, but there was one particular member who remained closed off and difficult to read. Overall, it seemed like he wasn't interested in being photographed, so I had to find appropriate ways to engage with him and get him to begin to lower his guard. Fortunately, I was given time to do this, so I didn't feel rushed or like I had to push too fast or too far. Instead, I waited for cues that made me feel invited and welcomed in the studio.

For weeks, I observed and took note as to when it felt appropriate to shoot, and I eventually discovered the times when that coincided with moments that were worth shooting. As this progressed, my presence was not only accepted but embraced, and even the shyest member began to slowly acknowledge me. This gave me the opportunity to discuss his work, my process, and our mutual contribution to the outcome. The moment things opened up to this type of conversation, I was able to find ways to connect with the entire band and lower their guards by making them feel at ease. I still remember those moments when the band felt good about a take or played something that really worked, because that's when everyone could let out a breath, have a laugh, and loosen up. Those were my times to deepen the connection, remind them why I was there, and prove that my presence wasn't counterproductive to their work.

The act of disarming requires that you tune into your subjects' personalities and feelings, and put to rest any stress or uncertainty they may be experiencing. As an image-maker, this means that you must create an environment where people feel engaged, empowered, and comfortable enough to let their true selves come through. After all, photography is a collaboration between you and the people you're documenting. Getting them used to your presence, your cameras, your tone, and your overall vibe — and enabling them to feel welcome and at ease within your vision — is what leads to truly beautiful photographs.

But in order to do this effectively, you must also remember that you can only disarm others when you, yourself, are disarmed. It took me many years to get to this level and understand what that feels like for me, but once I was able to enter a shoot calm and confident, my entire

workflow changed for the better. Knowing exactly what you're there to accomplish, while simultaneously letting things unfold and manifest naturally and without hesitation, is a beautiful thing in any art form, but it's especially satisfying when you're documenting people.

Get closer

When you're shooting portraits, space is an important thing to think about. Often, the farther you are from the person you're photographing, the more awkward it can be — at least at first. So when you're starting out and trying to help your subject ease into the shoot, get closer. Though it seems like it might be even more uncomfortable, it actually allows them to engage with the camera and feel like the two of you are creating something together, rather than them being on their own.

If you're a film enthusiast, you could also try shooting on a large- or medium-format camera. I've found that when you take one of these out on a shoot, it's common that they spark a curiosity and a sense of excitement with the person you're photographing. This can lead to natural conversation, questions, and an overall sense of being comfortable — all based on an interest in the camera. Once that foundation is established, that's when you know it's time to start making pictures, unbeknown to your subject.

DISARM YOUR SUBJECT

LEAVE YOUR EGO

My wife is a nurse in the neonatal intensive care unit, and her job is *real*. She saves lives, sees newborns die, and experiences intense highs and lows with a range of patients under various circumstances. She tells me these stories all the time, and they're heartbreaking, but she's dedicated to her work — and she's good at it. I say this because witnessing her commitment to public service day in and day out has given me a new perspective on my work as a photographer. It has not only influenced how I view every aspect of my job and what it means to me, but also where it sits in the bigger picture of life.

I believe that we are all tasked with different things in our lives, and no matter what that is, we should always do our best, work our hardest, and help make people happy when we can. But at the end of the day, I know that photography doesn't save lives. This isn't to say that I don't think it's meaningful — I simply believe we should remember that in the larger scheme of things, the outcome of a shoot is not life or death.

What I love about photography, and creative work in general, is its ability to forge deep connections, capture life-altering moments, and even put smiles on people's

faces. But the truth is, that beauty has little to do with the person doing the documentation, and everything to do with the people they're documenting. So whenever I start to get in my own head about what I'm doing on a given set, I try to remind myself that it isn't about me. Once you adopt this viewpoint, I've found that it enables you to step back from your ego and never take what you're doing too seriously.

When it comes to creative work, and life, the ego doesn't always allow us to see everything as it is. It has the capacity to blur reality and cloud judgement, affect what we see and do, and drive us toward specific outcomes and away from others. Whether we're aware of it or not, it limits things. For these reasons, it's extremely important to leave your ego behind when photographing people.

Though it can be easy to get wrapped up in what *your* objectives are for a shoot, what *you* think of a particular scene, or even why *you're* working on a project in the first place, focusing on yourself is one of the most harmful things you can do to your images. It takes you out of the moment and forms a wall between you and your subjects. Trust me — I've learned this the hard way.

Several years ago, I was hired to photograph a band that was on a record label owned by a friend of mine. It was during a time when I found myself feeling confident about my craft and abilities, and I remember thinking that it would be a small-peanuts assignment in comparison to the work I'd been doing. When the band showed up to the studio, they didn't have any definitive directions of their own, so I just did my own thing. Instead of taking the time to get to know them, I pursued my own ideas and rushed through things, which meant I never truly connected or collaborated with any of them. And it showed. The shoot was terrible, the images weren't all that original or reflective of the band, and

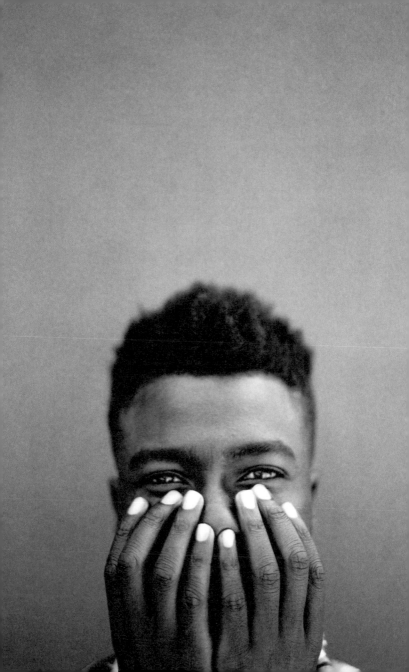

they ended up not using them — all because I let my ego control my outlook. I still think about it from time to time, and it bothers me to this day, especially because it involved a friend down the line.

Though it's a bummer for me to look back on, I learned a lot from this experience. Making pictures should always be a collaborative effort, and when the ego shifts the focus from your subject to yourself, it limits the creativity and trust on set by causing your subjects to disengage. Leaving the ego is what allows us, as image-makers, to be open to new ideas. We owe it to our subjects to listen and make them feel like equals. Only then can we tune in to our surroundings and produce our best work. The moment you lose yourself in what you're doing and focus your attention, thoughts, and conversation on your subject rather than yourself, you are able to make meaningful pictures. This is true no matter what type of project you're working on.

When I was first commissioned to shoot a campaign for Levi's, I was in over my head. But their executive creative director is a very generous person, and he believed that I could tackle the campaign. Because he'd gone to bat for me, I felt compelled to do my best work and to make sure I listened to everyone on the set so that there was a shared sense of ownership in the final photographs. I was beyond nervous, and the number of people on set was overwhelming, but I just kept reminding myself that it wasn't about me or *my* work. I made it my focus to be as present, fun, and collaborative as possible during those five days of shooting. And the images were better for it.

Whether I'm on a small or large shoot, I've found it's best to put myself in the same headspace and focus my energy on this type of collaboration. This doesn't mean that I don't feel confident in my abilities or take pride in my craft — confidence is the force that encourages us to try

new things and pushes us out of our comfort zones into new realms of mastery. But I believe that in order to let creativity flow naturally, we must quiet the voice of 'I know best' and hold creative control with an open hand.

We're all human, and we all want to create good work. But that doesn't mean we have to let our egos call the shots. Making original photographs requires that we step outside of ourselves and recognize what makes photography so special — the people *in front* of the lens.

TIP
Be open

I think the best way to thwart the ego is to remain objective and show up to a shoot open to new ideas. This simple act extends a bridge of respect between you and your subject and shows them that you view them as your equal.

If your subject suggests a wild idea, try it out. Even if you don't end up using the images from these instances, doing so will help establish a deeper connection and a sense of trust between you that will naturally give rise to more original concepts. Plus, you never know — doing something a little offbeat can sometimes spark new ideas that you never would have had otherwise.

And if you find yourself doing your own thing or getting stuck in your thoughts, remind yourself why you're there in the first place: *What are you there to do, and to what extent?* The moment you can get a grasp on what you're doing and why, your headspace will be cleared of ambiguity, which can inhibit collaboration and creative thinking.

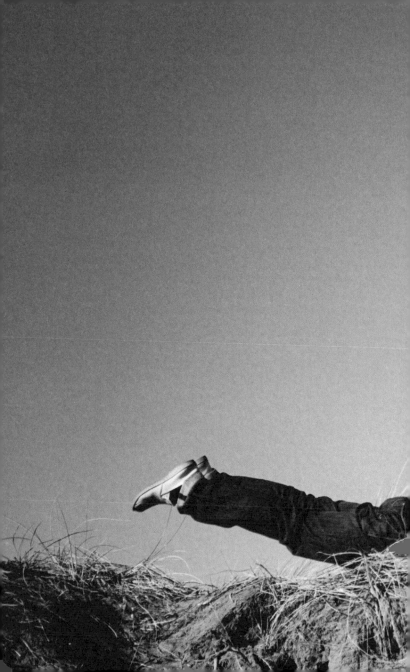

PLAY

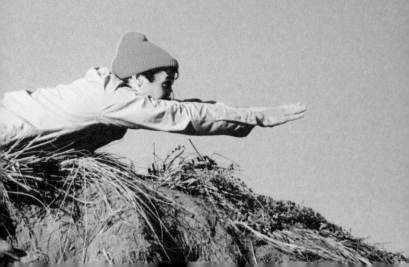

My earliest and fondest memories are of long summer days spent swimming in the sea, running through fields, and exploring nearby forests with my friends. These simple yet influential experiences are how I first learned to soak up and interact with the world. They helped shape and inform me, and I believe they are what first encouraged me to think creatively.

Childhood is a time that is often synonymous with play. It is filled with improvisation, imagination, and *fun*. But play is a notion that remains important well after our initial age of development. If we carry it with us into adulthood, it will continually present us with unique opportunities for creative growth. Fittingly, this is something I learned from my children.

From the moment I became a father, it was important for me to watch my kids grow up. I wanted to be there for every new encounter and document every bit of their upbringings that I could. In keeping up with them, I quickly learned that I had to bring a different level of energy to my work, and not only stay present and alert, but change the way that I made pictures.

The more my children grew, the more they asked questions, sought stories, and explored different ideas — and

naturally, play began to take on a more physical expression. It reminded me of the way I had once interacted with the world, and it prompted me to experience somewhat of a rebirth. But it also required that I become less fixated on specific framing and more focused on capturing the moment in time that was sprinting past me. There were no test shots, no second takes; there was only life, which was moving forward, fast. And I didn't want to miss a second of it.

Running alongside them through dirt paths and redwood groves, I learned to document with a new level of stamina and let go in a way that allowed me to try techniques that I'd been too nervous to experiment with in the past. Day after day, their assuredness in doing what they loved to do inspired my own confidence behind the camera. And, as an added bonus, I also figured out which equipment suited basically every type of activity.

While my kids have taught me many things, I believe this is the most important lesson they've instilled in me: to meet life with a lighthearted optimism and unbridled energy. When I learned to integrate this into my personal projects and commissions, the result was magic.

By approaching shoots and individual photographs through a playful lens, you allow things to be and to feel free. Play is the ingredient that allows you to truly create and let the camera become secondary. It is the element that adds personality and life to images, and what ultimately encourages people to just let go. And though images crafted through play don't necessarily have to incorporate physical movement, they possess a palpable energy that can be felt through every frame.

One of the first campaigns I ever applied this to was for a company called Howies. At the time, it was owned by David and Clare Hieatt (of the Do Lectures), and all they told me was that they wanted the clothing campaign to be

shot around the San Francisco Bay. The next thing I knew, they sent me a large duffel bag of clothes and told me: 'Go do your thing'. There was no shot list, no mood board, no brief — nothing. Just a giant duffel bag. I'd never been given that kind of creative freedom before, and instead of letting myself feel overwhelmed with the possibilities, I decided to do what sounded fun.

I grabbed my Leica M6 and my Contax T2 point-and-shoot cameras and hired my friends for the day. As I documented them climbing trees, traversing sand dunes, and skateboarding the hills of San Francisco, I didn't feel weighed down with unrealistic expectations, physical gear, or people on a set. It was so simple, so light. I will never forget that project — it forever changed how I view professional assignments and served as a jumping-off point to pursue work in a similar vein.

A few years later, David and Clare contacted me again, asking if I'd be interested in doing a long-term project for their new company, Hiut Denim: would I shoot a company culture yearbook for them every year for ten years? I immediately said yes, and couldn't imagine the creative exploration that might come from a ten-year visual narrative in conjunction with a brand I admired (I'll expand on that a little later). But that first shoot in West Wales felt like all play and no work. It was a week-long exploration filled with laughing, swimming, tree-climbing, and sharing stories by the fire. I must have shot 60 rolls of film over the course of those five days, and when I look back at those contact sheets, all I see is pure joy. To me, it was perfect.

I believe that all creative work should be equal parts fun and meaningful. If it's not — if it's gruelling, forced, or inauthentic — it's just not worth it, for you or the people you're photographing. Play is now the lens through which I see each project, each frame, each day. It is the filter

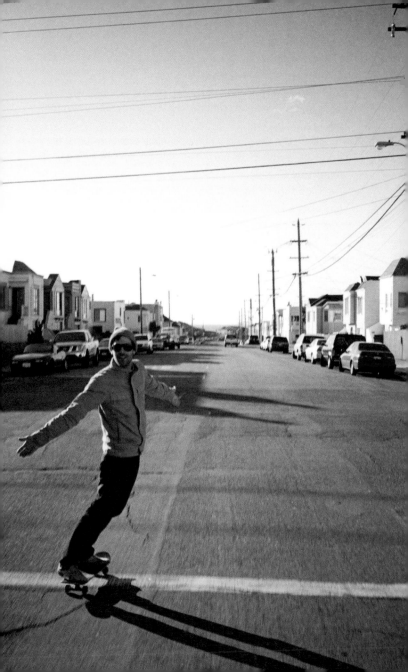

I look through when I exchange words and ideas with each and every one of my subjects. Because, honestly, without a sense of playfulness — without the energy and the possibilities that can come from it — photography can risk being a bit boring.

There is a time and a place to make quiet pictures and portraits, and — trust me — I love doing that. But it's equally important to expose people's true personalities with vigour. I've found that integrating play into my entire practice has opened the doors to the single greatest source of inspiration and candour. Just remember to always create a safe space to make pictures in and never put people at risk while shooting. If you do that while also stepping outside the box and following what you feel compelled to do, you'll capture moments you may not have ever predicted would happen. There's just nothing like it.

Know your gear

Regardless of which camera you choose to shoot with, when it comes to play, it's important that you're familiar with and connected to your gear. In order to capture fleeting moments, you really have to own your camera and champion its abilities to a level where you're almost unconscious of the technical aspect of shooting. Getting to a stage where you don't feel tethered to technique or technology allows for time and space to improvise and follow your whim.

If you can, give yourself time before the shoot to sit and think about the concepts you want to explore — and then envisage what it would be/feel like to make pictures under those circumstances, both for yourself and the person you're photographing. Whenever you're shooting, you are simply spending time with your subject, so try to think of ways to make the process fun and memorable.

Oh, and if you have kids, go hang out with them. They're bound to teach you a thing or two.

PLAY

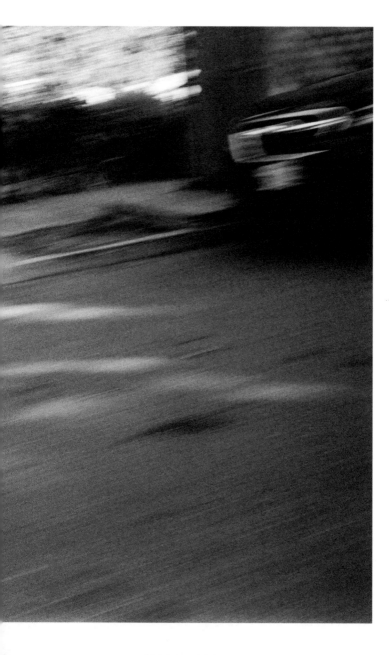

CREATE

There was a time in my early thirties when I was living between Los Angeles and San Francisco, and I would drive back and forth along Interstate-5 by myself. During those six-hour stretches, I began to take note of the specific nuances of the central California landscape and study the way its gradations changed from season to season. The fields, clouds, and trees were all so attractive to me, but I became particularly taken by the quality of the light. To me, it encapsulated the kind of beauty you encounter in dreams. It was only a matter of time before I started photographing the route.

I wanted to do something with the landscapes that wasn't typical. Since I'd rarely seen colour landscapes shot in a square format, I decided to photograph them on my Hasselblad camera. Something about the symmetry of each scene captured in a perfect square felt strikingly different and exciting to me. I was keen to be at the helm of my own vision, and the result was just as I'd imagined. Looking back, I think this was the point when my picture-taking became less about spontaneity and more about creating something special with every frame.

Photography is a medium that addresses how we see the world, what it means to us, and which of its components call to our senses. And as in any art form, the act of creating — of turning one's thoughts and ideas into something tangible or concrete — falls mostly within one's approach. Just like writing or painting, every aspect of photography can and should be creative, from ideation to preparation to documentation.

However, I believe that creating pictures requires more than a visual observation, an adjustment of settings, and the pressing of the shutter. For me, it includes a series of ingredients:

1. a connection with a subject or place
2. a real-time response to what's happening around you
3. an idea of how to capture it in a new and compelling way
4. a mood or tone that complements your objective
5. an image that fully embodies that moment, while aligning with all of the above

Each step of this process requires a creative approach that lends itself to a more original outcome.

Anyone can hold a camera and snap a photo — this is something that has been well proven in this day and age. But a meaningful image creates something new out of what life presents you with. Therein lies the difference between taking and making photographs. Creative images are secretly complex; they capture moments with a unique perspective and/or composition. For this reason, I believe they must be made with intent and consist of a concept, idea, or direction.

The first conceptual project I ever explored was centred around the power lines that stretch along San Francisco's Ocean Beach. For over a decade, I had stared up at their floating fragments and thought of how beautifully isolated

and desaturated they looked shrouded in the city's thick, grey fog. Then, one day, I decided to look at them through the viewfinder of my Hasselblad, and I got an idea. I wanted to photograph small sections of the wires and create one large composition made up of multiple square frames. So, over the course of an entire summer, autumn, and winter, I went out on foggy morning walks with my camera, searching for those stark black-and-white compositions in the sky. I must have shot over 50 rolls of film, as well as dozens of Polaroids, by the time the project was finished — but it was well worth it. The end result was an enlarged contact sheet of 12 images, which was eventually commissioned as artwork for Tortoise's album *Beacons of Ancestorship*. But even if it hadn't gone anywhere or been seen by anyone else, the project would still be special to me because it was the first time I really felt like I created something with my camera from start to finish.

I've learned that any time you're shooting, whether it be personal or professional in nature, you have the opportunity to create. When you look at space, tune in to an atmosphere, or observe the elements that contribute to a setting, you're given a platform to create moments based on the influence of everything around you. And it's equally important that those creations are crafted with care.

There are many variables that affect photographs, but most of them are subjective. While light, environment, content, perspective, and exposure all certainly come into play in a final picture, they aren't what make a photograph stand out. If you were to gather all of your favourite images, either from your own collection or from a photographer whom you admire, you'd notice that they have one thing in common: they hold visual weight. They radiate something that cannot be articulated — they're the pictures we enjoy looking at, resonate with, and remember because they evoke

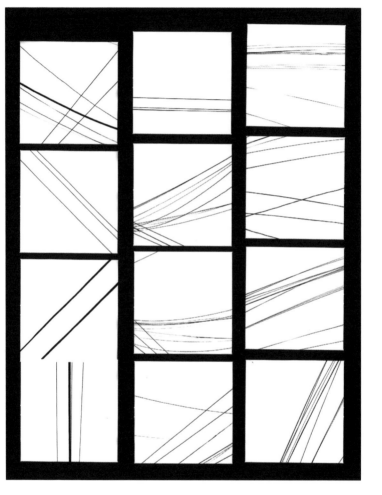

emotion in some way, shape, or form, no matter what scenes they depict. This characteristic may appear subtle at first, but it is the tell-tale sign of a photograph that has been created, from concept to print.

As picture-makers, it's up to us to take our time, craft genuine moments, and know when it's most compelling to create a photograph. Sometimes that comes naturally, and other times it takes a bit of practice. When in doubt, let fate, intuition, and a good sense of timing dictate what happens. I'd say these three notions are consistent in most of my work and, more often than not, they lead to truly interesting images.

TIP
Get inspired

When it comes to photography, creating primarily happens in the mind. Sure, we can do all kinds of tricks with our cameras to achieve specific visual results, but the most important aspect is how you choose to approach a shoot and respond to your surroundings. From there, everything else follows.

So how do you find your approach? The truth is, creativity looks different to everyone, so if you're trying to tap into your creative space, I find it's helpful to turn to what excites and inspires you. Watch films, listen to music, take a drive, visit a museum, read, get out and enjoy nature — whatever helps you get into a creative mindset. Then, channel something from that space and apply it to your shoot. Art begets art.

Whether you show up with a full-fledged concept or a simple idea, it's still important to continuously think about your interaction with your subject and setting, and adjust your plan to complement both. If you do this while simultaneously introducing new elements that inspire you, you're bound to create something compelling that still reflects the moment that you're in. Just don't over-create or force it.

And remember: Creation takes place before shooting, while shooting, and after shooting (while editing or in the darkroom). So there's plenty of space for experimentation.

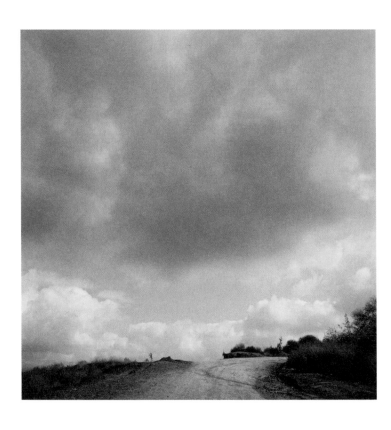

PACE YOURSELF

PLEASE WATCH
YOUR HEAD
ON THE
SCAFFOLDING

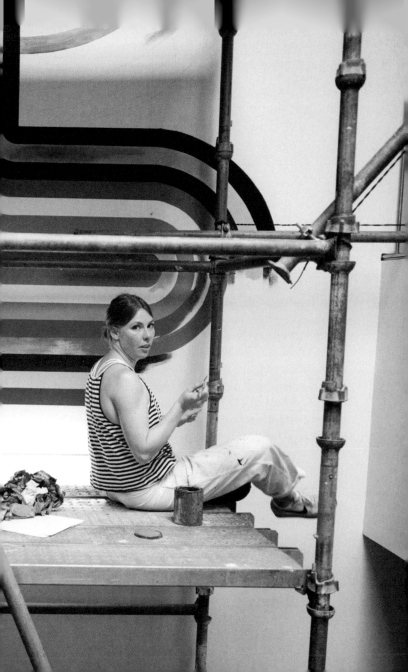

The concept of pace was first introduced to me when I was learning how to draw. At the time, I was frustrated that my work wasn't progressing as quickly as other kids in my classroom, so my parents suggested that I slow down and fully understand what I was looking to accomplish before I sped off to do it. (As it turned out, not everything in life was a race — even for us competitive types.) Even as a young kid, this philosophy helped me. It taught me to focus my attention, give myself time to craft my ideas, and not rush through something for the sake of getting to a finished product. Unsurprisingly, this lesson came up several times in my upbringing, and it is something that I continue to practise in my creative work and throughout my life today.

Pace is the tempo at which we make things. And from my experience, a slower pace simply yields greater things. When you take your time on a task, project or idea, you become more aware — of yourself, your surroundings, and how you fit into everything that's going on around you. It allows you to assess all aspects of your internal and external environments, be proactive in your creative approach, and, ultimately, make better decisions. And when

it comes to photography, making better decisions is what leads to capturing the right moments — the ones that are notoriously easy to miss if you're moving too quickly.

Though we don't always have the luxury of controlling how much time we have on a given project, we are always able to control the speed at which we think and move. If we quicken our pace, it often results in stress and tunnel vision, which can negatively affect the mood of a shoot as well as its outcome. But if we keep our minds and our movements steady, we create an atmosphere that is comfortable for both ourselves and our subjects — which, in turn, allows us to make the most of the time we do have. In this sense, it's actually a bit of a time-hack.

Technology has enabled us to move and shoot quickly, to make digital piles of pictures as we search for the perfect frame, the perfect subject, the perfect moment. But no matter what we choose to shoot with, the point of photography remains the same: to connect with and capture life as it is, in real-time, with all of its incredible imperfection. This isn't to say that shooting with the latest technology is a bad thing — it just comes with its own set of challenges in terms of pace.

I've personally found that shooting film naturally encourages you to slow down. Because film has such a tactile element to it — from loading to winding to processing — it inspires a pause at every step. It doesn't make it easy (or cheap) to snap photos furiously, so the alternative is careful consideration. It prompts you to set a focus, amble, and take the entirety of a scene into account — all the while, quietly teaching you to learn when the right moments are to press the shutter. It's really quite rhythmic. That said, regardless of whether you choose to shoot digital or analogue, if you stay rooted in a slow, easy pace, you'll instinctively learn to make the most of every moment.

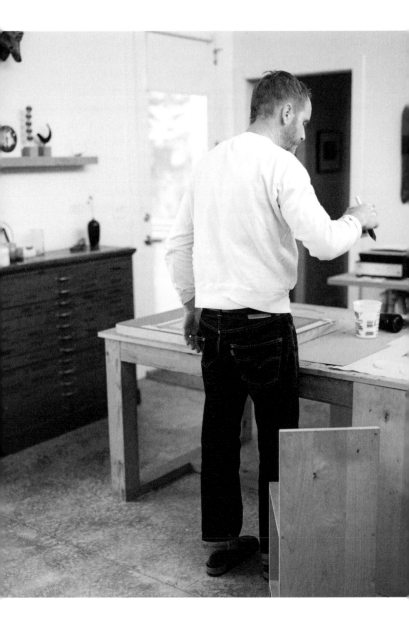

Several years ago, I shot a project for Levi's with artist Evan Hecox (pictured), whom I'd known for some time and had photographed before. While it was great to have an established sense of comfort and familiarity between us, I had never photographed Evan for a specific need or at someone else's creative request. Because we were shooting a brand campaign, I had to completely rethink how I wanted to photograph him, and contemplate how that approach could also showcase Levi's and its product. This was new territory for both Evan and me — in the past, my eyes had always been focused on his hands, his face, the visual work he was creating. This time, I had to focus on his form and the clothes he was wearing. I was fortunate enough to have a couple of days with Evan in his studio, so I was able to pace myself and really watch how he went about his work. This allowed me to begin to spot the moments when I could capture him authentically and still feature the product (in this case, his jeans). After a while, I began to notice that every time a record would end, Evan would walk over to his record player, squat down, and put on a new one. It was a commonplace act that we may not have thought anything of, but those modest vignettes ended up being the perfect times to capture him in an organic way, when he was comfortable and his real habits naturally featured the jeans.

Slowing down in this way gives us added time to understand the whole picture. When we pace ourselves before we fully commit to a creative idea, it helps us not to overthink, over-do, or under-deliver — in the end, it's what leads to fewer mistakes and less time wasted. In this particular case, keeping an even pace enabled me to work with Evan in a new way that showcased both his work and the jeans in scenarios that made sense, without pushing him to do things he wouldn't normally do.

Whenever you're behind the camera, it's important to remember that you're being gifted the opportunity to learn something new. Different situations teach us different things — and as no two shoots are the same, we are constantly being tutored by our surroundings. If you keep this in the front of your mind, you'll have no choice but to move and think slowly, because that's what you do when you're learning: you take your time so that you soak up every bit of information you can.

Nothing good will come out of shooting a million photos in a short amount of time — no matter what you're shooting or what format you're shooting on. You always have a limited amount of time with your subject, and the easiest way to abuse that time is by barrelling through and over-producing. Some of my favourite shoots have been 15 minutes, and others have consisted of 12-hour days. No matter what time frame you're given, I am of the firm belief that magic can be worked if you utilize that time effectively. After all, the only way to capture the beauty of life's hues, tones, and textures is to slow down and encounter them.

So take a breath, slow your pace, and make the most of what you have when you have it. Output isn't everything.

Pause, relax, reset

Whenever you're taking photographs of people, it's important to be mindful of your subject's energy level and whether or not they feel comfortable. I've found that if you put the camera down from time to time and integrate moments of pause while shooting, you encourage your subject to relax and reset, which prevents them from feeling overly aware or self-conscious. And even if your subject has no problem being photographed, taking breaks and chatting between frames can inspire new ideas or shifts in perspective, which can lead to more interesting images.

Additionally, whenever you're going into a shoot, it's critical that you know what gear you want to use and how you plan to use it. Though this is relevant to almost every practice, it is paramount when slowing your pace, as it allows you to forget about a large element of your work and let your mind focus on the possibilities of the scene in front of you.

INVEST

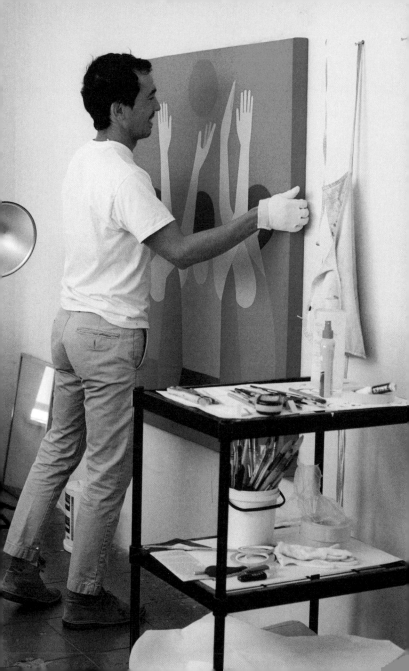

There are certain pictures that hark back to singular moments in time with such dynamism that they keep us coming back again and again. For me, the prime example of this can be found in David Douglas Duncan's Pablo Picasso collection. Duncan was the American photojournalist who documented the private life of the esteemed painter over a period of several years. Beginning in the late 1950s, Duncan was given rare access to Picasso's world in Cannes, France — from his morning routine and personal musings to his family life and time in the studio. But as the pair spent more and more time together, a special friendship flourished between them, which only furthered the emotional reach of Duncan's visually arresting photographs.

Through each frame, Duncan successfully captured the essence of Picasso's grand personality, vivacious works, and beloved Villa La Californie — as well as the people who made him happiest. Whether depicting the artist dancing with his children or walking his pet goat around the chateau, every image radiates a sense of playfulness and ease that feels unequivocally special. But the most beautiful aspect of these pictures is that none of them were set up

or staged — everything captured within them was wholly spontaneous, available to Duncan simply because he was a part of the scene.

This immersive project gave rise to seven books that chronicle the life, work, and love of Pablo Picasso. And today, the resulting images are regarded as one of the most impactful examples of documentary photography, as they record the poetic mystery and folklore surrounding Picasso and offer viewers an honest glimpse into the intimate life of one of the greatest artists in history. What I admire most about Duncan's account, however, is the way that it documents time. When viewed together, these photographs reveal the impact that life has on people, creativity, and environments. They show the change and progression of Picasso's personal outlook, work, and relationships — but also Duncan's.

I share this story because it is a collection of work that I've always viewed with reverence. It has encouraged me to invest time, energy, and emotion in my own creative work, and it has served as visual evidence that the best way to reach new heights in photography is to further your connection with your subjects. It's also what first prompted me to wonder what could happen if a project stretched beyond a single shoot. But it wasn't until several years later, when I started working with my good friend Geoff McFetridge, that I was ready to explore the answer.

I met Geoff in 2006 when I was commissioned to photograph him for an artist feature in an Australian fashion magazine. We had known of one another through mutual friends and were familiar with each other's work, so from the moment he greeted me at the door, we got on quite well. After spending hours in his studio, I began to better understand his personality and see that he was just as interesting outside of his work. The subtle, yet clever way

he approached visual language triggered something within me and reminded me how much I missed being involved with the arts. Even though we had only spent the day together, I knew I wanted to take a break from shooting musicians and delve into his world instead. At the end of the shoot, Geoff asked if I wanted to join him and his family in Holland for two weeks and photograph him as he worked on a solo show at MU Artspace in Eindhoven — and I said yes. To this day, I'm so glad I did.

After our trip, I showed Geoff one of David Douglas Duncan's books on Picasso and explained how I had wanted to create a project in a similar vein since I first started making pictures. I then asked if he might be interested in embarking on a ten-year-long collaboration with me. I think our time in Holland had helped him understand my approach, work, and presence, so he agreed. Our plan was to set off on a slow course, connecting a few times a year and picking up from where he was and what he was working on. I had no idea what would happen over the span of that time, but I knew it would result in something special — the true culmination of all my photographic practices.

With each session, I slowly gained access to Geoff's studio, home life, and internal ruminations, and built a rapport with him that enabled me to work beside him without interfering with his own creative flow. Over the course of those ten years, I not only documented the progression of Geoff's work, process, and ideas, but I captured the evolution of my own craft as well. And naturally, our friendship deepened alongside it. Through trust, respect, and genuine collaboration, Geoff gifted me the freedom and space to experiment with new practices, techniques, and concepts related to time. The result was a collection of images that I could not have otherwise created — all because we made the conscious choice to invest in the work.

When you focus on the quality of a creative idea rather than the quantity of campaigns you can juggle in a given time, incredible things begin to happen. You're able to understand your subject in a wholly unique way, reflect upon what you've captured up until that point, and build upon that the next time you shoot. It allows you to create a visual timeline that is in equal parts striking and enlightening, and expand upon all of the practices I've mentioned thus far.

My work with Geoff pushed my photography to an entirely new level that's still remarkable to me. It also made me realize that when you invest a bit of yourself into your creative projects, they give back to you exponentially.

It was roughly five years into my project with Geoff when David and Clare Hieatt reached out to see if I'd be interested in doing the long-term project for Hiut Denim as well. They'd heard about what I was working on and were curious about what a ten-year-long collaboration could look like for a brand. The idea was that I would shoot the images for a Hiut 'yearbook' once a year that would highlight the artistic community and culture surrounding the company. Once asked, I immediately thought back to my experience working with them at Howies and concluded that if I could do that shoot again, ten times, it would be a dream come true. I was also intrigued by the idea of creating a long-term visual narrative with a brand whose ethos and standards I felt both aligned with and complemented by. So I said yes.

The inaugural shoot involved travelling to the Hieatts' farm in West Wales and meeting the team and the family in person for the first time. I arrived in Cardigan late one evening, and the next morning I awoke to Nick Hand, Hiut's creative director, handing me a cup of tea and ushering me toward an outdoor fire pit where a lovely bunch of folks were gathered making eggs, bacon, and toast. I had never felt so welcomed with such admirable hospitality. I knew then and

there that it was going to be an incredible journey, based on meaningful connections rather than a mere product.

That week was pure fun. The team had invited a group of people to spend a week on the farm, catch up on the year's events, eat great food, and just hang out. Within a few hours, I began to feel like I was part of the community as well — but instead of a shovel in my hand, I was carrying around a camera. Every day that followed allowed for an expanse of time to ease into and explore different ideas. As was the case with Howies, there wasn't a shot list or pressure to deliver anything specific. In fact, I remember being shocked that I could photograph anything — even a stack of old tyres. Coming from a commercial world where the product had to be featured in every shot, the idea that anything was fair game was so refreshing. What the Hiut team did well was gather a group of people together and put all the pieces of the puzzle out on the table so that we could slowly begin to assemble scenes in a natural way. In the end, it never felt like work.

Though this project is still technically ongoing, I've already reaped so many benefits from it. Each book has allowed me to really dial in on what resonates with me most and build upon my learnings from the previous years. So while the first shoot was exciting and fast-paced on several levels, I intentionally slowed things down for the next shoots and shifted the tone of the pictures to be quieter and more laid-back, but still emotive. I've also photographed several of the same people year to year, which has made my job all the more satisfying. It's encouraged folks to become more at ease with me and my presence on the farm while also giving the images more personality and warmth.

Having several days to shoot a project is special, but having several years to photograph people is simply incredible. It challenges you to take things gradually and be

more aware of how everything moves and shifts around you. It makes you take greater pride in the images you choose to make, and it makes time feel infinite, in a way.

While I understand that this isn't necessarily the norm, and these types of projects don't make you money right off the bat, they are the ones that deepen your craft. I think it's important for creatives to reflect and see our work from an outside perspective — and doing long-term projects is what enables us to understand how we've grown, matured, and improved over a period of time. Choosing not to jump from project to project and shoot nonstop may seem like taking the slow road, but I believe it gets you farther in the end. So even if you can't commit to a ten-year project, invest what you can. The result will be unlike anything you could have ever imagined.

I am beyond grateful for each and every one of the projects I've worked on over the years, but I owe a lot to Geoff, David and Clare. They've helped me pursue the type of work I've always wanted to make, and ultimately altered the way that I approach photography. Because of that, my pictures will never be the same.

Over the course of my career, I've learned that the more you pour yourself into your work, the more it will give back to you. So if all else fails, invest in your projects. Build your relationships. And take the scenic route. Short-terms and beginnings are overrated.

TIP
Start small

We live in a world that caters to short attention spans. So, if you're wanting to invest in a long-term project, I'd recommend starting small and building your focus first. One of my favourite ways to do this is by picking a spot in your home and photographing it every hour throughout the day.

For example, there's a vase of flowers on top of our wooden dining room table, which is directly next to a large bay window that looks out on a towering redwood tree outside. One day, I was struck by the way the light filtered through the tree, so I took a Polaroid every hour for ten hours to see how the light affected the same stationary object, in this case, the vase of flowers. In the end, I was able to see which lighting I preferred and better understand how the light altered at each time of day.

It may seem simple, but smaller, time-related exercises like this can be great lessons when learning to invest your efforts before jumping into a long-term project.

When you feel you're ready for the next step, focus on your family. Photographing my kids is one of my favourite things to do. Documenting them consistently over the years has enabled me to see how they have both grown and changed through different periods in time. Plus, it's resulted in innately personal images. So, when in doubt, photograph the people who are close to you. The investment promises a meaningful outcome.

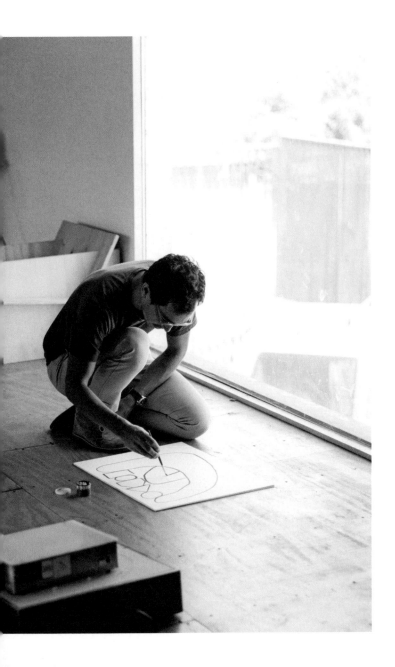

When I was growing up, my mother insisted that we visit the public library every single week. It became something I looked forward to and, ultimately, something that I appreciated later on in life. My brother and I would spend hours lost in the pages of fictional adventures while my sister sought out editorials in *Vogue*. But between my bouts of folklore, I would look through stacks of different issues with her, fascinated by the images and the people in them. Every spread was wild and exciting — especially since we lived in a pretty conservative part of the country — but I distinctly remember the day she showed me a photo essay by Peter Beard, an American photographer who was living in South Africa at the time. I had never seen anything like it. His photographs, and everything in them, looked so different, so beautiful to me. Each image seemed to blur the lines of fantasy and reality, forming a bridge between the world I knew and the ones I'd only encountered in storybooks.

I think being exposed to a lot of different types of literature and media early on had a profound impact on me. It introduced me to the power of story at a young age and altered the way I thought about the world. It also influenced

the types of things I was drawn to, even as a kid (I'm sure my mother realized this, as she always encouraged us to delve into narrative art forms).

The reason I share this bit of my upbringing is because I believe it was how I first started curating. It wasn't a conscious act, nor was it directed toward a specific project or end goal — I simply started surrounding myself with art that made me feel something. Little by little, I sought out stories, imagery and music that inspired me, and collected fragments of creative work that ended up influencing my own work later on.

No matter how young or old we are, each and every one of us is shaped by the books we read, the movies we watch, the places we go, and the things we do — as well as the people we spend our time with. By choosing what we're exposed to, we engage in a type of curation, and I believe this collection of influences is what informs our perspective as artists, even if we have yet to make anything. In layman's terms: We are the company we keep. And our work, as picture-makers, becomes an extension of that company.

Even before I started experimenting with photography, I was drawn to the artistry in others and did everything I could to be surrounded by it. While I aimlessly messed around with different formats of cameras, the end goal was always to document creativity and capture scenes that made people feel more connected to their own creative perspective. This desire is what led me to seek out and say yes to projects with strong narratives and use the medium as a way to approach people whose work inspired me in different ways.

Of all the projects I've worked on over the years, these have been the most fulfilling, on both a personal and professional level. By following my interests and choosing to work with individuals I admire — whether fine artists, writers,

musicians, etcetera — I've been able to make genuine connections, forge meaningful relationships, and curate a portfolio that represents who I am and what I stand for.

This is why I believe it's important to be particular about the people you choose to document, as well as the projects you take on. Doing so allows you to develop a recognizable style that connects your photographs and sets a cohesive tone, or point of view, within your work — even when it comes to commissions and more commercial settings. And, as an added bonus, working amid your inspirations elevates your images and challenges you to get better at your own craft.

When I agreed to be a part of that initial Howies shoot, I realized that I could find this artistry in paid work as well. Though the open-ended prompt seemed somewhat daunting at first, I felt confident that David and Clare had hired me for me, and that they wanted to see what I could do with the product. Focusing on this enabled me to really lean into what I love to do: use photographs to highlight creative freedom. And what I discovered was that I could successfully do that while still representing the product, honouring the brand and celebrating my subjects.

I understand that the 'duffel-bag brief' isn't a common one, but it's a good reminder that, even in commercial settings, you can always apply the perspective you've curated in your personal projects. And if you do, your work will become naturally cohesive — because it'll be honest, and it'll represent the manifestation of your curated inspirations. I think this is what makes people stand out as picture-makers. It prompts others to recognize your work for what it is and want to collaborate with you because of it.

To be honest, I was oblivious to this for the longest time. In fact, it wasn't until after the Howies shoot that I really began to understand what my style was. And I think my work with Geoff McFetridge is really what refined it.

While working with Geoff, I was reintroduced to my attraction to visual arts and storytelling, and I began to see what could happen when I dove head-first into what truly inspired me. It reminded me of my earliest influences and took me back to those library days. Once this happened, I started integrating elements of them into my images. From there, I continued photographing people whose work or life purpose I admired, while also exploring ways to tell longer-form narratives through my photographs. That's when I revisited a series I'd started back in the 1990s called *Working Artists*.

The *Working Artists* series had originally focused on sonic artists, and the premise was that I would photograph musicians I was friends with, or people whose circles I was a part of. But after working with Geoff, I had the idea to integrate long-term accounts of working visual artists into the series as well. My plan wasn't necessarily to amass tons of different artists quickly, but to slowly collaborate with a small group of people I was already connected to, with the occasional addition to let the whole thing grow organically. Over time, I connected with Thomas Campbell, Evan Hecox, Barry McGee, Clare Rojas, and Serena Mitnik-Miller, among others, and the series became a new pillar of my work.

This second wave of *Working Artists* was based on my love of visual arts, but also on my interest in each person I was photographing. The body of work became very reportage and intimate, as I never set out with any agenda but, rather, looked at it as a chance to spend time with people, get to know them, and understand their work on a deeper level. The photography always came about naturally from there, and it always felt special.

Through each of these projects, I've learned how important it is to share your personal work — the work that you're most proud of, and the work that you feel compelled

to make. I've also learned that you should never take an assignment or make pictures that you wouldn't want to share with the public because, eventually, people will just want you to make that work, which is often because that's the only work they've been exposed to.

Everything you photograph helps formulate your style of picture-making, and so much of what becomes recognizable in your portfolio is tied to the projects you choose to participate in. In this way, decision-making is also a type of curation. Ultimately, you want to be hired for what you do best — the work you're passionate about. So it's okay to be picky about what projects you sign up for and where you dedicate your time. Whenever you're presented with an opportunity, think about how the project will impact you, your creativity, and your ongoing work. Contemplate whether or not it will lead to more work in that field, or with that group of people. And, most importantly, figure out if it will bring you closer to what you love to do. If the answer is no, sometimes it's better to walk away.

If an art buyer, producer, creative director, or photo editor sees your personal work and hires you based on it, then you are gifted with the opportunity to make the work you actually want to make. This is why I've always felt it's important to continuously create personal work and find ways to publish it — that way, you are in control of the visual output that the public sees. Always be making the type of work you want to be paid to make. Once you do, the type of people you want to work with will gravitate toward you, and you'll be given new opportunities for creative exploration.

Over the years, I have met and collaborated with incredible people, and those individuals have connected me to countless projects in line with my interests — ones that probably would have never happened had I not worked with them. For example, when I moved from New York City to

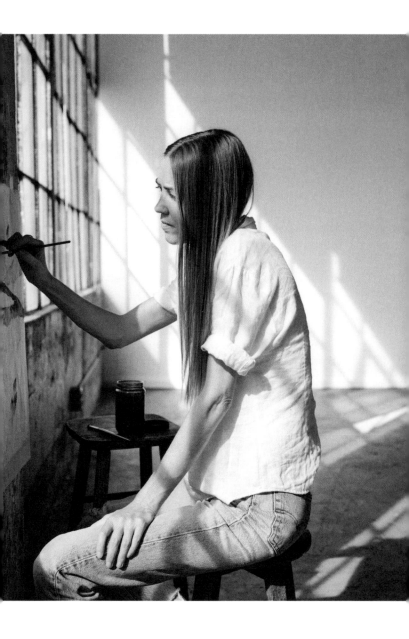

Oakland, California, in 2000, I met John Santos, a graduate graphic designer who taught at the California College of the Arts. John and I were introduced through mutual friends, and it was he who first exposed me to Geoff McFetridge's fine art and eventually connected us via email. This led to my long-term project with Geoff several years later. From there, Geoff introduced me to David and Clare Hieatt, which is how I was chosen to photograph the Howies campaign. Then, later on, I collaborated with David and Clare again and met Nick Hand on the Hiut Denim project. And because of that, I was introduced to the rest of the Do Lectures community, asked to give a talk at Do Wales, and given the opportunity to write this book. This is just one example thread of how things have come together — all because I curated an idea that was in line with my interests and chose to work with incredible people whose work and stories inspired me.

The medium of photography has taught me many things. It has opened my eyes to the intimate side of reportage, reignited my love for visual arts, introduced me to some of the most remarkable people I've ever met, and reminded me of the altogether beautiful parts of life. But it has also taught me how to curate work that leads to mindful connections, so that each project I focus my time on holds meaning in some capacity. For this reason, I always do my best to be quite particular in regards to the kind of pictures I make and the company I keep.

My best advice is to curate mindfully. Seek out what pulls you. Be picky. And make fewer, more meaningful images.

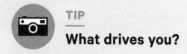

What drives you?

When it comes to curation, it's important to first understand
what drives you: what ignites your curiosity and prompts
you to create. If you're not sure, look at the things in and
around your life that excite you. Think about what you
enjoy reading or listening to, the places you continually
visit or travel to, and the people you love spending time
with. If you need to, recount what you studied in school or
the extracurricular activities you took part in while growing
up. Of all of these, what do you most resonate with? What
makes you come alive and lose track of time? Perhaps you're
drawn to typography and film-making, or foraging and
fishing in the sea. Whatever it is, contemplate ways you
could integrate it into your photography, either in a literal or
more abstract sense.

 Once you've pinpointed your inspirations and figured out
ways to bring them into your practice, you can then curate
your projects to better support your goals. One way to do
this is to create a list of criteria to weigh your opportunities
against. For example, when it comes to commissions, I prefer
to only take on projects that:

1. I'm excited by
2. focus on an individual, a group, or a brand that does
 something I believe in
3. positively contribute to a community
4. have a philanthropic connection
5. have the budget to support my idea and process

It may seem complicated, but once you start, it's easy to
keep going.

CURATE

Epilogue

I always enjoy reading the interviews at the back of *Vanity Fair*. They usually feature acclaimed or accomplished people from various fields, but no matter who those individuals are, they're asked the same 35 questions. These questions are derived from something called the Proust Questionnaire — an old parlour game that suggests that when someone answers every enquiry, their true nature is revealed. I find it interesting because over the years, the interviews have depicted a lot of different perspectives, even though they're each connected by the same set of questions. Of all 35, my favourite is number 22: 'What is your most treasured possession?' The answers that come from it are usually surprising, and mainly tangible. But they always strike me. Reading the differing answers in each issue has led me to ask myself that same question several times. On every occasion, my answer has remained: 'My memories.'

Memories don't burn in fires, get lost in computers, or get sold to auction houses. They always belong to their keepers and, over time, they can create their own line of folklore and pass new meaning to future generations. So while I love photography for many reasons, I believe that the most magical aspect about it is that it documents memories as they're made. But still, photographs and memories are not

one and the same. Images only capture fractions of seconds in time, from single perspectives, and serve as visual cues that piece timelines together. Memories, on the other hand, are processed by our eyes, ears, minds, and emotions. They capture everything and soak up details that often lie outside of the viewfinder.

For this reason, I feel lucky to have grown up in a time when documentation wasn't as common. Though some of my upbringing was documented — and I'm grateful for that — the majority of it wasn't. This commonplace side effect of growing up in the 1970s and 80s has made the photographs we do have from that time all the more sacred and rooted in story. But we live in an entirely new world now, and my children are growing up in an age where moments have the potential to be remembered differently.

Our current climate is one fuelled by digital distraction; as a result, it has made photography a sort of double-edged sword. I often see people racing through the San Francisco Museum of Modern Art, snapping pictures with their phones, so focused on the images they're taking that they don't engage with any of the art in front of them. And it makes me sad, because I can't help but think that after a few short hours, they won't remember a thing. This is becoming more and more common, but I don't believe that capturing should be a form of consumption — it's far too beautiful for that.

Photography is a way to connect us to the present, document memories, and express our appreciation for the beauty that surrounds us — but being a photographer in this age has made things really interesting, and challenging. We now have the ability to take pictures at any given time, and because we can, we often feel that we should. But it's up to us to choose when and when *not* to capture moments on camera.

The feeling of being physically present — of being a part of a moment and embracing what is in front of you — is incredibly fulfilling. I can't tell you how many times I've wanted to take photographs of my children and endlessly document each day of their childhoods, but decided against it so that I could be in the moment with them, building that sandcastle or climbing that tree. And I've never regretted my choice to put the camera down. I have so many happy moments with my children recorded on film, but these undocumented memories are the ones I find even more special — because I was able to be there, fully. They're the moments that have proved to be important to me as a father and to my children as they grow and learn. They're the stories that we each bring up, laugh about, and reminisce over — together.

There will always be more pictures that can be made, but it's up to us to decide when photography is most impactful. Sometimes it's best to put the camera down, slow your output, and engage in what's happening around you. It may feel a bit like quitting coffee at first, but if you do, you'll begin to form a greater appreciation for your surroundings. I know I have.

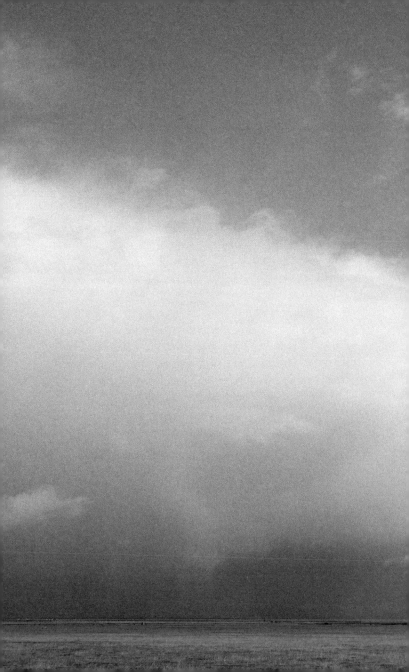

Resources

Books

Calder at Home
by Pedro E. Guerrero

Goodbye Picasso
by David Douglas Duncan

Immediate Family
by Sally Mann

In Praise of Shadows
by Jun'ichirō Tanizaki

In the American West
by Richard Avedon

Irving Penn: Small Trades
by Anne Lacoste and
Virginia Heckert

Movies and Documentaries

Born Free
Directed by James Hill

An incredibly moving 1960s
film about how humans should
connect with nature to both
learn and preserve.

Control
Directed by Anton Corbijn

This feels like a long-running
photoshoot with Anton and his
subjects. I grew up loving Joy
Division and New Order, so it's also
very personal to me in many ways.

In the Mood for Love
Directed by Wong Kar-wai

With cinematography by
Christopher Doyle. Every frame
is like a photograph to me.

Jane
Directed by Brett Morgen

A beautiful documentary about the
incredible work of Jane Goodall.

North by Northwest
Directed by Alfred Hitchcock

The consistency of Hitchcock's
colour palette and composition in
this film is so stunning to me.

Playtime
Directed by Jacques Tati

I love how Tati uses each shot to
isolate and play with colour in such
a simple yet effective way.

Do Talks

*How to get young people
to love the land*
by Alice Holden

Slow is beautiful
by James Freeman

*The competition between
stubbornness and fragility*
by Giles Duley

*What's it like to farm fabric
and allow textiles to tell
a story?*
by Adele Stafford

Why companies need you
by Geoff McFetridge

*Design is the clearest form
of communication*
by Geoff McFetridge

*Why we need to celebrate
craftsmen*
by Nick Hand

Exhibits

Brooklyn Gang
by Bruce Davidson

In the American West
by Richard Avedon

Irving Penn Retrospective
by Irving Penn

The Americans
by Robert Frank

The Modern Century
by Henri Cartier-Bresson

Interviews

American Masters —
*Pedro E. Guerrero:
A Photographer's Journey*

Charlie Rose —
*Anton Corbijn
Bruce Weber
Richard Avedon*

Photographers who
have influenced me

Danny Clinch
Danny Lyon
Dorothea Lange
Fan Ho
Irving Penn
Koto Bolofo
Lee Friedlander
Richard Avedon
Robert Frank
Sally Mann
Todd Hido

RESOURCES

Places

Europe
Torch Gallery Amsterdam
Camera Work Berlin
V1 Gallery Copenhagen
Fondazione Sozzani Milan
Magnum Gallery Paris
Fotografiska Stockholm

Japan
Tokyo Photographic Art
Museum Tokyo

UK
Hamiltons Gallery London
Huxley-Parlour Gallery London
The Photographers' Gallery
London

USA
Kala Art Institute Berkeley, CA
Pier 24 Photography
San Francisco, CA
The International Center
of Photography New York
Magnum Fine Prints Photo
Archive New York
Center for Documentary
Studies at Duke University
North Carolina

(Favourite) Cameras

Pentax 67
Hasselblad 500CM
Leica M6
Plaubel Makina
Fuji GF670
Hasselblad Xpan
Polaroid NPC 195
Polaroid 600 SE
Rollei 35 T

Film

Polaroid 665
Polaroid 669
Fujifilm FP-3000B
Kodak Portra 400 35mm & 120
Kodak T-Max 400 35mm & 120

Other Gear

Manfrotto tripod
I don't use tripods much, but when I
need one, this sure comes in handy.

Noritsu scanner
The LS-600, LS-1100 and HS-1800
are all great.

Sekonic light meter
You can't go wrong with any model
— they're all good.

Picture List

The numbers below correspond to the page numbers in the book.

6–7. Contact sheet of artist Geoff McFetridge doing a chalk drawing in a Los Angeles gallery, circa 2007. This is when I first met Geoff and he filled this chalkboard with artwork over the course of an hour. I shot 3 rolls of film. Kodak Portra film shot through Hasselblad camera.

10. My childhood friend Ray Buchanan skating in a school yard in Chapel Hill North Carolina circa 1997. Kodak TRI-X film shot through a Canon AE1 camera.

12. My son Liam and wife Thao, summer 2018. Kodak TMAX film shot through a Plaubel Makina camera.

15. On a shoot in downtown San Francisco. Property of Dockers USA.

16–17. On the road in California with the American music group Tortoise. Kodak TMAX film shot through a Leica M6.

18–19. Anna, San Francisco, originally commissioned for now defunct clothing brand Mill Mercantile. Kodak Portra film shot through a Pentax 67 camera.

24–25. Artist Serena Mitnik-Miller on the dune bluffs of San Francisco's Ocean Beach, circa 2011. Kodak Portra film shot through a Mamiya 6X9 press camera.

26–27. Musician Douglas McCombs from Tortoise in a diner, Vancouver BC. Kodak TMAX film shot through a Leica M6.

32–33. Tortoise performing in LA at Royce Hall UCLA. Kodak TRI-X film shot through a Nikon F camera.

34–35. Detail from a contact sheet of Kyle Field aka Little Wings, shot in a parking garage in the Mission District of San Francisco, circa 2013. Kodak Portra film shot through a Contax 645 camera.

38. Musician John Herndon from Tortoise, Vancouver BC, circa 2016. Kodak TMAX film shot through a Leica M6.

40. Reading bench in Sibley Volcanic Reserve, Oakland CA, circa 2019. Kodak Portra film shot through a Hasselblad camera.

42–43. Musician Chaz Bundick, aka Toro Y Moi, in South Park, San Francisco, circa 2015. Kodak TRI-X shot through a Leica M6.

48. Chaz Bundick, aka Toro Y Moi, at his studio in Oakland, circa 2016. Kodak Portra film shot through a Pentax 67 camera.

50–51. The Mattson 2 band shot on location in San Francisco, circa 2015. The shoot was disrupted by a group of dogs arriving via their walker. Instead of getting frustrated, I put my cameras down and let things unfold. This is the one photograph I took during the 15-minute dog social. Beautiful chaos. Kodak Portra film shot through a Hasselblad camera.

54. Remi, North Beach, San Francisco, circa 2018. Kodak TMAX film shot through a Pentax 67 camera.

58–59. Paul, on the sand dunes in San Francisco's Ocean Beach. An original commission for clothing brand, Howies. Kodak Portra film shot through a Contax T2 camera.

63. Paul skateboarding in the Outer Sunset district of San Francisco, circa 2007. Kodak Portra film shot through a Contax T2 camera.

66–67. My daughter Sophie cruising through the streets of Berkeley, circa 2020. I was skating right beside her whilst taking the photograph. Kodak TMAX film shot through a Leica M6 camera.

68–69. Artist Geoff McFetridge painting on a jetty at the beach at Guethary, France, circa 2019. Kodak TMAX film shot through a Leica M6 camera.

73. Contact sheet from the SF Lines series shot over the course a few years. The intent was to show the sequence or sum of the parts vs the singular image. Kodak TMAX film shot through a Hasselblad camera.

76. Beachwood Canyon Trail in Griffith Park, Los Angeles, circa 2006. Kodak Portra film shot through a Hasselblad camera.

77. Just off Interstate 5 near the California Grapevine, circa 2005. Kodak Portra film shot through a Hasselblad camera.

78–79. Artist Serena Mitnik-Miller painting a mural, Menlo Park, circa 2014. Kodak Portra film shot through a Hasselblad camera.

82. Artist Evan Hecox in his Denver studio, originally commissioned for Levis Strauss, 2014. Kodak Portra film shot through a Pentax 67 camera.

86–87. Artist Geoff McFetridge in his Los Angeles studio, circa 2013. Part of a 10+ year personal project documenting his life's work that continues to this day. Kodak Portra film shot through a Pentax 67 camera.

93. Grower Alice Holden on the farm in Cardigan, Wales, circa 2014. This was a commission from Hiut Denim for their third Yearbook. Kodak TMAX film shot through a Pentax 67 camera.

96–97. Geoff McFetridge painting at his studio in Los Angeles, circa 2013. Kodak TMAX film shot through Pentax 67 camera.

98–99. Sarah Simon of the Magic Magic Roses band. This was a commission for Pottok Prints, shot in her home in San Francisco, circa 2018. Kodak Portra film shot through a Pentax 67 camera.

105. Artist Afton Love in her East Oakland studio, circa 2017. Originally commission by Levi Strauss co. Kodak Portra film shot through a Pentax 67 camera.

108. My family in Carmel by the Sea, California, circa 2019. Kodak Portra film shot through a Pentax 67 camera.

112–113. Off Interstate 5, somewhere between SF and LA. Kodak Portra film shot through a Hasselblad camera.

120. Portrait by my friend, Michael Blumenfeld, when we worked together on a shoot in Boston Mass, circa 2018. Polaroid 669 film shot through a Polaroid 600SE camera.

124–125. The cameras I packed to go on tour with the American band Tortoise, winter 2016.

About the Author

Andrew Paynter is a photographer and director based in Oakland, California, who is interested in exploring character and the creative process. His clients include Coca-Cola, Adidas, Levi Strauss, Converse, Apple, American Express, The North Face, *Rolling Stone*, and *W* magazine. He has also embarked on several long-term photographic collaborations including decade-long projects with Hiut Denim and artist Geoff McFetridge, long-standing work with the bands Tortoise and The Mattson 2, and his ongoing personal series *Working Artists*. Andrew's work appears in *Do Purpose* and *Do Open*, both by David Hieatt and published by Do Books.

Thanks

Thank you to Miranda West at the Do Book Company
in London. I have really appreciated the opportunity
to write a book (and the challenge).

Thank you to David and Clare Hieatt in Cardigan.
This whole journey would have never happened if it
weren't for our meeting back in 2011.

Thank you to Nick and Harriet Hand in Bristol. I've always
appreciated and cherished your encouraging words
and counsel.

Thank you to Kacie McGeary in Sacramento for helping
me write this book. I couldn't have done this without you.

Thank you to Hiut Denim for the opportunity to work
on the Yearbook project.

Thank you to Wilf Whitty in Bristol. I sincerely appreciate
your help in designing this book.

Thank you to Geoff McFetridge in Los Angeles. Working
with you changed everything for me. Just, thank you.

Thank you to the Do Lectures team for making me give a talk even though I really just wanted to go to West Wales to experience the whole thing. I'm so glad I did it.

Thank you to Danny Clinch in New York City. You have always inspired me and given me the courage to keep on keepin' on. I appreciate that.

Thank you to Drew Brown in NYC/LA/London. You've always been my soundboard for all things photography. Thanks for all the encouraging calls and editing help.

Thank you to two of my favourite creative directors, Chad Hinson in San Francisco and David Carrewyn in Atlanta. You have both believed in me and gifted me projects where I could be creative and feel free.

Thank you to my parents, Lucy and George Paynter in Winston-Salem, for never giving up on me and teaching me the beauty of earnestness and manners.

Thank you to my siblings, Nancy and Charles, and to my late grandparents, Bertram and Nancy Payne, for inspiring me ever since I was young.

Thank you to Underdog Film Lab, Candela Fine Art Printing, Dickerman Prints, and Rayko Photo Center for helping me make tangible pictures.

And most importantly, thank you to my family here in Oakland. Thao, Sophie and Liam — I love you.

Books in the series

Do Agile Tim Drake

Do Beekeeping Orren Fox

Do Birth Caroline Flint

Do Breathe
 Michael Townsend Williams

Do Death Amanda Blainey

Do Design Alan Moore

Do Disrupt Mark Shayler

Do Fly Gavin Strange

Do Grow Alice Holden

Do Improvise Robert Poynton

Do Inhabit Sue Fan, Danielle Quigley

Do Lead Les McKeown

Do Listen Bobette Buster

Do Make James Otter

Do Open David Hieatt

Do Pause Robert Poynton

Do Photo Andrew Paynter

Do Present Mark Shayler

Do Preserve
 Anja Dunk, Jen Goss, Mimi Beaven

Do Protect Johnathan Rees

Do Purpose David Hieatt

Do Scale Les McKeown

Do Sea Salt
 Alison, David & Jess Lea-Wilson

Do Sing James Sills

Do Sourdough Andrew Whitley

Do Story Bobette Buster

Do Wild Baking Tom Herbert

Also available

Path A short story about reciprocity Louisa Thomsen Brits

The Skimming Stone A short story about courage Dominic Wilcox

Stay Curious How we created a world class event in a cowshed Clare Hieatt

Available in print and digital formats from bookshops, online retailers or via our website: **thedobook.co**

To hear about events and forthcoming titles, you can find us on social media @dobookco, or subscribe to our newsletter

Available in November 2009 from Mills & Boon® Special Moments™

THE INHERITED TWINS

"Date a lot of single mums, do you?"

"Not so far." Heath regarded Claire steadily. "What about you? Dating anybody?"

"No."

He let his gaze rove over her hair, face and lips. "Why not?"

"I'm running a business meant for three all by myself," she said. "It's in the red. I'm bringing up the twins all by myself, and in case you haven't noticed, they're a handful."

His expressive lips tilted up in a playful half smile. "A cute handful. They have to sleep sometime."

Their gazes meshed and the seconds drew out. His head bent. Hers tilted. Their lips drew ever closer.

He was going to kiss her.

And she was going to let him!

CHRISTMAS IN KEY WEST

"It's been years, Abby."

Reese stuck his hand out. "You wouldn't shake my hand last night. I thought I'd try again."

She relented, clasped his hand and stared at the long fingers wrapped around hers. Bits of twig and soil stuck to their joined palms.

"Cleaning the yard, I see."

She leaned on her rake. "You cops don't miss a clue, do you?"

Reese crossed his arms. "So how've you been?"

How have I been? Abby marvelled at the casualness of his question in the light of what her life had been like since she'd last seen him. But of course Reese never thought of that night.

He'd had thirteen years to forget.

She'd had thirteen years to remember.

And regret.

First published in Great Britain 2009
Harlequin Mills & Boon Limited,
Eton House, 18-24 Paradise Road, Richmond, Surrey TW9 1SR

The Inherited Twins © Cathy Gillen Thacker 2008
Christmas in Key West © Cynthia Thomason 2008

ISBN: 978 0 263 87648 2

23-1109

Harlequin Mills & Boon policy is to use papers that are natural, renewable and recyclable products and made from wood grown in sustainable forests. The logging and manufacturing processes conform to the legal environmental regulations of the country of origin.

Printed and bound in Spain
by Litografia Rosés S.A., Barcelona

THE INHERITED TWINS

BY
CATHY GILLEN THACKER

CHRISTMAS IN KEY WEST

BY
CYNTHIA THOMASON

™ MILLS & BOON®

THE INHERITED TWINS

BY
CATHY GILLEN THACKER

Cathy Gillen Thacker is married and a mother of three. She and her husband spent eighteen years in Texas, and now reside in North Carolina. Her mysteries, romantic comedies and heartwarming family stories have made numerous appearances on bestseller lists, but her best reward, she says, is knowing one of her books made someone's day a little brighter. A popular author for many years, she loves telling passionate stories with happy endings, and thinks nothing beats a good romance and a hot cup of tea! You can visit Cathy's website at www.cathygillenthacker.com for more information on her upcoming and previously published books, recipes and a list of her favourite things.

Chapter One

In most situations, twenty-nine-year-old Claire Olander had no problem standing her ground.

The only two Texans who could weaken her resolve ambled to a halt in front of her. In perfect synchronization, the "negotiators" turned their faces upward.

Her niece, Heidi, pushed the halo of short, baby-fine blond curls from her face and tucked her favorite baby doll under her arm, football-style, so the head faced front. "How come we have to clean up our toys now, Aunt Claire?" the preschooler demanded.

Her twin brother, Henry, adjusted his plastic yellow hard hat with one hand, then gave the small wooden bench he was "fixing" another twist with his toy wrench. His amber eyes darkened in protest as he pointed out with customary logic, "It's not dinnertime!"

Claire wished it was. Then the business meeting she had been dreading ever since the bank auditors left to tally their results, six weeks ago, would be history. Aware there was no use worrying her nearly four-year-old charges, she smiled and tidied the stacks of papers on her desk one last time.

Everything was going to be all right. She had to keep

remembering that. Just like her late sister, Liz-Beth, she was more than capable of mothering the twins and managing the family business they'd started. "We are cleaning up early, kiddos, because we have company coming this afternoon," she announced cheerfully. In fact, the Big Bad Wolf should be here at two o'clock.

Heidi sat down cross-legged on the floor, placed her doll, Sissy, carefully across her lap, and began stuffing building blocks ever so slowly into a plastic storage bin. "Who?"

Claire knelt down next to her, and began to help, albeit at a much quicker pace. "A man from the bank."

"Can he hammer stuff?" Henry demanded.

Claire surveyed the two children who were now hers to bring up, and shrugged. "I have no idea."

Heidi paused. "What *can* he do?" she asked, curiously.

"Manage a trust." *Destroy my hopes and dreams...*

Henry carefully fitted his wrench in the tool belt snapped around his waist, and sat down beside Heidi. "What's a trust?"

"The fund that's going to pay for your college education one day."

"Oh." He looked disappointed that it wasn't something he could "repair" with his tools.

"Is he our friend?" Heidi asked.

Claire fastened the lid on the building blocks bin, and put it on the shelf in her office reserved for the twins' playthings. "I've never met him, honey. He just moved here a couple of weeks ago." She'd heard a lot about him, though. The newest member of the Summit, Texas, business community was supposed to be thirty-three years old, to-die-for hand-some and single, a fact that had the marriage-minded females in the community buzzing. Fortunately for Claire,

she was not one of the group jockeying for attention. She had her hands full with her fledgling business and the twins she had inherited from her late sister and brother-in-law.

"Is he going to have good manners?" Henry, who'd lately become obsessed with what to do and what *not* to do, inquired.

"I'm sure Mr. H. R. McPherson is very polite," Claire said. Most bankers were.

Heidi put Sissy on her shoulder and gently patted her back, as if burping her. Her brow furrowed. "What's H. R. McDonald's?"

"H. R. McPherson, honey, and those are initials that stand for his first and middle names." Claire could not blame him for using them on business correspondence, even if it did make him sound a little like a human-resources department. "Although," she observed wryly, shelving the last of the toy train cars scattered about, "who would name their son Heathcliff *and* Rhett in this day and age, I don't know."

"As it happens," a low male voice drawled from the open doorway behind her, "the hopeless romantic who came up with that idea was my mother."

As the sexy voice filled the room, it was all Claire could do to suppress her embarrassment. Talk about bad timing! She'd just mouthed off about the man she could least afford to insult.

Slowly, she turned to face the interloper.

The ladies in town were right, she noted with an inward sigh. Tall, dark and handsome did not begin to do this man justice. He had to be at least six foot four inches tall, and buff the way guys who worked out regularly were. Nicely dressed, too, in a striking charcoal-gray business suit, navy-and-gray-striped shirt and sophisticated tie.

His midnight-blue eyes glimmering with amusement, he waited for her to say something.

Flushing, Claire flashed a smile. "This is awkward," she said.

"No kidding."

She took in the chiseled features beneath the thick black hair, the straight nose, the eminently kissable lips. "And you're early."

He shrugged and stepped closer, inundating her with the compelling mixture of soap, man and sun-drenched November air. "I wasn't sure how long it would take me to find the ranch." He extended his hand for the obligatory greeting, then assisted her to her feet. A tingle of awareness swept through her.

"I didn't think you'd mind," he added cordially.

Claire probably wouldn't have, had she not been down on the floor with the kids, speculating inappropriately about his lineage, at the exact moment he'd walked in.

Ever so slowly, he released her hand, and she felt her palm slide across the callused warmth of his. She stepped back, aware she was tingling all over from the press of skin to skin.

"You can call me Heath," he told her.

She swallowed nervously. "I'm Claire." Aware of the little ones taking refuge at her sides, she cupped her hands around their shoulders and drew them closer, conveying that they would always be safe with her. "And this is Heidi and Henry, the beneficiaries of the trust."

Heath shook their hands solemnly. "Pleased to meet you, Heidi. Henry, nice to meet you also."

"Pleased ta meet you!" the twins echoed, on cue.

Claire grinned, happy her lessons on manners were sinking in.

"So when do you want to get started?" Heath asked in a more businesslike tone.

"Just as soon as their sitter arrives," Claire declared, glad he was putting them on more solid ground.

FORTUNATELY FOR HEATH, that wasn't long in coming. A pickup truck parked in front of the office and a petite woman, with cropped salt-and-pepper hair, got out. Claire introduced Mae Lefman, who, with a warm smile, led the children out of the office.

Through the double hung windows that fronted the ranch office, Heath watched them go. "Nice place you've got here," he remarked.

He knew, of course, that the Red Sage Guest Ranch and Retreat had been in the Olander family for several generations, and that oil had been drawn from the ground, until the wells all went dry.

Claire's dad had dabbled in ranching and worked to restore the property to its natural state. Claire and her late sister and brother-in-law had figured out yet another way to earn a living from the twenty-nine-thousand-acre spread.

Which was why he was here.

Heath braced himself for what could be a very unpleasant meeting. Tensing visibly, Claire Olander gathered the flowing folds of her chiffon skirt close to her slender legs and sat down behind her desk. She wore a dark-green turtleneck sweater, the same hue as the floral pattern in her skirt, and a charcoal-gray corduroy blazer. Soft leather boots peeked out from beneath the hem of her skirt.

Her hair was the same wildly curly honey-blond as her niece's and nephew's, the shoulder-length strands pulled

back from her face in a clip on the back of her head. Silver feather earrings adorned her ears.

She was a fair bit shorter than he was, even with the three-inch heels on the boots—maybe five foot seven. Slender. Feminine. Sexy in an innocent, angelic way. She was also stubborn. He could see it in the feisty set of her chin and the determined look in her long-lashed amber eyes.

Claire Olander was used to having things her own way.

And that, Heath knew, could be a problem.

He sank into a chair opposite her. "As you know, I've been recently assigned by the bank to administer the trust your sister and her husband left for the twins."

"Right. The banker who was doing it retired from First Star Bank of Texas a few weeks ago."

Heath nodded. "As trustee, my duty is to protect the financial interests of the kids. I'm concerned. The results of the audit were not good."

This was, Heath noted, no surprise to Claire Olander. She held up a slender hand. "I'm aware the health of the business could be better, but I've only had the guest cottages up and running for the past eight months."

He had noted how shiny and new everything looked when he drove in. "Orrin Webb, my boss at the bank, told me you opened after the death of Liz-Beth and Sven."

With sadness flooding her face, Claire turned her attention to the scenery outside the window. "This was our dream. Neither of us wanted to sell the ranch. Nor were we interested in trying to run cattle here, the way our dad did."

"It's my understanding that you inherited all the surface improvements on the property—meaning the ranch house and the barn—and your sister was bequeathed the mineral rights."

"The latter of which are worth nothing, since the wells here were pumped dry forty years ago."

"The land is owned jointly and can only be sold in one piece, if all parties agree."

"That's correct."

Heath consulted his notes. "You and your sister had equal shares in the guest-ranch business."

Again Claire nodded.

"Heidi and Henry received all their parents' assets upon their death, all of which remain in trust."

"That's correct."

Heath looked up again, as determined to do his job as she was to do hers. "Wherein lies the problem. The trust needs to be generating—not losing—income. The results of the annual audit in September show that the business is in the red."

"Some months it's in the red, others it's in the black. For instance, we were fully booked most of June, July and half of August."

Heath had known she was going to be difficult. "What about now?" he pressed.

Her shoulders stiffened. "What do you mean?"

"How many of the twelve guest cottages are rented?"

Claire flushed. "Thanksgiving is two weeks away."

"That doesn't answer my question."

She let out an aggravated breath and shot him a challenging look that in no way detracted from her femininity. "Right now, we have three of the cottages rented. Mr. and Mrs. Finglestein from upstate New York are here for two weeks. They're avid birders. Ginger Haedrick is here until the house she is building is ready to move into—that may not be until Thanksgiving week, though she'd like to get in sooner and is pushing

the builder along. It might work—Ginger is one of the real-estate brokers in the area."

"I've met her." She seemed ambitious, almost ruthlessly so. "She came by the bank to give me her business card, and offered to find me a place to live as soon as my townhome in Fort Stockton sells."

"And then we have T. S. Sturgeon, the mystery writer, who's here on deadline, trying to finish a book. I think she'll be at least a few more weeks, but again, it all depends."

"Which means you have a quarter of the cottages rented," he stated.

"It's *off-season*."

"How are the bookings for the holidays?"

Claire Olander pursed her incredibly soft-looking lips. "Does it matter? It seems you've already made up your mind that the Red Sage Guest Ranch and Retreat is a failure."

"I didn't say that."

Eyes flashing, she took a deep, bolstering breath. "Your questions implied it."

Silence thrummed between them.

"Here's the bottom line." Heath tried again. "If nine months pass and the trust is not productive—not turning a profit—something must be done. The mineral rights could be sold, for example."

"No!" She cut him off, her voice unexpectedly sharp.

"Or a portion of the business."

"Absolutely not!" She vaulted to her feet.

Heath stood, too. He put his notes away. "Look, I'm aware this is a lot to digest. You've got two weeks to think about it. In any case, on December first, the Tuesday after Thanksgiving, I am going to have to make some changes."

"What if I can get the bookings up and demonstrate that the business will start turning a profit immediately? Would that change things?"

Heath nodded. "Definitely. The trust doesn't have to be making a large profit, Claire. Particularly if there is potential for a lot of growth in the long run. There just has to be some."

She shrugged and planted both hands on her slim hips. "Well, then, I'll make it happen."

Trying hard not to notice how the preemptive action had drawn her sweater and blazer against her breasts, Heath said, "Speaking of vacancies… What would you think about me renting one of the cabins for the next few weeks?"

Claire froze, regarding him suspiciously. "The ranch is a twenty-five-minute drive from town."

Heath told himself he was not doing this to help her out financially. Nor was he doing it because she was treating him in a way that young and beautiful women never did. "I don't mind the commute," he told her with a challenging grin. And he liked the peace and quiet of the ranch. Liked the backdrop of rough granite and wild meadows, the mountainous back-packing terrain. This, he thought, was southwest Texas at its best.

He'd only been out here half an hour and he could see why she was so determined to hang on to her inheritance.

She studied him impassively. "When did you want to move in?"

"Tonight."

To her credit, she didn't so much as blink. Rather, she reached into her desk and removed a rental contract, plucked a pen from the holder on her desk and pushed both toward him. "How long do you want to stay?"

"Until my place in Fort Stockton sells and I find one here."

This time, he noted, she did blink. "So we're talking…"

"Weeks. Possibly months."

She paused. Whether she was happy about his request or wary, he couldn't tell. "I assume we're talking about a one-bedroom cottage?" she said finally.

He matched her pragmatic tone. "Yes."

Claire told him what the rate would be.

"Sounds fine."

After she made a copy of his credit card, she took a map of the ranch and a thick ring of keys from her desk. "You can have Cabin 1, which is closest to the ranch house, or Cabin 8."

"I'll take the closest one to the ranch house," Heath said without hesitation.

Claire led the way out of the office. Together, they walked across the gravel parking area, past a big red barn, to the path that led to the dozen cottages. The rustically designed structures were spaced well apart and attractively landscaped with native grasses and shrubs. The November air was brisk and clean, the red sage the guest ranch was named after in full bloom.

Claire stopped at the first homestead-style cottage. The one-story building had white clapboard sides, red shutters and door, and a sloping slate-gray roof. She unlocked the door and gestured him to enter. "As you can see, the unit has a small sitting room and a galley kitchen. The bedroom has a queen-size bed. Thermostat is here." She pointed to the wall, then the closet. "Extra linens are there. Cabins are made up once a week, unless you want to pay for daily maid service."

"Once a week is fine."

"There is a complimentary breakfast buffet every morning in the front parlor of the ranch house." Claire pressed the key into his hand and glided toward the front door.

Heath followed, surprised how sorry he was to see her go. "Dinner—?"

She flashed a regretful smile. "—is not currently offered."

"How did it go?" Orrin Webb asked.

Heath bypassed his own office, heading for the branch manager's. Orrin was very old-school, from his salt-and-pepper crew cut, to the horn-rimmed glasses he wore. He exuded a by-the-book attitude, mirrored by his starched white, button-down shirt and dark suit.

Shrugging, Heath sank into a chair opposite his boss's desk. "About as well as could be expected, given the news I had to deliver."

Orrin rocked back in his chair and propped his fingertips together. "I take it she's resisting any easy fixes?"

"Like selling off part of the business? Yeah."

"You don't need her permission to do anything in regard to the trust," Orrin reminded him.

"The success of the bank depends on the continued goodwill of people in the community. If they think we're steamrolling over her and the kids, just to increase the bottom line, they won't be bringing their property to us to put in trust. They'll let someone else see to the fiscal welfare of their heirs."

The other banker smiled. "And here I thought you might have trouble getting the hang of life in a smaller town."

"Summit may only have five hundred people but there are ten thousand more in the surrounding county. I want all their business coming here."

"My thoughts exactly. So what are your plans?"

"First, get to know Claire Olander and acquaint myself with the guest-ranch business she and my clients own. See if it really has the potential for growth that she thinks it does." Because if it didn't, Heath knew, he was going to have to sell the twins' share, even if he had to do it over her objections.

"How are you going to do that?"

"By staying at the Red Sage until my place in Fort Stockton sells."

"She agreed to let you?" his boss asked.

"She needs the cottages rented. At the moment, the majority of them are vacant."

"Did you talk to her about Wiley Higgins?"

"She wasn't in a frame of mind to hear it."

"He's not going to wait long before he pursues his goal," Orrin warned.

"Well, he better wait a while. 'Cause I'm telling you, if he goes in there too soon, his chances of success are nil."

Orrin paused. "What do you think your chances are of getting Claire Olander to see things your way?"

That his intervention could, Heath thought, be the answer to all her prayers? "At the moment? Slim to none."

Chapter Two

Heath had just driven up and parked when Claire came out of the ranch office late that afternoon. She walked straight toward him. "I had a call from someone named Wiley Higgins today. He wants to see me about a business matter and he used you and the bank as a reference."

It was all Heath could do not to grimace. "I didn't know he intended to phone you today."

Claire's eyes narrowed. "What does this guy want? Aside from a cottage to rent from now until after Thanksgiving?"

Heath nodded at the dusty truck making its way up the lane. "Why don't you ask him yourself?"

As Wiley parked his pickup, then climbed down, Claire eyed the name and logo painted on the side: Higgins Oil Exploration.

She tensed, just as Heath figured she would.

The young wildcatter wore a turquoise Western shirt, mud-stained jeans and expensive alligator boots. He swept off his black Resistol, held it against his chest and extended his other hand. "Claire Olander?"

She shook hands with him, her reluctance to have anything to do with oil companies reflected in her wary expression. "Mr. Higgins, I presume," she murmured dryly.

"You said on the phone you had a cottage I could rent."

She nodded. "And you said you had a business proposition you wanted to discuss with me."

"If it's all the same to you, ma'am—" Wiley shoved his cowboy hat back on top of his tangled, dishwater-blond hair "—I'd rather do that over dinner this evening. Soon as I have a chance to get cleaned up. Maybe the two of us could go back into town?"

A wave of unexpected jealousy flowed through Heath. He frowned.

Claire shook her head. "That's not going to be possible. I have two little ones to feed."

As if on cue, Henry and Heidi walked out of the ranch office. "We're hungry, Aunt Claire!" her nephew announced.

"We're going to have dinner as soon as I take care of Mr. Higgins and show him where he is going to be staying."

Undeterred, Wiley suggested, "I could join the three of you."

Why couldn't the oilman get the message to back off? Heath wondered. He turned toward the interloper, his shoulder brushing Claire's in the process. "The ranch doesn't serve dinner," he interjected mildly.

"I'd be happy to pay extra," Wiley declared.

So would Heath, as it happened. And not just because it would be convenient.

Claire looked at him. He shrugged and said, "Serving dinner would be a way to increase income for the ranch on a daily basis. I'd be in."

"We'll make it worth your while," Wiley offered. "Twenty-five dollars for each of us. You can't say no to an extra fifty bucks."

Claire looked as if she just might. "You don't even know what we're having for dinner tonight," she protested.

The wildcatter straightened the brim of his hat. "Doesn't matter, so long as it's hot and home cooked."

Heath hadn't had a home-cooked meal since he'd moved from Fort Stockton and lost access to a full kitchen. "Got to agree with him there," he said.

"Fine. But just so you fellas know, it's a one-time-only proposition," Claire said. She handed Wiley the paperwork for his cabin and a key. "I'll meet you in the ranch house kitchen at six-thirty. Henry, Heidi, come on, we've got work to do."

HEATH HAD JUST FINISHED shaving and brushing his teeth when the cottage phone rang.

Claire was on the other end of the line. "Would you mind coming over about ten minutes early? I've got something I'd like to discuss with you."

"Be right there." Whistling, Heath crossed the yard. Thanks to the recent switch from daylight saving time, it was already dark. The lights of the sprawling ranch house shone warm and welcoming. The smells coming from the kitchen were even better.

The twins were seated at the kitchen table, busy with coloring books and crayons. They each had a small bowl of dry cereal and a glass of milk nearby—probably to take the edge off their hunger while they waited for whatever it was that smelled so good to finish cooking.

"Hi, kids." Heath took in their angelic faces and thought about the lack of family in his life, how much he wanted to have a wife and kids of his own and a home just like this to

come to every night…. He'd had his chance, of course, but it hadn't worked out. Now all he had were his regrets.

"Hi, Mr. Fearsome." It was Heidi who spoke, but both twins beamed.

"McPherson," Claire corrected.

"Mr. Fearsome," the little girl repeated, enunciating carefully.

Heath grinned. "Close enough. Need a hand?" he asked Claire.

"What I need to know…" she paused to taste the applesauce simmering on the stove "…is what's going on between you and Wiley Higgins."

Reluctantly, Heath moved his gaze from her soft, kissable lips to the fire in her eyes. "What do you mean?"

She added another sprinkle of cinnamon and a pinch of nutmeg to the aromatic compote. Deliberately, she set the spoon on its rest, wiped her hands on a tea towel. "I saw the two of you exchanging words in the yard before you entered your cottages."

Heath waited.

She propped her hands on her slender waist. "I have the feeling I'm at the center of the disagreement."

Hoping to spare the twins any unnecessary worry or alarm, Heath kept his gaze on Claire's and inched closer. "Then you would be right."

Her eyes darkened. "Why?"

He shrugged. "Wiley Higgins can be dogged in his quest for something."

"So in other words, you feel you need to protect me from his single-mindedness."

Unused to being penalized for taking charge of a business

situation, Heath said, "Not protect." If ever a woman seemed capable of standing on her own, it was Claire Olander.

"Then what would you call it?" she asked.

He gestured enigmatically. "Doing things in an orderly fashion."

She'd taken off the blazer she had been wearing earlier. Now she pushed the sleeves of her sweater to her elbows. "And how would we do that?"

Heath tried not to notice the smooth, pale skin of her forearms as he braced one hip against the counter. "We'd start by sitting down together and taking a detailed look at ways to improve your guest-ranch business."

She turned so that one of her hips was resting against the edge of the counter, too. "I've already done that," she snapped.

He maintained an even tone as he replied, "You haven't shared any of the ideas with me."

"Fine." Claire released an exasperated breath that lifted the swell of her breasts beneath the soft fabric of her sweater. "When did you want to do this?"

He shifted restlessly, to ease the building tension behind his fly. "As soon as possible." He wanted time to implement changes.

As Claire considered her options, she gave the simmering applesauce another stir. "The car pool picks the twins up at eight-thirty tomorrow morning. I can do it any time after that."

"Eight-thirty it is, then," Heath agreed promptly.

Wiley Higgins swaggered in just then, freshly showered and shaved. He looked from Claire to Heath and back again, then he smiled like a detective who had just found an interesting clue. "What'd I miss?"

CLAIRE WASN'T SURE whether she resented or welcomed the interruption. All she knew for certain was that Heath McPherson had the ability to get under her skin with surprising speed.

Working around him was not going to be easy. Either in this kitchen, where his imposing frame took up way too much space, or in business, when it came to satisfying the fiscal requirements of the trust. But she would manage—she had no choice.

"Have a seat, fellas." Claire took the roasting pan from the oven. She moved the already sliced pork tenderloin to a platter, and spooned roasted potatoes, green beans and applesauce into serving dishes. After placing them on the table, she brought out a tossed green salad from the fridge.

"Henry, do you want to try the pork tonight?" she asked.

When he shook his head, she popped two slices of whole wheat bread into the toaster and got out a jar of peanut butter.

Heidi explained solemnly, "Henry only eats peanut butter toast for dinner."

"Really?" Wiley said. "This food looks awfully good."

"I'll eat it," Heidi interjected proudly. "I like everything. But Henry doesn't."

Her brother glanced at Heath. Claire, too, was curious to see the man's reaction.

"I'm glad you know what works for you," he said. "It's important for a fellow to know his own mind."

Henry's eyes widened appreciatively. That was not the reaction he usually got.

Claire flashed Heath a grateful smile, then sat down at the table. While they helped themselves, family-style, to the

food, she cut straight to the chase with Wiley. "So what was this business you wanted to discuss with me?"

"I'm in Summit County to look for oil."

She lifted her palm. "The wells on the Red Sage went dry forty years ago."

That information didn't deter Wiley. "Conventional extraction yields only thirty percent. The rest of the oil squeezes into tiny cracks in a reservoir and clings to the underground rocks. There's a process now that wasn't available at the time your wells were capped, called water-flooding."

"I know all about injection wells," Claire said. Out of the corner of her eye, she saw Heath accept a bite of Heidi's green beans with great relish. Suppressing an amused smile, she continued, "The oil companies push water into the ground and try to wash out the remaining oil."

Wiley nodded, as Henry offered Heath a bite of peanut butter toast. "That'll get out a portion, but not all. Adding surfactant could get out even more."

Claire shook her head, as Heath offered Henry a bite of his meat, which he refused. "I don't want chemicals on my land," she said.

Ignoring the increased restlessness of the kids, Wiley pushed on. "We could also inject steam or carbon dioxide into the wells."

Henry offered Heath another bite of peanut butter toast, which was wordlessly accepted. Not to be outdone, Heidi gave him another green bean.

With effort, Claire pushed aside thoughts of how comfortable he was with the kids and what a great dad Heath would be, and brought her mind back to the business at hand. "Injecting steam requires putting in huge pressure vessels

to heat the water. I don't want anything that dangerous or noisy or intrusive on the ranch," she stated decisively. "The same goes for carbon dioxide."

"How about putting microbes into the wells then?"

It was all she could do not to roll her eyes. "Microbes produce large amounts of gas and pressure underground."

"Properly handled," Wiley countered, with the smoothness of a snake oil salesman, "that shouldn't be a problem."

Claire disagreed. "It's bacteria. We have well water out here. I'm not taking any chances that our drinking water might be contaminated, now or in the future."

Heath gave her an admiring glance. "You know a lot about this."

Glad for the interruption, she nodded. She wanted him to understand her position. "A couple years before my dad died, after he had stopped running cattle out here, an oilman came by and tried to convince him to reopen the wells. Dad said it took him forty years to get the land back to its natural state. No way was he letting heavy trucks and machinery tear up the place, after all his hard work."

Wiley cleaned his plate. "There could be a lot of money involved here, Claire."

About that, she noted in disappointment, Heath did not disagree. But then, what had she expected? He was a banker— a bottom-line guy.

"And it could be," she countered, "that the process of getting to whatever oil is left in there—if there is any in the ground on this ranch—is not going to be economically viable for you or any other wildcatter."

Wiley frowned. "Don't you want to find out?"

She scowled right back. "Nope."

And then and there, the twins' patience—what was left of it—ended.

Henry tipped his milk glass over. Heidi did the same. The liquid from Henry's flowed into Wiley's lap, that from Heidi's splashed onto Claire's. Both victims sucked in a distressed breath as Heath, who'd been unscathed, grabbed for napkins.

"Oh my goodness!" Claire jumped up to get clean dish towels to mop them up.

Wiley grimaced as the liquid soaked into his pants. He looked as uncomfortable as she felt. "No problem," he drawled. "Accidents happen."

Only, Claire thought, it hadn't been an accident.

"EVERYTHING OKAY?" Heath asked twenty minutes later, when Claire finally came back downstairs, this time without her two young charges.

"The twins are fine." She sighed, feeling a lot more comfortable now in faded jeans and a loose-fitting shirt. "Just overtired." She'd scolded them gently for their end-of-dinner behavior, then helped them brush their teeth and change, and finally tucked them into bed.

The effort left her feeling the way she did every night around this time—like she had just run a marathon.

Claire paused to look around. "What happened to Wiley?"

"He took his pecan pie à la mode and went back to his cottage to change and check his messages."

Before sprinting up the stairs with the twins, Claire had told the guys to help themselves to dessert and coffee. Heath had apparently not yet done so, in favor of cleaning up the table and scrubbing the pots and pans. She studied his rolled-up shirtsleeves, and the damp towel thrown across one broad

shoulder. He looked as at home in her kitchen as she was. She wouldn't have expected that of a man in his line of work.

She watched the play of muscles in his brawny forearms as he scrubbed down the table and counters with an enticing combination of strength and finesse. She edged closer, taking in the brisk woodsy fragrance of his cologne. "You didn't have to stay." But she was suddenly glad he had. It was nice having company—attractive male company—after hours.

Finished with the cleanup, he let the sudsy water out of the farmhouse-style sink. "I felt I owed you after such a delicious meal."

Claire reminded herself Heath was a paying guest. And as such, not a target for lusty fantasies.

Pushing away the image of those same nimble fingers on her bare skin, she quipped, "And a rather inglorious end."

He chuckled. "Tip things over accidentally-on-purpose often, do they?"

"No." Thank heavens.

Heath hung up the dish towel and lounged against the counter again, one palm flattened on the gleaming top. "I get why they did that to Wiley. He's a bit of a blowhard. But why they doused you—now that's a mystery."

Claire shook her head ruefully. "I think they were trying to tell me I should have paid more attention to them during the meal. Suppertime is their time. They get my undivided attention. I should have known better than to turn it into a business meeting and a chance to pick up some extra cash, by charging you two for the meal."

Heath's blue eyes narrowed. "Why did you?" he asked with curiosity.

She sighed. "I knew I had to hear Wiley out sometime, or risk him pestering me to death. I figured the twins' brief attention span would keep his sales pitch short, and I would have skated by, without offending a paying guest. Which, you may have noticed," she intoned dryly, "I need."

"And me?"

Easy, Claire thought, cutting them each a slice of pie. "I wanted you to know my opinion on what he is trying to do, and it was easier to have you hear it firsthand than for me to repeat it."

"Ah." Heath watched her scoop out the vanilla ice cream.

Their hands brushed as she handed him a plate and fork. "So now that you do—"

"That's it?" Heath interrupted, taking a seat at the kitchen table again. "I don't get a chance to weigh in? As trustee?"

Claire sat opposite him. "Not tonight." She marveled at how much this was beginning to feel like a date.

He shrugged, even as he savored his first bite of pecan pie. "Fair enough."

That, Claire thought, was a surprise. She had expected him to be just as pushy as Wiley Higgins, when it came to business. Yet he was giving her a pass, at least for now. To get on her good side? "So back to the dishes. Thank you for doing them."

"No problem."

"But in the future, it's not necessary." Claire resisted the intimacy his actions engendered. "You're a guest here. Not the help."

A brooding look came into his eyes. He spoke in a kind, matter-of-fact voice. "I was raised by a single mom. I remember how tired she was at the end of every day. So I helped

then. And I help now, whenever I see a woman in need of assistance."

A poignant silence fell between them. Was that how he saw her? Claire wondered. She deflected the rawness of the moment with a joke. "Date a lot of single moms, do you?"

"Not so far." Heath regarded Claire steadily. "What about you? Dating anybody?"

She flushed. "No. Not for the past couple of years."

Appearing just as distracted as she was, Heath let his gaze rove over her hair, face and lips before returning with laser accuracy to her eyes. "Why not?"

"I'm running a struggling business meant for three all by myself," Claire reminded him. "I'm bringing up the twins on my own, and in case you haven't noticed, they're a handful."

His expressive lips tilted up in a playful half smile. "A cute handful." He stood and carried his empty plate to the dishwasher.

Claire did the same. "They take every ounce of emotional energy I have, and then some."

"They have to sleep sometime."

"And generally, when they do, I do. Seriously, I was never so tired before I became their mom. My sister always made it look so easy." Claire sighed, wishing Heath didn't have a good eight or nine inches on her in height. The disparity in their bodies made him seem all that more overwhelming.

He clamped a gentle hand on her shoulder. "It probably was, comparatively, if there were two parents handling things."

Tingling beneath his grip, Claire stepped back. "So what are you saying?" she demanded, raising her hands in a mock gesture of helplessness. "I should get married? Go husband hunting?"

"Wouldn't hurt to open the door to the possibility," he told her wryly.

Aware that her pulse had picked up, Claire conceded, "Maybe in five, ten, fifteen years, when they go off to college. Until then, I'm on my own and staying that way."

"Sure about that?" he murmured.

Claire straightened with as much dignity as she could manage. "Quite sure."

He smiled. Their gazes meshed and the seconds ticked by. His head bent, and hers tilted upward. Their lips drew ever closer. He was going to kiss her, Claire realized suddenly, and she was going to let him!

Or at least he would have kissed her just then, had it not been for the pitter-patter of little feet just outside the kitchen door.

The adults turned in unison as Heidi and Henry entered the room. As always, they looked adorable in their pajamas, their blond curls askew.

Heidi had her favorite doll baby, Sissy, tucked beneath her arm again. "Aunt Claire?" she asked, her expression absolutely intent.

Claire's heartbeat quickened even more. "Yes, honey?"

"When are Mommy and Daddy coming home?"

Chapter Three

Claire breathed in sharply, clearly thrown off guard by the twins' innocent query. Briefly, a mixture of grief and shock crossed her face.

Just as quickly, she pulled herself together and approached the twins. Kneeling down in front of them, she wrapped her arms about their waists, and pulled them toward her. "Mommy and Daddy are in heaven," she said very gently. "Remember? We talked about this."

"Yeah," Heidi said, pointing upward as if to demonstrate her comprehension. "But heaven's up there in the sky."

"And birds are, too," Henry concurred.

"But birds come down. On the ground. So when are Mommy and Daddy going to come down on the ground, too, and come see us again?" Heidi asked plaintively.

"We miss 'em," Henry said sadly.

"I know you do," Claire said, her own voice thick with unshed tears. "I miss them, too. But they can't come back and be with us, as much as we want them to."

Heidi and Henry fell silent, their expressions both stoic and perplexed. Claire gave them another hug. "What do you say we go upstairs and I read you another story?"

"Can he come, too?" Henry pointed at Heath.

"Yeah. I bet he likes stories," Heidi declared.

"We can't ask Mr. McPherson to do that," Claire said softly.

The twins both looked as if they were about to pitch a fit.

Figuring a change of mood was in order, Heath interjected, "Sure, I can. In fact, I've got to tell you, I am one fine story-reader. I can even do voices."

Claire sent Heath a grateful look, making him glad he had intervened.

Heidi's brow furrowed. "What do you mean, you do voices?"

"Ah!" Heath held out a hand to Henry, who looked the most ready to revolt. "I guess I'll have to show you. What stories do you like best?"

"Ones about Bob the Builder," Henry said, thrusting out his bottom lip.

"Ones about dolls," Heidi declared. "And Sissy likes them, too."

Together, they all headed through the hallway, past the formal rooms, reserved for ranch guests, and up the wide front staircase. Claire looked over their heads and mouthed, "Thank you," to Heath.

He whispered back, "You're welcome."

Twenty minutes and four stories later, the twins were finally drowsy. "It's bedtime now, for real," Claire said. "You have preschool tomorrow morning, and you don't want to be too tired to enjoy it."

"Okay." Henry stifled a yawn, holding out his arms for a hug. Claire obliged. When she released him, Henry turned to Heath, and held out his arms again.

Ignoring the sudden lump in his throat, Heath hugged the little boy. At times like this, he wished he had made better choices. If he had, he might have married a woman who wanted children as much as he did. Instead, he was still searching for a woman who wanted the same things out of life. A woman who yearned for more than a successful husband and a growing bank account. A woman who would put family first. A woman like Claire. And kids like the twins.

Heidi hugged both of them, too, then smothered a yawn with the back of her hand, too. Clasping her doll Sissy, she snuggled down into the covers. "Night," she said, already closing her eyes.

Heath's heart filled with tenderness.

"I'll see you in the morning." Claire backed out of the room, Heath following suit. Soundlessly, the two of them crept down the stairs.

They walked back to the kitchen. "Do you want some coffee? I can't drink regular this late in the evening, but I can handle decaf," she told him.

"Sounds fine. Thanks."

Claire released a breath. "You were great just now."

Seeing how upset she still was, wanting to help in whatever way he could, Heath leaned in the doorway. "Does that happen often?"

"Once every couple of weeks now. Initially, it was all the time." Claire's hands trembled as she tried to fit the paper filter into the coffeemaker. Eyes focused on her task, she continued, "The psychologist our pediatrician referred us to said that children under age eight don't really grasp the concept of death. They don't understand the finality of it. So it takes them a long time to really accept and adjust to the

fact that their loved ones aren't coming back, that they won't see them again on this earth." Claire raked her teeth across her lower lip, shrugged her shoulders helplessly. "I've tried to explain about heaven, about how one day we'll all be together again, but I don't think they get that, either."

Without warning, the tears she had been holding back splashed down her cheeks.

Heath didn't have to think; he knew what he had to do. He crossed the kitchen in two long strides and took her into his arms. No sooner had he pulled her against his chest than the dam broke. Claire's whole body shook with silent sobs. His shirt soaked up her tears, and still she cried, her face pressed against his shoulder. He wrapped his arms closer around her, not sure what to say, only knowing that she needed to be held as much as he needed to hold her. Finally, the shuddering stopped.

Claire wiped the heel of her hand beneath her eyes, then drew back. "I'm sorry," she sniffed.

"Don't be."

She shook her head, looking aggrieved. "I shouldn't be behaving this way. Especially not with you…"

Heath stroked a hand through her hair. "You've got every right to be sad," he soothed. But even as he spoke, he could see she didn't want to feel that way. She wanted the mourning to be over. She wanted to be able to move on.

And he wanted to help her do that.

CLAIRE SAW THE KISS coming. Realized she could stop it. All it would take was a look, a sigh, a shake of her head. Instead, she lifted her face to his and stepped back into his embrace. Her lips parted as his touched hers, and then everything in

her life that was painful and wrong, everything that should never have happened, faded away.

She reveled in the taste and smell of him, in the tenderness of his touch and the reckless abandon of his kiss. He held her as if she were the most fragile possession on earth. He kissed her as if she were the strongest. And in truth she felt both.

Like she could handle anything.

She just didn't want to handle it alone.

Not anymore.

And that, more than anything, was why she broke off the kiss and stepped back.

They faced each other, their breathing erratic.

But the apology she half expected from Heath never came.

And it was easy to see why.

Judging from his expression, he wasn't sorry he kissed her. Any more than she was that he had. And what was up with that? She knew better than to mix business with pleasure, to get involved with a paying guest. And she especially shouldn't be kissing the man in charge of the twins' trust fund. Which was why she had to get him out of here before they got any closer.

She flashed an officious smile and glided away from him. "Let me get you a cup of coffee for the walk back to your cottage."

"Thanks."

She filled a mug, turned and handed it to him. Their hands brushed once again as the transfer was made, and Claire felt another whisper of desire float through her, stronger than before.

Until now, she hadn't realized how lonely she was.

Now, she knew.

And so did he.

"See you in the morning," he said.

"Eight-thirty," she confirmed, her heart still pounding, all her senses in overdrive.

But, as it happened, she saw him sooner than that. Heath was in the front parlor, helping himself at the breakfast buffet, when she shepherded the kids toward the front door, to wait for their preschool car pool. He was clad in a navy-and-white pin-striped shirt and navy suit that made the most of his tall, muscled frame and brought out the blue of his eyes. One look at his ruggedly handsome face and enticing smile and she knew he was thinking about the kiss they'd shared, as much as she was.

Deliberately, Claire turned away. "Now, remember," she told the twins, as she stopped at the front hall closet and took a gift-wrapped package off the shelf. "You're going to a birthday party this afternoon. Buddy Nesbitt's mommy and daddy are going to drive everybody to Buddy's house, and you're going to have pizza and birthday cake, and play games. And then when the party is over, I'm going to come and get you and drive you home."

"Are they going to have candles?" Henry asked, standing patiently as Claire helped him into his light jacket.

"Yes. I'm sure they'll have candles on Buddy's cake."

"Is he going to do that wish thing and blow them out?" Heidi asked.

"Yes, he gets to make a wish, and then he blows the candles out."

"But he can't tell anybody or it won't come true," Heidi recollected solemnly.

"Right. Birthday wishes are secret," Claire said.

"I want a birthday," Henry declared.

"Your birthdays are coming up next week."

Heidi perked up. "Do we get a party?"

"You do," Claire said. "It's going to be at the park and you can invite all your friends. It should be a lot of fun."

"Yes!" Henry clapped his hands together.

Hearing a car rumbling up the drive, Claire opened the door and herded the kids out to the nine-passenger vehicle. She handed the present to the mom driving the car, for safe-keeping, made sure the twins were both buckled in, then stood waving as the van disappeared again.

Heath came out to stand beside her. "The twins seem okay this morning," he noted.

Remembering how much help he had been to her the night before, she turned to him with a wry smile. "That's the way it is. One minute they're confused and grieving, the next it's like nothing ever happened."

Heath searched her eyes. "I gather you have a harder time bouncing back?"

"Unfortunately, I understand the finality of our loss." As an image of her late sister came to mind, Claire swallowed. She focused her attention on the horizon as she confessed, "I think the holidays are going to be tough."

Sympathy radiated in his low voice. "Your first…"

She nodded. "Without Liz-Beth and Sven, yes." She swallowed again, then knotted her hands into determined fists at her sides. "But we'll get through it, because we still have a lot to be thankful for." She paused, drew a bolstering breath. "Speaking of which, you ready to go over to the ranch office and talk about how we can make the numbers work?"

He nodded, all business once again. "Lead the way."

HEATH SETTLED IN A CHAIR on the other side of Claire's desk, aware this wasn't an ordinary business meeting, any more than the kiss they'd shared the night before had been ordinary. What happened in the next few weeks would either make or break Claire's dreams for the Red Sage, while simultaneously securing the twins' inheritance.

Heath did not want to be in the position to make that kind of impact on her hopes for the future. But it was his job. And he always did his job.

Claire folded her hands together and consulted the handwritten notes in front of her. "You said the other day that as long as the business demonstrated the potential for growth, as long as the guest ranch could turn a small profit, you wouldn't have to sell anything."

Trying not to notice how pretty she looked in a dark-gold sweater and brown-and-gold paisley skirt, Heath nodded. "The problem is, according to the rates you've set for the rooms, that's not going to happen, with the kind of occupancy you've got right now."

She leaned back in her swivel chair. "We were at capacity for seven weeks this summer."

Heath kept his eyes locked on hers. "And not even half occupied since September."

A delicate flush highlighted her cheeks. "I put up a Web site, and that's bringing in some business. But obviously I've got to do more, which is why I've written to every newspaper and magazine editor in the state and let them know we're open for quiet R & R, family reunions, business retreats."

"When did you do that?"

Resentment colored her tone. "I started sending out letters the end of August, the beginning of September, when things slowed down."

A good move, but possibly not enough. "What's the response been?" Heath asked.

The evasive look was back in her eyes. She started to rise. "Can I get you some coffee?"

He respected her too much to be anything less than forthright. He shook his head in answer to her question and said, "It's not enough just to send out brochures."

She sank back in her desk chair and rocked back and forth impatiently. "I've made phone calls, too."

"Any results?"

She hedged. "All it would take is one good review in *Southwestern Living* magazine, or the travel section of a Houston or Dallas paper travel section, and I'd be fully booked in no time."

"Even if you were to get good press right now, I'm afraid it might be too little too late."

Claire massaged the back of her neck with both hands. "If we could just hang on until next spring, and be patient…"

Heath pretended not to notice the way her posture drew his attention to her curves. "Right now the ranch is operating anywhere from five hundred dollars a month in the black to five thousand dollars in the red."

"I know." Claire dropped her hands. A pleading note came into her voice. "But if you average those numbers over the nine months we've been open, I'm only short a thousand a month."

He wished he could cut her a break. "What about the winter months coming up?" he inquired matter-of-factly. "Do you have bookings?"

Again she looked regretful. "Some."

"How many?"

Claire sighed. "Not enough."

Not nearly enough, he thought in disappointment, when she reluctantly showed him her list of reservations. "Is there any other way you can bring in money?"

She tilted her head and the subtle movement brought him the lavender scent of her perfume. "We had plans to turn the barn into a party facility, use it for wedding receptions and big parties, but Sven and Liz-Beth died before we could get started on that."

It was a good idea. Unfortunately, it couldn't happen fast enough. "You could charge for breakfast."

Claire disagreed. "All the big hotel chains offer free breakfast with an overnight stay now. To stay competitive, I have to do that, too."

Silence fell as they both stared at the numbers on the pages in front of them. "Is there any equipment you could sell—like a tractor or something—to temporarily add to the profits?"

"We liquefied everything we could when we were building the cottages. What little lawn we have mowed now, that isn't xeriscaped or returned to the wild, is done by a rancher in the area." Claire leaned forward, and Heath sensed it was all she could do not to grip his hands. "If I can get good press, more exposure, I can turn this around."

Heath figured he could ask around at the bank, see if anyone at the other branches had any ideas, or was in a position to call in a favor. In the meantime, he would be straight with her. "You've got a little less than two weeks."

Claire was unable to mask her disappointment. "And if I can't manage to turn things around by then?" she asked warily.

He exhaled, hating to be the bearer of bad news to such a sweet woman. "Then we're going to have to look at doing

one of two things. Lease or sell at least part of the mineral rights to the ranch. Or sell off part—or all—of the twins' share of the business."

If he had to do either, Heath knew, she would end up resenting the heck out of him.

There'd be no more kisses.

No more confidences.

Not even the possibility of romance.

And that really stunk.

IT WAS NEARLY EIGHT in the evening by the time Heath left the bank, grabbed a bite to eat and got back to the Red Sage. As he pulled into the parking lot, real-estate broker Ginger Haedrick drew up beside him. They got out of their vehicles at the same time.

Ginger gestured toward the office, where lights were blazing. "What's going on?"

Through the windows, Heath could see most of the other Red Sage guests milling around Claire. "I don't know. Let's find out."

The two of them went over to the office.

When they walked in, Heidi and Henry looked up from the toy corner. They had obviously already had their baths, and were in their pajamas.

"Hey!" Henry's face lit up. He elbowed his sister. "Look! It's Mr. Fearsome."

Heidi grinned, too. She plucked a picture book off the shelf and ran over to him. "Can you read us another story with voices?"

"We went to a party today," Henry declared, ignoring his twin. "They had cake and everything."

"Yeah." Heidi clutched her storybook to her chest, and peered up at Heath. "We helped Buddy blow out the candles because he couldn't do it all by himself."

"That's great." Heath smiled.

Ginger looked over at the banquet table in the corner. It was covered with a gingham tablecloth as well as boxes of pizza, paper plates and napkins. An ice-filled washtub holding canned sodas sat on the floor next to it. "Y'all having a party?" she asked, in a tone that indicated if it were true, it wasn't much of a celebration.

"We're helping Claire make a sales video for the ranch," Mr. Finglestein said. He and his wife were dressed identically in khaki trousers, plaid shirts and multipocketed canvas vests. Both had binoculars slung around their necks. The excitement in their eyes made them look younger than their fifty-something years.

Mrs. Finglestein nodded and indicated the jumble of cameras, cables and laptops connected to Claire's computer. "We're letting Claire use some of the footage we've shot while we've been birding."

T. S. Sturgeon, the mystery writer on deadline, looked up from the yellow legal pad she was scribbling on. "I'm writing the copy." She paused and considered Heath. "You have a nice voice. Deep. Resonant. Quietly authoritative. Maybe you should do some of the voice-overs."

Mrs. Finglestein nodded. "It would be worth your while. If you help, you get a free night's stay."

Claire avoided Heath's eyes. With good reason, he thought. Making the sales video was a good idea, but reducing her profits for the month even further by giving away free lodging was not.

"Ginger could give it a try, too," T.S. said. "Maybe have both a man and a woman speaking."

Mrs. Finglestein nodded. "Might broaden the appeal."

The twins tugged on Heath's pant legs, soundlessly pleading for him to pick them up. Aware they were a little old for that, but also probably a little overwhelmed by the chaotic activity, he scooped one up in each arm.

"Read to us!" Heidi tried to give him the book, and ended up thunking him in the chin.

Claire sent them a distressed look. "Kids…!"

The door to the office opened. Mae Lefman, babysitter and part-time ranch employee, walked in.

Claire's spine relaxed in relief.

"I got here as soon as I could," Mae said, with a smile.

"They're all ready for bed," Claire told her. She crossed over to the children, and one by one, removed them from Heath's arms, kissing and hugging them before setting them down next to Mae.

"I have work to do." Claire knelt and faced Heidi and Henry, meeting them on their level. "So Mrs. Lefman is going to put you to bed and stay there with you until I'm finished."

"Can Mr. Fearsome read us a story with voices?"

"No, honey, not tonight. But Mrs. Lefman will read to you."

"How about Curious George books?" Mae suggested, holding out a hand to each twin. "They're lots of fun."

Wistfully, Heath watched the children walk across the yard to the ranch house. It shouldn't matter to him who read the kids a bedtime story. But somehow it did…

Which probably meant he was getting way too involved.

"So how about it?" T.S. asked, drawing Heath back to the present. "Either of you interested in doing the voice-overs?"

"Thanks for the invitation, but Heath and I already have plans," Ginger interjected. "I promised to show him some real-estate listings this evening so we can start looking at properties tomorrow. Maybe we can help some other time?"

"Don't worry about it." Claire looked at Ginger with the patience of a saint, given the agent's rather snotty attitude. "But thank you for the offer."

"If you need a voice-over," Heath interjected, "or any other help, count me in. I don't know a lot about putting together a video, but I'm a quick study."

"Thanks. But I think we've got it covered. Y'all should stick to your original plans."

She was jealous, Heath realized with surprise. And there was no reason for her to be. Now was not the time to clear that up, however. That was a discussion best had without an audience. "Well, if you think of anything I can do, let me know," he volunteered. "I'll be back later."

Claire nodded and turned back to the computer screen in front of her.

Clearly resenting anything that got in the way of her making a sale, Ginger touched Heath's elbow and escorted him toward the door. "The house I want to show you hasn't come on the market just yet," she said, loudly enough for everyone else to hear. "But it's renovated and move-in ready. If you like it, we can make a preemptive bid," she added, ignoring the fact he'd told her he did not want to purchase anything until his old home had sold. "You could be moved into your new place before the Thanksgiving holiday…."

And not so coincidentally, Heath thought, off the Red Sage. Away from Claire and the kids….

"Pushy, isn't she?" T.S. murmured, after the two had left.

Struggling not to feel resentful, Claire shrugged, "Ginger's just doing her job."

"She's after Heath," Mrs. Finglestein stated.

So what if she was? It wasn't Claire's business. One kiss did not make her and Heath a couple, or anywhere close to it. They hadn't even gone on a date. Nor were they likely to, given their complicated business relationship. "He's single," she said stiffly.

Mr. Finglestein studied her. "*You* should make a play for him," he announced.

Claire flushed. Deep down, she'd had much the same thought. "Why do you say that?"

He shrugged. "I don't know."

"Because you'd make a cute couple!" his wife exclaimed.

"Not everyone needs to be married." T.S. turned to Claire with a wink. "But a little romance is always nice."

Claire's face was now fire-engine red. "He's a guest!" she declared, as if that settled it.

"And you're a woman and he's a man," Mrs. Finglestein quipped. "Seriously. You're both available. We all saw the way Heath was looking at you just now. You should think about pursuing the attraction."

"What's the harm in generating a few sparks?" T.S. teased.

None, Claire thought. Unless her plan to make the guest ranch a success sputtered and failed, and Heath was forced—by virtue of his own responsibilities—to end her family's dreams.

Chapter Four

Figuring he should take advantage of the trails everyone had been raving about, Heath set his alarm, grabbed a flashlight and went for a predawn run. The morning was crisp and clear and the air felt good in his lungs. Coming back to the ranch house afterward, he noticed that the lights were on.

Through the windows, Heath could see Claire moving around the kitchen.

He wondered if she was still ticked off at him, and even more curious as to why it mattered so much. After all, the two of them had just met.

He exhaled.

It all came down to the kiss they'd shared. His response to her, hers to him. There was definitely something there. Some special chemistry he could not ignore. He paused to stretch out his muscles, drew a few more deep, cooling breaths, then sauntered in.

Claire took a pan of freshly baked cinnamon rolls from the oven and set them on the counter to cool.

"Everything okay?" he asked.

She gave the pot of oatmeal a stir. "Why wouldn't it be?"

Damn, but she looked gorgeous in a long denim skirt, a

chestnut-hued sweater and the stack-heeled boots she wore around the ranch. Her honey-blond curls had a mussed, casual look that suited her perfectly. Heath edged closer. "You were up awfully late last night."

Bypassing the coffee simmering on the warmer, she poured him a tall glass of ice water from the pitcher on the counter. "How do you know?"

Heath chugged the liquid gratefully. "I saw the lights."

Her expression closed, she didn't comment.

Okay, so she was ticked off at him. "Did you get your video finished?" he pressed.

"Yes." Seeing he'd finished his water, she poured him some coffee with the impersonal politeness of a restaurant hostess.

Heath studied the pink color in her cheeks. "What's the plan?"

Claire avoided his eyes as she mixed confectioner's sugar, vanilla and milk. "Why are you asking?"

He matched her contentious tone. "Why don't you want to tell me?"

She raised her chin, resentment simmering in her amber eyes. "Perhaps because you don't approve and you don't even know what I'm doing," she blurted.

Heath took a sip of coffee, finding it as delicious as everything else she cooked, which somehow rankled even more. "I didn't say that," he stated evenly.

She released a short, bitter laugh. "Didn't have to. I could see the little cash register in your brain going when you heard I bartered a night's rent in exchange for help making the video."

Heath exhaled. "You have to admit that's not going to improve your cash flow."

"We'll see," she said shortly.

He finished his coffee in silence and set his mug down on the counter. "You don't want to tell me anything more about it?"

She reached for the decanter and refilled his mug. "Nope."

Another silence fell, until Heath finally cleared his throat. "About Ginger…"

Claire tasted the frosting she was making and added a bit more vanilla. She hit the switch on the mixer, keeping her eyes on the concoction swirling around in the bowl. "I really don't want to talk about Ginger, either," she said tightly.

Resisting the urge to forgo all conversation and simply pull her close and kiss her again, he said, "I know how she made it sound last night."

"Really." Claire turned off the mixer and planted a hand on her hip. "And how was that?"

"Like she and I are getting closer than we are."

Claire's brow lifted. "Shouldn't you be having this conversation with her?"

"I don't have to—Ginger knows where she and I stand. Ours is a business relationship, period."

"Yeah, well—" Claire's lower lip shot out "—so is ours, and you kissed me."

Heath tore his gaze from her mouth. "That kiss had nothing to do with business," he told her gruffly.

"I agree." Her eyes glimmered with emotion. "Which is why it shouldn't happen again, given the fact that you and I have a *business* relationship."

"Actually, we don't have a business relationship," Heath corrected, aware that, ethically, there was a fine line, and he was walking it. "My business arrangement is with your niece and nephew."

Claire began icing the rolls. "You represent the fiduciary interests of the kids. And I'm their guardian."

"Which puts us on the same team, because you want what is best for them, too."

The buzzer went off. She slipped on heat-proof gloves and removed a casserole from the oven. "I'm just not sure we agree what that is going to be."

Heath wasn't, either. "I want you to succeed," he said finally.

Noting him eyeing the egg, sausage, cheese and potatoe medley, she went ahead and cut him a square. It was piping hot and delicious, and only helped make her case that she knew what she was doing here....

"Then do whatever you have to with the bank and the trust to give me more time," she pleaded, in a way that made it very hard to resist.

Heath reminded himself to stay in business mode. "I'd like to help you in any way I can."

"But you're not going to, right?" Claire twisted her lips as the phone rang, then reached over and picked it up. "Red Sage Guest Ranch, Claire Olander speaking.... Your parents and their friends stayed at the ranch last summer? I'm sorry. I don't remember, but we were.... I don't normally rent to anyone under twenty-one. I see." She paused. "You understand it's a dry county and we don't allow drinking on the ranch?"

Heath cleaned his plate as the phone conversation continued. Claire gestured for him to help himself to more. She grabbed a piece of paper and pen and began jotting down names and numbers.

"Right now, we have seven cabins available. Three are two bedroom, with a sofa bed in the living room, so they can sleep a maximum of six adults. If you want to do that, I'm

going to have to charge you per adult. Tonight? Sure. I can have everything ready by seven-thirty. Cash is fine. Thank you. Yes. See you then."

Heath lifted a brow. It was easy to see something good had happened, from the excited gleam in her eyes.

"We've got twenty-eight college kids checking in tonight," she reported.

The number sounded good. The type of guest did not. "There goes the peace and quiet."

Heath expected her to be insulted. Instead she laughed and went back to icing rolls. "You *are* old."

Heath could not understand why she wasn't concerned. "They'll be up all night," he predicted. Not to mention the damage to the property that might be done.

Claire regarded him confidently. "I don't think so."

He blew out a frustrated breath. "Then you're naive."

She continued to smile as if she'd won the million-dollar lottery. "Are we done calling names here?"

"Who's calling names?" Ginger breezed in the back door. "Any chance I can grab a roll and a cup of coffee for the road?"

"Help yourself."

The real-estate agent plucked one of the unfrosted rolls off the tray, then smiled at Heath. "I'll pick you up at the bank at five tonight?"

"Make it six," he said, wishing she hadn't chosen this moment to remind Claire they were going out to look at property.

Ginger smiled. "Six it is, then." Breakfast in hand, she sashayed toward the door. Reaching it, she turned back and said with deliberate cheer, "Have a great day, y'all."

Claire gave Heath a look that said he had just lost every bit of ground he had gained with her, and then some.

"Oh, I plan to," she said.

CLAIRE MANAGED TO AVOID any direct personal contact with Heath for the next two days. She was busy with the influx of guests, and he was rarely around, despite the fact it was a weekend. Claire told herself she was happy he wasn't there. One less thing to worry about. Obsess over. Yet on Sunday afternoon, as she was stripping cabins of their linens and towels after the group checked out, and she heard Heidi say, "There he is!" her spirits inexplicably rose.

She knew who the twins were talking about even before she turned around.

Looking innocent as could be, Heath sauntered toward them, stopping when the twins barreled into his legs. The two giggled in delight as he swooped them up in his arms simultaneously.

No one had done that since Sven died.

Claire felt tears well up inside her, but she pushed them away. She was *not* going to cry right now…. She took a deep, bolstering breath.

"Did you see all the bi'cles?" Henry asked Heath.

He spared her a quick, assessing glance before turning back to the little boy. "I sure did."

"There were lots and lots of them," Heidi exclaimed.

"We're too little to ride bi'cles," Henry announced.

"Yeah. If we want to ride something, we have to ride our trikes!" Heidi said.

"Want to see us ride our trikes?" Henry asked.

"After we're done," Claire interjected, before they could jump out of Heath's arms and run off to get them. "We're in

the process of taking out all the trash and collecting the linens. Remember? Say goodbye to Mr. McPherson, kids, so we can get back to our chores."

Their expressions altered instantly. "Do we hafta?" Henry asked sadly.

Heidi's lower lip shot out petulantly.

Their disappointment affected Heath. "Actually, I'm not doing anything. I could push the cart, too."

"But you're a guest." Claire protested.

Gently, Heath set the twins back down on the ground in front of Cottage 2. He challenged her with a steady. "You accepted help from other guests."

As if it were already settled, Henry walked up to the hotel laundry cart. "We'll show you how to do it. First I gotta fix it with my wrench." He got the plastic tool out of the carpenter's belt around his waist and twisted and tightened the handle. Finished, he stepped back to admire his handiwork, the way he had seen his dad do.

Claire's heart ached for him.

Heidi hugged Sissy close to her chest. Twisting a curly lock of her blond hair around her fingertip, she stared up at Heath as if he were the answer to her prayers.

Deciding it was easier to accept Heath's assistance than explain to the twins why she couldn't, Claire walked back inside the cottage, picked up the bundle of bed and bath linens and dumped them into the cart. The plastic bag of trash went into a second wheeled container.

With Heath "helping," the twins wheeled the cart to the next cottage in need of cleaning.

Claire unlocked the door and ushered the kids inside. "Come in while I collect the linens," she said.

Heath followed. "You were right, and I was wrong," he told her.

She went to one side of the bed, he went to the other. Together, they made short work of stripping off the sheets. Somehow, the action was as intimate as sleeping together. Maybe because of all the forbidden images being in a bedroom with this gorgeous man conjured up....

Sensing Heath was not a man who apologized often, she took the bait. "Wrong how?"

"About the college kids. I've never seen hotel guests that quiet, never mind at that age." He shook his head in wonderment. "How'd you do it?"

Claire smiled smugly. "I promised them ten percent off their tabs if no noise complaints were registered."

"Still, it was a risk…"

"Not really. As soon as I heard they were trying out for the Olympic team, I knew they'd be all about their training. The only thing I had to do was make arrangements at a restaurant in town for their evening meal, according to their strict dietary requirements, and be here to hand out keys and open up the barn so they could store their bikes in there every evening."

"I guess this means you'll make a profit this month."

"Yes, as it matter of fact it does." Not by a whole lot, Claire conceded silently, but enough to move to the plus side of the ledger. Or it would have been, had she not just spent all that money mailing out DVDs to travel editors across the Southwest in hopes of getting some good press. Figuring Heath did not need to know that yet, however, she merely smiled.

"So what are you going to do when you finish this?" he asked.

"Henry and Heidi and I are going to put the sheets in the washing machines, make invitations for their birthday party and take them to the post office."

He slid his fingers in the back pockets of his jeans. "Sounds fun."

"You're going to help with that, too?" Heidi beamed.

Heath looked at Claire, brow raised in silent inquiry, and waited for her response.

FOR A MOMENT, Heath thought Claire was going to brush him off. Then she said, ever so casually, "It's up to Mr. McPherson, kids. He may have to go look at some more houses or something."

Nice dig. Excellent delivery. Heath grinned like the innocent man he was. "I'd love to help with the invitations."

The kids danced around, practically falling over themselves in excitement. "Mine are going to be purple and yellow!" Henry declared, as they walked into the ranch office.

"Mine are all going to be red," Heidi reported as Claire got out the multicolored ink pads and stamp set.

"You don't have to worry about your clothes." Claire looked him over, head to toe, lingering just a millisecond too long on the apex of his jeans before returning, with a telltale flush, to his eyes. "The ink we're going to be using is nontoxic and washes out easily."

"Good to know." Although it wouldn't matter if he got something on himself, since he was dressed in worn jeans and an old shirt.

Heath folded his tall frame into a child-size chair at the wooden table the kids used for crafts.

Looking about as comfortable as he felt in the cramped

quarters, Claire sat opposite him. Their knees bumped beneath the table, giving Heath a momentary sense of warmth.

"What color do you like best?" Henry asked, as Claire passed out the invitations and showed the kids where they could place their stamps.

Heath had to think about that. He didn't really have a favorite color. Or did he?

His gaze still on Claire's face, he said finally, "When it comes to eyes, I like golden-brown the best." As she began to blush, he told the kids in mock seriousness, "Amber is what they call it, I think."

"What color are my eyes?" Heidi propped her fist on her chin.

"Amber," Claire said.

"What are color are mine?" Henry asked.

"They are also amber. As are mine," Claire continued, heading off the question she knew was coming next.

"What color are your eyes?" Heidi asked Heath. She leaned closer.

"What color do you think they are?" He bent down so she could see.

"Blue," she declared.

Heath turned to Henry.

"I think they're blue, too," he stated.

"Then I like blue eyes," Heidi declared, stamping madly.

Heath turned to Claire. "What about you? Do you like blue eyes?"

"On some people," she replied tartly. The challenge in her expression made him laugh.

A moment later, she regarded him wryly. "So how *is* your house hunting going?"

Aware that he had never been less interested in a potential investment, Heath pressed the stamp of a bunny rabbit into a pad of yellow ink. Imitating the kids' artistic style, he decorated the invitation he was working on. They kept surreptitiously checking on his "technique," while he worked just as hard to keep an eye on what they were doing, so he could copy it correctly.

"I've looked at only two houses in Summit so far. A spec house that's about half built, and actually got a bid on it Friday morning, so it's no longer available. That's why Ginger was so insistent I see it when I did. She knew another party was interested. She showed me another one—a resale—Friday evening. It didn't officially go on the market until yesterday, and she wanted me to have first look and a chance to make a bid."

"And?" Claire started stamping pink sailboats.

Heath and Heidi traded invitations and worked on each other's with just as much enthusiasm as they had their own. "It was as great as Ginger said, completely redone inside and out."

"And yet I gather you weren't interested?"

In such situations, Heath relied on his gut feeling. His instinct told him not to commit to any property at the moment. "I'm not even sure where I want to live yet. In town or not. I always thought I'd want to live in the city—or as close to city as we get out here—and not the country. But being on the ranch the last few days has changed my mind." He paused, reflecting. "I like the quiet." And a whole lot more.

CLAIRE LIKED HAVING HEATH here. Too much. "Maybe you should consider looking at a small ranch," she said eventually, ignoring the sexual tension simmering between them.

His eyes lit up. "That's an idea. Although I don't think I want to raise cattle or breed horses."

Claire couldn't contain an impish grin. "You could always put an oil well in your front yard," she teased.

"Funny."

She sighed. "I wish I thought so."

Heath's gaze became protective. "Wiley still bugging you?"

Telling herself Heath's gallantry meant nothing, she said, "I've rarely seen him since he made his pitch at dinner the other night. Mae told me he's been working on all the neighbors, trying to get them to let him prospect on their land."

"Any takers?"

"I haven't heard so." That didn't mean there wouldn't be. Money talked. Big money talked louder. But that wasn't what she wanted to know about. Claire tapped her chin with her index finger. "Come to think of it, I've hardly seen you the last few days, either."

"That's because I've been working overtime at the bank," Heath replied. "I just took over the management of a trust that's extremely complicated, and losing money right and left. I had to restructure it. Figure out which investments had to go, which could stay."

He was so pragmatic.

He must have noticed the tense, uneasy set of her shoulders. "I'm not going to do that to your trust. Any changes that would need to be made would be fairly straightforward. And you know that, because we've already gone over the options."

Unfortunately, the only one Claire really wanted was the one goal she might not be able to make happen.

Bored by the adult conversation, Henry yelled, "We're all

done, Aunt Claire!" To prove it, he stamped the back of his hand and then his wrist.

Heidi grinned and stamped her wrist, too. "Can we mail them now?"

"Yes." Claire went to the Out basket on her desk to collect the preaddressed, stamped envelopes.

"Then can we eat? I'm hungry!" said Henry.

Claire glanced at the clock on the wall. It was almost four! How had it gotten so late? Had she and Heath really been talking that long? Had the kids actually sat still for all that time?

"Let me take you to dinner," he said.

Claire wished she could go out with Heath, and have a real, adults-only date. "I can't," she told him with sincere regret. "I have to drop these off at the post office and then make dinner for the kids."

"They can come."

"Come where?" Henry shouted, at the top of his lungs.

"With us. Into town. To a restaurant. Does that sound good?"

"Yeah!" Heidi bounced up and down in excitement.

Claire took in the twins' ebullient state. "Once again, you don't know what you've signed up for," she told Heath, glad he had done so, anyway.

"Once again, I'm eager to find out."

THEY WENT TO THE Summit post office and mailed the birthday invitations, slipping them through the slot inside the post-office lobby.

Their mission accomplished, they strolled back to Claire's SUV and put the kids in their safety seats.

"Where did you want to go to dinner?" she asked Heath as she turned her red Grand Cherokee onto Main Street.

"You choose the place," he said.

Claire drove past the fast-food restaurant with the new playground. The kids loved going there, but never ended up eating anything—they spent all their time climbing on the indoor gym. They didn't like Asian cuisine. She cooked both Tex-Mex and barbecue regularly. They'd just had pizza the other night. "How about the new family-style steak place across from Callahan's Mercantile & Feed?" She hadn't yet had a chance to try it, but she'd heard it was good and not too expensive. Casual places like that usually had a children's menu. And they could go in their jeans without feeling out of place.

Heath's grin confirmed him to be the meat and potatoes aficionado she had suspected. "Sounds good to me."

It was still early enough for them to be seated right away.

The waiter set crayons and pictures to color in front of the kids, then handed Heath and Claire menus. He took their drink orders and headed off.

Claire turned to the children's selections on the last page. Her expression fell.

"Problem?" Heath asked.

"No *p-e-a-n-u-t b-u-t-t-e-r.*"

"You want to…"

"No." This was as good a time as any to try to get Henry to broaden his horizons again, foodwise. "Henry, Heidi. Let me tell you what your choices are for dinner."

They looked up, listening.

"Macaroni and cheese. Chicken fingers. Hot dogs. Hamburgers. Or sirloin steak."

"Mmm." Heidi had to think about it. "Mac'roni," she said.

"Okay. You're also going to get green beans and applesauce and milk with that."

"Okay." She went back to coloring in earnest.

"Henry, what did you want?" Claire asked.

"Peanut butter toast."

"They don't have that here, honey."

"I eat peanut butter," Henry repeated, in a tone that brooked no negotiation.

Claire could push the issue, of course. If she did, there would likely be a meltdown.

What would Liz-Beth and Sven have done? She had no idea. Before they died, Henry had eaten a wide variety of foods.

Heath reached across the table and laid his hand on top of hers. His touch was warm and reassuring. "Let me see what I can do," he murmured gently.

Before Claire could respond, he was off. Claire spotted him talking to the manager, then, to her amazement, he went out the front door of the restaurant.

The waiter returned with their drinks, and a basket of specialty breads.

Short minutes later, Heath came back in the front door, carrying a small paper bag. He handed it to the hostess and then rejoined them at their table. He winked at Claire. "Not to worry. We're all set."

He had just elevated himself to hero status. And that standing only went higher as the meal progressed.

He was patient with the kids. Attentive to Claire. Managed to keep the conversation going while they waited for the meal, and still color pictures with both children in turn.

When they had nearly finished their artwork, Heath told Henry, "That's a very good-looking fire truck, Henry. And, Heidi, that is a very nice mommy, daddy and baby that you colored."

"Are you a daddy?" Henry asked.

The waiter grinned as he set their plates in front of them.

Heath answered the query with the solemnity it was delivered. "No. I'm not."

"Why?" Heidi asked, eyeing Heath's steak, baked potato and steamed broccoli with a lot more interest than her own macaroni and cheese.

Henry wasted no time pushing his coloring aside and chowing down on the platter of peanut butter toast that had appeared before him. "Yeah, why?" he echoed, around a mouthful of food.

Claire touched a finger to her lips, gently reminding Henry to finish chewing before he talked.

"Hasn't happened yet," Heath said.

"Why?" Heidi pressed, as only an almost-four-year-old can.

"Because up until now I hadn't met the right woman." He paused and looked deep into Claire's eyes. And in that instant, she felt her entire universe shift.

"Funny," he said softly, "how quickly things can change."

Chapter Five

If the statement had come from anyone else, Claire would have declared it a line and a half. The look in Heath's eyes was sincere.

She knew how he felt.

Something was happening here.

Something quite unexpected…

"I have a baby," Heidi piped up, breaking the spell.

It was all Claire could do to hold in a sigh of regret.

Heath looked similarly disappointed. His glance told her he was fully prepared to pick up later where they had left off, at a time when Heidi wasn't waiting expectantly for a reply.

Heath turned his attention back to the children. "I know. Your baby doll's name is Sissy."

"But she couldn't come with us. She had to stay home. I can play with her later."

"I'm sure Sissy will like that." Heath cut some of his steak, fluffy baked potato and broccoli into preschool-size bites, under Heidi's watchful eye. He put it all on his bread-and-butter plate and slid it toward Heidi. She beamed in a mixture of gratitude and adoration, and tried a bite of his steak.

The waiter appeared with a tray containing two small

plates of French-fried potatoes and zucchini, and two little dipping dishes of ketchup. "I believe these are sufficiently cooled now, sir," he told Heath.

"Thank you." Heath put one dish between him and Henry, the other between Claire and Heidi. "I think we can all share these, don't you?" he said.

Henry eyed the fried veggies with a mixture of suspicion and longing. "I like peanut butter toast," he stated firmly.

"I can see. You're really chowing down on that. But if you decide you want something else, you can have some of this, too," Heath told him.

"That was very kind of you," Claire said, feeling her defenses melt a little more.

Henry picked up a fried zucchini stick and examined it on all sides before setting it down on the tablecloth beside his plate. He looked at Heath, curious again, just not about the food. "Do you have a dog?"

Heath seemed only slightly more surprised by the question, which had seemed to come out of nowhere, than Claire was. "No. I had one when I was a kid, though."

"So did I," Claire said. "Actually, we had several."

"I want a dog," Henry announced.

"When you're older, and can help take care of him, I promise you we will get you a dog," she agreed.

"What kind?" Heath asked, with a grin that was all male.

Claire had given it a lot of thought. "Golden retriever, I think. They're so gentle and patient with kids. But Labrador retrievers are great, too. Although they're more high energy than goldens."

Heath shrugged, the broad muscles of his shoulder straining against the fabric of his brushed cotton shirt. "It wouldn't be a problem if you had somebody to run with him. Or her."

Claire could imagine Heath racing over the ranch trails in the morning, a beautiful big dog at his side. She could imagine herself doing the same. She could even imagine them running together, the dog in the lead….

Her eyes locked with Heath's. Held. It was almost as if he knew what she was thinking, and wanted the same thing…

A discreet throat clearing disrupted the moment. Claire turned. Wiley Higgins was standing beside their table, hat in hand. "Saw you when I walked in." He inclined his head toward a ranching couple who had property a few miles from the Red Sage, obviously, his dining companions for the evening. "Thought I'd stop by and see if you had time to meet with me tomorrow afternoon. Say around four or five? Heath, I'd like you to be there, too."

Claire stiffened. "I think we've already said everything there is to say."

"I just want to throw some numbers at you. Discuss a few possibilities. I won't take much time, I promise," Wiley stated.

Claire turned to Heath. As usual when the discussion was on business, he was poker-faced and completely in favor of hearing Wiley out. Which meant, one way or another, she was going to have to listen to Wiley's latest proposal, too. If only to be able to explain to Heath why she didn't want to do it.

They settled on four o'clock the next day at the ranch office. Wiley said good-evening, and sauntered off. Claire sighed in frustration and turned back to Heath. "He doesn't give up, does he?"

Heath shrugged as if he had expected as much. "Wildcatters usually don't. That's what makes them so successful."

What about Heath? Claire wondered suddenly.

How far would he go to in the interest of business? Was this dinner all a part of his attempt to wear her down, when it came to making changes to the trust? Or was it, as she secretly hoped, part of a campaign to win his way into her heart? And possibly, her bed?

"ALL RIGHT, EVERYONE, it's time for baths and bed," Claire told the twins when they arrived back at the ranch.

"Can Mr. Fearsome read us stories with voices tonight?" Heidi asked.

"He does it better than you, Aunt Claire," Henry told her frankly. The tyke dropped his voice to a low growl. "When he talks, sometimes it's like this."

Heath grinned at the imitation and locked eyes with Claire. "I'm sure your aunt Claire reads a mean story," he said dryly, hoping she would ask him to stay.

"We like both ways," Heidi said. "Yours—" she pointed to Claire "—and yours." She pointed to Heath.

Claire looked at him, a question in her warm amber eyes.

"I don't mind," he said. He had nothing to go back to besides an empty cottage. Normally, he relished the quiet. Not now. Maybe, he thought, never again…

"Let me get them bathed and ready for bed, and then you can read to them."

Heath nodded. "Mind if I put on a pot of coffee?"

She continued gazing at him. "Mind making it decaf?"

"Sounds good."

The twins were so tired, one story sufficed. Claire kissed and hugged them each in turn. They nodded drowsily and lifted their arms to Heath.

Suddenly feeling more like a dad to them than a family

friend, he kissed them good-night, too. Then Claire and he walked back downstairs. "Coffee smells good," she remarked.

The fatigue of the day showed on her pretty face. Heath steered her in the direction of the living-room sofa. "I'll bring you a mug."

"You're going to spoil me," she warned over her shoulder.

He wished he could. Claire was the least spoilable woman he had ever met.

She was in a quiet, reflective mood when he returned.

He handed her her coffee and sat down beside her—not too close, but not too far away.

She had kicked off her boots and propped her sock-clad feet up on the coffee table strewn with adult magazines and children's storybooks. "Thanks for dinner tonight." She looked over at him shyly. "It was wonderful to get out like that."

He studied her feminine profile. "You don't go out much?"

A hint of sadness crept into her expression. "Not since Liz-Beth and Sven died." She blew at her steaming coffee and sipped. Perked up again. "Henry almost tasted a zucchini stick tonight."

Almost being the operative word. Puzzled, Heath asked, "Has he always been that picky?"

"Well. Yes and no. The first year or so he ate just about any food Liz-Beth put in front of him, where Heidi was a lot more cautious. She had to think about anything the least bit different before she put it in her mouth. Then they kind of reversed roles. And now Heidi wants whatever everyone else has. She's more interested in our dinners than her own, which you noticed. Thank you for letting her have some of yours, by the way."

"I'm glad she enjoyed it."

Lazily, Claire stretched her calves and wiggled her toes. "Plus, you saved the day by going over to the mercantile to get peanut butter and bread for Henry's toast."

Heath tore his eyes from the slender fit of her jeans. Like his, they were worn along the seams, faded, and soft as a glove. "The manager of the steak house was happy to accommodate us." He took off his boots and propped his sock-clad feet on the coffee table next to hers.

"Anyway, back to Henry's peanut butter obsession." Claire laid her head back against the sofa cushion. "It was the only thing that comforted him after the loss of his parents, so I wasn't going to take that away from him. The pediatrician said as long as the bread is whole grain and he gets milk every day, and a multivitamin tablet, he'll be fine. She expects him to outgrow it soon." Claire lifted the mug to her lips and took another sip. "The only thing he will eat aside from that is any kind of dessert." She grinned.

Heath returned her smile. "I noticed." After declining practically everything else at the restaurant, Henry had attacked his chocolate pudding and whipped cream with gusto.

"So I've been sneaking applesauce and pureed zucchini or carrots into cupcakes and cookies, every now and again," Claire said.

"Smart."

"And sometimes I can put a little fruit into a milkshake and get him to drink that, but it's pretty hit-and-miss. He really has to be in the mood. Although he does like apple and orange juice, so he gets some vitamins there."

Heath regarded her with respect. "Complicated."

She inclined her head. "I know he's just trying to exert what control he can over his universe. Heidi's doing the

same thing. That's why she asks so many questions, and has this constant need to know what is going on." Claire paused. "It's almost as if she thinks if she works hard and long enough on the puzzle of why her parents passed on, that she'll be able to magically bring them back or something."

Heath had noticed what a little detective Heidi was. "How did they die?"

"They were driving home after a business trip. Bad weather hit unexpectedly. Their car went off the road and into a ravine. They were killed instantly."

"I'm sorry. That must have been very hard on you and the kids."

Claire nodded.

He took Claire's hand in his. She relaxed and twined her fingers with his. "Anyway, I know they're trying to make sense of their loss, as best they can, so…I try to be patient and understanding and make them feel as safe and secure as every kid should."

Sensing the children weren't the only ones in need of some tender loving care, Heath turned and pulled Claire into his arms. He tunneled his hands lovingly through her hair. Let his mouth fall to hers. At the first touch of their lips, she sighed and moved against him. With a low moan of satisfaction, he threaded his fingers through the curls at the nape of her neck and angled her head so their kiss could deepen. His other hand moved against her spine, urging her closer. Her mouth was pliant against his, warm and sexy. Her breasts were pressed against his chest. His tongue twined with hers. And still it wasn't enough.

Claire wasn't sure how it happened. All she knew was that one moment she was sitting next to Heath on the sofa,

kissing, and the next she was on his lap, her bottom nestled against the hardness of his thighs, the proof of his desire pressed against the most intimate part of her. It didn't matter that they were both still fully dressed. Her insides tingled, and with that came the need to be so much closer.

She shifted again, wrapping her arms around his neck and straddling his lap. All the while, they kept on kissing. His hand worked its way under her sweater to the bare skin of her back, her ribs. Her nipples ached, until he reached up and covered her breasts with his palms. And Claire knew, even as she realized she had never felt this way before, that it was too much of a risk to continue.

She sighed, drew his hands away. "Heath…"

"I know." He kissed her again and again, each caress sweeter and slower and more loving than the last.

Finally, they broke it off altogether. "I better get going," he told her breathlessly, gazing into her eyes. "Otherwise…"

Otherwise, they'd be tempted to make love tonight.

And for so many reasons, Claire thought wistfully, that just couldn't happen.

"Good work on the Mitchelson trust," Orrin Webb told Heath at the bank the next morning.

"Thanks." He clicked the save icon on his computer and waited.

Orrin shut the door. Hands in his pockets, he strolled over to the window behind Heath's desk and gazed out at Main Street. Thanksgiving was ten days away, but the Summit, Texas, municipal workers were already hanging evergreen wreaths with big red velvet bows from every old-fashioned lamppost in the charming downtown area. The advent of the

holidays made Heath more aware than ever of the lack of family in his life. It made him wish he had a wife like Claire and kids like the twins, and a home as warm and loving as the one they shared on the Red Sage Ranch.

He knew life wasn't perfect, but they made him feel like it could be. And that in turn made him want to trust his instincts again. Start actively looking for the woman who could give him the lasting love and commitment required to build a strong, enduring family—the kind that wouldn't be torn apart by different hopes and dreams…

Oblivious to the nature of Heath's thoughts, Orrin continued speaking about the business at hand. "The restructured trust is going to bring in a nice income from this point forward. The Mitchelson family won't be sorry they handed over the management of their inheritance to First Star Bank of Texas."

"That's good to hear," Heath said.

"Have you made any decisions regarding the trust for Claire Olander's niece and nephew?"

"I'm still considering what would be best." Hoping with ten more days she'd be able to pull off a miracle.

"What about the mineral rights on the land?"

"She and I have an appointment to talk with Wiley Higgins this afternoon. And there's another option, too." Briefly, Heath filled Orrin in on the latest regarding the Wagner Group.

Orrin paused. "You know, if you'd rather, I could assign this trust to Freddy Howitzer."

Freddy Howitzer was a numbers guy. Great with a certain kind of trust, where multiple beneficiaries were involved and the only thing that mattered at the end of the day was the amount of income generated from said trust. He was terrible

when it came to situations that involved grief-stricken families. Freddy did not have the delicate people skills required—Heath did. "I can handle this," he told his boss. And he could do it in a way that would leave everyone happy.

Orrin moved closer. "Rumor has it you might be getting personally involved with the twins' aunt."

Guilt flared inside Heath. It wasn't like him to mix business and pleasure, but that was exactly what he was doing here. Reflexively, he pushed the emotion away and went back into business mode. There was no reason he couldn't handle this with keen, compassionate skill, same as any other trust. The fact it was going to be tricky to manage just meant he was going to have to be more on his toes.

As for the other…

"Since when did you start listening to gossip?" he chided his boss.

Orrin ignored Heath's attempt to sidestep the question. Looking more old-school than ever, he said, "You were seen having dinner with her and the kids last night."

Heath stood and moved restlessly to the window in turn. He looked across the street and saw a turkey poster on the window of Ruby's Barbecue, beneath a boldly lettered sign that said Preorder Your Smoked Turkey and Ham Now! Pick Up Thanksgiving Day!

Trying not to think what he'd be doing on Thanksgiving this year—fielding off invitations from pitying friends, or watching football and eating takeout alone—Heath turned. "Trust execs take clients to dinner all the time."

Orrin pushed his bifocals halfway down the bridge of his nose. "I didn't see an expense account for the meal."

That's because Heath hadn't filled one out. It hadn't felt

right to do so, since the dinner had been a lot more personal than professional in tone. Yet, beneath his desire to spend time with Claire and the kids, a legitimate purpose had been served.

Heath looked Orrin in the eye, able to be candid about this much. "I want Claire to trust me. To know that whatever has to happen to make the trust fiscally productive at the end of the day is the right thing. To do that, I have to get to know her and the kids. I have to win her confidence, since she owns all of the buildings and improvements on the ranch and is the children's legal guardian." He cleared his throat. "Ethically, you and I both know it's fine for me to be their friend, as well as their advisor, as long as I don't benefit financially from the relationship. Furthermore, in small communities like Summit, where everyone knows everyone else, this is the way it works. There are no strangers, unless someone is new in town."

"It's still a fine line," Orrin cautioned.

But one Heath would walk. Because it was the only way he could protect Claire and the kids. And whether they realized it or not, they needed his help.

"HAVE YOU HEARD ANYTHING from magazine and newspaper editors yet?" Mrs. Finglestein asked Monday afternoon, when she stopped in to the ranch office with her husband after another full day of bird-watching.

Heath came in right after them. He was early, but Claire had expected as much.

"No, I haven't," she answered.

"You'd think," Mr. Finglestein fretted, "given the size of those enormous gift baskets you sent with the DVDs, that someone would have at least called to say thank-you."

Ignoring the look of surprise—followed swiftly by

number-crunching disapproval—on Heath's face, Claire smiled. "The baskets were delivered just this morning. I doubt anyone's had a chance to even look at the footage of the ranch or the brochures we sent."

"Well, we're going to do everything we can to help you get your bookings up," Mrs. Finglestein vowed. "Because we are having a fabulous time."

"Thank you," Claire said.

"And we're going to try that Mexican restaurant you told us about this evening. So if you'd like us to bring anything back for you…?"

"I think we're good here. But don't forget to try the chiles rellenos. They're fabulous!"

"We certainly will!" Mr. Finglestein said.

When Wiley Higgins walked in, the mood in the room went from cheerful to tense in an instant. "Well…we'll let you get to…whatever," Mrs. Finglestein said. The couple departed gracefully.

Wiley shrugged out of the denim jacket he had on and opened his briefcase. "I imagine you want to cut straight to the chase." He handed over a folder containing a typewritten proposal for her to peruse. "I've talked to all the ranchers in the area and looked at the past specs for oil recovered from all the properties. The least amount pumped was from the Red Sage. Therefore, I'm figuring this property has the most oil still left in the ground.

"If you'll look at the numbers, given the price of crude right now, you'll see that if even one of the injection wells we're proposing to drill produces the on-average amount, you and your heirs will be sitting pretty for years to come. But I'm getting ahead of myself here. Before we go to

contract on anything, we need more data. We need to send a vibrator truck onto the property, blast sound waves through the reservoir rock and measure the results on geophones."

He paused to take a breath. "We'll also need to move electric current through the rock to see if we can locate exactly where the oil-bearing strata are located. And then we're going to need to look at the rocks themselves, so we'll need to drill core samples from the likely locations, once we figure out where they are." His eyes lit up. "And best yet, we're going to pay you to allow us to further explore what your options might be. The fee schedule for all of this is on page ten of the handout I gave you."

Claire studied it. At first glance, the number was astounding, more profit than she would make in a year if the guest ranch was fully booked.

"You can see we're prepared to be very generous," Wiley said.

Claire could see why the Higginses sent Wiley out to make the pitch for their family-run operation. He was very persuasive, as well as enthusiastic.

"And all I have to do is let you drive one big truck—"

"Actually, it will be more like four or five large trucks, and half a dozen pickups, carrying the geologists and rough-necks," Wiley corrected.

"Onto my property. And then drill and shock and generally tear up the land, as well as all the hike and bike trails and xeriscape plants we've put in."

"I admit it will tear things up a bit. But think of the payback, if we hit oil."

"Actually," Claire said tightly, "I'm thinking of what this

little prospecting expedition would do to my guest-ranch business."

"Doesn't look like it's doing much, anyway." Wiley shrugged.

"Okay. That's it. You need to leave now." Claire grabbed his arm and his jacket.

"I understand this is a lot to consider." Wiley let her steer him as far as the porch outside the ranch office before digging in his heels. "And I can give you another week, tops, but I have to know before Thanksgiving. 'Cause otherwise we're going with our second choice ranch."

"Good luck with that," Claire said.

"Think about it," Wiley stated flatly. "Before you say no." He looked at Heath. "Talk some sense into her," he growled, then stalked off.

Claire turned back to Heath. As trustee in charge of the mineral rights on the Red Sage, he would make the final decision. Yet he had remained silent throughout the meeting. "Well? Don't you have anything to say?" she demanded.

Heath shrugged and looked her straight in the eye. "Would you listen if I did?"

Chapter Six

Claire looked at Heath intently. "I want to hear what you're thinking."

She had asked. It was only fair he enlighten her. Heath stood, legs braced, as if for battle. He pushed the edges of his suit coat back and propped his hands on his hips "You didn't even try to negotiate with Wiley."

Claire paced across the office. "What difference does it make what that man is willing to pay for the privilege of hunting for oil if I don't want him tearing up my property and chasing away all the wildlife?"

Although Heath had hoped to be gentle, he had no choice but to remind her of the facts. "The mineral rights belong to the kids. And the ranch is twenty-nine thousand acres."

Her chin took on the stubborn tilt he was beginning to know so well. "I'm aware of that." She jabbed the air with her index finger. "I'm also aware that you, as trustee, get to make the final decision about what is going to be done or not done in this regard."

"As I told you initially, I don't want to do anything that would not garner family support and approval, unless I absolutely have to."

"I hope you mean that."

"I do." Heath paused and looked her over. She was all fired up, more beautiful than ever. The soft denim fabric of her skirt hugged her hips and thighs, as nicely as a black V-necked sweater did her upper body. Opaque black leggings made the most of her spectacular legs. But it was the flush in her cheeks and the contentious pout on her lips that drew his glance again and again. "Unfortunately, time is running out," he told her reluctantly. "You've now got less than ten days to demonstrate the business is either showing a profit or soon to show a profit. And we both know that might not happen."

"I think it will," Claire argued.

"Why aren't you at least considering the possibility of letting Wiley Higgins wildcat for oil on the farthest reaches of the Red Sage?"

Claire went back to pacing. "First of all, the capped wells that Wiley is interested in aren't all that far from the ranch house, only two hundred acres or so south of here. Thanks to the efforts my father and mother put in, the property has grown into a very wild and beautiful nature preserve. It's where you run in the mornings, and I walk with the kids, and the Finglesteins go to bird-watch." Her voice hardened. "There's no way I'm letting them haul heavy equipment over the terrain, uncap those wells and send sound waves or electric charges into the rock. So negotiating for something I don't intend to do anyway would be pointless, as well as a headache I don't need right now. I'd rather the trust sell off part of the guest-ranch business first."

Heath nodded agreeably. "Okay. Now we're getting somewhere," he said.

CLAIRE DIDN'T WANT TO "get somewhere" if it meant giving up. She wanted to be a dreamer like her mom and dad had been. Only, she wanted to do what they hadn't been able to do. She wanted to be able to make her vision come to fruition in a way that was also profitable, instead of a tax liability that eventually drained every cent of oil money they'd inherited from her grandparents.

Heath sat on the edge of her desk and continued in a candid tone. "I talked to an executive with the Wagner Group this morning. They're expanding into the business retreat industry. And they're interested in at least taking a look at the Red Sage as a possible acquisition. The only problem is, they want full ownership and control of any property they acquire."

Claire suddenly felt as if the air had been sucked out of her lungs. "Which means I'd be out of a home and a job," she concluded.

Again, Heath shook his head. "Not necessarily." He paused to look into her eyes. "I explained your situation. They said they would be willing to consider you as property manager, as part of the deal, if they decided they wanted the ranch, and that's no sure thing."

"Look." Feeling trapped, she whirled, hands held out in front of her. "I can't stop you from selling the twins' half of the business, but there is *no way* I'm selling my half. So if you intend to look for buyers, even theoretically, you need to look for someone who is going to be okay with that."

Heath nodded. "Got it."

"Good." Claire breathed a sigh of relief. "So the Wagner Group is out."

Heath's expression remained impassive. "Got that, too," he noted dryly.

She searched his face. "You think I'm being overemotional about the oil thing, don't you?"

He shrugged.

Usually Claire didn't care what people thought, but it bugged her to have Heath believe she was behaving irrationally. Even if he was too polite to say so.

She grabbed her keys and strode toward the door. "Come over to the house with me. I want to show you something."

Heath rolled to his feet in one fluid motion. "Okay."

Claire locked up and they walked across the yard. The wind was whipping up, and the sky was cloudy. It was beginning to get dark.

"Where are the twins?" Heath asked as they entered through the back door.

It *was* unusual, Claire noted, having the ranch house this quiet as they closed in on the supper hour. She walked through the kitchen, snapping on lights. "Over at Mae Lefman's ranch. I asked her if she could watch them while I met with you and Wiley, but it had to be at her place since she's making pies to freeze for Thanksgiving Day." Claire hurried through the living room. "Have a seat while I—" The phone rang. She muttered under her breath and went back to get it. "Hello?"

"Claire?" Mae said.

In the background, Claire could hear the twins crying. She tensed in alarm. "What's going on?"

"They just noticed it was starting to get dark, and they got rather upset."

"Can you put them on speakerphone?"

"Sure."

"Kids?" Claire spoke into the receiver. "This is Aunt Claire."

"Where are you?" Heidi wailed.

"We want to go home!" Henry declared.

"I'll be right there," she said gently. "But stop crying, okay? Now I'm going to speak to Mrs. Lefman."

"Claire?"

"I'm driving right over." She hung up and turned to Heath. "I've got to go get the kids."

His dark-blue eyes mirrored her concern. "What happened?" he asked.

"I don't know." She grabbed her purse and keys. "Sometimes they get upset for no reason." She shrugged, wishing once again Liz-Beth and Sven were still alive, to be able to help with this. "It could be they're overtired."

Heath followed her toward the door. "Want me to go with you?"

She was about to tell him he didn't have to do that, then stopped. The truth was she could use some help. Because even when she got the twins home, she would have to prepare dinner for them. "If you wouldn't mind," she said, figuring what she wanted to show Heath could wait until later, "it would be great."

HEIDI BURST INTO TEARS the second she saw Claire walk into the Lefmans' cozy ranch house. Henry quickly followed suit.

"Where were you?" the little girl sobbed.

"We was worried!" Henry cried, then hiccupped.

"You could have gone to heaven!" Heidi declared, even more distraught.

Claire dropped her bag, knelt on the floor and stretched her arms wide. The twins ran into them, clinging to her with

such heartfelt anguish that Claire felt her own eyes fill with tears. She held their small bodies close to her and pressed a kiss on top of each twin's head. "I didn't go to heaven," she said thickly. "I'm right here."

Mae, looking a little misty herself, pressed a hand to her heart. *"I'm so sorry,"* she mouthed to Claire. "I had no idea," she murmured. "I mean…they were fine. They were helping me with the pies, and then all of a sudden…"

Claire nodded and held the twins even closer. "You don't have to explain. It's happened a lot since…" *We lost Sven and Liz-Beth.*

Mae looked even more distraught.

With effort, Claire disengaged herself enough to get back to her feet. As she did, Henry caught sight of Heath, standing awkwardly in the doorway. "Mr. Fearsome!" he shouted jubilantly. Tears faded and he began to smile.

Heidi grinned, too. They raced to embrace Heath, both of them hanging on to his legs as if he were the answer to their prayers.

"Did you come to get us, too?" Heidi asked, lifting her arms to be picked up.

Heath effortlessly hoisted a forty-pound child in each arm. "I sure did," he said, looking as happy to see the twins as they were to see him.

"I'm hungry," Henry announced loudly.

"Me, too," his sister declared.

Mae chuckled, glad to see the children's good mood had been restored.

"Can we go to a restaurant with you again?" Heidi asked.

"We're going to have dinner at home," Claire interjected quickly.

Their faces fell.

"But Mr. McPherson is certainly welcome to join us," she concluded.

Heath looked at the upturned faces. "What do you think, guys? Should I?"

"Yes!" they shouted, their earlier fears forgotten.

"Then I guess we better get going," Claire said. "Heidi, Henry, say goodbye to Mrs. Lefman and thank her for watching you this afternoon."

They did as asked. Claire collected their jackets, expressed her own gratitude to Mae, and then the four of them headed out to her SUV.

"There's something I'd like to know." Claire looked at the twins as they finished up their dinner: peanut butter on whole wheat toast for Henry; turkey burgers, steamed broccoli and oven fries with ketchup for the rest of them. For dessert, fruit smoothies in front of everyone. "What kind of cake are you going to want for your birthday party?"

"Cupcakes!" Henry said.

"With sprinkles!" Heidi added.

Heath grinned, looking sexy and at ease in the ranch house kitchen, with the sleeves of his dress shirt rolled up to just beneath the elbow, tie off, the first two buttons on his shirt undone.

"I meant vanilla or chocolate or strawberry," Claire explained.

"Peach," Heidi declared.

That hadn't been one of the choices. But when Henry said, "Yeah, peach," Claire decided to go with it.

"Okay, peach cupcakes it is, with vanilla frosting and

sprinkles." This would be a good opportunity to sneak some fruit into Henry's diet.

"Finish up your smoothies, then we're headed upstairs for bed and bath."

They grinned. "Can Mr. Fearsome read us a story with voices?" Henry asked.

Trying not to think how much she was coming to depend on him, she assented. "Okay, but let's make it fast. Mr. Fearsome…I mean, Mr. McPherson…has had a long day. And I'm sure he's anxious to get back to his cottage."

But as it turned out, once the kids were tucked in, he looked anything but ready to depart. "You said you wanted to show me something earlier," he remarked, after they went back downstairs. "Before we got the SOS from Mae Lefman. What was it?"

Claire studied him. They'd had such a pleasant evening, she hated to bring business back into it. "You sure you're up for it?"

"Positive."

"Okay. Make yourself comfortable and I'll go and get it."

When she came down ten minutes later, Heath was in the kitchen, finishing up the dinner dishes. Gratitude filled her heart. "You didn't have to do this," she said.

He handed her a cup of coffee. "Not every night someone makes me a turkey burger and a fruit smoothie, all in one meal."

"Liked it, huh?" *As much as I liked having you here with us?*

"The whole dinner was delicious. What do you have there?"

"Albums. My dad was bedridden for the last year or so of his life. It drove him crazy to be confined like that. To keep

himself busy, he went through boxes of family photographs and compiled this history of the ranch. I thought you might be interested in looking at it. Hopefully it'll help you to understand what the Red Sage means to me."

HEATH SAT AT THE KITCHEN table, poring over the chronology that began back in the early 1900s when Claire's great-grandfather had purchased the Red Sage. "I hope you don't mind if I make the birthday cupcakes while you do that," she said.

Able to envision many more such evenings like this, Heath started to rise. "If you want me to help—"

"No. I've got it." She took a bag of peaches out of the freezer and put them in the microwave to defrost. "I'd much rather you look at that."

Heath settled in, content to read while Claire moved gracefully around the kitchen. "The ranch looks remarkably like it did back then," he noted. "Except, of course, the ranch house and barn were the only two buildings on the property."

Her lips quirked in a teasing half smile. "Just wait."

"So your great-grandfather raised sheep?"

"Yes." Claire put all the ingredients on the counter, next to the stand mixer. "He wasn't all that popular, since this was cattle country at the time."

"I gather there are problems trying to run two different types of animals so close together?"

Claire dumped sugar and butter in a bowl. "Especially when the land isn't fenced, and cattle had to be driven to the trains for transport to market."

"It looks like things changed when your grandfather Olander took over."

"Yes. He concentrated on breeding horses. But he never had the money or the patience to invest in really fine stock to start his herds, so he wasn't able to make much of a profit on the horses he did sell."

"It looks like the property went to seed a little."

Claire turned on the mixer. "It was definitely going downhill until they found oil. Then, as you can see by the condition of the house and how they expanded it, they were flush with money. To the point they didn't have to work, and they didn't."

Heath studied the photos of some of the drilling sites. The previously beautiful land had been ravaged. Ugly drilling platforms towered over dusty tracts, devoid of vegetation. Rough roads had been cut across the property and the oil workers had set up tent villages to sleep in. Later photos showed the land was populated with nodding donkeys as far as the eye could see. The area around every pump had been torn up, scraped bare and filled with deep ruts made by heavy equipment.

"This is what you're afraid will happen if you let Wiley Higgins uncap your wells and explore your property."

Claire spooned batter into paper cups, then slid them into the metal muffin tins. "It's hard to see how it wouldn't happen."

Heath turned the page. "Is this your father and mother?"

"Yes. They took over the Red Sage when my grandfather died. Their mission was to make sure all the wells—which were by then bone dry—were capped, all the extraneous equipment that had been left behind, hauled away. They brought in tractors and graded the land, to remove the deep

ruts." She looked over at him. "Every year they brought in more native plants that didn't require a lot of water to flourish—like mountain sage, cedar and mesquite—and they spread wildflower seeds. They also limited the cattle ranching they did to a small portion of the property, where the stream runs through."

Heath flipped through more pages of pictures, as she slid the baking pans into the oven and set the timer. "It doesn't look like they ran more than fifty head of cattle at a time."

"It was almost a hobby for my father, since they still had oil money from the original boom. By the time my dad died, he'd run through all that, so my sister and I had a decision to make—sell the place, take the money and run...or find something else to do with it. Faced with losing it forever, we realized how much we loved it here, and we decided to do everything we could to keep the Red Sage in the family."

Heath finally understood why Claire was acting as she had. The Red Sage was the link not just to her heritage and her past, but to the family she had lost. "I'm glad you showed these to me," he said. He closed the last album cover, put it atop the stack he had perused, and stood.

"Liz-Beth and Sven wanted the twins to grow up here," she said quietly. "They wanted them to have the kind of carefree childhood we had, surrounded by the natural beauty of the land."

"It's more than that."

"You're right. I couldn't bear to leave here," she said thickly.

Heath took her in his arms. He held her close and smoothed her hair with the flat of his hand. "So you've never lived anywhere else?"

She leaned against him with a sigh. "I went to college

in Austin, and then lived in Dallas for five years after that—working as a marketing rep, and then a regional sales manager, for several different territories. I traveled all over Texas. As great as all the little towns and big cities were, nothing compared to the way I feel about this place."

"I'm beginning to see why," Heath murmured.

Then he did what he had been wanting to do all evening. He lowered his head and kissed her. And once they started kissing, they couldn't seem to stop. All the while, Heath knew it was dangerous to start anything that might shift the balance of a relationship that was so new and tenuous.

They had enough against them. But with her so near, and the need within him so strong, he found he couldn't walk away. Desire flowed through him in hot waves as she met the thrust and parry of his tongue with a steamy kiss. An ache started in his groin, spread outward. Unable to resist touching her, he ran his hands down her hips, over her back and shoulders, then down again, cupping the soft curve of her bottom, as he held her against him. Emotions ran riot inside him. He wanted her…now, even as the more rational part of him knew this was not the right time.

Claire felt she had been waiting forever to find happiness, to discover this incredible passion. Her knees were weak as he pinned her between the counter and his body, and she wreathed both arms around his neck, opened her mouth fully to the erotic pressure of his, let his tongue stroke hers. Needing more, she went up on tiptoe and arched against him.

So what if none of this was going to be simple or easy? Claire thought, completely swept up in her feelings as she savored the moment. Now that Heath understood her better, the two of them could get through this business phase, and

then it would be easy to make the rest of it work. Heath cared about the kids. She could see it in his eyes. He might even be seriously interested in her—at least she hoped that was the case. Because she knew she was feeling something special for him.

Something way too wonderful to be interrupted by the oven timer going off....

But it *was* going off. Loudly. And the jarring noise brought them swiftly back to reality. To the fact that they were standing in her kitchen, with so much unresolved....

"Saved by the bell," Claire joked breathlessly.

Heath, too, seemed to think they needed to take things a bit slower. He exhaled, stepped back until they were no longer pressed together. "And the fact we still have a business to sort out. Once that's done—" with a tender look in his eyes, he let her go completely "—I'm going to pursue you with everything I've got."

Claire grinned, feeling happier than she had in a long time. "I'll look forward to it," she said.

Chapter Seven

Heath had just hung up the phone the next morning when Claire popped her head in the door of his office. "Got a minute?" she asked.

Surprised to see her at the bank, never mind looking so happy, he waved her in. "Can I get you a cup of coffee? Some orange juice?"

She shook her head and sank into the chair in front of his desk, setting her shoulder bag on the floor. "I can't stay. I just wanted to apprise you of the latest developments regarding the business." She tugged at the hem of her short brown skirt, which almost reached her knees. "Do you want the good news first or the bad?"

Heath tore his eyes from the lissome line of her calves. He liked the way Claire paired her skirts with similar-colored leggings. It was a sexy look, and one that suited her well. "The good."

Claire relaxed back in her chair. "Buzz Aberg, the travel editor from *Southwestern Living* magazine, called me this morning. He's taking me up on my invitation and coming to the Red Sage."

So she had pulled it off. Heath stepped around to the

front of his desk and sat on the edge, facing her. "That's great." He studied the mixed emotions on her face. "What's the bad news?"

Claire let out a beleaguered sigh, the motion lifting and lowering her breasts. "The only time Buzz has available between now and December first is Thanksgiving weekend, and he's already committed to hosting his entire extended family for the holiday. So I told him he could bring them all and we'd provide not only lodging but Thanksgiving dinner—on us."

Which would definitely not be good for the bottom line this month, Heath thought. Although exactly how far it would put her under would require another look at the books. "How many are in Buzz's family?" he asked calmly.

Claire wrinkled her nose and tugged at the collar of her turtleneck sweater. "That's the bad news. There are forty-six. Even doubling up, they are going need to nine of the cabins. Ginger is moving out tomorrow evening—her house is finally ready—but Wiley, Ms. Sturgeon and the Finglesteins plan to be there through Thanksgiving at least. So I was wondering if you would consider moving into the guest room in the ranch house a couple days before they're due to arrive, and bunk there until after the Aberg clan leaves."

Live under the same roof as Claire and the kids? See them last thing at night and first thing every morning? Heath didn't even have to think about it. "No problem. Be glad to help you out."

She raked her teeth across her lip. "But…? I see some hesitation on your face."

Not about being close to Claire and the twins; he was

certain that would be a good thing. He kept his eyes on hers. "It sounds like quite an undertaking."

She sighed and admitted, "It is going to be. For one thing, I've never cooked Thanksgiving dinner for everyone—that was always my sister's domain. She roasted the bird and planned the menu. I was just the sous-chef." Claire squared her shoulders. She met his eyes. "But I have all the recipes she used, as well as ones I have been collecting that look good. Not to mention that Ms. Sturgeon and the Finglesteins have agreed to help out with the cooking and serving in exchange for attending the meal…and another few days comp on their bill."

Heath frowned. "You understand this is going to bring your profits for the month down considerably."

"I also know you have to spend money to make money. *Southwestern Living* magazine has a circulation of 2.2 million. Plus, they run a Web site that gets over one hundred thousand hits per day, on average," Claire retorted stubbornly.

"If Buzz Aberg and his family have a great experience at the Red Sage, I'm hoping he will not only feature us in the magazine—probably the soonest that could happen is the spring—but that he will also list the ranch as a Must Visit on their Web site right away, along with a link to our own Web site. That kind of buzz—if you'll forgive the pun—could give us capital to expand almost overnight. So in my view it's worth the risk."

Her enthusiasm was contagious. "What can I do to help?" Heath asked.

"Spend every spare moment helping me get ready for the influx of visitors?" Claire murmured persuasively.

It would be a pleasure, he thought, particularly if it meant

they wouldn't have to alter the business portion of the trust the following week. "Consider it done."

She stood and held out her hand, then changed her mind at the last minute and lightly kissed his cheek instead. She stepped back before the moment could turn intimate. "You really are a great guy."

Heath knew she thought so now. And would probably continue to think so if things worked out for the guest ranch the way she hoped.

If they didn't…if he had to be the bearer of bad news and sell the twins' portion of the ranch business to ensure the fiscal soundness of their trust…he doubted she would feel the same way. Which just meant he had to trust her marketing and sales expertise and redouble his efforts to help her. "So I'll see you this evening?"

"Plan on having dinner with us. And bring your math skills as well as your appetite. I'm going to need help figuring out how to adjust all the recipes to crowd size, so I can see what dishes are really doable, and which are not."

IT LOOKED AS IF A TORNADO had exploded in the play area of the ranch office, Heath thought several hours later. Books and toys were strewn everywhere. And the area surrounding Claire's desk was not much better. She had open cookbooks scattered all around her, taking up nearly every available inch of space as she sat cross-legged on the floor, making notes on a yellow legal pad.

Behind her, Heidi and Henry were equally busy. Henry had his tool belt and yellow hard hat on and was using his play wrench on every inch of the file cabinet. Beside him, Heidi had a child-size cleaning rag and toy bottle Heath

assumed was meant to be spray cleaner, because she was pretending to pour some on the window ledge and then was rubbing the cloth over the pretend liquid.

"Looks like I got here just in time," he said, strolling in.

Claire looked up with a smile. The twins dropped what they were doing and raced to greet him.

"It's Mr. Fearsome!"

"Aunt Claire said you was going to come see us!"

Heath swung them up in his arms. Without thinking about it, he pressed a kiss on each curly head. "It's really good to see you guys," he said, as they hugged him fiercely.

"It's really good to see you!" they chimed almost in unison.

Claire unfolded her long legs and rose gracefully. She turned her face up to his. Heath realized he wanted to kiss her, too, but not in a casual greeting. He wanted to hold her and kiss her the way he had last night before they'd said goodbye, the way he couldn't kiss her at the bank this morning. In a manner that was definitely not G-rated. If the sudden glow in her cheeks was any indication, she was thinking the same thing.

Aware of their rapt audience, Heath contented himself with the thought that the greeting he would have given her, had they been alone, could come later. Much later. When they didn't have to worry about what anyone else thought.

"Hey," he said.

"Hey," she replied softly, looking into his eyes. "How was the rest of your day?"

"Good," Heath said as the e-mail signal on Claire's computer dinged.

"Hold that thought." She stepped around her desk and, still standing, punched in a few commands. As she read, the smile on her face faded. "Oh, no," she whispered.

"Problem?" he asked, setting first Heidi, then her brother on the floor.

Claire punched in another command on the keyboard, starting her printer. Seconds later, a page slid out of the high-speed machine. "Kids, would you mind if I spoke to Mr. McPherson outside for a moment?" she said.

They nodded and went back to their play area, while Claire ushered Heath out onto the porch, page in hand. The kids could see them through the glass, and vice versa. She watched them pick up their toys, then turned away so they couldn't see what she was saying. Although the sun was shining, the temperature was already dropping into the low fifties. She shivered in the cool breeze.

Heath took off his suit coat and draped it over her shoulders. "What's going on?"

"Big trouble." She leaned against the building, out of the wind. "The deluxe toy tool set I purchased for Henry's birthday present was back-ordered again. It should have been delivered today. Instead, it won't be here in time for his birthday party tomorrow afternoon."

Not good, Heath thought.

"It's the only thing he wants, and I've already gotten Heidi's heart's desire—a baby bath set. There's no time to order Henry's gift from any other Internet supplier, and the nearest toy superstore is in Fort Stockton."

Heath handed her his cell phone. "You want to call and see if they have it?"

Claire nodded, and rushed inside again to get the phone number. Through the glass, Heath could see that Henry was back to "fixing" things with his toy wrench, while Heidi was busy cleaning.

"Just another few minutes, kids," Claire said, and with a grateful look, she rejoined Heath, then made the call.

"Well, they have one tool set left, and they'll hold it for me, but only until close of business today, which is 8:00 p.m. So I'm going to have to go."

"I could run over for you," Heath offered. "I need to check on my townhome and pick up some more clothes and books, anyway."

"Thanks, but I think I better go myself, just in case it isn't in stock, despite what they said. If they *don't* have it, I'm going to have to pick out something else for Henry." She sighed wearily. "And if that happens, I'll have to pick something else for Heidi, too, because it wouldn't be fair for her to get the exact thing she asked for if Henry doesn't get the exact thing *he* wanted. I'll just save those items for Christmas presents."

"Parenting sure is complicated," Heath teased, impressed she took her duties so seriously. The twins had no idea how lucky they were.

Claire's voice cracked. "It's just…it's their first birthday without Liz-Beth and Sven, and I really want it to be as happy as I can make it for them."

Heath touched her shoulder gently. "I understand. Do you want me to stay here and babysit them? Or go with you?"

"I'd rather you go with me, if Mae can babysit."

As it turned out, Mae was only too happy to come right on over.

"Things are looking up again," Claire told Heath, handing him back his cell phone. Obviously relieved everything was going to work out after all, she stepped back inside the office, Heath following right behind.

WHEN CLAIRE LET OUT a gasp, Heath couldn't blame her for being distressed. The cover to her printer and fax machines had been pried off, while liquid hand soap was smeared across her entire desk.

"We're getting ready for company!" Heidi declared, as she pumped even more soap onto the edge of Claire's desk and rubbed it in with her cloth.

Henry shoved his toy wrench deep into the fax machine. "Yeah, and I'm fixing your machines!"

Claire rushed to stop the flow of any more gooey cleaner, while Heath went to rescue the toy wrench and snap the covers back on both fax and printer. Luckily, it appeared no real harm was done.

Claire got a roll of paper towels and some hot water and real furniture cleaner and put her desk to rights. "I appreciate all the help," she said kindly, then went on to explain in depth what was a toy and what was not.

Henry and Heidi listened intently.

What could have been a tearful crisis turned out to be a valuable learning experience.

"You were great with the kids," Heath told her, once they were on their way to Fort Stockton.

"Liz-Beth and Sven were great teachers. They always knew just what to say and do," she answered.

"Seems like that skill runs in the family."

A troubled look flashed in Claire's eyes, then disappeared. She shrugged off the incident. "It was my fault, anyway. I wasn't keeping a close eye on them."

Sensing she needed reassurance, Heath said, "They love you."

"I love them, too."

But it looked, Heath noted, as if Claire thought her love was not enough.

Silence fell. She opened up her briefcase and pulled out her yellow legal pad. Her mood much more subdued, she said, "As long as we have the time, would you mind giving me your opinion of these Thanksgiving dinner menus? Because I need to get this worked out this evening. I want several possibilities to present to Buzz Aberg tomorrow morning, for his family's approval."

By the time they reached the toy store in Fort Stockton, they had four different menus for him to choose from, as well as a list of decorations she was going to need.

Luckily, the deluxe tool kit was still on hold. Claire picked that up, as well as a few items for the goody bags the birthday party guests would be taking home with them. Heath picked up two presents, too, ones Claire was sure the twins were going to like.

From there, she and Heath drove to his place, a townhome in a new development geared for singles.

"Feel free to look around," he said when they walked in the door.

IT WAS AN INVITATION Claire couldn't ignore, particularly when seeing the way a man lived always told a woman so much about him. And she wanted to know who Heath was, deep down.

Switching on lights as he went, Heath crossed the beautifully appointed living room to a breakfast bar near the kitchen. Claire followed, drinking in every detail of the heavy, espresso-colored wood furniture and sleek cream sofa, silk draperies and eclectic accessories.

A display of sales brochures was prominently displayed

on the black marble countertop of the equally impressive, state-of-the-art kitchen. Next to it was a smattering of cards left by real-estate agents who had been there to either preview the property or take clients through.

"Well, it looks like I'm drawing some interest," Heath said.

"It's very nice," she commented, walking through to the formal dining room, which sported a beautiful table, buffet and Persian rug that all coordinated perfectly with the pale-green walls. "Like something out of a home décor catalog."

He flashed a puzzled smile. "Why do I think that's not so good, in your view?"

Because, she thought, it pointed out once again the disparity in their lives. A disparity she was no longer sure would be that easy to overcome. Not wanting to insult him for having great taste in furnishings and color schemes, she forced a smile and said, "This is great for a devoted bachelor like yourself."

He crossed the space between them in three easy strides. "I still hear a 'but' in there," he chided, taking her into his arms.

She warmed at the strength of those arms. "I can't really see me bringing Heidi or Henry here."

Heath threaded his fingers through her hair. "Why not?"

Claire's heart began to beat like a bass drum. "Because Heidi might smear liquid soap on all your beautiful furniture, while Henry's busy taking something apart that shouldn't be taken apart."

Heath brushed a strand of hair from her cheek and tucked it behind her ear. "You think that would bother me?"

Reminded how very much was at stake here, Claire said softly, "I think it would bother *me*."

"You know what I think?" He exhaled slowly and con-

tinued to study her in the quiet of his townhome. "I think you're making excuses."

Claire glanced away. "Excuses about what?"

"About why you and I aren't going to work."

She gulped. That was exactly what she'd been thinking. She moved past him and, because there was no place else to go downstairs, headed up the staircase. She shot him a quelling look over her shoulder. "I think we can be friends."

He looked as if he wanted to shake her or kiss her senseless—she couldn't tell which. "Suppose I don't want to be just friends."

Claire paused at the top of the stairs and watched as he climbed to her side. "Then what do you want?" she demanded.

"Truthfully?" He stared at her, a wealth of feeling in his eyes. "This."

He backed her up against the wall and caged her with his body. She could feel the heavy thudding of his heart and see the sensuality in his smile as his head lowered slowly, to hers. She didn't want to give in to him, into something that seemed stronger than the both of them, but his will was fiercer than hers. With a low moan, she tipped her head back to give him access. Their lips meshed, and the world fell away. All she knew, all she wanted to know, was the comfort of his mouth moving over hers, and the magical power he seemed to hold over her heart. As she savored the taste of him, she couldn't remember anything ever feeling this right, this real, this solid.

"Tell me you want this, too," Heath said, between sweet, seductive kisses.

"I want this, too," she whispered, winding her arms

around his neck and pressing her breasts against his chest. Another shiver of excitement went through her. "So much."

Then his mouth was on hers again in a kiss that was shattering in its possessiveness. He deepened the pressure, his palms on her back drawing her intimately near. He kissed her as if he was in love with her and would be for all time. As if he meant to have her. Hearts pounding, they kissed their way down the hall, into his bedroom. Wrapped in each other's arms, they tumbled onto his king-size bed. As they settled onto the pillows, the affection in Heath's eyes was all the incentive she needed. She could hardly believe this was happening, and yet there was no denying the need, the yearning, deep inside her.

Driven to abandon, she surrendered to the feel of his hands slipping beneath her clothing to touch her breasts, her tummy, her thighs. Her clothes came off, with his help. His came off with hers. Naked, they slid between the sheets, with nothing between them but desire. Aware she had never felt sexier in her life, she kissed him passionately, savoring every second of their coming together.

When the kiss ended, he made his way slowly down her body, exploring every curve and dip with almost unbearable tenderness. Urgency swept through her as he suckled one breast, then the other, before shifting lower still, to her navel, her abdomen. Claire trembled as he reached between her legs and found the sweet spot there. She shifted restlessly, only to have him hold fast, and then his mouth was on her in the most intimate of kisses. Longing streamed through her and she came apart in his hands.

And then it was her turn to please him, bestowing on him the same languid exploration of his hard, strong body, until it was more than he could take.

He shifted so she was beneath him once again. Sliding a hand beneath her hips, he lifted her and surged into her with one smooth stroke. She gasped at the mesmerizing feel of him, buried deep inside her, and then all was lost in the power of their joining. She wanted him, wanted this sweet, magical pleasure….

His bedroom grew hot and close, their bodies slick and warm. Together, blood running hot and quick, they moved toward the height of ecstasy, losing all in the shattering pleasure.

HEATH ROLLED ONTO his side, taking Claire with him. Lying face-to-face, they both worked to slow their breathing. Neither could seem to stop grinning. And he had a feeling he knew why. He had never felt a greater contentment.

"Wow," Claire exclaimed tremulously at last.

"Wow," Heath echoed.

They smiled at each other some more.

Then, as Heath feared, the moment began to feel awkward. Sensing Claire was feeling some remorse—for how quickly and unexpectedly they had ended up in bed together tonight—he stroked a hand down her back. He knew she didn't do things like this casually, any more than he did.

Sex came with strings, and with those strings, commitment.

"If only I could stay here forever," she murmured, conflict evident in her amber eyes. Extricating herself from his arms, she sighed in regret. "But I can't. I've got a babysitter to get home to."

He watched as she rolled away from him and, clutching the sheet to her bare breasts, sat up on the edge of his bed. Her blond curls all tousled, cheeks flushed, lips swollen from

their kisses, she made a delectable sight. She looked so beautiful he wanted nothing more than to make love to her again and again.

But it wasn't going to be.

Not tonight.

His eyes still on her, Heath stood reluctantly and began to dress. She needed time to process this. He could see that. He would give it to her, even though restraining his own urges and staying away from her right now was the last thing he wanted. "This is just the beginning, Claire," he told her softly.

"Sure you know what you're signing on for?" she teased, dressing in turn. The only thing that gave away her discomfort was the slight trembling of her fingers, and the fact she couldn't quite manage the zipper on her skirt, not without his help, anyway. "Because I'm a package deal now, and the twins are quite a handful."

Letting her know with a look and a touch they had nothing to be ashamed about, Heath said gruffly, "That's nothing I can't manage." And to prove it, he took her into his arms and kissed her soundly once again.

And he kept kissing her, until there was no more denying it—the physical passion between them was a force too powerful to be denied. Alone, it might not be a sufficient foundation for a relationship, but it was a good start. A helluva good start. For now, Heath would be content with that.

Chapter Eight

Claire had just finished setting out the breakfast buffet when Heath walked into the ranch house dining room. He looked incredibly sexy and approachable in a charcoal suit, light-green shirt and striped tie. As their eyes met, the memories of the night before came back in a rush. Claire flushed. Heath smiled with an optimism in his eyes that mirrored her own.

Maybe this was going to work out after all, she thought. Certainly, she could imagine herself with Heath, meeting like this every morning for weeks and months to come…and not just because he was renting one of her cottages.

The twins bolted toward him. "Are you coming to our birthday party today, Mr. Fearsome?" Henry asked.

Heath hunkered down so he was on eye level with the dynamic duo. "What time is it?"

Heidi and Henry both wrapped their arms around his broad shoulders and tilted their faces up at him, while Claire supplied the details. "Twelve-thirty to one-thirty—at the picnic pavilion in the park."

"All our friends from preschool are going to be there!" Heidi announced.

"Lunch is provided," Claire added.

"And cupcakes! With candles!" Henry declared.

"I would be delighted to come to your party," Heath told them, and the twins hugged him happily.

"Let's let Mr. McPherson have his breakfast," Claire said, disengaging them gently.

The children ran off to go play, talking excitedly amongst themselves. "You're looking pretty this morning," Heath said, once they were alone.

She felt pretty—from the inside out. Claire handed him a plate from the buffet. "Careful, or everyone who sees us is going to know…"

"That the two of you are falling in love?" Mrs. Finglestein finished, strolling into the dining room. She and her husband were clad in their usual khaki outfits. "Dears, that is old news."

Mr. Finglestein nodded toward his wife proudly. "Can't hide anything from her. She's got a sixth sense about these things."

"You two are going to make it for the long haul," she predicted.

Ginger strolled in, every bit the real-estate professional. Bypassing the sumptuous buffet, she headed straight for the coffee. Clearly not all that happy about the news that Claire and Heath were hooking up, she poured herself a cup and stirred in artificial sweetener. "Whatever the case…if you decide to buy sooner rather than later, Heath—or if you decide to sell the ranch after all, Claire—I've got listings I can show you both."

"Thanks," Claire said, preparing a breakfast tray to take down to T. S. Sturgeon's cottage. "I'm not selling."

"Good," the Finglesteins said in unison.

Ginger glanced at Claire with an enigmatic look on her

face. Then she turned to Heath. "I'm moving out this evening, and I could use a little help loading things into my car. Will you be around?"

"Be my pleasure to assist you," he replied, ever the Texas gentleman.

Wiley Higgins strode in. He helped himself to two of the breakfast sandwiches and a bowl of fruit.

"How's the search for oil going?" Mr. Finglestein asked him.

"I'm close to a deal with a rancher down the road," the wildcatter said, pouring coffee into his thermos.

"I hope you're able to close it," Claire said sincerely.

Wiley shrugged. "It's not my first choice," he said, giving her a look that let her know she still had time to change her mind.

A horn sounded in the front driveway.

Startled, Claire looked out the window. The driver from the car pool was early. Glad for any excuse to cut off further talk about mineral rights and oil exploration, she rushed out into the hall. "Heidi! Henry! Grab your backpacks. It's time to go!"

"CLAIRE DOESN'T KNOW the VP from the Wagner Group is in town, does she?" Ginger remarked as she and Heath walked out to their respective cars, for the morning commute to Summit.

"How'd you hear about that?" Heath asked, feeling a little guilty that he hadn't told Claire yet. He'd meant to but the time had just never seemed right. And to be truthful, he wasn't sure how she would take the news.

The real-estate agent shrugged. "As the top-producing broker in the area, I tend to get wind of everything happening or about to happen in the business community. And I had

dinner with Ted Bauer last night. He wanted my opinion on the area in general, and the Red Sage in particular, and I gave it to him."

"I hope it was a positive review."

Ginger grew reflective. "I told him the ranch has the potential to become a great spa if a company like the Wagner Group were to buy it and run it."

Heath looked at the mountains in the distance and thought once again how beautiful it was out here. He turned back to Ginger. "Claire's not looking to sell out completely."

"In my view, that's the only way it would work, if you want to turn this place into a real moneymaker. Face it, Heath. Consumers want luxury these days. Not down-home ambience."

Depends on the consumer, Heath mused silently. He got his car keys out of his pocket. "Do me a favor and don't mention this to Claire."

"Don't worry. I'm not going to do anything to get on Ted Bauer's bad side. If the Wagner Group does come to the area, their employees are going to need homes. I plan to be first in line to sell to them."

And no doubt would succeed, Heath realized, as he said goodbye to her and got in his car.

He respected Ginger's ambition. Her tendency to mow down anyone in her path, professionally or personally, was less admirable.

He favored a more tempered approach.

He wanted to be known as a stellar businessman—with heart. That was not an easy line to walk.

Particularly when he was becoming as involved as he was with Claire and the twins.

Romancing her would not be uncomplicated, given all the

commitments she juggled. Nevertheless, Heath was certain he was up to the challenge.

Dealing with the business of trying to ensure the twins' trust was fiscally productive was a different matter entirely. He understood Claire nixing any further oil exploration on the Red Sage. However, she still had to make changes that would put the ranch—and hence the twins' half of the trust—on firm financial ground.

Heath hoped that she would listen with an open mind to what he and Ted Bauer planned to propose to her this afternoon. In the meantime, he had work to do, two presents to wrap and a birthday celebration to attend.

Normally not all that much of a party person, Heath found himself watching the clock all morning. Unfortunately, just as he was heading out the door, he got a call from an important client he had been trying to reach for several weeks.

By the time their business was concluded, the twins' party had already been under way for at least fifteen minutes.

Heath hurried to his car and drove to the park. He could see the balloons bobbing from the posts of the picnic pavilion as he hurried to wrap the presents with the paper and Scotch tape he had purchased on the way into work.

Finished, he strode quickly across the grass. It was clear from the disarray of paper plates and cups that the kids had already finished their meal of pizza. Claire was standing in a group of casually attired mothers who were supervising the dozen or so four-year-olds in what looked like a finger-painting activity.

"You see," Claire was saying, "if you dip your hand in the paint and spread your fingers out to one side, your thumb the other and then press down, it looks like you've made a Thanks-

giving turkey! You can do one in every color. All you have to do is wipe your hands on the paper towel and… Heath!"

"Mr. Fearsome!" The twins leaped up in unison and ran to greet him. Dodging the two badly wrapped presents in his hands, they barreled into him and hugged him fiercely, one on each side, their tiny hands pressing into the back of his coat jacket and the front of his thighs.

Claire gasped.

A collective groan swept through the group of mothers in attendance.

"You came to our party!" Henry said. "You're here!"

"And slightly more colorful for the effort," Claire observed dryly. "I am so sorry," she said, offering a look of sincere apology.

"It's okay," Heath said, trying not to calculate what the suit had cost.

"It's washable finger paint, which probably means it should come out of a dry-cleanable fabric."

"I'm sure it will." Even if it didn't, it was worth it to Heath, given the hero's welcome he had just received. He'd never had kids look at him as adoringly as the twins did, never been as emotionally attached to any two children as he was to them.

Claire admonished the children to thank Heath for the presents, which they did, then shooed the kids back to the finger-painting table. They resumed working on their colorful collage of Thanksgiving turkeys, while Claire returned with a roll of paper towels. "Might as well blot off what we can," she said.

To make things easier, Heath took off his suit jacket. Claire dabbed that while he did the front of his trousers.

"We saved you some pizza," Claire said.

"Yeah." Henry came back to report. "I ate pizza, too, but I saved my peanut butter sandwich for later. You can have some. I'll share it with you if you want."

Knowing how seriously Henry took his preferred rations, Heath patted the little boy's shoulder. "Well, thanks, Henry." Heath briefly caught Claire's eye. They exchanged looks of shared wonder. "I'm glad you had some pizza," Heath continued.

"Yeah," Henry admitted, as if somewhat surprised. "It was good!" He raced off to be with the other kids.

"Wow." Heath turned to Claire.

"I know," she murmured. She handed him a plate of food and a glass of iced tea. "That was a big step for the little guy."

For them all, Heath thought. It meant Henry was finally settling in.

Noting Claire looked as happy as the twins about his attendance, Heath ate quickly, then eager to be even more involved, helped with the last of the finger painting.

Next came the musical portion of the party—a rousing rendition of the Chicken Dance, complete with a lot of bobbing and arm flapping and *bwack bwack bwack bwack bwacks*. And then the Hokey Pokey. Although he had never been particularly fond of either activity, Heath somehow found himself out on the grass, in the middle of the group. The other mothers danced, too—he wasn't the only adult out there—but he was pretty sure that of all of them, he looked the most foolish, a fact confirmed by the amused grins of the other adults in attendance.

The twins took turns batting their birthday piñata, until all the candy came tumbling out. Finally, it was time for the peach cupcakes with vanilla frosting and sprinkles.

"Do we get to make a wish?" Heidi asked Claire.

"And it has to be a secret, right?" Henry added.

"Yes, you get to make a wish before you blow out the candles. And the wish is supposed to be a secret."

"'Cause otherwise," one of the other children called out, "the wish won't come true."

"Yeah, if you don't tell anybody what it is, it will come true!" another child explained.

That wasn't a promise Heath would have made, given the unpredictability of children's whims and the probability of any desire coming true. Suppose, for instance, Henry wished for a pet elephant in the backyard. Obviously, that would not come true.

But then, maybe if that were his wish, Henry wouldn't expect it to come true. These were pretty bright kids, after all….

Claire finished lighting the candles, four for each twin. She took a few pictures then led the children and adults in song. With closed eyes, Henry and Heidi held hands and made their secret wishes.

"Okay. Open your eyes and blow out the candles!" Claire said.

They blew as hard as they could, while everyone clapped and cheered, and finally, the flames went out. The twins beamed with pleasure. Heath was happy to note that Claire's fear that this first birthday without their parents would be traumatic for them hadn't been realized.

He hung around while Claire handed out gift bags to every child who'd attended. Along with the twins, he helped her carry the coolers, and leftover cupcakes, and presents to her SUV.

"Thanks for coming," she said, almost shyly, "and being such a good sport. And not to worry, I'll handle your dry-cleaning bill."

Heath glanced down at his suit trousers. "It's okay. It'll give my colleagues at the bank something to rib me about. Meantime, are you free later this afternoon—say, around four o'clock?"

"Yes." She tensed a little. "Why?"

Heath wished he didn't have to force this on her, but his job required that he do so. "Ted Bauer, a VP from the Wagner Group, is in town. He and I are going to talk, and I'd like you to be part of the conversation. To make it easier for you, we can come to the ranch office."

Some of the happiness left Claire's eyes. "You know how I feel…"

Yes, Heath did, but he would not be protecting the twins' financial interests the way he should unless he followed through on this. "It's important you consider all the options, just as I intend to do."

Claire looked as if she wanted to argue, then put on her businesswoman's hat and reconsidered. "I'll see you in a few hours then."

CLOUDS ROLLED IN FROM the north as the afternoon progressed. The poor visibility and slick roads made driving hazardous and it was pouring rain by the time Heath got to the ranch. Ted Bauer was already opposite Claire by the time he walked into the ranch office. The short, affable man with thinning red hair was exchanging pleasantries with her, while the twins were once again making a wreck of their play corner, seeming unusually hyper.

"Sorry I wasn't here to do the introductions," Heath apologized cheerfully, shaking the rain off his finger-paint-stained business suit.

"No problem. Claire and I were just getting acquainted," Ted said.

"The Wagner Group runs a much more high-end operation than I do," Claire told Heath.

"Which on the surface is no problem," Ted stated, "should we eventually be interested in acquiring the Red Sage Guest Ranch and Retreat as one of our properties. We could always use the current cottages to house staff."

It was all Claire could do not to wince, Heath noted.

"The cottages are nice," Heath found himself saying. "I'm living in one right now."

"Nice meaning rustic," Ted corrected, his attitude as polite as it was candid. "Our properties cater to the superrich. Their expectations include only the very best. Thousand-thread-count linens, twenty-four-hour room service, on-site massages, nutritional consultations, trainers, even diagnostic blood tests and bone scans."

Claire blinked in amazement.

Ted continued, "Some of our competitors are taking it a step further by offering clairvoyants, astrologers, sex therapists and tarot-card readers, but we're not prepared to go that far."

She sighed and shook her head. "I can't see Red Sage ever being part of that…"

"No, of course not," Ted assured her quickly. "But if we came in, we'd bring it up to par."

Claire shot a look at Heath, then another at Ted. "I think there's been some miscommunication. I'm not looking to sell out completely. In fact, I won't even consider it."

Ted frowned impatiently. "That's the only way the Wagner Group will do business. Apparently you two have some matters to iron out, and our negotiations can't continue until you do so." Putting an abrupt end to the meeting, he left his card, told Claire to call him if she changed her position, and strode out into the rain.

Heath turned back to Claire. "This meeting today was just a starting point in negotiations," he said, unable to contain his frustration with her inflexible attitude and the quickly diminishing timeline he had to come up with a solution. "Or at least it should have been," he amended more gently, "had you not shot down any further talks right out of the gate."

CLAIRE LOOKED AT HEATH, her mouth dry. She knew that tone. Her skeptical friends had used it when she'd told them she planned to return to the ranch and convert it to a guest lodging and retreat facility. It was the tone that said she was a naive fool, best protected from her own fanciful dreams of success. It was the voice of someone who felt he knew better than she did, what was right for her and the Red Sage.

She'd thought Heath supported her in her quest to make her vision a success. Had she been wrong? With difficulty, she forced herself to ask, "Are you saying you think I should sell out completely?"

"I'm saying that partial interest in a real moneymaker is a lot better than full interest in a business that's perpetually in dire straits. Fortunately, Ted is enough of a professional to be open to further discussion if contacted."

"Meaning what, you're going to override my feelings on this?"

"Technically…"

"I know you can do it, Heath. I'm asking if you're going to betray me."

He was silent. Which was, Claire thought, all the answer she needed. "I see." She took him by the elbow and pushed him toward the door. "Thanks for stopping by."

He held out his hands in supplication. "Claire. We need to talk about this."

"Not now."

"When then? Time is running out."

As if she didn't know that! "When I get my thoughts together, I'll let you know." She propelled him through the portal and shut the door behind him.

"Are you sad, Aunt Claire?" Heidi asked.

"I think she's mad," Henry decided.

"It's just business," Claire assured them with a brisk, motherly smile.

"Business isn't fun," Henry said.

"But birthday parties are," Heidi stated. "Can we have another birthday party tomorrow?"

Glad for the respite from her dark thoughts, Claire knelt to help them pick up their toys, "No, kiddos, we can't. Birthdays only come once a year."

A fact she was very glad of, two and a half hours later, when she finally readied the twins for sleep, read them a story and tucked them in bed. They had completely exhausted her, and she still had so much to do to get ready for Buzz Aberg and his guests.

With a sigh, she went down to the dining room, where she had set up a crafts area. She had just finished the first horn

of plenty when a knock sounded on the front door and she went to answer it.

Claire found the rain letting up, but braced herself against the cold gusty wind that blew through the yard. Heath stood on the other side of the portal with a resolute look on his handsome face.

She'd seen him helping Ginger load her things in her car, earlier. He'd still been in his suit and had gotten pretty wet. It looked as if he had shaved and cleaned up since—he was now clad in a black windbreaker, jeans and scuffed Western boots.

Trying not to shiver in the chilly blast, she folded her arms in front of her and lifted her chin. "I'm not ready to talk to you just yet."

"That's okay." He flashed a cynical half smile. "I don't mind doing all the talking." He breezed on in.

She sighed and let him pass, shut the heavy oak door behind him, then went to the thermostat in the hallway to switch on the heat. "I mean it, Heath. I haven't had time to collect my thoughts."

He slipped off his jacket and hung it on the coat tree next to the stairs. Taking her hand, he walked with her into the living room, where he guided her to the end of the sofa, choosing a wing chair himself, so they were face-to-face. "Then perhaps you could listen," he said in a soft, serious voice. "I conceded to your wishes, even though, technically, I didn't have to take them into consideration. I didn't give Wiley permission to explore for oil on the land the twins inherited, without your consent."

Claire swallowed. "And I appreciate that," she said evenly, though her temper was rising once again. "What I didn't

appreciate was the suggestion that I should sell out to the Wagner Group!"

"Even if it meant you wouldn't have to worry about finances for the rest of your life, and neither would the twins? Even if it meant you could possibly work a deal to have a job as property manager—and the executive pay that goes with such responsibility? To have the ranch house and perhaps several of the cottages for your own use?" He ran a hand through his hair. "Did you think of any of those options? Did you consider that, with the right advocates negotiating on both sides, you could end up with an arrangement everyone will be happy with?"

With it put that way, she did feel like a fool…. Claire sighed. "Look, I know from a strictly numbers perspective it makes sense."

"But…?"

"But it feels like if I do this I'd be taking the easy way out—and giving up on the dream I shared with Liz-Beth and Sven. And that," she concluded, "feels like a betrayal."

Chapter Nine

"Liz-Beth and Sven would understand it's too much for one person to take on," Heath told her. The fault here lay in the way the trust had been set up, in the fact that Liz-Beth and Sven had died before the business could get up and going. He knew Claire had done the best she could, under very trying circumstances. But there was no shame in reevaluating and going in a different direction than originally expected. Businesses did it all the time.

He paused to look deep into her eyes. "You have something more important to consider," he murmured. "You have the twins and their financial futures, their parents' wish that they grow up on the Red Sage—even if it is in a slightly different way than their parents envisioned. You have to protect that first, and worry about any career goals and aspirations you and your sister and her husband had, second."

Claire was studying him soberly when a small voice piped up from the bottom of the staircase.

"Aunt Claire?" Henry called plaintively. "I waked up."

"I waked up, too," Heidi said.

Heath turned in time to see the children trudge unhappily

across the room. Both were rubbing their eyes and appeared to have been crying.

He felt an unexpected lump in his own throat.

"Hi, Mr. Fearsome," Henry said, bypassing Claire's arms to climb onto Heath's lap.

Looking just as unhappy, Heidi slid onto Claire's. "Yeah. Hi, Mr. Fearsome," she said sleepily.

Claire wrapped her arms around her niece.

Deciding that was a good idea, Heath did the same with Henry.

"What are you two doing awake?" Claire asked, looking sweetly maternal as she hugged the little girl close. "Did you have a bad dream?"

They locked glances for a second, seeming to communicate the way many twins did. Finally, Henry exhaled slowly and said, "We're sad."

A flicker of pain flashed in Claire's eyes. Heath felt an answering pang in his gut.

She prodded gently, "Can you tell me why you're sad?"

Even though, Heath guessed, she probably already knew. It was hard to lose a parent. Even harder to lose both when you were that young.

Another silence fell.

Heidi rubbed the soft fabric of her flannel pajama top between her fingers.

Henry rested his head on Heath's shoulder, giving Heath a taste of what it would feel like to be a dad, rather than just a friend of the family. And not just any dad, but Henry and Heidi's…. And "Aunt Claire's" husband.

Finally, Heidi murmured, "Because we miss Mommy and Daddy."

"Do you think they're sad, too?" Henry asked, looking at Claire, and then up at Heath.

"Because they didn't get to come to our birthday party today?" Heidi added.

Realizing how bittersweet today must have been for the kids, Heath felt a pressure behind his eyes. And that was weird. He never cried….

Claire held out one arm to Henry. He slid off Heath's lap and into her embrace. Holding both twins close, she lovingly stroked their curls and said, "Actually, your mommy and daddy kind of were there with you today."

"But we didn't see them!" Henry protested.

Obvious frustration at being unable to communicate with the kids as well as she wanted to showed in Claire's amber eyes. "I meant in spirit," she corrected softly. "They were watching over you from heaven."

The twins regarded her uncomprehendingly.

Claire tried again. "I know it's confusing, because we can't see or hear Mommy and Daddy. But they can see and hear us, and they're watching over us and keeping us safe all the time." Claire stroked her palms down the little ones' backs in a comforting massage. She bent her head and pressed a kiss to the top of each child's head. "If you shut your eyes and think real hard you can feel their love. When you do that, it wraps around you like a big warm blanket."

The twins smiled faintly at the analogy.

While Heath gazed on admiringly, Claire paused and looked into the eyes of each. "And you know you don't ever have to worry, because you've got all the love they ever gave you right here in your hearts." She touched the center of her chest. "And the love you felt for them is there, too. It

will always be there, deep inside you, making you feel good." Her voice thickened, her own emotions welling as she continued, "So let's try it, okay? Let's all close our eyes and remember what it was like to feel Mommy's and Daddy's arms around us, holding us close, holding us safe."

In unison, everyone's lashes fell, shuttering their eyes. Slowly, Heath saw their breathing even out, their small bodies relax in their aunt's loving embrace. "Can you feel it now?" Claire murmured.

Heath could. He'd never felt more love in his entire life. Hadn't even know, until now, it was possible.

Both children nodded. "Good," she said. "So," she added after another long, soothing cuddle, "are you ready to go back to bed now?"

Both children opened their eyes. Sadness faded. Contemplation appeared.

"Can we put cupcakes on a plate first?" Henry asked.

Claire appeared as surprised by the unexpected request as Heath felt.

"With milk. Like we do for Santa Claus, with cookies," Heidi explained.

"So Mommy and Daddy can have birthday cupcakes, too, when they come to watch over us tonight, while we sleep," Henry said.

Clearly, Heath noted, this was something the twins had discussed.

Her surprise fading as quickly as it had appeared, Claire nodded. "I think that's a wonderful idea!"

Heath and the twins went with her to the kitchen. They got out two plates, two cupcakes, two napkins and two glasses of milk. "Let's put them by the fireplace," Henry said.

"Yeah, where we put the cookies for Santa," Heidi explained.

Once that was accomplished, Claire had the children say good-night to Heath.

Before she could herd them up to bed, Henry turned to him and said, "I want Mr. Fearsome to tuck us in, too!"

"SORRY ABOUT ALL THAT," Claire said after they finally returned downstairs.

"You handled their grief really well," Heath remarked.

"Thanks." She let out a sober breath, then raked both hands through her hair, looking a little frazzled. "It's hard to know what to do or say sometimes. I mean, I've had expert advice. But there's nothing that can prepare you for the queries that come up in the moment."

"It's not just the twins. You miss Liz-Beth and Sven desperately, too, don't you?"

Moisture glittered in her eyes and was promptly blinked back. She wandered into the dining room, stood staring down at the crafts material scattered across the table. "As difficult as the twins' birthday was, I know Thanksgiving and Christmas are going to be even harder. Especially Christmas," she said hoarsely.

Heath had seen firsthand how strong she was in all aspects of her life. And how tenderhearted and compassionate, too. But it was her determination to be there for the twins whenever they needed her that would continue to carry her through the tough times. "You'll manage," he told her, meaning it.

Without warning, the tears she'd been holding back spilled over her lashes. She pressed a hand to her lips and stifled a small, anguished sob. Heath didn't have to think about what to do next; he put his arms around her and pulled her

close. She melted against him, her body trembling, and the front of his shirt grew damp with her tears.

Finally, she drew back and lifted her face to his.

Whatever she'd been about to say was lost as their eyes locked.

Heath knew it wasn't just business bringing him over here tonight, or her grief keeping him here, to comfort her. It was also the developing attraction between them, which went far beyond the physical and the intellectual, reaching down inside him and grabbing his heart. An attraction that had him wanting to be part of her and the kids' life from this day forward. That had him wanting to bend his head to hers and kiss her. Not just once, he thought, as his lips sought and found hers, but again and again and again....

Claire hadn't meant to find comfort in Heath's strong arms. The tenderness in his embrace—the empathy mixed with desire in his kiss—had her kissing him back, more and more passionately, until it was either let things progress, or stop...while they still could.

Wary of the twins upstairs, perhaps not even asleep yet, she tensed.

Getting the message, Heath reluctantly slowed, then leaned back.

"The pitfalls of romancing a woman with children," she said breathlessly.

"Or the benefit," he replied quietly, taking in the longing in her eyes, which matched that in his heart. "Because when we make love again, and we will, it won't be an impulse. It will be because you've thought it through and mean for it to happen."

And once it did, Heath thought, there would be no turning back for either of them.

"ANY CLOSER TO RESOLVING the situation regarding the trust for Claire Olander's niece and nephew?" Orrin Webb asked Heath the next day, over lunch.

He looked at his boss. "Using the mineral rights as a source of income is out."

"What about the Wagner Group? Any luck there?"

"They're interested and could be, I think, persuaded to buy the Red Sage, given a little time and careful, committed negotiation."

"I hear a 'but' in there."

"Claire Olander is not crazy about the idea."

"Ms. Olander is not crazy about anything other than making a go of it herself, and you and I both know what the chances of that are."

Just because it was a long shot didn't mean it wouldn't happen, Heath thought, aware that no one was hoping Claire would pull off a last-minute miracle more than he was. Then the rest of this would be unnecessary and the two of them could get on with building their relationship.

Directing his mind away from his love life and back to the business at hand, Heath told his boss, "I'm going to keep Ted Bauer interested while Claire takes her last shot at making the business profitable. Or at least shows the potential for it to be so in the very near future."

"And if she fails?"

He tensed. Talking this way felt disloyal, even though they all knew he had a job to do here, and would not be dissuaded from doing it. "There are still a couple of options I haven't pitched that would work in the short run, but not the long."

Orrin looked interested. "Such as?"

Heath shrugged. "Claire can only sell the land if she lets go of all twenty-nine thousand at once. There are no such restrictions on the cottages or office, which are owned by the business. Selling even one of the cottages outright would bring in enough of a cash infusion to put the Red Sage in the black for a year."

"Like a time-share?"

"Or permanent residence." For himself, Heath thought. If and when Claire's business picked up, he could always sell it back to her. As long as he didn't profit directly and excessively, it was a perfectly ethical move.

"And there's another way she could expand…."

He spent the rest of lunch strategizing with Orrin. Together they tried to figure out how they could make that possibility work in the short time frame they had available, without Claire even knowing about it—or worrying over the obstacles involved—until it was nearly a done deal.

"You're putting a lot of effort into helping this young woman out," Orrin said.

"It's my job," he stated.

His colleague's face split in a craggy smile. "Keep telling yourself that," he advised dryly, as they headed back to the bank.

Heath had just settled at his desk when his cell phone rang. It was Claire. He picked up and heard the frantic note in her voice. "Oh, Heath," she said, "Thank heaven you're there! Buzz Aberg's e-mail server is down, and he's been trying to fax me the guest list as well as dietary requirements of the guests he's bringing with him on Wednesday. But now my fax has suddenly stopped working altogether. I tried to get it going, but it's making this horrible grinding sound…."

That didn't bode well, Heath thought, recalling how the cover had been yanked off the day before by Henry, and put back on by Heath. He'd assumed, because the ready light was still on and he hadn't seen anything amiss, that there was no damage to the machine. Belatedly, he realized he should have given it a test run just to be sure, instead of assuming all was well.

Live and learn.

"Is your e-mail working?" he asked calmly.

"Yes."

"All right. Have Buzz fax the information to me, here at the bank. I'll scan it and send it over to you via e-mail attachment right away."

Claire exhaled in relief. "You're a lifesaver."

She certainly made him feel like a hero. So did the kids, whenever he was around them. "No problem," Heath said casually, aware he was glowing like an idiot, which was ridiculous, since he was partially responsible for her current dilemma.

But Claire was already going on. "I mean it. I owe you for this! How about dinner—tonight?"

Heath grinned, already looking forward to it. "Consider it a date."

A FRESH WAVE OF November rain was threatening when Heath left the bank that evening. He turned his collar up against the cold and thought about the warm and cozy evening ahead. Suddenly, the weather didn't seem so gloomy.

As he'd half expected, Claire and the twins were still in the ranch office when he got back there at six o'clock. For once, it didn't look as if the play corner had suffered an explosion

of toys. Instead, Heidi and Henry were seated at their small table, coloring intently.

Henry shot a sheepish look at Heath. Heidi, with her usual curiosity, asked, "Are you going to fix Aunt Claire's fax machine?"

It seemed imperative to both twins that he did.

"I'm going to try," he said, already taking off his suit coat and rolling up his sleeves. There were no guarantees. He was a financial, not a technical, wizard.

Claire drifted closer. The scent of her lavender perfume clung to her skin and hair. "I've never heard any of my electronics make a sound like this one is making," Claire stated, wringing her hands.

Heath could see the fax waiting message flashing on the machine.

"Mind if I give it a try?" he asked.

She shrugged. "Can't do any more damage than has already been done."

He pressed Print, but the machine made an awful grinding sound.

Heath quickly pressed the stop button. "I see what you mean. That is pretty bad."

The twins ducked their heads and got even busier.

Heath loosened his tie. "Got an instruction manual?"

Claire winced. "That's part of the problem—I can't find it. These machines were always Sven's domain, and I have yet to figure out where he put the various manuals."

Heath looked behind the machine for the power cord. "No worries. I'll just turn it off, unplug it and lift the lid."

Heath revealed the guts of the malfunctioning machine. At first glance, he saw nothing wrong with it. The

printer cartridge appeared to be correctly snapped into place. There was a paper jam, however. Puzzled that the paper jam error message hadn't been flashing, Heath carefully worked the edges of torn paper out of the roller guide inside the machine. Instead of coming off in one rumpled sheet, it ripped off in bits, leaving more fragments trapped inside.

Henry edged nearer. He'd put on his yellow hard hat, and handed Heath his play wrench and screwdriver. "You can use these," he offered.

Heath regarded the "tools" with the same seriousness. "Thank you, Henry."

Heidi crowded in close and looked over Heath's other shoulder. "How come it's not working?" she asked, her small brow furrowed.

Claire came next. She handed Heath a real toolbox. "Just in case," she said.

"Thanks."

Heath had never had such a big audience for something he wasn't sure he could accomplish. With all eyes upon him, he went back to work, drawing out more paper and then, tucked into a narrow space in the side of the machine, a matchbox-size motorcycle. A paper clip. Two rubber bands.

"Henry…" Claire sighed.

Heidi immediately jumped to her brother's defense. "He was just trying to fix it for you."

Henry ducked his head. "It needed some toys to play with," he mumbled.

It had had that all right, Heath mused as he pulled out a Magic Marker, a ballpoint pen, two postage stamps and an eraser. Afraid there might be still more, he turned to Claire. "Got a flashlight?"

Once she'd handed one over, Heath poked around again. He found a couple more rubber bands and some additional bits of stuck paper. "It seems clear now," he said finally. "Let's give it a try." He plugged the machine back in, replaced the cover and pressed Print.

And miracle of miracles, it actually worked.

"I'M SO EMBARRASSED," Claire told Heath later, as she went about cleaning up the supper dishes after the kids were in bed for the night.

She bent to fit a pan in the lower rack of the dishwasher, while he cleared the table for her.

"I knew Henry had taken the cover off, of course, since I was there when he did it, albeit not paying attention. But it never occurred to me that he or Heidi might put anything in there. I guess it just goes to show how preoccupied I've been with the preparations for the Aberg party."

Heath knew she was nervous about the upcoming Thanksgiving weekend. And with good reason. She had a lot riding on it. What she didn't know yet was that this was not her only option; he had found other ways to potentially save the day.

But figuring this wasn't the optimum time to bring that up, since it wasn't a done deal yet, he temporarily kept mum on the subject.

"Look at it this way." He grabbed a spray bottle and misted the table with kitchen disinfectant. "People with kids always have such interesting stories to tell." He grinned at her. "Now I'll have some, too."

She grinned back at him and shook her head. "I notice you said 'some' stories, as in plural," she teased, shutting the dishwasher door.

Heath pulled her close and bent his head. "I plan on sticking around for more."

They kissed in a way that was reminiscent of the night they'd made love. It was filled with so much promise for their future. Sighing, Claire splayed her hands across his chest. The intimacy of the touch reminded him of other things.

Her eyes lit up as she felt the pressure growing. "Heath…"

He struggled to contain his arousal. Letting his hands drop to her waist, he shifted reluctantly, so they were no longer touching where he most longed to be. "I know." He swallowed. "With the kids upstairs asleep…" It wasn't hard to guess where this conversation was going.

Claire extricated herself from his arms and stepped away, self-conscious color tingeing her cheeks. "I'm just not comfortable with the idea of us being intimate when they're sleeping in the next room and could wake up at any moment, needing comfort, and barge right in." Regret shone in her eyes. "They're confused enough already about everything that has happened in the last year, the overwhelming loss. Even subtle changes upset them so much."

Heath understood. He respected Claire for being so in tune with the twins' needs and feelings. It was the mark of a good parent. But she was a woman, too. And she needed to administer to her own needs, as well. She needed to be cared for, in the way only he could care for her.

Ready to take as much time as necessary for Claire to feel comfortable with the idea of them being together, he murmured, "So back to us carving out some time alone, where we won't feel like we're in a fishbowl, or have to worry about what everyone else will think…" Or conclude—prematurely.

Claire's eyes lit up in a way that let him know she had already been privately thinking about that herself, weighing possibilities, wanting even as she remained cautious. Heath understood. Relationships between men and women were complicated affairs, driven by so much more than lust and friendship. Despite his best effort, he had misread signs, taken the future for granted. He didn't want to crash and burn again. On the other hand, he thought determinedly, nothing ventured, nothing gained. Everything within him told him he and Claire were on the brink of something exceptional. To not explore that would be foolish, too...

"Mae is going to babysit the kids on Saturday. I'll be making my monthly trip into Fort Stockton to visit the warehouse store there, plus buy in bulk a lot of the food items we'll need for our weekend guests, including the turkeys." She reached for his hand. "It's probably going to be crazy, with crowds up the wazoo, given that Thanksgiving is now just days away...but if you want to go with me, I could ask Mae if she'll babysit the twins into the evening. Which means the two of us could have a real, adults-only, sit-down-in-a-restaurant dinner, before we returned to the ranch."

"As long as it's a date..." Heath brought her closer for another long, tantalizing kiss, indicative of the kind of passion they could experience again, if only they could find the right time and place.

"It definitely is." She nestled contentedly against him.

"Then we're on," he said.

Chapter Ten

Heath heard the voices the moment he stepped into the ranch house Friday evening.

"It's my turn!"

"No, it's my turn!"

"No, it's *my turn!*" This was followed by a bloodcurdling scream, and then another....

Claire came dashing out into the hall. "Stop! Right now! Both of you!"

Heidi and Henry froze.

She retrieved the toy xylophone they had been fighting over and set it aside.

The twins waited, knowing, it seemed, that they were in trouble. Big trouble, for creating such a ruckus.

Claire put her fingers to her temples in the age-old gesture of a parent who was about to lose her mind.

"Okay. Two-minute time-out for both of you."

"Aw…" The protest rang throughout the hall.

Claire lifted an eyebrow. "Want to make it three?"

The twins fell silent.

"Okay. Henry, you take your time-out on the stairs. Heidi, you sit on the bench at the other end of the hall. Go! Now!"

Reluctantly, they trudged to their assigned places.

Claire took the offending object, opened the front hall closet and set it on the highest shelf, way out of reach. She shut the door, glanced at her watch, waited some more. Heath wandered into the living room and he stood at the window, looking out at the rain coming down in sheets.

Finally, Claire said, "Okay. Time-out is over. I expect you to apologize to each other and to me."

"We're sorry," Heidi and Henry said in unison, doing everything but sticking out their tongues at each other.

"You have to mean it for it to count," Claire said.

They sighed and grew more contrite. "I'm sorry," Heidi repeated, and when Henry apologized, too, they hugged one another.

"Okay." Claire sat down on the stairs. "Let's talk."

The twins settled on either side of her.

"I know you two are bored."

"We want to play outside," Henry said for both of them.

"Well, you can't," Claire decreed bluntly. "Not in a cold November rain."

Two lower lips shot out. Then Heidi got a gleam in her eye. "Can we play hide-and-seek then?" she asked.

Henry wrapped his arm around his twin's shoulder, as if the quarrel between the two had never happened. "Yeah. We want you to play, too, Aunt Claire." They peered into the living room, where Heath was still waiting for the "family conference" to be over. "And Mr. Fearsome, too!"

Heath thrust both hands in the pockets of his jeans, and ambled out into the hall.

Claire slanted a shy look at him. "I'm sure Mr. McPherson has better things to do."

"Actually," he said, flashing her a crooked smile, "I don't."

"Okay, but only for half an hour," Claire advised, in a voice that brooked no disobedience. "Then it's going to be bath and bedtime. Got it?"

The children beamed. They turned and gave each other a clumsy, preschool version of a high five, happy, it seemed, that their hours of weather-induced boredom were over. "Got it!"

"Okay, Mr. Fearsome," Claire said, giving him a grateful smile and a high five of her own. "You're 'it'!"

"YOU LOOK…STRESSED," Heath noted when they met up early Saturday morning outside her SUV.

"It's just hit me, all I have to get done today," Claire said.

Looking rugged and relaxed in a long-sleeved, gray polo shirt and jeans, his thick black hair gleaming in the morning sun, Heath cast an easy smile her way. "Want me to drive?"

You have no idea how much, she thought. "That would be great."

Claire put her going-out-to-dinner clothes in the rear compartment, next to his, then grabbed her briefcase and climbed into the passenger seat.

As they drove off, the twins waved from one of the ranch house windows. Mae stood beside them, smiling and waving, too.

As soon as they were out of sight, Claire reached for her notebook and calculator. At Heath's curious glance, she explained, "I don't know how closely you looked at the fax you forwarded to me, but one of the things Buzz sent me the other day was a list of dietary requirements. So I had to come up with appropriate recipes and a way to separate out the

specially prepared foods from the normal selections." She sighed. "I've got no idea how big or small people's appetites are going to be. I certainly don't want anyone to go away hungry. So I'm going to err on the side of too much, figuring if I have leftovers, I can always turn them into soup and sandwiches the next day."

"Sounds smart."

"Plus, there are the six other meals I said I would prepare for his group before they leave the ranch on Sunday morning."

Heath sent her an admiring glance. "That's a lot of work."

Claire's tone grew reflective. "And something I'll be doing a lot of if I can tap into the corporate retreat or family reunion market—which is my hope."

As they hit the open highway, Heath set the cruise control on the Jeep. Claire shifted slightly in her seat so she could take in his craggy profile. Damn, but he was fascinating to look at, not to mention kiss…which was something she hoped they would have a chance to do at leisure at some point during this excursion.

"Do you have enough firepower to cook all that food?" he asked curiously.

Claire made a face, as tension set in once again. Reluctantly, she admitted, "Not in the ranch house kitchen. Fortunately, T.S., the Finglesteins and Wiley have all agreed to let me use the stoves and ovens in their cottages, as well. I'll need them to cook four massive turkeys simultaneously."

"So what's the plan? You'll be running from place to place?"

"More or less." Claire sighed again and held up a hand. "I know. I keep thinking I've bitten off more than I can chew, but then I remind myself how much it's going to help if we get a four- or five-star rating from *Southwestern Living* magazine

and a plug on their Web site—and I know it's all going to be worth it." Enthusiasm bubbled up inside her. "I can feel it, Heath. The Red Sage Guest Ranch and Retreat is on the verge of being one of those places you don't want to miss, and when that happens it'll be totally booked year-round!"

It appeared her enthusiasm was contagious. He reached over and squeezed her hand in encouragement. "I'll help as much as I can. I'm not much of a chef, but I can follow directions pretty well."

"I appreciate it." Claire paused, thinking how much her life had changed since Heath had entered it, wishing he weren't driving so she could kiss him now. She contented herself by curling her fingers around his biceps, stroking tenderly. "Although I have to say, I don't know how I'm ever going to repay you."

His muscles warming beneath her grip, he glanced at her. "That's the beauty of dating me," he drawled. "You don't have to."

The assumption in his dark-blue eyes made her catch her breath. "Are we dating?" As in an official ongoing thing…?

His mind made up, Heath said, "Starting tonight we are."

"I DON'T KNOW HOW YOU'VE maintained your good cheer," Claire told Heath when they pulled up in front of his town house at five o'clock that evening.

The day's shopping had been a nightmare of long lines, staggering costs that put a huge dent in the guest-ranch books, and endless preholiday traffic.

"Easy," Heath said. As he got out of the SUV and went around to the cargo area, where the four fresh turkeys that they had just picked up from the organic butcher were

stowed. "I just kept looking forward to tonight." He picked up two turkeys. Claire took two grocery bags of items that needed refrigeration. They carried them inside to Heath's empty refrigerator, stowed them, and went back for more. It took some doing, but eventually they managed to fit it all in. The cargo area of her SUV, however, was still packed tight with everything from soap and toilet paper to fresh fruits and vegetables.

Unfortunately, because Heath had left his own vehicle back at the ranch, it was all they had to drive this evening.

"Our restaurant reservations are at six-thirty," Heath said as they went back into his elegantly appointed home. He paused at the bottom of the staircase. "I'd like to hit the shower before we go."

The restaurant he had chosen was the best five-star establishment in the area. Claire hadn't been to a steak house that nice since she had stopped working as a marketing rep, two years before. She was a little nervous about what it all meant. Was this what life would be like, dating Heath? Or was he simply going all-out because it was their first official date and he wanted it to be memorable?

"Me, too," she said. She needed the time to take off her frazzled career-woman hat and slip into a mood that was a lot more relaxed and conducive for romance.

He paused. "Everything you need should be in the guest bath."

Her heart began to race. "Thanks."

"I'll take the other. Unless," he murmured, "you'd prefer a bubble bath. In which case, you'll want to use the whirlpool tub in the master bathroom."

A bubble bath sounded heavenly, but the thought of loung-

ing around like that in the tub he used every day…or had when he was still living here…was a bit too disconcerting.

In all likelihood it would make her want to skip dinner and just invite him into the tub with her, to see if their previous encounter had been every bit as wonderful as she recalled.

Telling herself the lovemaking would come later, when the time was right, Claire shook her head. "A shower will be just fine."

Heath carried her garment bag up for her, and she took it from there, luxuriating in the warm spray. Afterward she arranged her curls into an upswept do that perfectly complemented her black cocktail dress. She accessorized her outfit with a simple gold necklace with a crescent moon dangling from the chain, and matching earrings.

And it was only when she went back to the garment bag to pull out her shoes that she realized she had a problem.

HEATH KNEW THE MOMENT he met up with Claire in the living room that something was wrong.

It couldn't be her hair or her jewelry—both were perfect. It couldn't be her dress. She radiated sexiness and sophistication in the clingy black fabric that draped her slender curves like a lover's caress. Nor did he think it was her stockings—they were black and sheer and made the most of her showstopping legs.

She groaned in dismay when his glance dropped lower, then stopped at her feet. "I look ridiculous, don't I?" she said.

Not the word he would have chosen. Although perhaps appropriate, given that she had on one black sling-back pump and one high-heeled, black Mary Jane.

"It could be worse," he teased. "At least you have one right shoe and one left shoe."

"Ha ha." She looked down at her feet, shook her head. "The problem is, the only other shoes I have with me are my cowgirl boots."

Heath shrugged, sliding hands into the pockets of his black suit. "I think you look fine. More than fine."

Claire rolled her eyes. "Uh-huh. Do we have time to stop at a shoe store before we go to the restaurant?"

"Sure. There's one on the way."

Claire pressed a hand over her heart in relief. "Thank heaven."

Heath thought she was a knockout even with mismatched shoes. He knew the eye of every unattached man in the place would be on her tonight. Lucky for him, she was his date.

Unable to resist, he teased, "You might start a trend, you know."

She regarded him with a sour expression. "Or not."

Once again, Heath drove. They'd gotten about a mile and a half from his place when the SUV sounded an alert. Heath looked down at the dashboard, to find the check engine light flashing.

Not good, he thought. Not good at all.

"Oh, no," Claire groaned.

"When was the last time you had your vehicle serviced?" he asked, hoping this wasn't indicative of something dire. He didn't want anything ruining their precious time together, and having to deal with a major car repair would definitely throw a monkey wrench into the evening.

She was apparently thinking the same thing because her eyes filled with panic. "It was serviced last month. Everything was fine."

And now it wasn't. Heath frowned. "We really shouldn't

drive it with the warning light on." Not far, anyway. The engine could catch fire. It could throw a rod, blow a piston....

Claire bit her lip. "Where could we take it at six-fifteen on a Saturday night?"

As far as Heath was concerned, there was only one option. Although it came with complications he really didn't want this evening.

He switched on the left turn signal. "My ex-brother-in-law has an auto shop not far from here. We'll go there."

Claire blinked. "Ex-brother-in-law?" she repeated, as if she couldn't have heard correctly.

Heath had a sinking feeling at the look on her face. Maybe he should have mentioned the fact that he'd been married. "Yeah," he said, wishing he could erase that entire chapter of his life, save for his close relationship with his ex-wife's family. "I'm divorced," he stated, looking Claire right in the eye. "Have been for a couple of years."

DIVORCED. The word echoed over and over in Claire's head. Too late, she realized she had never asked about his marital status. When she'd heard via the Summit grapevine that he was single, and witnessed for herself his desire for a family of his own, she had just assumed he had never been married. That he was as untested in the connubial bliss department as she. Instead, he had tried matrimony and gotten out. That knowledge sent her spinning off on yet another tangent. What had happened to end the relationship?

Her thoughts were still awhirl when Heath turned into the parking lot of Bubba's Garage. The closed sign was already on the front door, but the lights were on, and Claire could see a husky guy with a shaved head moving around inside.

Heath got out of her SUV and waved at him. The next thing she knew the lone mechanic was coming out to greet them.

"Claire, I'd like you to meet Bubba Granger. Best mechanic around. Bubba, my date, Claire Olander."

The big man slapped Heath on the back. "'Bout time you got back out there," he said cheerfully.

Not the response she would have expected from a former brother-in-law, but perhaps a good sign…?

Heath told Bubba about their problem. "The check engine light just came on. We've got to get back to Summit tonight…"

He nodded, all business. "Better have a look under the hood to see what's going on."

He went back to open up the garage, and called over his shoulder, "Drive it on in. We'll run the diagnostics and see what we come up with."

Feeling a little on edge, Claire paced back and forth, shivering in the cool night air, while Bubba hooked the computer up to her car. Heath phoned the restaurant to let them know they were running late.

He was still on the phone when a Jaguar sedan pulled up. A striking brunette clad in a backless silver dress and Manolo Blahnik shoes stepped out. Eyebrows raised, she gave Claire a long, telling look, then headed straight for Heath. She shook her head as if coming upon a mirage. "I thought it was you."

And yet, Claire thought, there was something distinctly unpleasant in her undertone.

Heath's expression remained impassive. "Gina."

She continued to study him with what seemed like a lot of repressed anger. "I thought you'd left Fort Stockton," she stated.

"I'm still trying to sell my townhome," he replied cordially.

Hello! Claire thought. *I'm still here.* But Heath wasn't looking at her. Gina, however, was. Not in a way that made Claire comfortable.

"Aren't you going to introduce me?" the woman said.

"Gina, Claire. Claire, Gina."

Another twist of the dagger. "I'm Heath's ex-wife," Gina said smoothly. "And you are…?"

"His girlfriend," Claire said, before she could stop herself.

Gina's elegantly plucked brows lifted even higher. "I hope you know what you're in for," she drawled. "Romantic, this guy is not."

Bubba hurried out to join them. He glared at his sister, as if silently telling her to knock it off, then turned back to Heath and Claire. "It's a faulty sensor," he declared. "Perfectly safe to drive. Just take it into the dealership when you get home. They'll replace it, no problem. Should even be under warranty."

Claire breathed a big sigh of relief. "Thank you so much."

"Bubba, I owe you." Heath shook his hand.

"You kidding me?" the man said with heartfelt affection. "I *owe* you, man. Big time."

Heath looked at Gina. "Nice to see you again," he said smoothly.

"Wish I could say the same," she retorted bitterly, earning another reprimanding glare from her brother.

Heath took Claire's hand. "If we still want a table, we better get going," he said.

Chapter Eleven

"You want to tell me what that was all about?" Claire asked, when they were seated in the elegant ambience of the upscale steak house.

"I helped Bubba get the small-business loan that he used to start his own garage," Heath said.

She wrapped her fingers around her wineglass. "I meant with Gina."

He winced. "Obviously, she doesn't like me very much."

Claire waited for him to go on. Eventually, he did.

"She feels I let her down."

Claire read the guilt in his expression. She had a hard time reconciling that emotion with the inherently chivalrous man she knew. "Did you?"

He sat back in his chair with a frown. "In the sense that I was never romantic enough for her, yes. Gina wanted every day to be something out of a fairy tale. She didn't like it if I had to work late, or take important customers out for meals. She was upset that I wanted children, which she didn't, even though that was something we had discussed before we ever got engaged, and had supposedly agreed upon."

"So she said she would give you children and then reneged?"

Heath nodded. "She had second thoughts about ruining her figure with a pregnancy."

Not exactly a romantic view of childbirth, Claire thought. But it seemed to fit the striking woman she had met tonight. Claire studied the hurt expression on Heath's face. "How long were you married?"

"Seven years."

That, she hadn't expected. "A long time."

"Yes." He nodded, taking a sip of his wine. "It was."

Claire supposed that fit. Heath was a man who took his responsibilities seriously. Marriage, for him, like his job at the bank, would be at the top of the list. "How did you end up marrying her in the first place?" she asked.

He shrugged. "We were young. We both grew up in the poorest area of the county. Our families had trailer homes side by side. Gina's mom died when she was a kid and she was very enamored of my mother's talents as a hairstylist. I didn't have a dad—he took off before I was born and was never heard from again—so I gravitated toward Gina and Bubba's father." Heath's tone became somber. "He was a good, salt-of-the-earth kind of guy who worked on air-conditioning systems for a living. Health problems left him unemployed for months at a time, so they were always in the ditch financially. My mom worked hard, but she wasn't one for putting any money aside for a rainy day, and it seemed like we were always one step shy of financial ruin, too."

"That sounds tough."

Heath helped himself to a bacon-wrapped sea scallop, with apricot chutney. He cut into it and offered her a bite off his fork. In turn, she offered him a taste of her lobster bisque.

"It showed me what I didn't want," he continued, his blue

eyes darkening. "Gave me the impetus to win scholarships and go to college and work like hell when I got out, so I would never be living hand-to-mouth the way we'd had to most of the time."

It was clear the experience had impacted him emotionally as well as intellectually. It made her understand why he was such a focused-on-the numbers kind of guy. "Did Gina go to college, too?" Claire asked curiously.

It was apparent from the clothes she was wearing that his ex had also done well for herself financially.

Heath waited until the waiter had cleared the appetizers and set their salads in front of them before he continued. "She dropped out midway through her junior year to work full-time at a mall dress shop. She wanted to spend money on clothes, not tuition and books. She figured I'd make a good enough living for both of us. It was just sort of understood that we would marry as soon as I graduated from college, and we did."

Claire thought about how young they had been. At twenty-one, she had been nowhere near ready for marriage. She admired Heath for taking on so large a commitment at such an early age. "So how did it all fall apart?" she asked gently.

"The truth is, things were never all that good between us, but we hung in there because we had common goals—a better life, a nice home of our own, cars… Not to mention paying off our student loans."

"And you achieved all that."

"Within five years, yes."

"But then the trouble started."

He nodded. "We had been arguing about whether or not to start a family, or move to a more exclusive neighborhood.

Then I turned down a job with a bank in New York City. I went for the interview, and realized I just didn't want to live in the Northeast. I love the Lone Star State. Texas is my home. I knew I wouldn't be a multimillionaire if I worked here, but I'd be able to buy everything I wanted and needed, take care of my mom financially—which I did until she died a couple of years ago—and still save for my future." He signed pensively. "That wasn't what Gina wanted. She yearned to go far away and never look back. I couldn't do that. Didn't want to do that. The rancor between us escalated until we finally divorced, by mutual consent. Anyway, she's been married twice since, and managed to elevate her bank accounts both times." He paused. "I wish her well. I wish her happiness."

Claire didn't think Gina was ever going to get it, not with those values. But her estimation of Heath grew. He'd weathered an acrimonious divorce and hadn't let it make him bitter. Instead, he seemed as eager to embark on a relationship with her as she was with him. Life was looking up.

IT WAS NEARLY TEN by the time Claire and Heath left the steak house. "I better check in with Mae, let her know we're going to be a little later than expected," Claire said, as soon as they got back to Heath's townhome. She wished they had more time to be together, but she would just make do with what they did have.

"Oh, thank goodness you called," Mae said. "I was just looking at the weather report. There's heavy fog in the mountains between here and Fort Stockton. It's not supposed to dissipate till midmorning tomorrow. You really shouldn't try to drive back until then."

Claire was torn between elation—more time with Heath!—and worry. "The twins—"

"Had a great day playing with my grandkids, and are now sound asleep. They'll be fine, Claire. I promise. I'll stay here with them, and you keep safe. Don't start home until nine tomorrow morning."

Mae's advice made sense. Driving *would* be treacherous. Claire ended the call, then filled Heath in.

He took the news with the same ease he always showed.

Claire shook her head in wonderment, thinking back over the evening's travails and triumphs. "I'm not sure if this is the worst date ever, or the best," she teased.

He flashed her a crooked grin and leaned against the banister in the foyer. "What do you mean?"

Claire looked down at her footwear. "Well, it started out bad, with mismatched shoes and car trouble, an unexpected run-in with your ex-wife, and a dinner reservation we almost missed."

"Kind of like Murphy's Law of Dates." His dark brows drew together in mock seriousness.

"Exactly." Deciding the time had come to ditch the mistake in footwear, Claire stepped out of her shoes and padded toward him in her stocking feet. The added difference in their height made her feel small and dainty. "But then the car problem turned out to be little more than a nuisance, I decided the shoes didn't matter, our dinner was absolutely wonderful, and now I've just got an excuse to stay out all night."

Claire twirled around happily, spread her arms and dipped in a small, playful curtsy. She felt like a princess who had just been let out of her turret—on an evening pass.

"Can't say I object to that," Heath murmured, looking every bit as delighted as she was by the unexpected turn of events.

He planted his hands on her shoulders, she splayed hers across the solid warmth of his chest. "It's kind of like the date that never got started, initially, but now can't seem to end."

Heath's eyes gleamed with mischief. "We could say good-night if we wanted." He inclined his head. "Part company."

Claire's breath stalled in her chest, and she tingled in anticipation of another way they could go. Especially now that they had all night. "Is that what you want?" she asked softly.

Holding her gaze, he shook his head and let his hands slide down her arms to her wrists, using the leverage to draw them closer still. "I'd like to cherish every second of this unexpected extension of our time together."

They stood facing each other, a scant half inch apart. "Me, too."

Deliberately, he drew her even closer, so their bodies were touching intimately. Then his palms were framing her face and he was lifting it to his. "So what do you want to do next?"

Claire didn't even have to think. Throwing caution to the wind, she pressed her lips to his. His body tautened, and then all was lost in the searing heat and intensity of the kiss. His lips were hot, sensual and persuasive, and Claire kissed him with growing passion.

Heath was everything she wanted in a man. He was strong, smart, sexy. As tough as he was tender. As his tongue swept her mouth, laying claim again and again, she knew she had only been half living until now. He made her want to experience life and pleasure fully. He made her want to take the time to make love and be loved, and she welcomed what was coming….

Heath had expected this to happen. He'd known after the first time they were together that other occasions would

follow. He hadn't expected to be so emotionally involved so fast, but as he felt the eager surrender of Claire's body, pressed against his, he knew he was in this all the way. Something happened when they were together. Maybe it was simple chemistry. Maybe it was love. Maybe this was what it felt like when two people were meant to be together for the rest of their lives. He didn't know.

What he was sure of was that Claire fascinated him, had done so from the first moment they'd laid eyes on each other. She exasperated him. Drove him crazy with desire. Made him feel he could tell her anything. Everything. Made him feel as if, together, they could accomplish whatever they dreamed of....

Which was why it was so easy to sweep her into his arms and carry her up the stairs, down the hall to the master suite. Heart pounding, he set her next to the bed. She moaned, a helpless little sound that sent blood rushing to his groin. Senses swimming, he kissed her again, putting everything he had into it, determining that this night would be every bit as memorable as it deserved to be.

Still kissing her, he eased the zipper of her dress down. Pushed the fabric off her shoulders.

She was wearing a sexy little wisp of a black bra that barely contained her breasts. He could see her pale pink nipples jutting against the lace. He pushed her gown lower, and discovered not the panty hose he'd found the last time he made love to her, but a garter belt, stockings and tiny panties every bit as sheer and provocative as the bra.

Groaning at how beautiful she looked in her lingerie, he pushed her dress to the floor, and, trembling, she stepped out of it.

"My turn," Claire said softly. Every bit as willing to please, she tugged off his jacket, undid his tie, unbuttoned his shirt.

She eased the cloth away, let it flutter to the floor next to her dress, then ran her hands over his chest, exploring the flat male nipples, finding the indentation of his waist, his navel.

He shuddered when her hands went to his fly.

He caught her wrist, held it tight. "Maybe that should wait." He already wanted her so badly…

"No way." She undid his belt, drew the zipper down, then his pants. "If I'm in my undies, you have to be, too," she teased, running her palm over his arousal.

Feeling as if he might explode then and there, he took off his shoes, pants and socks. Then, aching with the need to savor and possess, he took control once again.

Her lips were wet and swollen from his kisses, her hair tousled, her cheeks pink. They'd hardly begun and already her body was primed and ready for him. Aware that nothing had ever seemed as right, as having her here with him, he kissed her again, lazily at first, then hotter, harder, deeper.

Every bit as caught up in their lovemaking as he was, Claire moaned and opened her mouth to the pressure of his, tangling her tongue with his, using the sweet suction of her lips to draw him in even farther. Her hands caressed his back, his spine, his buttocks, his thighs, before starting at his shoulders and provocatively making their way down all over again.

Not to be outdone, he bent her backward over one arm, held her there, while his head dropped to explore the exquisiteness of her breasts. Her nipples were tight little buds of desire. He explored them through the sheer lace of her bra, laving, suckling, caressing, until she was moaning, lifting her hips.

Aware he'd never wanted a woman more, Heath lowered her to the bed. Took off her bra. Unhooked the garters. Pulled her panties down, then, with the light, sure stroking of his hands, got her to part her legs for him.

She was so beautiful, so sleek and feminine. Her breath hitched when he eased his thumb back and forth over her soft, slick core. Succumbing, Claire shut her eyes, let her head fall back. She gave in to the sensation, arching her spine when he repeated the tender assault with lips and tongue. Reveling at her responsiveness, he explored the whole of her femininity, caressing, stroking, teasing, moving his fingers inside to stretch and torment, until they were wet with her essence. She bucked upward, stretching her toes and urging him on, whimpering softly all the while, and then climaxed with such intensity it was all he could do not to join her in ecstasy.

"No fair," Claire whispered, as she slowly caught her breath. She clasped his head in her hands as he made his way back to her mouth. "I wanted to wait for you."

Perspiration beaded her body, moisture coated her inner thighs. "But since I didn't..." With the sultry smile of a satisfied woman, she pushed him flat on his back, stripped off his boxer briefs. "It's my turn...to be in charge..."

It sounded good, except... "Not sure how long you have," he gasped. He loved the way she looked, so alluring, so ravished, so completely and utterly his....

"As long as I want," Claire murmured as he trembled with the effort to hold back his own response.

Claire had never been an adventurous lover. Never had the confidence to really go after what she wanted in bed. But with Heath it was different. When he looked at her in that

reverent, unsettling way, he made her feel like the most beautiful woman on earth. Which was why it was so easy to let her hair drift over his stomach, to glide lower, to explore his body with the same loving intensity he had shown exploring hers. His muscles were hard, his skin satin, his chest hair crisp and curly. He smelled like soap and cologne and the provocative musk of arousal. His sheer masculinity heightened her senses and drove her to explore, touching, stroking, caressing…

"My turn again," Heath said. Swiftly trading places with her, so she was on her back, he draped himself over her, easing between her legs, as if he'd done it a million times before.

Quivering, she wound her arms and legs around him and declared, "*Our* turn."

Uttering a soft, triumphant sound, Heath pressed against her and kissed her hard. Kissed her until there was no denying what either of them wanted. Desire took over, making her feel hot, inside and out. And then he was lifting her hips, parting her legs even farther, and they were gloriously, inevitably one.

"This is meant to be," Heath whispered, as he penetrated her a little more. And then more, until he was in as deep as he could go. Sliding out, slowly, slowly back in, with each deliberate, passionate movement possessing her all the more. Toes curling, she clung to him, enjoying the wild ride. When she would have hurried him along, he held back even more, making her understand what it was to savor every sensation, to throb with the need to let go completely. Hands cupping her bare bottom, he lifted her a little higher. She tightened around him, pulling him deeper still, until there was no more thinking, only feeling, only wanting, only this incredible

mounting passion and the sensation of sharing one heart and soul. Of moving toward a single goal.

Then all reason fled, and they were free-falling into an oblivion that was as sweet and satisfying as anything either had ever felt.

FOR LONG MINUTES following, aftershocks coursed through their bodies. This time, though, as Heath rolled onto his back, taking her with him, Claire was in no hurry to draw away.

She lay spent, her head on his chest, his body taut and warm beneath her. Heath tightened his arms around her and pressed a kiss into her hair in a way that made her feel even more loved. "That," he said, "was something." The low, husky tone of his voice demonstrated that he was just as affected by what had transpired as she.

Claire sighed contentedly, knowing she had never felt so safe, so treasured. "Wasn't it?"

She had come here hoping they would have another chance to make love. She had expected doing so would be full of excitement and physical thrills. She hadn't expected Heath to rock her world emotionally, but that was exactly what he had done.

He had shown her how to let her guard down. How to relax and enjoy their time together as thoroughly as possible, how to open up to the possibilities of life and love. He'd made her want to explore the sensual side of herself, and share her life with him. And that was a revelation, too.

She hadn't figured that kind of commitment was in the cards for her.

She'd discovered that her heart had very different ideas, when it came to Heath and the future....

He had seemed similarly affected when they were making love, and now, as they continued to hold each other close.

He kissed her shoulder, the nape of her neck, the lobe of her ear, before returning with slow deliberation to her mouth. "How much of a sports aficionado are you?" he murmured, after another leisurely kiss.

"Not sure," she said dryly. "Why?"

He trailed a hand down her arm. "I was just wondering how you might feel about an 'instant replay.'"

She shifted onto her stomach, draped one of her legs between his and propped her chin on her fist. "Actually," she drawled, "I get bored doing the same things over and over again. So…" She threw back the sheet and climbed astride him.

Heath's eyes lit up. "You may have a point there," he murmured. "There's always something to be gained by trying something new."

Claire laughed softly. She dropped down so her breasts rubbed against his chest, and delivered another languid kiss. "So what do you say we try…this?" She rose slightly on her knees, then dropped down again, the lower half of her caressing the lower half of him.

He groaned at the pleasurable friction, and then, gripping her waist, made them one again. "I'd call it the perfect end to the perfect date."

"MRS. LEFMAN SAID YOU couldn't come home last night 'cause there was fog in the mountains!" Henry announced, at ten-thirty the next morning, when Claire and Heath finally walked in the front door.

Score one for low visibility, Claire thought. "That's right." And that little twist of fate had solidified her and Heath as

a couple. Not that he'd actually said anything to her to verify this. But it was evident in the way he looked at her, in the way he'd kissed her this morning before they'd headed out the door. Like someone in love…

Which was, coincidentally, exactly the way she had kissed him, Claire thought, casting a sideways glance at Heath.

"How come there was fog in the mountains?" Heidi asked, drawing Claire back to the present.

"Because of all the storm fronts that have been coming through the last few days," she explained.

"Are they all gone now?" the little girl asked.

The clear blue sky up above suggested they might be. Unfortunately, weather reports on the radio today indicated otherwise. "We're going to have nice weather for the next three days, and then it's going to rain again on Wednesday evening."

Just in time for Buzz Aberg and all the Thanksgiving guests to start arriving.

But Claire plastered a bright smile on her face so the kids wouldn't pick up on her worries.

After the twins helped the adults unload the SUV and put everything away, Claire suggested they all take advantage of the good weather while it lasted. Heidi and Henry beamed when she agreed to let them put seed in the bird feeders scattered around the property, and they could barely contain their delight when Heath suggested a picnic lunch to take with them.

The four soon set off under cloudless skies, and a balmy sixty-degree temperature. Henry insisted on wearing his yellow hard hat and toy tool belt, in case any of the feeders needed fixing. Heidi wore her play baby carrier, with Sissy

tucked against her chest. The twins led the way down the familiar hike and bike path, Claire and Heath taking up the rear.

"I had a message from Wiley Higgins on my voice mail," Claire said. "Apparently, he still hasn't signed that other ranch. He wants one more shot at looking for oil on the Red Sage."

"You could put him off until next Monday," Heath suggested.

Claire darted him a glance. Why would she want to do that?

"See if things work out with *Southwestern Living* magazine the way you want before you shut that door entirely," he explained.

Claire stiffened at the notion that Heath was not one hundred percent behind her efforts to save the business the old-fashioned way, via ingenuity, plain hard work and superior salesmanship. Ninety-nine point nine percent was not good enough!

Unable to conceal the layer of ice that had come into her tone, she said, "Whether things work out with Buzz Aberg or not, I'm not taking Wiley up on his offer."

Silence fell between them as they walked along the trail. She could feel his disapproval. And although Claire now understood why—no doubt Heath was making some comparison between his mother's refusal to act responsibly and spare his family the pain of near financial ruin, and Claire's own desire for a happy ending via a timely magazine endorsement of the guest ranch—that did not make it any easier for her to bear.

Claire wanted Heath to support her without question. To believe as she did. Negative energy could only bring her, and the business, down.

Heath took her elbow when an uneven stretch caused her to momentarily lose her footing. "Have you thought about

getting a small-business loan to renovate the barn into a party facility?"

Claire leaned into him briefly, then moved away. "A small-business loan requires ten percent down, minimum. I don't have it. Liz-Beth, Sven and I mortgaged everything there was in order to build the cottages." Which meant she was still cash poor. Even more so after yesterday's spending spree…

Heath shrugged off her concern. "That's not an uncommon problem for people wanting to start or expand their own businesses. For instance, I helped Bubba, my ex-brother-in-law, put together some outside money from investors so he could apply for the loan that enabled him to start his garage."

When it came to money, things were never as easy as they seemed. However, Claire tried to keep an open mind about what he was proposing.

Heath supervised while the twins filled a low-standing bird feeder, then helped them put the lid back on.

"What did Bubba have to give in exchange?" Claire asked eventually.

"A guaranteed return on par with a good mutual fund. And he had to report to a supervisory board, comprised of said investors."

A chill went down Claire's spine. "What does that mean—'report'?"

Heath met her gaze with equanimity. "He had to meet with them bimonthly and have their approval for all fiscal decisions."

Claire exhaled, her frustration mounting. "So if he wanted to purchase something, or hire employees…"

"Bubba had to run it by them first," Heath said pragmatically.

Claire scowled as the twins raced on ahead to a clump of blooming red sage. "That sounds like a major headache."

Heath shook his head. "They were all sound businesspeople. They provided valuable input to Bubba on everything from lease options to building codes to the employee handbook for his company."

"So, in other words, Bubba's business was no longer his own—at least not the way he first envisioned it," Claire said sarcastically. "And he paid a lot higher interest rate for that borrowed down payment than if he'd had a regular bank loan."

"Yes. But given the fact he didn't have the collateral to obtain a regular loan, and the investment was high risk, it was a fair exchange. And as I said, Bubba benefited from all the advice. In any case, he paid those start-up funds back within a year, and once that was done, resumed full ownership and control of his business. As you would, I'm sure." Heath paused a short distance away from the twins, who were busy picking red blossoms from the bush, to take back to the ranch house. "It's a little late, but I could put something together for you before the December first deadline."

Claire shook her head. "I can't see myself answering to anyone, Heath, no matter how well-intentioned." She couldn't believe he would ask her to do that, either. "And that goes double for any board of advising investors."

It was Heath's turn to frown. "At least think about it," he urged, looking intently into her eyes.

Claire turned away. "I can't, Heath. I'm sorry," she told him softly, doing her best, once again, to ignore the palpable disappointment in his expression. "I'd rather give up on the guest ranch entirely than do something like that."

HEATH LET THE SUBJECT drop because he didn't want to spoil the end of their weekend together. His silence, however, did not mean he had changed his view about the kind of preemptive action Claire needed to take.

Knowing she had no intention of changing her mind, he made his own plans for protecting the business portion of the twins' trust, and acted appropriately under the circumstances.

He knew he would have to talk to Claire about his plans. He would do so at a time when all her other options had been exhausted and she was likely to at least listen to him.

In the meantime, he had to enlist help of his own. And by the time he walked into the Summit restaurant early Monday morning, Ginger Haedrick was already there, talking on her cell phone.

She lifted her hand in a wave. He took a seat opposite her as she concluded her business conversation.

"What is so important that you're missing the breakfast buffet at the Red Sage and meeting me here in town instead?" Ginger asked, looking every bit the Type A woman in her olive-green wool suit.

Leave it to her to cut straight to the chase. "I have a property I want you to break down and appraise for me," he said. "And I want it done quietly."

"Okay. Any particular reason why?" She got out a yellow pad and pen and started taking notes.

Heath hedged, wary of revealing too much. "I may be interested in purchasing a portion of it."

Ginger paused in obvious confusion. "I thought you weren't interested in buying anything until your townhome in Fort Stockton sold."

"That's still my preference." He sipped his coffee.

"Is the property you want me to investigate on the market?"

"No."

Ginger sat back. "Okay, now you've got me fascinated."

Briefly, Heath explained his idea.

Recognition dawned in her eyes. "Claire knows nothing about this, right?"

Heath felt a flare of guilt, which he suppressed. "I'm hoping it won't come to this," he stated candidly.

"But you'll be ready to act quickly if it does?"

No sense pretending. Heath nodded.

Ginger tapped her pen on the pad. "Why don't you just tell Claire what you've got in mind?"

"A lot of reasons," he insisted.

"I'm listening."

Aware that Ginger was not likely to undertake such a covert action unless he was straight with her, Heath said, "I respect Claire's ability to dream. I could never do what she has done, starting a guest ranch from scratch."

Ginger understood, even if at heart she was more like Claire than Heath. "You're more a company guy."

"Right. I like working for a big bank, having that kind of security."

"And Claire wants none of it."

"For her, working for someone else is not an acceptable option."

"Which is why she nixed the idea of selling out to the Wagner Group," the real-estate agent said thoughtfully.

"You heard about that?"

She shrugged. "I'm still trying to sell the VP, Ted Bauer, on the area. Although personally, I think Claire's a fool for not letting Wiley Higgins hunt for oil on her property. Either option is money in the bank."

"I'm trying to increase the monetary return on the twins' trust in a way that is acceptable to all."

Ginger scoffed. "You keep telling yourself that," she teased. "At least until you can own up to the real reason behind your actions."

Heath paid for breakfast and told Ginger he needed the information he'd asked her to get for him by Sunday afternoon at the very latest.

"No problem." She walked with him to the parking lot. "I had no plans for the Thanksgiving weekend, anyway."

Heath paused next to her car. He knew what it was like to have nowhere to go on holidays. Damn lonely. "I thought Claire invited you to the ranch, for dinner there."

Ginger waved off the invitation with a decided lack of enthusiasm. "I declined. Homey gatherings aren't my thing. But y'all have a good time, and I'll meet up with you—" she lightly touched Heath's arm "—on Sunday afternoon, to go over the figures and, if need be, write up a bid."

Heath wished Claire had more time. He wanted her to succeed on her own, without any help from him. But he knew she might not, so, for everyone's sake, he had to be prepared to make a last-minute save, even if she resented him for it.

Ginger studied him, taking in the ambivalence he was unable to hide. She leaned in confidentially and stated, "Don't look so conflicted. You are *not* stabbing Claire in the back by doing this."

Then why, Heath wondered, as he and Ginger said a cordial goodbye, did it feel as if he was?

Chapter Twelve

Claire stood on Main Street, barely believing her eyes. Heath and Ginger Haedrick were walking out of a coffee shop together engaged in what appeared to be a very intimate conversation…and an even more emotional goodbye.

Since when had the two of them become such good friends? she wondered.

And why hadn't Heath mentioned he was seeing Ginger this morning?

Was he back to looking at property? Did that mean he wanted to leave his cottage at the Red Sage?

If that was the case, perhaps he thought it might be too uncomfortable to stay there if she didn't have all her ducks in a row financially by December first. Which meant he'd have to make a decision about protecting the twins' fiduciary interests.

Or was he frustrated because she'd been too busy caring for the twins and making additional preparations for the Thanksgiving weekend to find time for him last night?

Claire had no answers. All she did know was that she didn't want it to look like she was spying on him, so she ducked into Callahan's Mercantile & Feed, intent on running

the errand that had kept her in Summit after dropping off the kids in the preschool car pool.

The proprietress, Hannah Callahan Daugherty, came toward her, her adopted daughter, Isabella Zhu Ming, toddling beside her. "Here for all those hurricane globes and candles?" Hannah asked cheerfully.

Claire nodded. She had ordered fifty of them in advance of a winter storm that was now making its way across the country. She crossed her fingers. "I'm really hoping we won't need them."

"It looks like all the snow and ice is going to stay well north of us. All we're going to get are some powerful bands of thunderstorms."

She found little comfort in that. "We could still lose electricity."

"Don't say that!" Hannah held up both hands as if to ward off a jinx. "With all those holiday meals to cook! And the storm due to hit late Wednesday and continue through early Thursday morning. That could be a disaster."

Especially out in the rural part of the county, where she lived, Claire thought. "I'm hoping if I am well prepared we won't need any of this," she stated glumly.

Hannah rang up the purchases, while keeping one eye on two-year-old Isabella, who was sitting on a rug behind the cash register playing with a tower of Lego blocks. "That's the way it goes. If you're not prepared, you can expect disaster. If you go all out to make sure you are prepared, nothing happens."

Which was what Claire was counting on. She had too much riding on this weekend.

She was still ruminating on the weather as she headed

back home. Mae was in the ranch house kitchen when she arrived, making piecrusts that would be baked later in the week. Mrs. Finglestein was helping. "I thought you and your husband would be out birding this morning," Claire said to her guest.

It was a beautiful day, sunny and clear.

The woman smiled. "We're going this afternoon. Right now he's uploading a lot of the video we've shot thus far back to our birding group in upstate New York. They're all a little skeptical at what we've been telling them we've seen thus far so we thought we'd send them proof." She winked. "Be warned, though, you might have a rush of reservations this winter and spring, as a result."

"I'd be happy to host anyone who would like to come," Claire said, as an idea began to form. If only she wasn't so busy with the Buzz Aberg group coming in on Wednesday, she'd get on it right now.

Mae gave her a long look. "Everything okay?"

She pushed the image of Heath and Ginger from her mind. "I'm feeling a little frazzled."

Mae's eyes narrowed. "Looks like more than that to me."

"To me, too," Mrs. Finglestein said, "if you don't mind me saying so."

O-kay. Well, maybe it was time for a second and third opinion on what might or might not be going on. "How well did either of you get to know Ginger Haedrick when she was staying here?" Claire asked casually.

The two women exchanged glances and shrugged.

"She wasn't much for chitchat," Mrs. Finglestein said finally.

Mae agreed. "Unless it was about business. Then you couldn't get her to stop talking."

"Did she ever talk about dating anyone?" Claire could have shot herself the moment the words were out of her mouth.

"Oh, yes," Mrs. Finglestein declared.

Mae lifted a brow, as did Claire.

"She's a 'player,'" the woman explained. "Only goes out with a man if she likes his financial prospects."

Mae nodded. "She's looking for someone who is as vested in the bottom line as she is. Someone who could give her 'the good life,' is how she put it. And given how determined Ginger is, I think she'll get it."

Which could only mean that she was after Heath, Claire thought, her spirits plummeting even more.

"HAVE I DONE SOMETHING?" Heath asked Claire Monday evening. "Are you angry with me?"

Trying not to think how it felt to have competition for the man she had come to think, however foolishly, as all hers, she held the front door for him.

Too late, she realized they had never really laid out any ground rules. Never declared themselves an official couple or vowed to date each other exclusively. Heath hadn't been breaking any rules because there were none to disrespect!

Aware he was still trying to figure out the shift in her mood, she fought back a self-conscious flush. "No," she said stiffly. "Of course not."

He paused in the doorway, suitcase full of clothes in his hand, and gave her a probing look. "Is it going to be a problem, having me bunk under the same roof as you and

the twins for the next seven days? Because if it is, I could probably find a room in town."

Near Ginger? "Don't be ridiculous," Claire snapped. "The ranch house is plenty big. And the twins are going to love having you close by."

An enigmatic glint came into his blue eyes. "Then what is it?"

"I saw you today."

"Where?" he asked, moving so near she had to tilt her head back to see his face.

"Leaving the coffee shop with Ginger Haedrick," she blurted.

A flash of guilt and evasiveness crossed his face. "We had a breakfast meeting," he said flatly.

"It's none of my business." Desperate to get out of the closed space, she tried to step by him. He put out a hand to stop her.

"It is your business if you're jealous."

Irritated that he saw so much of her true feelings when she wanted him to see nothing, she huffed. "I'm not jealous!"

"Funny," he murmured, "I could swear otherwise."

Another silence stretched. Crossing her arms beneath her breasts, Claire shivered with a chill that had nothing to do with the room temperature. "Are you dating her?"

Heath did a double take. "Why would you think that?"

Glad she'd been so far off the mark, she avoided his eyes. "We've never said we were exclusive."

Heath clamped both his hands on her spine and brought her close. "Then let me set the record straight," he murmured, dropping his head and delivering a long, passionate kiss that stole her breath. Raking his fingers through her

tousled curls, he kissed her again and again, until yearning welled deep inside her. Until she was all too ready to look in his eyes and listen to his soft, husky confession.

"The only woman I am interested in, Claire Olander, the only woman I will ever be interested in," he said, pausing to kiss her again, "is you…"

IT WAS ONLY LATER, as Claire got ready for bed, that she realized Heath had never really answered her question. He'd just kissed her until all her doubts fled.

Then he'd carried the rest of his stuff in.

She'd bidden him good-night after she'd made sure he had settled comfortably into his guest room. Then she'd checked on the twins, who were still sleeping peacefully, and retired to her own room.

Alone, she couldn't help thinking back to the look he'd had on his face when she'd asked him about his breakfast with Ginger. As if he were guilty of holding back something. And that stunned her. Up to now, Heath had been direct in his approach to the situation. He'd told it like it was, at least according to the numbers. Given her options. Let her make her own choices, while still letting her know that at the end of the day if she didn't succeed, something she probably wouldn't like would have to be done about the trust for the twins, in order to protect their inheritance. So what could he be keeping from her now? Why—and how—was he in cahoots with Ginger? Were the two of them already making contingency plans to sell off at least part of the ranch? How was she going to feel if Heath had to be the person to squash her family's dream?

Would she resent him so much that any further romance

would be impossible? Or would she rise above it, and accept the fact that he was only doing his job, just as she was trying like heck to do hers?

Claire turned over on her stomach and buried her face in her pillow.

She had to stop courting failure, even in her most uncertain moments. She had to think positive. Work hard. And make her vision for the ranch a reality.

THE REST OF TUESDAY and most of Wednesday passed in a blur of activity. All the cottages were cleaned and polished. All the prep work that could possibly be done in the kitchen was accomplished. All four mammoth turkeys were washed and made ready to go in the ovens. Stuffing was prepared, vegetables scrubbed and cut up, pies baked.

By the time Buzz Aberg and his family started checking in, around 6:00 p.m. on Wednesday evening, storm clouds were rolling in, the first of several waves of thunderstorms projected over the next few days.

"You're worried, aren't you?" Heath said, when Claire had finally finished settling everyone in, around eight-thirty.

Raindrops spattered as the two of them made their way from the ranch office to the house.

She nodded. "I had planned to have Thanksgiving dinner outside tomorrow, on tables set up in the yard. I'm still hoping to do that, if it's not too muddy and we get a break in the rain—at least for the day."

Heath caught her hand in his and ducked beneath the portico that sheltered the back entrance to the house. "It's going to be okay. I'll be here the entire weekend, ready to assist in whatever way I can."

Claire warmed at the affection in his blue eyes. "My white knight to the rescue?" she teased softly.

Heath grinned. "More than that." He pulled her into the shadows and delivered a steamy kiss that promised so much more than friendship and desire. She looked up, wishing she didn't know what an insatiable lover he was.

If only she didn't have any other responsibilities tonight... If only she was still a single woman with a job that delivered a steady paycheck and a lot fewer hours... She'd be free to spend the entire holiday weekend with Heath, making love whenever, wherever they pleased.

Reading her mind, he traced her lower lip with the pad of his thumb. "Our time will come, before the weekend's over. I promise you that."

"I'm going to hold you to it," Claire whispered back.

They kissed again. Then, aware that Mae was inside, waiting to go home to her own family and responsibilities, they headed inside.

Mae was in the kitchen, taking the last of the pies out of the oven. The rest were cooling on a multilayered restaurant baking rack.

She smiled at Claire. "The twins went to bed about an hour ago. I guess I don't have to tell you they're very excited."

Claire chuckled. "They love a holiday."

"Anyway, unless something comes up, I'll see you on Friday morning, bright and early," Mae said.

Claire nodded. "And thanks for everything."

"No problem." She flashed a smile as she picked up her umbrella and headed out the door.

The kitchen smelled heavenly.

Heath and Claire were alone once again. Though for

how long was anyone's guess. With the guests still getting settled into the various cottages, Claire expected a few more phone calls or even knocks on the door before the evening was over.

"Think it would be terrible of us to cut a small piece out of one of those pies?" she asked Heath, trying to think of another satisfying way to spend the evening together, other than by climbing into her bed and making love all night long. But with storms predicted and the twins just down the hall, that was probably not a good idea.

Oblivious to the passionate nature of her thoughts, Heath studied the array of pies with their flaky golden crusts.

"After all, we've got to have some reward for all the hard work we've been doing," Claire added with a wink. "So…" she splayed her hands over his chest "…got any preferences?"

Heath's muscles hardened beneath her touch. He looked past her. "The mincemeat looks pretty good."

"Then mincemeat it is." Claire cut two pieces, still warm from the oven, and topped both with whipped cream.

She and Heath lounged side by side against the counter, shoulders touching, and enjoyed their pie. No sooner had they finished than they found themselves kissing again, even as thunder rumbled in the background and rain began pelting the ground.

Reluctantly, they drew apart, by unspoken agreement deciding to wait for a better place and time.

"We better check on the twins," Heath murmured as lightning flashed again. The rain came down even harder, followed by reverberating thunder.

Claire took his hand in hers. "You know how they are about storms," she said.

Upstairs, Heath and Claire looked in on Heidi and Henry. To their amazement, despite the rumbling outside, both children were still curled up in their beds, sound asleep. Claire adjusted the covers tenderly, stood there a second longer, then backed out of the room.

Gallant as always, Heath said, "I know you've got an early day tomorrow."

She nodded, wishing she didn't. But given all that was riding on a fabulous Red Sage experience for the Aberg clan, she couldn't afford to be an ounce short on energy. So she kissed Heath again, slowly and sweetly, and retired to her bedroom. She had just climbed beneath the covers when lightning flashed so brightly it lit up the entire sky, and thunder rumbled so hard and close it shook the house.

She dashed to the window, just in time to see the top branches of a live oak tree a hundred feet from the house splinter and catch fire. Then another deafening clap of thunder sounded.

Claire's bedroom door slammed open.

The twins, crying hysterically, ran in, followed swiftly by Heath.

"Get in bed!" Heidi screamed.

"We've got to put the covers over our head!" Henry shouted.

Knowing the only thing that would calm the twins was refuge in her queen-size poster bed, Claire waved them toward it.

Wondering what her guests were making of this fierce storm, and thankful they had not yet lost electricity, she checked to make sure the pouring rain had put out the fire in the tree. After assuring herself that it had, she climbed in after the twins.

"You, too, Mr. Fearsome!" Henry directed.

"You've got to get safe!" Heidi cried.

Heath looked at Claire.

Another clap of thunder sounded, louder and closer than ever.

Claire lifted the covers on the other side. "Hurry," she said.

Clad in striped pajama bottoms and a V-necked T-shirt, Heath climbed in. Before they knew it, Henry was in his arms and had a death grip around Heath's neck. Heidi had done the same with Claire. Heath and Claire found themselves lying side by side, each with a quaking four-year-old draped over their chest.

They soothed them through the duration of the storm, which lasted another fifteen or twenty minutes. Finally, the thunder and lightning went away, and all that was left was the soft, rhythmic sound of falling rain.

"You ready to go back to your own beds now?" Claire asked wryly, aware this wasn't how she'd prefer to spend time in bed with the man next to her.

"Nooo!" the twins shouted in unison. "We want to sleep with you and Mr. Fearsome!"

Claire looked over the top of Heidi's head. Her room was still lit by her bedside reading lamp, so it was easy to see the mixture of compassion and patience in his eyes.

"I'm comfortable," he said. "Henry, you doing okay?"

"Yes." The boy gripped Heath's neck tighter and nestled his face in his shoulder, just as he used to bury his head in the crook of Sven's neck.

Claire asked gently, "Heidi, are you okay?"

The child nodded, then after a second asked, "Aunt Claire, is it thundering in heaven, too?"

As always, the question caught Claire off guard, like a blow to her solar plexus. How to answer that? Finally, she said, "I don't think so, honey."

"But heaven is in the sky!" Heidi protested.

"And thunder and lightning are in the sky," Henry pointed out.

"So Mommy and Daddy must be scared, too," his sister declared.

Claire paused, thinking how best to soothe and reassure them. "Heaven is like the sky," she said finally. "There are fluffy white clouds there. And angels. And lots of good things. The thunderstorms we are having tonight are in a different sky."

The twins stared at her, uncomprehending.

Once again, Claire felt she'd made a mess of things. As if she wasn't cut out for any of this. As if she wasn't strong or gifted enough to be a parent, never mind under these challenging circumstances.

Still, because the twins were depending on her, she tried again. "Where Mommy and Daddy are…the heaven they are in…is a wonderful place."

"With lots of sunshine and red flowers and stuff," Henry guessed.

Claire nodded, then said, as inspiration struck, "It's a lot like this ranch. The heaven they are in has everything they love and cherished in life." *Except the two of you,* she added mentally. "They're very happy there. They are safe. And loved. And warm. You don't have to worry about Mommy and Daddy. They're okay."

"And they're watching over us," Henry recalled.

Claire nodded, the familiar knot of grief in her throat once again. "Every moment of every day," she promised hoarsely.

Half an hour later, the twins were both fast asleep. Claire was getting very drowsy, too. Beside her, snuggled close, too, Heath was already asleep. Both of them still had a child in their arms, and with another thunderstorm approaching— she could hear the rumble in the distance, and see the flashes lighting her window—she decided against waking Heath to try to get the kids back in their own beds.

Better to just go with what was successful, she thought drowsily. And right now, the sensation of familial intimacy was what was working. The image of Heath as daddy figure to the twins, potential life mate and husband to her, was all she needed to have a truly happy Thanksgiving holiday.

Chapter Thirteen

Claire woke to sunlight pouring through the windows.

Heidi was snuggled up next to her in the center of her bed, Henry nestled beside his sister, and Heath lay prone on the far edge of the mattress, sound asleep. Luxuriating for a moment in the cozy feeling of well-being that came after waking from such a deep, restful sleep, Claire turned to study the new man in her life.

Heath took her breath away. He was so gorgeous, with sleep-rumpled black hair, and the stubble of a beard lining his chin. She longed to lean over and kiss him, the way a princess might kiss her prince to waken him. Would have, if they'd been alone...

The fringe of inky-black lashes lifted. Turning slightly, Heath rested his sleepy blue eyes on her. A sexy smile turned up the corners of his lips. "Morning," he whispered.

A thrill raced through her. "Morning," she whispered back.

He nodded at the sleeping darlings between them. "Not how I figured we'd be spending our *second* night together," he murmured with a wink. "But fun just the same."

Claire reached over to link hands with him. "You were great last night." So solid and strong and reassuring.

He tightened his grip. "So were you."

He held her eyes. "How much time do we have before you have to get to work?"

Work. Company. Buzz Aberg and his many guests. She had almost forgotten!

Claire turned to glance at the bedside clock and saw the flashing lights that indicated a power failure. Oh, no…!

They had lost electricity at some point in the night.

And although it had come back on, none of the clocks on the ranch would have the right time.

"We overslept!" She sat up in a rush.

Henry and Heidi snuggled deeper into the covers.

"By how much?" Heath was not wearing his watch, either.

"I've got no idea!" Claire slipped from the bed, suddenly conscious of the fact that she wasn't wearing a bra beneath her long-sleeved pajama T-shirt.

The chilly air of the house made her nipples contract, a fact not lost on Heath, sleepy eyes or not. She grabbed a robe.

But if the alarm had gone off when she'd set it, it would still be dark outside… "I've got to take a shower, get started."

He waved her on, already easing from under the covers. "I'll get cleaned up, too, so I can help."

By the time Claire had swept her damp curls into a clip on the back of her head, and put on a figure-hugging denim skirt and a turtleneck sweater with the Red Sage Guest Ranch logo across the front, the twins were wide-awake and playing on the rumpled covers of her bed.

"We slept with both you and Mr. Fearsome last night!" Henry stated, enthralled the way only a four-year-old could be.

"Yeah, we cuddled real good," Heidi noted.

Please don't let them mention this to the guests, Claire

prayed silently, as she adeptly steered the conversation to another topic.

But of course, as luck would have it, they did.

It was, in fact, the first thing the twins talked about when they dashed into the breakfast buffet.

"Henry and Heidi are very frightened of thunderstorms," Claire found herself explaining to Buzz Aberg's entire family and the other ranch guests as she replenished the orange juice dispenser. "To the point they've gotten the idea that the only safe place. when they happen at night, is my bed."

"Yeah," Henry expounded after agreeing to sample some scrambled eggs along with his toast and juice. "We had to invite Mr. Fearsome to come with us, too. So's he wouldn't get kaboomed by the lightning!"

"He didn't *want* to come in with us," Heidi elaborated, "but we made him."

"They were quite unreasonable in their fear," Heath commented to the guests, in a droll tone that elicited knowing expressions and more than a few chuckles.

"Fortunately, Heath was adept at comforting them, as well as a good sport." Claire telegraphed her gratitude to him for that, even as she fought a self-conscious blush.

Speculative looks abounded, along with a few nods of approval.

"Ever thought of becoming a dad?" Mr. Finglestein asked the question that seemed to be on everyone's mind.

"You seem to have a knack for parenting," his wife observed.

Heath locked eyes with Claire. And in that instant, she knew something fundamental was changing. A door to the future was opening. "More and more," he said.

SEVERAL HOURS LATER, Heidi and Henry skidded to a stop just inside the ranch house kitchen, where Mrs. Finglestein and Claire were busy stuffing the four turkeys, which would soon be put into the ovens to bake. Heath was counting out glasses and silverware.

"Aunt Claire," Heidi said plaintively, "can we go outside? It's not raining no more."

"Anymore," Claire corrected, "And, no, you can't, because it's way too muddy right now."

"Then can you and Mr. Fearsome play hide-and-seek with us?" Henry asked.

"I'm afraid not." Claire wished she did not have to disappoint them. "I've got way too much work to do to get ready for the Thanksgiving feast this afternoon. But I'll tell you what I can do for you two. I'll put your favorite video on for you."

The twins looked less than thrilled. Claire understood. They were attuned to the energy in the air. They wanted to be part of it. And couldn't be, at least not on the level they would have liked, had it been a more low-key, strictly family affair.

Vowing to make it up to them later, Claire led them into the family room and set up the television for them. She returned to the kitchen. Buzz Aberg walked in just as Heath said, "How many place settings did we need again?"

When Claire told him, they realized they were five short. And that party rental place where she'd gotten the china and crystal for the event was not open today.

"What do you want me to do?" Heath asked.

My hero, Claire thought with a sigh.

"Claire." Mr. Finglestein came in the door, before she could answer. "Bad news. That next wave of rain and the

drop in temperature? The weather reports all predict it to be coming in around four-thirty this afternoon now, instead of seven."

Which meant she couldn't have the tables on the lawn, as she had planned. "We'll have to set up inside then."

"How?" Mrs. Finglestein asked.

Claire walked out into the front hall. Heath, Buzz and Mr. Finglestein all followed.

She heard a giggle, saw a flash of color and spotted one of the twins running up the stairs, and disappearing around the corner.

Oh, dear… They were getting wild.

The TV she'd left on had lost its viewers.

Claire switched it off and made a mental note to track them down as soon as possible and find *something* for them to do. Meanwhile, she had nine tables, six of them portable banquet tables, seating six each. The formal trestle table in the dining room sat eighteen. She sized up the available space on the first floor and tried to figure out how to make more. "I guess we'll have to move furniture."

An hour later, they had tables all over the downstairs. It was a far from perfect arrangement, but the best they could do under the circumstances. At least they'd guarantee dinner seating out of the rain for everyone. Claire just hoped the storm didn't knock out the electricity again, at least not until after the food was prepared.

She consulted Buzz—who had graciously helped move sofas and chairs out of the way—about the new arrangement. "Do you want a formal seating chart?"

He frowned. "We probably better. Otherwise, there might be some grumbling…"

As Claire went to get a notepad and pen to work on it, she saw another flash of movement crossing the floor, a shoe peeking out from beneath a coat tree crammed with garments. The twins were still playing hide-and-seek. Well, as long as it was keeping them happily occupied, she supposed it was okay.

Half an hour, and several sightings of mischief later, Claire had the seating arrangement completed to Buzz's satisfaction.

"The Red Sage really is a lovely place," he said.

"Thank you." Claire smiled. They moved through the large living room, toward the front porch, where they stepped out into the afternoon sunshine. The temperature was a balmy sixty-five. Still not a cloud in the sky. It would have been a perfect day to have the feast outside on the lawn. A perfect day for the twins to be playing outside, had it not still been so muddy.

Privately vowing once again to make it up to them, Claire switched back to ranch manager mode and informed Buzz, "I've arranged for everyone who requested it to have horses available tomorrow, so you can cover the ranch on horse-back. We're bringing in dirt bikes and hiking guides for the others, weather permitting."

Buzz nodded. "It really is heaven out there," he reflected.

Claire looked toward the mountains in the distance, the rugged canyon and rolling, sage-dotted territory in between. "I've always thought it was heaven, too," she said warmly. "Or as close as you'll get to it, here on earth."

"Wow, IT SMELLS GOOD in here," Heath said, several hours later.

Claire smiled, pleased everything was going so well, despite the challenges of trying to be a mom and a business-

woman simultaneously. "And we haven't even put the sides in the ovens yet."

She looked at Heath, so glad he had volunteered to work with her on this. It gave her an inkling what their future might hold. "Are the twins still playing hide-and-seek?"

He chuckled. "Last I saw."

Last she had seen, too. "Which was…?"

"Not sure. Maybe half an hour ago?"

Claire glanced at her watch. She couldn't believe how time was flying. "I better find them. They should have had lunch, or at least a substantial snack, a while ago." She headed into the hall, where tables were now set with snowy-white tablecloths, autumn-hued runners and a careful mix of rented and Claire's own family china and silver service.

The downstairs rooms were quiet. So was the second floor. Fighting back a vague feeling of alarm, Claire picked up her pace. "Heidi?" she called. "Henry?"

There was no response of any kind.

Claire's heart kicked against her ribs. "Come out, come out, wherever you are!" she said.

There was still no answer. She retraced her steps, looking under beds, in closets, behind furniture and draperies. Again, nothing.

Claire sprinted back down the stairs.

Heath was in the kitchen, setting up the caterer-size chafing dishes that would keep food warm while it was being plated. "Did they come in here?" She couldn't keep the panic out of her voice.

He immediately stopped what he was doing. "I'll help you look."

"Heidi! Henry!" They made their way through the ranch house, looking high and low. With a sinking heart, Claire checked the mudroom, staring at the hooks and shoe rack where the twins' outdoor play clothing was stored. Both their jackets—the lightweight windbreakers and their heavier fall coats—were there. But their boots and school backpacks were gone.

"THIS IS ALL MY FAULT," Claire told Heath, as they set out on the section of trail they had opted to cover. The stretch she felt Heidi and Henry were most likely to traverse. If the kids didn't lose their sense of direction, that is. It was hard to know how accurate their inner radar was—they had never been out on the ranch alone.

Heath cast a glance at the increasingly gloomy afternoon sky. "We're going to find them," he vowed.

The double set of footprints had marched through the mud, away from the ranch house, only to completely disappear on the cedar-chip-strewn trail.

Fortunately, there were plenty of volunteers spreading out and yelling for Heidi and Henry.

All the adults, save Buzz Aberg's wife, who was watching over the dinner—had offered to traverse sections of path. Mr. and Mrs. Finglestein, who were intimately acquainted with the Red Sage trail system, were handing out flashlights, walkie-talkies, maps and flares.

The sheriff's department had been called in, along with Claire's neighbors. The worry was darkness, which would fall in another two hours, or sooner if the approaching storm hit before then.

Wind whipped up, sending leaves and dirt flying.

"I should never have attempted this," Claire told Heath miserably, as they scanned the landscape. She paused to use her field glasses, to no avail. "I should have known it was too much. That I wasn't paying enough attention to the twins."

"They've been doing fine," Heath argued gruffly.

She fought back another wave of panic. "Obviously not, or they wouldn't have run away."

Heath scowled as he topped another rise and eyed the sage-covered countryside with determination. "Maybe they didn't run away. Maybe they're just looking for something."

Taken aback, Claire blinked. "Such as?"

He turned, shrugged. "A way to make sense of everything that's happened the last year…" His husky voice dropped a notch and his eyes met hers. "All they've lost, all they have gained."

And suddenly Claire knew why the twins had come out here. And what Heidi and Henry hoped…wished…they would find.

LIGHTNING WAS FLASHING and thunder booming in the distance when Claire and Heath topped the ridge that was the highest point on the ranch. Like the answer to their prayers, they saw two curly blond heads huddled together in the brush. The twins were clinging together as rain began to pelt their small bodies.

"Heidi! Henry!" Claire shouted, aware that she had never felt more grateful for anything in her entire life.

The twins turned toward her. The next thing she knew they were running into her and Heath's arms.

"We came to heaven to see Mommy and Daddy…" Heidi sobbed, one of her arms wreathed around Claire's neck, the other around Heath's.

Holding on to Claire and Heath the same way, Henry hiccupped. "Only they w-w-wasn't here. Even though me and Heidi wished really really hard on our birthday candles that they *would* come and see us…"

"Mommy and Daddy want to see us so much. Don't they?" Heidi asked in a quavering voice, while Heath got on the walkie-talkie and told everyone their prayers had been answered—the twins had been found.

Henry nodded, seeming finally to understand as much as a four-year-old was capable of comprehending about life and death. "Mommy and Daddy just can't come and see us."

"That's right," Claire murmured, stroking their damp hair, realizing for the first time in her life that she was up to this challenge, because she had to be.

"Which is why your mommy and daddy asked me to take care of you, because they knew they had to go to heaven, and weren't going to be here anymore," she continued, re-assuring the twins gently.

"But they do love you and they're watching over you, every minute of every day." That was why she and Heath had come to find them so quickly, Claire figured. They'd had a little help from Liz-Beth and Sven in heaven above.

"Mr. Fearsome, too?" Henry asked, with hope in his eyes.

Heath nodded before Claire could react. And she knew his involvement wasn't just a financial one any longer. Heath had taken the kids into his heart as much as she had taken them into hers. And the love they all shared was turning them into "family."

"THANKS FOR FINDING US with Aunt Claire, Mr. Fearsome." Henry yawned, sleepily. It was several hours later, and the twins were ready for bed.

"We was really scared 'cause we were lost." Heidi stifled a big yawn in turn.

"Your aunt Claire and I were scared, too," Heath told the children solemnly, as he and Claire tucked them into bed. "Do you have any idea how upset we would be if anything ever happened to you?"

"Very upset?" Heidi guessed.

"Very, *very* upset," he declared emotionally. He hugged each of them in turn.

Claire hugged the twins, too. "So don't ever run off like that again, okay? Promise me!"

"Okay," Henry agreed.

"We won't," his sister added, struggling to hold her eyes open.

Claire and Heath sat with them until they fell asleep, then eased from the room.

Outside it was raining like crazy. The temperature had dropped to the low fifties. The ranch house was warm and cozy, and still smelled of the many good things that had been cooked and served for dinner.

Across the yard, the cottages were all lit up within, creating a tableau cozy enough to inspire a Kincaid painting.

Thanks to the voluntary efforts of their guests, there were no more tables to clear or dishes to wash. Even the soiled linens had all been bundled up and carted to the laundry room. Claire was glad she and Heath had the rest of the evening to themselves for some much deserved time alone.

Knowing that what was in her heart had to be said, even

if now wasn't the ideal time, Claire switched on the washing machine and turned to him. "When the kids said they needed you to protect them during the storm, they weren't the only ones," she said frankly.

She searched his eyes. "You've done so much for me the past few weeks, helping out with the kids and the business, being so supportive regarding my feelings about the guest ranch, even though I know that, as banker and trust executor, you still have reservations about how this will all pan out. I just want you to know…" Claire paused, took a deep breath. "I couldn't have gotten through today without you."

Chapter Fourteen

Guilt slammed into Heath's chest with the force of a truck.

He doubted Claire would think he was *supportive* if she knew the fail-safe measures he had been taking. Measures that looked increasingly as if they were going to be necessary to implement if she wanted to maintain the business she and her late sister and brother-in-law had worked so hard to start.

"And there's something else," Claire continued, slipping into his arms. "Something even more important." She pressed her soft body against him. "I don't just desire you, Heath, or want you as a friend—I want a relationship with you…the kind that lasts for years and years."

Her throaty confession caught him by surprise. It wasn't that he didn't suspect how she felt; he did. He'd known by the way she looked at him sometimes, the way she touched him, kissed him and made love with him what they had going with each other.

It was the real thing.

Real enough to withstand learning the truth about how he had been attempting to protect her fiscally, without her knowledge?

Seeing his hesitation, Claire put up a staying hand and

ducked her head shyly. "You don't have to say anything. I know it's too soon for us to be talking like this."

Feelings surged inside him. Loving the way she felt against him, so warm and soft and womanly, he gathered her closer still. Gazing into her eyes, he did what he rarely did— confessed what was in the deepest regions of his heart. "I want an exclusive relationship with you, too, Claire, more than anything." And he kissed her with all the passion he felt.

When at last they came up for air, Claire paused, wet her lips. She seemed to know instinctively there was still something standing between them, keeping them apart. Figuring now was not the time to confess anything relating to business, especially something likely to cause an argument, Heath grinned.

"This wasn't how I envisioned the moment we'd decide to make our arrangement a more permanent one. I figured at the very least there'd be candlelight. A romantic dinner. A walk beneath a starry sky."

"Not a clandestine tryst in the laundry room, at the end of one of the most grueling Thanksgiving Days ever?"

Knowing he wanted Claire in a way he'd never wanted any woman before, he drawled, "The holiday had its perks."

Her cheeks warmed with a self-conscious blush. "Such as?"

"Seeing you in the kitchen this morning, all flushed and pretty, commanding everything going on with such aplomb."

She looked at him with gratitude and stated fervently, "I'm really glad you were by my side when we found the kids."

So was Heath—the experience had made him realize how much Claire and the twins needed him, and how much he wanted to be there for them. He linked hands with her, folding her smaller, more delicate palm into his. "I also liked

being with you when we tucked them in tonight. Not to mention having Thanksgiving dinner with you and the kids and everyone else, and enjoying what was a truly incredible holiday meal, despite all the calamities."

Claire pressed her face against his shoulder and relaxed against him, letting out a contented sigh. "Amazing how well that meal came off, considering."

Luckily for them, Heath thought, Buzz Aberg's wife was a veteran of many a holiday meal and knew just how to slow things down, and then speed 'em up to feed the hungry crew.

"We have a lot to be thankful for," Claire murmured.

"Yes, we do. Especially…" Heath kicked the door shut behind them and drew her close yet again "…this."

The laundry room was not the place Claire would have chosen to make love with Heath, but the moment his arms were around her and his mouth was on hers, she knew they'd never make it to her bed. Not when she needed and wanted him this badly.

The first contact of tongue to tongue was so electric she moaned. Gripping her shoulders, he guided her back against the wall, using his body to pin her there. She reveled in the feel of his hard, strong form even as she went up on tiptoe to return his kiss.

They'd had so little time together, she really wanted to go slow with him tonight, make the moment last….

She slipped her hands under his sweater, running them up his back and down again, not stopping until she had his buttocks cupped in her palms. He kissed her slowly at first, then harder, deeper, until she was using sultry thrusts of her tongue and the sweet suction of her lips to drive him crazy, too.

Without breaking the kiss, he reached beneath her skirt,

divesting her of panty hose and the tiny triangle of silk she wore. Then he knelt before her, and with light, sure strokes of his hands, convinced her to part her legs for him.

"Tell me you want me," he murmured.

Wanting him didn't begin to cover it. She moistened her lips as he discovered the sweetness within, using mouth and hands and tongue. "I want you."

He continued the tantalizing love play until his fingers were wet with her essence. Head falling back, she arched against him, letting him explore the delicate folds to his heart's content. Pleasure swept through her, until she was deliciously aroused, unable to stand it a second longer.

"Heath…" She caught his head with her hands and looked down at him.

He grinned up at her with sheer male appreciation, slid back up to take her mouth in a seductive mating dance, thrusting his hands beneath her blouse. Unhooking her bra, he palmed her breasts and captured the sweet globes in his hands.

She tugged off his sweater. Her palms glided around him, massaging the muscled contours on either side of his spine, then, lower, the sexy curve of his buttocks, through the fine wool of his slacks. All the while, she kissed him, happy to take her time as he cupped the full weight of her breasts with his palms, flicking the nipples with his thumbs before bending to pay homage with his lips and tongue.

The next thing she knew her legs were wrapped around his waist. Shifting her upward, he moved to possess her. Heat, then need, filled her soul as he brought them together in the most provocative of ways.

Determined to give her the kind of thorough lovemaking she deserved, Heath drew out every caress, sweeping his hands

down her body, kissing her until he felt her trembling. Then slowly, deliberately, their bodies melded in boneless pleasure. He surged forward, filling her to completion, and then there was no more prolonging the inevitable. They were climbing past barriers, seeking release, finding each other in the most intimate of ways.

Afterward, they clung together breathlessly.

And, in that moment, Heath knew the last thing he wanted was any secrets between them. Which meant that as soon as the weekend ended and the pressure was off, he would tell her everything he had in mind to preserve the twins' inheritance…and to ensure the prosperity of Claire's family legacy.

"YOU'RE TO BE congratulated," Buzz Aberg drawled Sunday afternoon when he strode into the ranch office to hand over all the keys and complete the checkout process for his group. "I can't remember when my family had such a great Thanksgiving weekend."

"Even with all the calamities the first day or so?" Claire asked with a laugh.

"Hey, what's a family holiday without a little drama?" He winked.

Even if it hadn't been his clan causing the ruckus, Claire thought. "And everyone pitching in," she added, serious now.

Buzz sobered, too. "How are the twins doing, by the way?"

"Better," she reflected, finally feeling as if she was getting a handle on this mothering business, after all. "They're still grieving the loss of their parents, of course, but it's as if something changed on Thursday, when they were out there all alone. As if they finally started to come to terms with the changes in their lives."

Changes no one could have foreseen, or wanted. "I think on some level they still know it's going to take a while, but they also know that Heath and I will be there to see them through it," she stated.

Buzz gave her the empathetic look of a fellow parent. "It's easy to see that they love you—and Heath—very much," he said gently.

Claire thought so, too.

Buzz glanced at the corner where all the toys were stowed. "Where are they this afternoon?"

Claire smiled. "On a playdate with preschool friends for the rest of the day." She and Heath both felt the change of scenery would do them good, so he had driven them into town for her. Their friends' parents were going to drive them back to the ranch after supper, so she could concentrate on her business. Speaking of which…

"Have you made a decision about whether or not to run a review of the ranch in *Southwestern Living?*" Claire asked.

Buzz gave her a thumbs-up. "I think it's such a great place to celebrate the holiday we're going to run it in the November issue next year."

Claire's heart sank. That was twelve months from now. She tried to play it cool, and not put Buzz, who had already gone out of his way to accommodate her, on the spot. "What about the Web site?" she asked cordially. "Can you post a review there now?"

"No. That won't go up until the issue the review is published in hits the newsstands."

Which would be way too late to help her drum up business right now, Claire realized in disappointment. So she would have to go back and work on Plan B. Get it nailed

down before she talked to Heath at the bank on Tuesday. That gave her just a little over forty hours… She did her best to squelch a sigh.

Buzz continued, "You'll be pleased to know that the Red Sage is going to be given a five-star review, our highest. We'll be back out to take pictures of some of the more scenic places in the ranch, a few months prior to publication. So if that party barn of yours is up and running, by say…July, we'll be able to include that, too."

"That's great." Claire smiled, shook hands with him and walked him to the door.

As he exited, the Finglesteins walked in, to turn in their key. They were dressed in winter clothing geared for their destination, upstate New York. "Claire, once again, we can't tell you how much we enjoyed our stay," Mrs. Finglestein exclaimed.

"If that's the case," she said with a smile, prepared to call in every favor owed her, and then some, "perhaps there is something you can do for me…."

THE LAST OF THE GUESTS were driving out of the ranch when Heath drove in. Claire went out to meet him. She wound her arms around his neck, and they indulged in a kiss. "Alone at last." By her calculation, they had two hours to do whatever they pleased. She didn't intend to waste a second of it. Given the way he was kissing her, he didn't, either.

He kissed her ear, down the slope of her neck. "I was going to say 'your place or mine?' but since my place is still your place, at least for the moment…"

Claire laughed. Arm in arm, they started for the ranch house, only to have another vehicle pull up behind them. Claire paused as a familiar figure stepped out of her car.

Hating the interruption, but aware she still had a job to do as innkeeper, Claire walked toward the real-estate broker. "Ginger. What brings you back to the ranch?"

Ginger reached into her Mercedes and brought out a briefcase. "I'm here to see Heath."

Stunned, Claire turned to him.

Ignoring the question in Claire's eyes, Heath gave Ginger Haedrick a meaningful look. "This isn't a good time."

To his obvious frustration, she didn't take his none-too-subtle hint. "You asked me to put a rush on the information. I did. I'd like to at least give you the facts and figures now, since I worked most of the last two days putting it together for you. And, Claire, you should see this, too."

Heath's uncomfortable reaction caused Claire's suspicions to rise.

"As I said—" Heath began bluntly, making it clear he wanted Ginger to leave.

Not about to let that happen, without at least getting an idea as to what was going on, Claire held up a palm. "I'd like to hear what Ginger has to say. Let's go over to the ranch office." Where she could at least pretend to be in control of the situation.

When they were all seated, Ginger handed out two folders with her business logo on the cover. Inside, Claire was stunned to find photos of the various cottages, as well as the Red Sage ranch house and barn. They were the kind of pictures usually featured in realty company advertisements.

"As you can see, I've assigned a price to each of the surface improvements on the property," Ginger said. "I also looked up the mortgage on each building. So even if you were to pay a real-estate commission, you would still emerge

with a nice profit, per building, assuming you got your asking price."

Claire worked to keep her voice even. "That's nice information to have, but I'm not selling the cottages."

Ginger's eyes widened. "That's not what Heath said…"

He stood, signaling the meeting was over. "Thank you for putting this together, Ginger. We'll be in touch." He walked her out while Claire stewed.

When he returned to the office, it was all Claire could do to maintain her composure. "You want to tell me what that was all about?" she demanded coolly.

Heath sat down, as if nothing were amiss. "First, I want to know how the final meeting with Buzz Aberg went."

Mirroring his oh-so-easy attitude, Claire perched on the edge of her desk, facing him. "*Southwestern Living* is giving the Red Sage a five-star review," she announced with pride. Then she added reluctantly, "Unfortunately the glowing summation won't be printed until next Thanksgiving."

"So it's good for the long term…"

"And lousy for the short term," Claire summed up, still feeling equal parts elated and discouraged. She studied his implacable expression, then noted, with dismay, "Which, obviously, you expected."

He gave her a level look. "I plan for every contingency, Claire. It's my job."

Hurt warred with indignation. "So you're what?" Unable to contain her skyrocketing emotions a second longer, she bounded off her desk and paced the room restlessly, fists balled at her sides. "Planning to sell the cottages out from under me?" She whirled to face him. "Or at least the half of the business owned by the trust for the twins?"

He stood slowly. "I had in mind putting one cottage on the market."

Unable to believe his gall, Claire sent him a withering glare. "Thanks for letting me know!" she said sweetly, unable to believe she had allowed herself to be so vulnerable with him. She had known all along how different they were.

"I wasn't going to do it without your knowledge."

"Did you plan on getting my consent?" she demanded heatedly.

Heath shrugged, refusing to back down. "I had hoped to." He enunciated the words clearly.

Feeling all the more devastated, she queried, "And if not…?"

He stepped closer and his low voice took on that uncompromising note she knew so well. "As I've explained, the trust must produce some income. It can't continue operating as it has for the past nine months. The loss you incurred hosting Buzz Aberg and his family puts your ledgers firmly in the red, not just for the month of November, but the current fiscal year, which—for your business—started in September." He took a deep breath before continuing. "We have to find a way to counter that, if you want to maintain the Red Sage pretty much as is. One way to do that is by selling off part of the assets, such as one of the cottages."

Claire shot daggers at him. "But you know how I feel—"

He held up a hand before he had a chance to protest further. "Just listen. That would still leave you with eleven cottages to rent out, until things turn around. Then, under terms I'm proposing, you could purchase the cottage back, if you so desired, or work a deal with the new owner to lease it out as well. Maybe as sort of a time-share."

Claire drew a shaky breath, her thoughts in turmoil. All

she knew for sure was that she had never felt so betrayed. "So you never really believed in me or my merit as a businesswoman, after all!" Had everything between them been an act on his part? she wondered. Worse, how had she ended up with a man who doubted her capability, and made it public knowledge that he felt that way?

"I believe you are a visionary," Heath said cautiously.

"Just not the kind of person who can successfully implement grand plans," Claire retorted, her voice tinged with bitterness.

Heath held his ground. "They are separate skill sets."

And he obviously considered her decidedly lacking in one of them!

Stung by his lack of respect, knowing without respect there could be no love, none that mattered, anyway, Claire moved closer. "Well, I'll tell you what hasn't been separate and should have been!" she fumed. "My feelings for you and the control you exercise over the trust for the twins and the future of the Red Sage Guest Ranch!"

Heath folded his arms across his chest. "You have to know I would never do anything to hurt you."

Claire wondered how she could have been foolish enough to imagine the two of them sharing a life together.

"Don't you get it?" she cried bitterly, as her dream of loving each other as equals shattered. "In undermining me this way, you already have."

"So THE TWO OF YOU broke up?" Orrin Webb surmised the next day, in the staff room at the bank.

Heath exhaled, as the stone that was lodged in his chest grew heavier. "Looks like. Although we didn't actually get

that far in our discussion. Claire kicked me off the property before I had a chance to finish talking with her."

She'd given him just enough time to pack his bags and head out. Instead of moving back into the cottage he had vacated for the overflow of guests, he'd found a motel room in town. And spent the night alternately missing Claire and being furious with her, for being so irrational yet again.

Heath's mentor shook his head. "You shouldn't have gone behind her back to get those appraisals."

"I needed to know the value of the cottages to see if the idea was even plausible."

Orrin plucked an apple Danish from the bakery tray. "She felt blindsided."

Frustration combined with the guilt that roiled in Heath's gut. "I was trying to help." In fact, he felt he should be commended for his actions, not censured.

The older banker poured coffee into a mug. "Maybe you're too close to the heirs of the trust to manage it properly."

Heath sipped his own coffee. His boss had clearly made the brew. It was hot, black and strong enough to stand a stick in. "That is the first thing we agree on today." Since he'd become involved with Claire, his professional detachment had disappeared. He'd viewed the entire situation way too personally, and for a while, anyway, that had hampered his ability to do his job.

"You still have a chance to salvage the situation."

Heath hoped so. A life without Claire and the twins was no life at all.

"CONSIDERABLY QUIETER here this morning than over the weekend," Mae noted Monday, when she came in to work.

Together, she and Claire headed to the first cottage to be cleaned that morning, the one nearest the ranch house.

"I guess Heath will be moving back in today, right? Now that the cottages are all emptied out."

Claire shook her head. "He moved out altogether."

"Heath moved out?" Mae asked with surprise, as they pushed the cleaning cart in the door.

Claire carried in fresh linens. "Yesterday."

"That sounds...ominous."

Claire knew she had to talk to someone. And since Mae was the closest thing she had these days to a mother, she confided everything that had transpired.

The older woman listened intently. "Hmm," she said when Claire had finished.

"What does that mean?" Claire demanded.

"Just thinking."

This was like pulling burrs out of a dog's coat. "About...?"

"You didn't seem to mind Heath's help reading the twins stories and putting them to bed at night. I don't recall you complaining when he sacrificed every moment of spare time he had last week to help you get ready, and then cater to Buzz Aberg and his family. In fact, I believe Heath logged way more hours than I did. Unpaid."

Heat crept into Claire's cheeks. "He offered to do that."

"And you accepted with nary a complaint. And yet whenever he's tried to help you in a monetary sense by asking you to consider offers from Wiley Higgins or the Wagner Group or Ginger Haedrick's realty, all you feel is insulted."

Claire stripped the sheets from the bed with a vengeance. "He should have respected my ability to run this guest ranch!"

Mae gathered up the linens from the bathroom, dumped them in the wheeled hamper. "Like you respected his abilities as a banker and trust manager to come up with creative financial solutions to what was clearly his problem as much as yours?"

Claire fell silent.

Mae patted her shoulder and continued gently, "All I'm saying is that it takes two to make a relationship work, and two to make it fail. You need to decide which side of the equation you're on. And then go from there."

CLAIRE THOUGHT ABOUT WHAT Mae had said the rest of the day, while she worked on her own solution to the lack of bookings. By evening, she had accomplished what had once seemed impossible. Tempering the vindication she felt was the loss of Heath in her life.

She knew in retrospect that Mae was right.

She had been far too hasty in giving Heath the boot.

Claire glanced at Liz-Beth's photo on her desk. "I know, little sis," she said softly. "I'm never going to get what you found with Sven if I won't swallow my pride."

And that was the first thing she intended to do the next morning. After the twins left for preschool.

Thankfully, the breakfast buffet at the Red Sage Tuesday morning was sparsely attended. Wiley Higgins, who was now scouting for oil on one of her neighbors' ranches, zipped in the moment she set the food and beverages out. Her only other guest at the moment was T. S. Sturgeon, who was putting the finishing touches on her novel. And after working all night, she was now sleeping. The novelist had requested a tray be delivered to her cottage later.

"Where's Mr. Fearsome?" Heidi asked, while she and her brother waited for the car pool to pick them up.

It wasn't the first time in the previous thirty-six hours the twins had mentioned Heath. To Claire, it seemed they did so at least twice an hour.

"Yeah," Henry chimed in, defiantly enunciating every word. "We want to say hi to him!"

Claire gulped around the knot in her throat. It was not too late to fix things between the two of them. It couldn't be. "Mr. Fearsome is not staying with us anymore," she explained to the twins, for what seemed like the millionth time since his departure.

"How come?" Henry demanded, as if by asking the same question repeatedly he'd eventually hear an answer he liked.

Because, like a fool, I told Heath I didn't want to see him anymore, and kicked him off the property, Claire thought.

Fortunately, she was going to see him this afternoon, because today was December first, and she had to go to the bank to talk to him about the twins' trust fund.

"Don't you want him to be our friend anymore?" Heidi asked.

That's just the problem, Claire thought, as a familiar vehicle drove up the lane and parked in front of the ranch house. *I do.*

The luxury sedan was followed by an equally familiar minivan.

Heath got out of the first vehicle, while the driver of that morning's preschool car pool waited patiently.

"Mr. Fearsome!" Ignoring their ride, backpacks banging at their sides, the twins raced out the door, down the steps and around the open car door. They barreled into Heath, engulfing him in exuberant hugs. "We missed you!"

"I missed you, too." His voice was husky with emotion, his eyes warm and tender. His clothing was totally professional, however, suggesting he was here on trust business and nothing more.

Pretending an inner cool she couldn't begin to feel, Claire instructed the kids to say goodbye to Heath, then went to strap them into their seats. She waited until the minivan had driven off, before turning back to him.

Her heart sank when she saw he already had his briefcase in his hand. Which could only mean one thing: he *was* here strictly on business.

Disappointment spiraled through her.

Yet she knew this was important, too. And needed to be dealt with, ASAP. Using politeness as a shield, she said, "There's no need for us to talk on the porch. Please come in." With a stiff smile on her face, she paused before the breakfast buffet. "Can I get you something?"

His attitude was equally formal. "No. Thank you."

Deciding the ranch house held far too many memories for a conversation of this ilk, Claire led Heath to the office. Which, as it turned out, held just as many memories. Of Heath striding in to meet with her…. Bending down to talk to the kids…. Taking off his suit coat, rolling up his sleeves, and fixing her broken fax machine…. Pulling her into his arms to deliver a hot, searing kiss—one of many they had shared over the last few weeks.

Shoving her emotions aside, she gestured for him to have a seat, and tried to compose herself while they got business out of the way. "I thought we had an appointment for later this morning in town…"

One that had been set up weeks ago, before she and Heath became romantically involved.

One neither of them had seen fit to reschedule or cancel, even with the recent turn of events.

Heath gave her a brief, officious look. "You do. But it's not going to be with me. I'm here to let you know that as of right now, I am no longer managing the twins' trust. That will be done by Orrin Webb, the branch manager and my boss."

This, Claire had not expected, although maybe she should have. Her heartbeat quickening, she tried to decipher what it all meant.

"I requested the management of the trust be reassigned," Heath explained.

Claire's anxiety rose. Ignoring the sudden wobbliness in her knees, she sat down behind her desk. "Why?"

His lips twisted ruefully. "Because I've become way too emotionally involved with the trust beneficiaries and their guardian."

A statement, Claire noted cautiously, that could be read any number of ways. Wary of jumping to conclusions, she inquired, "Is this going to be good or bad for me?"

The sexy smile she knew and loved flashed across his face. He lounged back in his chair, relaxing as the talk turned unerringly to business. "It'll be good for a couple of reasons. Orrin is incredibly experienced and a wiz at merging the practical and the sentimental, while maintaining a fiscally strong bottom line."

Claire tried not to notice how blue Heath's eyes looked in the morning light. Or think how much she wished she could dispense with all this and simply kiss him. "And

second?" she asked, unable to do anything about the distinctly husky sound of her low voice.

Heath stood, taking command of the room and the conversation once again. "You and I will no longer have reason to disagree over the management of the trust, because if you accept my proposal, and I sincerely hope that you will…" he paused to remove some papers from his briefcase "…then your current financial problems will be over."

"Really," Claire said doubtfully, almost afraid to hope that everything could work out between them, after all.

He gazed into her eyes. "Really," he answered softly.

A terse but expectant silence fell between them. He handed her a written offer for the cottage he had been staying in before the Thanksgiving weekend. Claire studied the paper, and found the offer to be more than generous. It had his name on the contract as purchaser of the property.

"You'll notice it gives you first right of refusal in any future sale, and also the right to request that I not actually live in the dwelling." He paused to let her consider that, before continuing deferentially, "If that's the case, and the cottage is used only for rental purposes to ranch guests, as property owner I would get a percentage of the profits from that."

Claire adapted his businesslike attitude. "Sounds fair."

"The cash from the sale of the cottage would in turn give you the ten percent down payment for the low-interest small-business loan you need to turn the barn into a five-star party facility. Rental fees from that would more than put the Red Sage in the black from here on out." He then proceeded to further detail the specifics of his business proposal.

Claire leafed through the various agreements he had given her. Impressed, and more than a little overwhelmed, she

murmured, "This plan is incredible. Add to that my deal with bird-watching groups in the East…"

Heath lifted a curious brow.

It was Claire's turn to shine. "Thanks to the video shot by the Finglesteins showcasing one hundred and twenty of the three hundred bird species that inhabit the ranch during the course of the year—and my willingness to discount room rates to groups—I've got reservations all the way through next summer. I had planned to present the news to you at the bank today."

His expression rueful, Heath stroked his jaw. Then his blue eyes brightened with admiration. "So you didn't need my help."

Now was the time, Claire thought, to go for it. Put her feelings on the line and see what happened. Her heart pounding, she rose from her chair and walked around her desk to do what she hadn't done before—meet him halfway. "I wouldn't say that."

Heath regarded her with a look that brought forth a spate of feelings.

Swallowing the last of her pride, she slipped her arms about his neck. "I do need you, Heath," she confessed, pressing her body against his. "And I want you in my life." She kissed him fervently, letting all her feelings show.

Heath stroked a hand through her hair and tilted her face up to his. "I need and want you, too, Claire. So much…"

They kissed again, even more meaningfully.

When the passionate kiss finally drew to a halt, Claire gazed into his eyes. "And I'm sorry about the way I reacted to the news of what you were trying to do." She swallowed. "I thought to be successful, to earn your respect, I had to succeed entirely on my own, at least from a management

perspective. I see now that isn't true. Garnering potential solutions to my problems from other sources is a part of my job, not the sign of weakness I deemed it to be."

Heath accepted her apology even as he offered up one of his own. "You had a right to be angry. I went behind your back."

Claire shook her head, fingering the knot of his tie. "Only because I was so unreceptive to the help you were trying to give me."

He slid a hand beneath her chin and tilted her face up to his again. As their eyes met, he confessed, "I should have trusted that you would figure out how to make your dreams a reality, given a little more time."

Happiness bubbled through her. Claire splayed her hands across his chest and felt the strong, reassuring beat of his heart. "Maybe in the future we should accept that we'll never be as strong alone as we are together."

Heath flashed her a victorious grin. "You're right about that."

They paused for another long, sustaining kiss. "I love you, Claire, with all my heart," he whispered in her ear.

She nestled against him as she heard the words she had longed to hear, and at last, all her dreams began to come true. "I love you, too, Heath." More than she had ever thought possible.

Chapter Fifteen

Thanksgiving, the following year...

"Mr. Fearsome, Mr. Fearsome, I've got the ring pillow!" Henry raced to catch up with Heath.

"And I've got the basket of flowers!" Heidi said, dashing along at her brother's side.

Heath knelt and looked into the faces of the two children he had come to love so much. "A finer flower girl and ring bearer could not be found," he told the twins with a solemnity befitting the occasion.

Henry tugged on the bow tie of his child-size tuxedo, until it was completely askew. "I'm going to do my part real good," he declared.

"Me, too. I'm going to put flowers everywhere!" Heidi promised, touching the floral wreath in her hair and then the satin bow on her pretty organza dress.

Heath straightened the boy's bow tie again, while Henry presented the velvet pillow he'd been carrying since they arrived at the Summit, Texas, community chapel. "See the rings? They're shiny and new!"

"Yes, they certainly are," Heath agreed.

Like his feelings for Claire.

Slightly over a year had passed since they had met. So much had changed, and so much had stayed the same. Thanks to the interior renovation of the Red Sage party barn, reservations for the ranch were up two hundred percent. Bird-watchers from all over the country were now flocking to the ranch to view the three hundred species of birds. The just-published review from *Southwestern Living* magazine had increased interest and bookings, to the point Claire was looking at expanding again, with more cottages and an additional area of primitive campgrounds, for those interested in roughing it.

"Can we walk up there?" Heidi pointed to the ribbon-and-flower-bedecked aisle, where the wedding vows would be spoken.

"Not yet," Heath said. "We have to wait for Aunt Claire to come out of there." He pointed to the anteroom where Claire and her bridesmaids were still dressing.

Heidi's lower lip shot out. "I want to see her!" she declared.

"Me, too!" Henry hopped up and down on one foot.

Me, three, Heath said silently, since every second away from his bride-to-be was a second too long.

Telling himself to be patient, he glanced again at the pews. Approximately half the guests had arrived….

For the sake of tradition, he was about to try to stall the twins—yet again—when the door opened and a slender hand beckoned. The twins rushed forward. "Aunt Claire!" They disappeared through the door.

Heath looked after them wistfully, wishing he, too, could get a glimpse of the beautiful woman inside.

The hand beckoned once again.

His spirits rose.

Heidi stuck her head out the door. "Come on, Mr. Fearsome! Aunt Claire says it's okay!"

He didn't have to be invited twice. Hands in his pockets, he sauntered in.

All too willing to grant the family-to-be a little privacy, the bridesmaids slipped out.

The door shut.

The four of them were alone, and Claire was a vision in white. Delicate, ethereal, strong, sexy, smart. In short, everything he had ever wanted in a woman and a wife.

She looked him up and down, her smile spreading. "Nice." Her eyes twinkled as she continued perusing him in a fashion that promised a very compelling wedding night. "Very nice."

Heart racing, Heath took her in his arms. "I could say the same about you," he murmured appreciatively.

Always beautiful, Claire looked spectacular today. She had a wreath like Heidi's in her hair, with a short veil attached. Her wedding dress was made of white satin, and left most of her shoulders and arms bare. It hugged her midriff tightly before flowing out at her waist.

"What about us, Aunt Claire?" Heidi demanded for herself and her brother.

"You look very nice, too," Heath and Claire said in unison.

The door opened once again. Mae Lefman stood there. She smiled at Claire and Heath. "I'll take these two off your hands for a few minutes."

Heidi and Henry raced toward their favorite neighbor and babysitter. "Bye, Aunt Claire! Bye, Mr. Fearsome!"

"Think they'll ever start calling me uncle?" Heath asked,

when the door shut yet again and he and Claire were alone at last.

Looking deep into his eyes, Claire murmured, "Eventually. Although…" she paused to straighten Heath's bow tie with the kind of wifely devotion he was already savoring "…I think their mispronunciation of your last name is kind of cute."

Heath chuckled. "I admit I'm kind of attached to it, too."

They kissed again.

When they drew apart, Claire left her arms around his neck and said, "I want you to know, Mr. Fearsome, that today is the best day of my life."

"So far," Heath qualified, tracing her silky lower lip with the pad of his thumb. "We've got many, many more to come."

"Yes," Claire echoed softly, "we do."

That sentiment was repeated in their wedding ceremony.

And in the wedding reception and Thanksgiving dinner that followed at the Red Sage Guest Ranch party barn. The space had been turned into a high-ceilinged banquet hall complete with an amazing dance floor, crystal chandeliers and polished oak walls. When everyone was seated at linen-draped tables, Heath stood and raised his elegant crystal glass in a toast. "To everyone here and all we have to be thankful for," he proposed, "on this Thanksgiving Day." Which was so much…

"Here, here," the guests murmured in response.

"Kiss Aunt Claire again, Mr. Fearsome!" Henry yelled enthusiastically, above the clink of glasses.

"Yeah, kiss her!" Heidi insisted, clapping her hands together.

Amid smiles and murmurs of approval, Heath happily complied.

* * * * *

CHRISTMAS IN KEY WEST

BY
CYNTHIA THOMASON

Cynthia Thomason writes contemporary and historical romances and dabbles in mysteries. She has won a National Reader's Choice Award and the 2008 Golden Quill. When she's not writing, she works as a licensed auctioneer for the auction company she and her husband own. As an estate buyer for the auction, she has come across unusual items, many of which have found their way into her books. She has one son, an entertainment reporter. Cynthia dreams of perching on a mountain top in North Carolina every autumn to watch the leaves turn. You can read more about her at www.cynthiathomason.com.

This book is dedicated to my mother,
Barbara Brackett, with love
for all the Christmases past, present and future.

CHAPTER ONE

REESE HUNKERED DOWN on one knee and burrowed his fingers into a patch of soft golden fur covered by a colorful neckerchief. "You have a good day, buddy," he said to the Labrador retriever. "Take a couple of naps for me." Giving the dog a goodbye scratch behind the ears, he walked outside and got into his patrol car. He'd already talked to the dispatcher on duty. The night had been a quiet one. Reese hoped the calm would continue at least for the next three days, at which point a new crop of tourists would descend upon Key West in the four-day Thanksgiving break.

He'd just backed out of his driveway when a message came through on his radio. Instantly tuning in, he hoped the call from the station would be nothing more important than a request to stop for doughnuts. "This is Reese," he said into the mic on his shoulder. He preferred using his real name instead of his official police-speak identity when he could. "What's up?"

His hope for continued calm evaporated when the dispatcher said, "It's Huey Vernay, Reese. He's at it again."

Reese gripped the steering wheel in response to the coiling in his stomach. Anything to do with Huey, his trinket business or the happenings at Vernay House pro-

duced this reaction. "Did we get another complaint from a tourist about his attitude?"

"Nope. This is worse."

The coiling resulted in an all-too-familiar pain in his neck. "What's he done now?"

"Edna Howell just called. She said Huey started another fire in his backyard and the smell came over her fence. She claims that if she opens her windows, she'll suffocate from toxic fumes."

"Here we go again," Reese muttered as he turned onto Duval and headed toward Southard Street, where the ten-room Vernay House had stood since the late 1850s. He leaned out the window, caught a whiff of burning rubber. "Shit."

"What's that?" the dispatcher asked.

"Sorry, Merlene. Call the fire department. I'm only a couple of blocks from Huey's now. I'll go on over."

"Roger that, Reese. Do you need backup?"

As much as he'd like to foist the responsibility on anyone else in the department who would take it, he declined. He didn't see flames shooting into the air, so that was a good sign. "Probably not. But I'll want a half bottle of aspirin when this is over, so make sure we have some."

The dispatcher chuckled before signing off, and Reese gave up hope of filling his thermal mug with coffee from Martha's Eye Opener Café. He flipped the switch on the car's light bar and sped toward Southard Street.

REESE PULLED TO A STOP in the plume of smoke drifting over the wraparound porch of Vernay House. He got out of the cruiser and waved his hand in front of his face to dispel the foul air. Walking around to the backyard, he spied Huey Vernay standing upwind from a smoldering pit

of who knows what. Thank goodness the flames that still existed were minor, but acrid gray clouds hung over the old Classic Revival mansion.

Reese strode to the big man, who was bare-chested except for the apron of his denim overalls. Smudges of soot blotched his face and arms. A typical scowl creased his face.

"What the hell do you think you're doing, Huey?" Reese asked.

The man took a drag on the stub of his cigarette and released a long, wispy stream of smoke. He flicked the butt to the dirt and ground it in with the heel of his boot. Looping his thumbs through the straps of his overalls, he said, "What's it look like?"

Reese wanted to say, *Insanity,* but refrained, knowing that answer was too close to the truth.

Huey raised his bushy white eyebrows in the condescending smirk he'd perfected after years of boasting about his blue-blooded-Louis-the-Something background. Genetically speaking, French ancestry, even ties to royalty, didn't count for much in modern-day Key West, but Huey refused to accept that. "I'm abiding by the almighty Community Improvement Board and the code enforcement officer's order to clean my place up."

"You know darn well you can't do that by lighting a fire," Reese stated. "I warned you about this a week ago when you set that blaze in your garbage can."

"I'm doing it different this time," Huey retorted. "You complained that I didn't have a proper containment screen on the top of the can, so now I'm burning my trash in the open. There isn't a law against that as far as I've heard."

Reese looked down at the pile of garbage slowly disintegrating into spitting embers. "I've only been here a

couple of minutes, Huey, and I've already come up with five codes you're breaking right now."

"Well, hell, Reese, you can't have it both ways. The island's gestapo can't tell me my home is an eyesore and then have you stop by and prevent me from sprucing it up."

Sirens sounded in the distance. Aware that even laid-back Key West was in the midst of rush hour, Reese tuned to the radio channel connecting him to the island's fire department. "Tell your boys they can slow down," he said to the dispatcher. "The fire's under control. I still need them here to do a damage assessment, but there's no immediate threat to property." He signed off and glared at Huey. "I'm going to my car to get the paperwork," he said. "You're getting citations this time."

Huey's eyes, as gray as the smoke around him, became slits. He tugged on the full beard that had earned him first place in the Ernest Hemingway look-alike contest four out of the past ten years. "What for? Doing my civic duty?"

Ignoring the sarcasm, Reese went around the house to retrieve the necessary reports. After he'd written the first citation, he walked back and handed a copy to Huey. "This is for burning household waste."

Huey stared at the paper that had been thrust into his hand. "Of course I'm burning household waste. That's exactly what that officious son of a bitch you sent out here told me to get rid of."

"You can't burn it, Huey. You can only set fire to lawn debris. I gave you a copy of the rules the last time I was here."

"You did? Guess I must have burned it in this pile by mistake."

Refusing to be goaded into making an equally sarcastic comeback, Reese studied the smoldering items in the

widening circle of blackened weeds and said, "You've got a rubber tire in there, along with plastic and metal containers that, if I knew what they'd once held, might scare the crap out of me." He handed Huey a second ticket. "This is for not having your fire within the appropriate setback. You're too close to the fence line."

Huey stared at the fence separating his property from his neighbor's. "That damn busybody Edna Howell. The old biddy ratted me out—"

"And for not clearing an area around the pit to ensure containment," Reese continued. He wrote the third citation. "This is for not having a shovel and hose nearby in case the fire spreads."

He was starting a fourth ticket when Huey reached out and placed his big hand over Reese's. "You've made your point. Now we both know you can write."

Reese frowned at him. Huey was consistently the most difficult resident on the island to deal with. He held on to grudges longer than anyone Reese had ever known. And Huey had a hell of a lot of grudges to stew over, including one against Reese and his family that dated back a lot of years. "I thought I made all this clear last week when you had the previous fire," he said. "I should have ticketed you then."

Huey ruffled the papers in Reese's face. "I'll tell you what you can do with your citations, Mr. Big Shot."

Reese struggled to hold on to his temper. "You want me to arrest you, Huey? Because I will. You're threatening an officer of the law—"

"Phooey. I remember when you were still wet behind the ears. It wasn't so many years ago, Reese Burkett, that you were on the other side of the law more often than not, and don't you forget it. Many's the night I sat on my porch

and watched the cops chasing you and that Cuban gang you hung out with."

Reese sighed, admitting to himself that Huey had a point. Reese had gotten into a lot of trouble on this island. That was why folks had been surprised he'd accepted a position with the Key West Police Department when he'd gotten out of the navy.

He started to remind Huey that both of them had episodes in their pasts that were better left buried, but his words were interrupted by a crew of firemen coming around the side of the house.

Larry Blanchard, fire captain and another Key West native, warned Huey about his reckless actions. "I should charge you for what this unnecessary call cost the citizens of this town," he said.

"Go ahead." Huey clasped his wrists together and held them in front of him, daring someone to slap cuffs on him. "I can't pay it. You know what it's like for a small, independent businessman these days. Can barely keep food on the table."

Blanchard rolled his eyes, and it was all Reese could do not to point out that Huey hadn't made a decent living in years. Having ruined his reputation as the local handyman by charging folks for inferior work, he now sold cheap souvenirs to tourists from a mobile vendor's cart during the nightly sunset festivities on Mallory Square. Still, Reese found it hard to believe that Huey had trouble paying his grocery tab. The six-footer tipped the scales at well over two hundred pounds.

"You've got fourteen days to pay these citations," Reese said.

Huey passed his hand over his collar-length white hair.

"Don't hold your breath. I won't have the money in four-teen *weeks*. And if I did, I wouldn't give it to you jackass bureaucrats."

"Then I'll be back to get you."

"Fine. I'll be waiting. The people of this island can provide me with a bed and three squares a day."

Although Huey had been an eyewitness to some trouble Reese had gotten into thirteen years ago, the last thing Reese wanted was to arrest the guy. He dreaded listening to Huey's complaints while he served time. And he certainly didn't relish providing Huey with any more excuses for not earning a living. But mostly Reese didn't want to haul Huey in because the Vernays had been on this island for more than a hundred and fifty years. Not all of their history here was good, but they were as much a part of Key West lore as Stephen Mallory, John Simonton or Samuel Southard, men who'd had streets named after them because of their illustrious contributions to the island. No street was named for the Vernays.

Regretfully, Reese had to accept that he was running out of options with Huey. The stubborn old guy wasn't giving him any choice other than jail. Reese scratched his head. Except for the option he'd used as a last resort once before in similar circumstances. Maybe Loretta could talk some sense into her ex-husband this time, too.

He stopped the fire captain as he circled the contaminated pile. "How's it look, Larry?"

"It's out, but there could still be some hot spots. To totally decontaminate the site, we should clear the whole pile out of here."

Reese nodded toward Huey's rusty old truck, which sat in front of the decrepit carriage house. "Never mind," he

said loudly. "Huey's cost the city enough for one day." He glared at the man. "You haul this trash down to the sanitation site after it cools, or call the junk dealer to come take it away. You hear me?"

"I'm not deaf, Reese," he snapped. "Just pissed off, and that doesn't affect my hearing."

"I'm just making myself clear," Reese said. "I'm stopping back this afternoon to see that you've started cleaning this toxic mess up. And if it isn't all gone in two days, I'll slap you with another fine."

"That doesn't surprise me."

Reese got in his cruiser and headed to the station. He'd missed breakfast, but that wasn't the main reason he was already thinking about lunch. He'd made up his mind to go to Phil's Pirate Shack on Caroline Street. Hopeful about talking to Loretta Vernay, he could also order a grouper sandwich to go.

EVERY TIME A CUSTOMER opened the door at Phil's, a grease-smeared plastic pirate's head hanging on a hook over the entrance cut loose with a squawky rendition of "Ho, Ho, Ho and a Bottle of Rum." Reese entered the establishment at noon and glanced around at the usual crowd of locals who knew this was the place for the best seafood on the island. And unlike many of the restaurants in town, the prices were fair.

A few customers hollered at him, mostly construction workers building or remodeling ever-expanding resort hotels, or guides and charter operators from the area's marinas. These were guys for whom the fresh-catch scent at the Pirate Shack was cologne. Reese walked over to a table where the two mechanics from Burkett's Paradise

Marina were chowing down on fish and chips. "How's everything going?" he asked the men.

"Wouldn't do any good to complain," Bill MacKenzie said. He scooted a chair away from the table with the toe of his work boot, indicating Reese should join them.

He waved off the invitation. "I'm getting a takeout," he said.

Bill took a swallow from a long-necked beer bottle. "We wanted your father to eat with us, but your mom asked him to pick out some fabric for curtains or something."

Reese chuckled. His mother was always doing something to their Gulf-side stilt house—a fact that made Frank Burkett cringe. At this stage in his life, Reese's dad was basically content with a comfortable recliner and a television. The marina had provided a good living for the family since he'd resigned as a cop and opened the business twenty years earlier. And his wife was a major reason for that success. Ellen Burkett was an excellent manager.

"You guys enjoy your lunch," Reese said, scanning around the restaurant for Loretta. He spied her coming out of the kitchen with a platter of food skillfully balanced on her hand. Reese smiled at her. He didn't know Loretta's age, but he figured her for around fifty, sixteen years older than he was. She looked good. Kept her short hair a light blond, her figure trim and appealing. A lot of women who'd lived most of their lives in the unforgiving island sun showed the effects of ultraviolet rays in creases around their eyes and lips, as well as scars from skin cancer treatments. Not Loretta. Reese guessed she must have a closetful of wide-brimmed hats. And he knew for certain that she was one Vernay who would always have a smile for him.

She gestured with her free hand. "Be with you in a minute, Reese."

He propped his foot on the empty chair and talked with his friends until she was free. When she approached, her order pad at the ready, he led her away from the others.

"What can I get you, honey?" she asked him.

"A grouper sandwich to go, coleslaw instead of fries. But that's not the only reason I'm here."

"Oh?" She grinned. "Anything else, and you'll have to check with Phil."

Reese smiled. Loretta and Phil had been together for almost twelve years, once she'd finally given up on Huey, packed her bags and walked out of Vernay House for good. And since that time, the mansion had suffered twelve years of nobody caring about it.

"If I didn't know that Phil could beat me with one hand tied behind his back, I'd be tempted," Reese said. "But this has to do with an entirely different matter." He sobered, cleared his throat and watched Loretta's blue eyes narrow suspiciously. She was a smart woman and caught on fast.

"You're not here about Huey, are you?"

Keeping his expression resolute, he replied, "I know you're busy, but I need to talk to you."

She lowered her voice. "I asked you to leave me out of Huey's problems, Reese. Besides, Phil could come out of the kitchen anytime, and if he hears us discussing Huey, he'll blow a gasket."

Reese stated the obvious, hoping it would make a difference. "Huey's his brother, Loretta. He must care about what happens to him."

"He did once," she said, "but not anymore. Phil has vowed never to lend him money again or come to his

rescue." She leaned in close and spoke in a whisper. "I know Huey was hurt when I left him for Phil, but darn it, Reese, it's been twelve years, past time for Huey to get on with his life."

Reese wasn't sure he agreed. In fact, the way the romantic triangle had ended up was one aspect of Huey's life that earned Reese's sympathy. Another was that Huey had said goodbye to his daughter shortly before Loretta walked out on him.

"Phil doesn't even like me talking about Huey," Loretta said, "and frankly, that's how I want it, too."

"I'm going to have to arrest him, Loretta."

She sagged against the bar. "Oh, come on, Reese. You don't mean that. Huey's a problem. Nobody knows that better than me. But arrest him? He's sixty-five years old. And he's not a criminal."

"Maybe not in the sense you're thinking, but he's a public nuisance and he's breaking the law. At least once a week I've got to drive over to his place and remind him that living in the Conch Republic doesn't mean that we're divorced from the rest of the country. We have the same laws here as on the mainland, and Huey seems to enjoy stretching them to the limit."

Her voice filled with resignation, she asked, "What did he do this time?"

Reese explained about the fire, Mrs. Howell's phone call and the complaints they'd gotten from tourists recently. "No wonder he doesn't make a living selling those cheap souvenirs," Reese said. "One encounter with Huey, and nobody wants to buy anything he's offering. All the tourists think about is getting away from him."

Loretta shook her head. "I don't know what I can do."

"I'll give you a chance to talk to him one more time. He has fourteen days to pay his latest citations, and a couple of days to dispose of a load of offensive garbage in the yard. If he does those things, and if you can convince him to abide by the laws around here, I'll cut him a break... again."

She sighed. "Huey doesn't like to listen to me, Reese. You know that."

Reese felt bad for putting Loretta in the middle of this situation, but he knew darn well she'd never forgive him if he arrested Huey without telling her first. She might claim to have given up on the man, but somewhere deep inside her, an affection for him still flickered.

"Okay," Reese said. "I understand your position, but I felt I owed it to you to tell you before I acted."

She tapped her order pad on the bar. "I appreciate that. You still want your sandwich?"

"I'm happy to say Huey hasn't ruined my appetite."

She turned to go to the kitchen, but stopped after a few steps. Turning back, she said, "Actually, there's one person, and one only, who might be able to get through to him."

Reese knew exactly who she meant, and an image of a cute, blue-eyed blonde filled his mind. "I didn't think it was my place to suggest Abby," he murmured.

"He still listens to her," Loretta said. "Not that he follows her advice. But if anybody can get him to behave himself, it would be our daughter."

Reese was beginning to see a way out of this dilemma. "So what are you saying? That you'll call her?"

"I hate to. She's got her career in Atlanta. She's busy. And she's really not comfortable being here."

Reese only nodded. He hadn't seen Abigail Vernay in

thirteen years. He was aware that she returned to the island sometimes. She still maintained a connection to Huey and her mother, but she stayed away from the public areas when she was here, and remained only a couple of days. Their paths hadn't crossed in the seven years he'd been back.

All that supported what Loretta had told him. Abby did seem to have misgivings about coming home. Reese just hoped the history between them wasn't one of the reasons.

What had happened was ancient history. She'd probably forgotten all about it. Still, Reese couldn't be certain. Women's memories were tricky things.

CHAPTER TWO

"HE'S GOT TWO WEEKS to pay a bunch of fines, Abby, or Reese Burkett's going to arrest him."

Abby had been unable to get her last conversation with her mother out of her mind. When Loretta had informed her of Huey's latest trouble and its consequences, she had been furious. "Arrest him?" she'd practically shouted at her mom, though her anger had been directed at the island's arrogant police captain. "Reese had better not lay a hand on Poppy."

Now, two days later, as she neared Southard Street, Abby was ready to do whatever was necessary to protect her father. Once she'd calmed down, she had admitted that his behavior *had* gotten out of hand. She also recognized that she had the best chance of talking some sense into him and keeping him from going to jail. "You're the one person Huey seems to tolerate these days," her mother had said.

Abby smiled, thinking about the unique father-daughter bond they shared, a bond that had been tested over the years but remained strong because of weekly phone calls and genuine concern. But now, Abby had to admit her dad needed something more from her than a supportive, long-distance relationship. He needed to start behaving like a grown-up.

So, taking into account the month of personal days and

vacation time she'd accumulated, Abby made a difficult decision. After turning over a mountain of paperwork to a colleague, and explaining her situation to the most vulnerable of her cases, she'd arranged for a leave from her job so she could stay in Key West through Christmas. Her involvement with the young women in her caseload didn't end just because she was away, of course. She'd made sure everyone who depended on her had her cell phone number.

Leaving Atlanta had been difficult, but Abby was convinced she was doing the right thing for her family. If anyone could help Huey out of the mess he'd gotten himself into, it was her, not an island cop who thought he could change her dad by intimidating him. She only wished she could avoid Reese throughout her stay, as she had in the past, though she doubted that would be possible. Key West was, and always had been, a small town.

Thanksgiving Day was nearly over when Abby drove up to her old house with a couple of take-out turkey dinners on the floor of her car. She hadn't told her father she was coming, for two reasons: she didn't want him to worry about her making the long drive, and she didn't want to answer questions about why she'd planned the trip.

As she pulled up the cracked cement driveway, she encountered debris that spread from the lawn into the street. Much of it was charred and unrecognizable—and an indication that things were as bad as her mother had said. Abby parked, got out of her car and wrinkled her nose at the foul odor from the garbage.

Then she gazed up at the two-and-a-half-story house she'd grown up in. At one time she'd been proud that the 1857 mansion had been built by her great-great-great-grandfather Armand Vernay, a self-made millionaire during

the island's infamous shipwrecking days. Today, eleven months since her last visit, Abby only sensed decay and desperation around her, emphasizing even more the painful memories of the choices she'd made thirteen years ago, and the consequences she'd been forced to live with.

Scraggly oleander bushes, once brilliant with pink blossoms, now reached heights of more than ten feet and invaded the wraparound porch. Bare limbs chafed the delicate rippled glass in the ancient windows. The wide brick pathway, where once two people could walk arm in arm to the front door, barely allowed one person to climb the three steps without risk of scratching ankles on unkempt brambles. Most of the windows were shuttered, giving the house a sad, deserted feel.

Clutching the turkey dinners, she picked her way toward the porch, half expecting Huey to burst through the door. He always seemed to have a special radar where she was concerned, somehow knowing when she was around. Disappointed, she walked in the door, which was never locked, and called his name.

Silence. She stared into the parlor, noting the disarray. Mail, mostly flyers, littered Huey's desk. Dust lay thick on the old mahogany pieces she used to polish with such care. She progressed down the hall, again calling for her father. Once in the kitchen, she set the turkey dinners on the table and peered out the window. Maybe he was in the backyard. She glanced at the overgrown bushes and a large, darkened patch of dirt that looked as though it had been burned—confirmation of Huey's run-in with Reese.

Abby shook her head and returned to the hall. Maybe Poppy was napping. She'd go upstairs and awaken him, she decided, just before her cell phone rang. She pulled the

phone from her jeans pocket, read the digital display and answered. "Mom?"

"Hi, honey. Have you arrived at Huey's yet?"

"Yes, I just got here."

"Good. I didn't want to call and upset you while you were still on the road. I was afraid you'd drive too fast to get here."

Abby sat heavily on the bottom step of the staircase. "Mom, what's happened? Poppy's not here."

"I know." Loretta paused. "Now, don't think the worst, but he's in the hospital."

"The hospital?" Abby rose and hurried to the front door. "Why? What's wrong with him?"

"He fell, Abby. He'll be okay, but he's got a few bruises and a concussion. The doctors want to keep him overnight for observation."

"My God. Poor Poppy." She picked up her purse, which she'd dropped on the hall stand, and went outside. "I'll head right over. Are you coming, too?"

"I went when I first heard, but once I knew Huey was okay, I came to work. You can call here at the Shack if you need me."

"Okay. But wait, Mom, don't hang up. How did it happen? Why did Poppy fall?"

Loretta breathed deeply. "You won't like hearing this, Ab."

"Mom…"

"Huey says Reese Burkett attacked him."

ABBY'S HANDS SHOOK on the steering wheel as she drove the mile to the island hospital. She tried to picture Reese Burkett with her fingers wrapped around his neck. But instead of popping veins on his forehead, and broken blood

vessels in his eyes, all that came to mind was a youthful,
cocky smile and heavily lashed green eyes full of confi-
dence and invincibility. That was Reese then. She had no
idea what he looked like now, only that she would experi-
ence an admittedly selfish gratification in discovering he'd
packed forty pounds onto his athletic frame and lost most
of his thick dark hair. How dare he manhandle her father?
She'd meet him in court, facing an abuse charge!

The sun was setting as she parked in the hospital lot and
entered the lobby. Mechanically, she showed the required
identification, had her picture taken and patted the ID
sticker onto her blouse. She was used to hospital security
regulations. In the course of her job, she visited many hos-
pitals in the Atlanta area.

Huey was on the second floor. Abby exited the elevator,
quickly scanned the directional signs for his room number
and headed to the end of the hall. She heard Alex Trebek
read an answer on *Jeopardy,* then recognized her dad's
voice giving the proper response before the contestants
could buzz in.

Huey snapped his fingers as she entered the room. He'd
gotten the *Jeopardy* question right.

Abby hurried to his bedside, then stopped short when
she saw the bruise around his closed right eye. "Poppy!"

He turned to her, and a huge grin spread across his face.
"Well, I'll be. Baby girl! What are you doing here? You
found out I was in this joint?"

"Not until I got into town, about thirty minutes ago.
Mom phoned and told me you'd been admitted."

He stared at her with his good eye. "So what are you
doing here? It isn't Christmas yet."

"No, but I came early, to spend more time with you."

"What? You're staying through December?"

"That's the plan."

"That's not like you, Abigail—taking off work so long."

"It's fine, Poppy. Everything's covered."

"But you never stay more than a couple of days."

"I know, but this is different." She pulled up a chair. "Anyway, I don't want to talk about me. I want to know what happened to you. How are you feeling?" She lifted the tube leading into his arm. "And what's this for?"

He lowered the TV volume with his remote. "It's nothing," he said. "Everybody gets a drip of some kind, they tell me. That's just sugar water or something." He tapped the side of his head. "It's the old noggin that's giving me trouble. But they gave me something that makes Alex Trebek look like Loni Anderson."

Abby leaned close. "What about your eye?"

"Oh, yeah, that. Haven't had a shiner in years."

She rested her hand on his arm. "Poppy, what happened? Tell me how you ended up in here."

He snorted. "You need to ask your old beau about it, Abigail."

"Don't call him that. He was never my beau, and you know it. If Reese did this to you, I want to hear the details."

"He did it, all right. Knocked me flatter than an IHOP pancake in my own front yard." Huey suddenly sat up straight. He stared over Abby's shoulder and gazed cantankerously at the doorway. "And there's the abuser now. Come to try and put the cuffs on me again, Reese?"

Abby spun around, the chair legs scraping on the speckled linoleum. Her heart pounded. There he was, well built, still with a full head of hair. *Damn you, Reese,* she thought, hating that her chest clenched with resentment and

heartache and other emotions that, if she analyzed them, might scare her to death.

She stood up and placed her hand over her stomach in an effort to calm the trembling inside. She hadn't seen Reese in thirteen years. He'd matured, but he hadn't really changed. At twenty-one, he'd given lots of girls reason to hope he would ask them out, her included, though at barely eighteen, she hadn't sparked his interest. Until… She shook her head, banishing the image of that one night she'd tried so hard to forget, a night he obviously had.

As he walked toward her, Reese stared, obviously searching for her in the recesses of his mind. His lips twitched, as if he almost wanted to smile but figured it was inappropriate. He wiped his hand down the side of his jeans and held it out to her. "I can't believe it. Is it really you, Abby?"

She refused his handshake—a small act of defiance to let him know she was aware of his role in this travesty of justice tonight. "It is," she said, her voice harsh. "And I've arrived just in time, it seems."

"Come to finish me off, did ya, Burkett?" Huey muttered. He tugged on Abby's arm, getting her full attention. "Don't leave the room, Abigail. I'm going to need a witness."

"That won't be necessary, Huey," Reese said, twisting a ball cap in his hands. "I just stopped by to see how you're doing."

"How do you think I'm doing?" Huey said. "You roughed me up pretty good, *Captain* Burkett." He pointed to his eye. "I may lose my vision in this one."

Abby gasped. "Poppy, is that true?"

Reese frowned. "It's not true. I've talked to the doctor. Your dad's going to be fine."

"Lucky for you," Abby said. "If Poppy suffers any permanent injury because of what you did…"

Reese scratched the back of his head. "Abby, can I talk to you in the hallway?"

She glared at him with all the bravado she could muster. "I don't think that's necessary."

"Give me five minutes, Abby, please."

She looked at her dad, who reached for the TV remote and punched up the volume a couple of notches. "Go ahead," he said. "But don't believe a word he says. He tried to arrest me today and it got ugly. That's the truth of it."

Reese shook his head. "I'm sorry, Huey. I apologized to you earlier, and I'm apologizing again. I didn't want you getting hurt. You can't think that I did."

"Don't ask me what was going on in your head, I just know what I felt when you attacked me. And I got the bruises to prove it."

Reese stretched out his arm. "Abby?"

"Five minutes." She stepped ahead of him, then walked a few feet down the hall.

"Can we find a place to sit and talk?" he asked.

She stayed where she was. "This is okay. I don't want to be too far away in case Poppy calls me."

"Fine." Reese tucked the ball cap under his arm and ran his fingers through his hair. Strands fell onto his forehead, and Abby locked her gaze on the nurses' station rather than stare at him. "I know how this must look to you," he began.

"No, you don't," she said, focusing on his face again. "Because if you did, you wouldn't be here. You'd be out trying to hire a lawyer."

"I don't need a lawyer, Abby. What happened was unfortunate, but there was no physical abuse."

She didn't respond, letting him squirm. "Since you're here, I assume Loretta called you."

She nodded. "Thank goodness."

"Right. Anyway, then she told you that Huey's been starting fires on his property, which is an escalation of his other irritating antics."

"And I'm sure that, as a representative of the police force, you did your duty and warned him to stop."

"I did. Several times."

"And he cooperated?"

"For now, yes. But it's only been a few days. I also told him to get rid of a pile of burned, potentially toxic substances that remained from his last bonfire. The stuff is offensive to his neighbors. It stinks."

Abby remained silent. She couldn't very well argue the point. She'd experienced the foul odor herself.

"Anyway, responding to a complaint call from another resident of Southard Street, I went back to Huey's place today and discovered that he had dumped the mess at the edge of his yard, with most of it spilling onto the street. That's illegal dumping, violation of code number—"

"Never mind," she interrupted. "I'm not arguing with you about minor infractions my father may have committed. I want to know why you manhandled a senior citizen, a man at least thirty years older than you."

"I'm getting to that."

She glanced at her wristwatch. "You'd better hurry. You've only got two minutes left."

When he glared at her, she backed up a step. Perhaps she was hitting too hard.

"I told Huey I was going to arrest him. He deserved it, and damn it, Abby, I could *still* arrest him."

"If you think you're intimidating me with your threats, Reese, you're wrong. I'm not the teenage girl who left this island years ago. I've experienced a few things—"

He held up his hand. "I don't think for a minute you're that same girl, Abby. I'm hoping you're ready to hear a *reasonable* explanation for what happened."

Reasonable? Abby quickly tamped down her anger by mentally counting to ten. Was he insinuating that her behavior thirteen years ago hadn't been reasonable?

"In typical Huey fashion," Reese continued, "your father refused to get in the car and come down to the station."

Abby had no defense for that charge. She knew her father too well.

"He stood there over that trash like he was king of his self-made mountain, and wouldn't budge. In fact, he even said that if I wanted him in the patrol car, I'd have to drag him into it."

Abby could almost hear her dad's voice.

"That did it, Abby. After I'd warned him time and again about breaking the laws in Key West, I'd reached my limit. I stepped around the trash heap, grabbed his arm and started to pull—gently, mind you—pull him to the car."

"And what happened?"

"He yanked free, stumbled, slipped on something gooey at the edge of the yard and fell. Unfortunately, his head hit the mailbox, and that's how he got the black eye. The other bruises and the concussion? Collateral damage, I suspect."

She waited a moment, tapped her toe against the floor and said, "That's the story you're sticking with?"

Reese raised his hands. "Abby, that's the story. Period. I called an ambulance, and the rest you know."

She would definitely confirm this version with her

father. In the meantime, she made a great show of checking her watch again. "We're done here," she said.

Reese reached out as if to touch her arm. She stepped away and he dropped his hand. "I'm sorry it happened," he said. "That's why I'm here tonight—to make sure Huey's all right."

"And you have," she said. "You're free to go and celebrate Thanksgiving."

"Celebrating is the last thing on my mind," he said. "But I will go."

He walked to the elevator. Once inside, he pulled on the baseball cap and stared at her from under the bill. Then the doors closed, and Abby drew the first normal breath she'd taken in more than five minutes. But at least the worst was over. She'd seen Reese again and she hadn't melted or fainted or even babbled. She'd stood her ground pretty well. Now, though, as she went back to her dad's room, she realized that nearly every limb of her body was trembling. She'd have to work on controlling that reaction.

Jeopardy had ended. The TV was silent. "Buzz the nurse, Abby," Huey said. "Earlier they told me I could go home if I had somebody to observe me through the night. I guess you've got a good enough pair of eyes, so I want out of this place."

"Okay, Poppy. I'll see if I can arrange for your discharge."

He swung his legs over the side of the bed. "So what'd you think of Burkett after all these years?" he asked. "He's a piece of work, isn't he? Officious son of—"

"Let's not talk about that now," she said. "Let's just get you home. Those two turkey dinners I brought might still be edible."

CHAPTER THREE

On Friday morning, Abby raked dried leaves and twigs into a large pile. Somewhere under this mess that used to be her front yard, grass had to exist. And if it didn't, she'd plant seeds, fertilize and hope for the best.

After scooping part of the pile onto her rake, she dumped the refuse into a garbage can. Thank goodness the trash collector she'd phoned earlier had removed the burned debris from Southard Street. Abby considered the money well spent, since Reese wouldn't have anything to complain about for a while. She wondered why her father hadn't called the trash man himself. Did Poppy not have thirty dollars?

She'd just resumed her raking when the window to the second-story master bedroom opened and her father stepped onto the balcony, a cup of coffee in hand. She'd checked on him several times during the night, and he'd slept well, almost as if he hadn't a care in the world.

"Good morning, Poppy," Abby called up to him. "How are you feeling?"

He rested his elbows on the railing and gave her a robust smile. "Fine, but what are you doing down there? It's barely eight o'clock, way too early for you to be making all this racket."

She glanced at what she'd accomplished in the past hour. "This yard won't rake itself."

"But I don't get up this early. I have to work today."

She leaned on the rake handle and reined in her impatience. Unless his routine had changed, and she doubted it had, hours would pass before he pulled his vendor's cart from the side of the old theater building where he stored it, and set up his souvenir business in Mallory Square. "We'll decide about you going to the square later. It'll depend on how you're feeling then. Besides, you don't work until sundown, and the festivities are over by nine o'clock."

"That doesn't mean I want my daughter disturbing my rest before I'm ready to get up."

"Funny, but I was thinking that if you're feeling better, you could help out." She pointed to the veranda, where she'd stacked assorted lawn tools. "I brought two rakes from the carriage house."

"I'd help you, but I've got this bad eye. Keeps me a bit off-kilter, if you know what I mean. I hope someone comes along to give you a hand, though, baby girl." He pointed a shaky finger. "Only, not *that* someone."

A blue-striped Key West patrol car rounded the corner of Duval and Southard Streets. Abby couldn't see the identity of the driver, but her heart leaped to her throat just the same. When the car stopped directly behind her Mazda, Huey let loose a few choice words and disappeared into the house, leaving Abby to face Reese, who was stepping out of the cruiser.

Dressed in a standard police uniform, he walked toward her. "I hear Huey came home last night. How's he doing?"

"He's okay."

Reese gave her a lopsided smile. "Then you're not going to sue me or the department?"

Once she'd had a chance to consider Reese's explanation, Abby had reached the conclusion that his story was probably closer to the truth than her father's. Huey's version had included such colorful phrases as "rough-necked bully" and "power-hungry tyrant," while he referred to himself as "innocent victim." But not knowing Reese's reason for showing up this morning, she simply said, "I'm keeping my options open."

Reese smiled again and glanced around the yard. "I see the trash has been removed."

She gave him a smug look. "Of course. We're law-abiding residents of Key West, Reese. Ones who should not have to be fearful of being arrested."

He nodded. "Nope. Not anymore. Not about this, at least."

"Gee, it's nice that the police department is sending out one of its finest to follow up with surveillance of some of the most dangerous citizens."

"That's not why I'm here—exactly," he said.

"Oh?"

He held out his hand. "You wouldn't shake with me last night. I thought I'd try again." When she didn't move, he added, "It's been years, Abby."

She relented, clasped his hand and stared at the long fingers wrapped around hers. Bits of twigs and soil stuck to their joined palms. She pulled her hand back and wiped it against her jeans. He did the same. "Cleaning the yard, I see."

She swiped her rake across the dirt. "You cops don't miss a clue, do you?"

Reese folded his arms over his chest. "So how have you been?"

How have I been? Abby marveled at how absurdly casual his question was in light of what her life had been like since she'd last seen him. But of course, Reese never thought of that night. He'd had thirteen years to forget. She'd had thirteen years to remember. And regret.

She answered blandly, though her heartbeat pounded in her ears, nearly deafening her. "Fine." Ironically, in spite of the churning in her stomach now, that was mostly true—or should be. She had a fulfilling job, many friends and nice neighbors. And past relationships that didn't linger over-long in her mind when they ended. She had offers for dates that she sometimes accepted. In fact, her life was so busy she didn't allow herself to think about what was missing in it or what had gone wrong.

He looked toward the house, his features indicating a sort of benign acceptance. "I know Loretta called you. I'm sorry for putting both of you in the middle of this problem with your father."

Abby's back immediately stiffened—an involuntary reaction she experienced when dealing with anyone who even hinted that something might be wrong with Huey. "There's no problem. Poppy seems okay to me. But if it makes you feel any better about interfering in people's lives, I can tell you that we're working on a few things."

"I don't want this situation to get blown out of proportion, Abby. I have a job to do. You know that, don't you?"

She pretended to concentrate on her work. "I wonder how many acts of aggression have been committed under the guise of that excuse."

He started to respond, but she added, "It's okay, Reese. You have to protect the people of Key West from the threat-

ening presence of a confused senior citizen. It must be a mammoth responsibility."

He rubbed his thumb over his clean-shaven chin and stared at her a moment, as though trying to decide if her sarcasm was for real. After a moment, he said, "I can't imagine why we haven't run into each other in the seven years since I've been back."

"I don't return to the island often," she said. *At least, I haven't in the past seven years.*

"How long you planning to stay this visit?"

She glared at him determinedly. "As long as it takes to get the authorities off my father's case."

His lips curled into a genuine grin. "It's a great time of year to be here. Decorations are going up on Duval Street and Mallory Square today. Plans are under way for the Christmas boat parade. You'll see a lot you remember about the holidays, plus some new additions."

"Can't wait," she said. How nice for Reese to chat about holiday decorations as if he weren't on a one-man mission to pester Huey into having the worst Christmas ever.

Deciding they'd had enough small talk, Abby was about to release Reese from this obligatory visit when her father shouted, "Scram!" A single word delivered from the veranda with enough force to approximate a shot from a rifle.

Startled, Abby spun around. Reese, seemingly unconcerned, took a slow step toward the porch. "'Morning, Huey," he said.

"Get off my property, Burkett!"

Huey filled the front entrance. His old shotgun rested against his right elbow, the barrel pointed toward the porch floor.

Abby rushed to him. "Poppy, what are you doing?"

He had the good sense to set the weapon against the door frame. "Reminding certain people that this is Vernay property."

She grabbed the gun and put it out of his reach. "Do you always greet visitors by threatening them with firepower?"

"Mostly just pain-in-the-ass police captains." He stared at her, obviously noting her shocked expression. "It's not loaded, Abby. I keep it for show."

She opened the breech of the shotgun he'd taught her to use years ago, and looked down the barrel. To her relief, he was being truthful. It was empty. "Someone could see you with this thing and get the wrong impression."

"No, they wouldn't," Huey said, his good eye narrowed at Reese. "They'd get just the impression I want them to have."

Huey appeared determined to make her efforts on his behalf impossibly difficult. She took the gun inside the house and came back to the porch. "Reese, I didn't know about this."

He shrugged. "Don't worry about it. He's got the proper paperwork for that old thing, and everybody's aware that he doesn't have shells for it."

"That you flatfoots know about, anyway," Huey said. "Just because you sent Loretta over here to search doesn't mean she found every bit of contraband." When Abby started to protest, he waved off her concern and whispered, "Keep your cool, Abigail. If I even have bullets, I don't remember where they are."

Reese looked down at the sidewalk and shook his head. Abby couldn't help sympathizing with his plight for just that moment. Huey didn't make keeping the peace on Southard Street easy.

"You folks have a nice morning," Reese said, heading

back to his squad car. "You need anything, just call the station."

"That'll be the day," Huey couldn't resist replying.

STILL SHAKING FROM a tumult of emotions she'd hoped not to experience, Abby sat on the porch steps and dropped her head in her hands. "For heaven's sake, Poppy, that whole thing with the shotgun was embarrassing."

Huey leaned against a support pole and looked down at her. "Don't be embarrassed by anything having to do with Reese Burkett. That man ruined your life."

She sighed. "He didn't ruin anything. My life is perfectly fine." *As long as I don't allow my thoughts to go back more than twelve years.*

"Well, he ruined mine, and I'd hate to think you were having any romantic notions about him."

She turned her head to give her father a cold stare. "Don't be ridiculous."

"He's the wrong guy for you to be fantasizing about."

"I am not fantasizing about Reese. For you to even suggest such a thing is insulting and demeaning." Abby wasn't sure how Huey's suggestion was either one of those things. Nor was she completely honest when she said she didn't fantasize about Reese. When a woman went to the lengths she had over the past years to avoid a man, it was a safe bet that she fantasized about him plenty. Just maybe not in a good way.

Huey pulled a wicker chair close to the edge of the porch and sat. "Ab, while we're being so truthful…"

Were they?

"I'm still wondering why you're here so much before Christmas. You're not having trouble at work, are you?"

"No. Everything is fine at work. I left a few of my teen pregnancy cases in limbo, but the girls can call me or any of the other counselors anytime. They know that."

Huey nodded, seeming to accept that explanation. "And why are you staying so long?"

She turned on the step to see him clearly. "You're almost giving me the impression that you don't want me here for a full month."

He raised his hand. "Nope. That's not it. If it was up to me, I'd have you move back here permanently. We have babies who need good families in the Keys, too. I'm just thinking that your mother might have called you with some cock-and-bull story about me having some problems with Reese."

"Poppy..."

"I can handle Reese. I can take care of anybody who comes on this property."

She thought of the shotgun. "A few minutes ago I saw how you treat trespassers."

"You're damn right, baby girl. This half acre is Vernay land. Always will be. Your mother had no business involving you."

"She's worried about you."

"The hell she is." He lit a cigarette and took a long drag. "I'm glad you're here, Abigail, but I'm starting to believe that you've bought into your mother's hysteria about the way things are with me."

Abby leaned toward him. "I'm not so sure it's hysteria, Poppy. Your confrontation with Reese yesterday convinced me that there are problems. I'm here to help, and if that means both of us standing up to Reese, then I'm with you all the way."

He frowned. "So *now* you're ready to square off with Reese?"

"Yes, now. And if this is some veiled accusation about how I handled the past, I've warned you before not to bring it up."

He shrugged. "Consider it forgotten. For now."

Abby stood. "I'll make you some breakfast."

She felt the press of familiar feelings of guilt as she went into the house. She knew the blame for what had happened thirteen years ago lay mostly on her shoulders. She was the one who had made the crucial decision.

REESE CALLED THE STATION and told the sergeant on duty that he'd be a few minutes late. The previous half hour with Abby had left him shaken. He'd gone over to see if he could make things right between the Vernays and himself. After all, Huey had been hurt on Reese's watch, and he could just imagine how Abby viewed the incident. Fortunately, Huey's injuries were minor, but they wouldn't have happened at all if Reese hadn't shown up and tried to force the guy into the patrol car. Cops often made tough decisions that they either had to rationalize or learn to live with later.

He headed north on Route 1 toward Burkett's Paradise Marina. If anyone understood the pressures a cop lived under, it was Frank Burkett. Though he'd given up the job years ago, he still felt a strong kinship with the guys on the force.

Reese parked in the marina lot next to his father's beefed-up Ford pickup, which was used for hauling boats. He got out of the patrol car and walked into the pristine blue-and-white metal building that combined a full-service mechanics area with a sales department that stocked every imaginable device for the avid boater, fisherman or recreational water enthusiast.

Ellen Burkett was behind the cash register, cashing out a customer who'd loaded up on prerigged trolling lines and plastic lures. Frank sat at the end of the counter, a cup of coffee steaming in front of him. "Hey, son," he called out. "What's going on in town? Rounding up any bad guys?"

Frank started every conversation with a question about Reese's job as a cop. He never began by saying how many boats he'd rented out, or if the billfish were running. Reese knew why his father had quit the force. Ellen had wanted him to. She'd claimed the stress was getting to her and she was tired of worrying about him every time he put on his uniform and left the house. Deep down, Reese knew his mother had always hoped her husband would be more than a patrol cop. She'd got her wish. Now he was the owner of the biggest marina on the island. And he spent every morning sitting and drinking coffee.

Reese ambled up to the counter. "Haven't run into any bad guys today," he said, "unless you count Huey Vernay. I was just at his place."

Ellen spared a glance in Reese's direction before returning her attention to the customer.

Frank stirred his coffee. "How's Huey doing? I heard on my scanner yesterday that the paramedics were called out to his house."

Frank listened to his home scanner to keep up with what happened on the island. Reese frowned. No doubt about it. His dad had been a good cop, and a happier man when he was on the force. In fact, Reese had been disappointed in him when he'd given in to Ellen's demands. Even as a kid, Reese had known that a man shouldn't stop doing what he was put on earth to do, just to please somebody else.

Reese had ignored his mother's pleas and become a cop

himself. Public service ran in his and his dad's veins. Reese, however, wouldn't give up his place in the department for anything. Especially now that he'd earned the position of captain of the Patrol Operations Bureau. He hoped to be chief someday.

"Reese?" his dad said. "Is Huey okay?"

"Oh, yeah. He just took a tumble in his front yard and got a black eye."

Frank shook his head. "Poor guy. It never gets any easier for him."

Ellen finished her transaction and came up to them. "Don't waste your sympathy on Huey Vernay," she said. "Have you forgotten that he's the one who told the police about Reese's involvement with those immigrants?"

"No, we haven't, Mom," Reese said. "But let it go. It happened years ago."

She sniffed. "I'm afraid I'm not so forgiving. Huey's motives when he turned you in had more to do with getting even with the Burketts than doing his civic duty. Besides, he brings all his misfortune on himself."

Frank conceded her point with a nod. "I suppose, but it's still a shame. He's likable enough if you peel away that crusty exterior."

Ellen busied herself clearing away Frank's coffee cup and wiping nonexistent stains from the counter. "Actually, we may not have to worry about Huey much longer," she said.

Reese stared at her. "What do you mean?"

"I heard something at city hall the other day. If Huey doesn't pay his back taxes, they're going to auction off his house. If we're lucky, maybe he'll move away."

Reese stopped her by placing his hand over hers. "Are you serious?"

"Absolutely. He owes a small fortune."

"And you just found out about this?"

"I had heard rumors," she said. "But now it's the year end. The county always does property appraisals about this time. Huey's taxes have shot up like everybody else's. And he still owes last year's payment and some from the year before."

Her husband stood. "Ellen, you didn't tell me any of this."

"Well, now you know, Frank. I say it's good news. That old house of Huey's is an eyesore, and the Community Improvement Board can't get him to do anything. This is what he deserves. Besides, we should worry about ourselves. Our taxes are going up, as well. Yours, too, Reese. Wait till you get the bill."

Reese rubbed his forehead. "Abby's not going to be happy when she hears this."

Ellen looked at him. "Abby? What's she got to do with this? Is she here?"

"Yep. I just left her in the front yard, raking up stuff from last summer's storms."

His mother's eyes widened. "I didn't know Abby was coming to town."

"Loretta called her to help out with Huey."

Ellen crossed her arms. "She's got quite a job there. I hope you don't get mixed up with that bunch, Reese. The whole lot of them are trouble. Loretta taking up with Huey's brother, Huey acting like a crazy man… How long is Abby staying?"

"I didn't ask her. But if what you say is true, she's got more worries with Huey than just his code violations."

Leaving the marina, Reese wondered if Abby had heard about the taxes. She probably hadn't, since Ellen knew ev-

erything on the island before anyone else found out, and he figured Huey wouldn't have told her.

Reese pictured Abby's reaction when she learned the news, and he decided to check his mother's facts on his own. Then he'd take an even bigger step. He'd tell Abby himself. She already resented his interference in Huey's life, but she had to believe she could trust him. He wasn't that wild guy she'd known years ago. He was a cop now, not a crusader who ignored the law.

He sat in his truck a minute, looking over the water, hoping the panorama of a glass-smooth Gulf would calm him. Not today. Not when Abby's troubles were on his mind. She'd stood right up to him this morning, staunchly denying that Huey had any problems.

He remembered that proud stubbornness from when she'd been in high school. She always kept herself apart from everyone. Apart and above. He'd never once heard of Abigail Vernay breaking the rules or getting into trouble. She'd been a straight-A student and always seemed to possess a fierce determination to succeed despite not having a lot of support from home. When Abby was just a kid, Loretta had tried to be a good mother to her, stretching limited dollars every way she could. But Huey had always managed to screw up.

Reese recalled Loretta's saying that Abby worked in social services in Atlanta. He figured she'd be tops at whatever she did.

He cranked up the engine on the patrol car and smiled. In his youth, he'd pulled a lot of stunts he wasn't proud of. Some of them he would arrest himself for now. And a couple of them, including that one brief encounter with Abby, came back to haunt him sometimes. But he'd bet that Abby didn't have much in her past to be ashamed of.

CHAPTER FOUR

FORTY-FIVE MINUTES AFTER Reese's unexpected visit, Abby stacked the breakfast dishes in the drainer and tried, unsuccessfully, not to think about him. She'd heard of some significant events in Reese's life over the years. Her mother had told her when he'd married, and then when he'd divorced, seven years ago. Abby didn't know the details, just as she didn't know if he was involved with anyone now. One thing she told herself. If Reese was in a serious relationship, she shouldn't care.

She hung the dishrag over the sink and looked out the window. Why in heaven's name was she wasting even a moment of thought on a man she'd sworn she'd gotten over completely? Unless she hadn't.

If only she'd been smarter all those years ago! She wouldn't be wasting brain cells on him now.

Grateful when her cell phone rang, she went to the kitchen table, where she'd left it. She recognized the caller's name and pressed the connect button as her concern mounted. "Alicia?"

"Miss Vernay? I'm sorry to call you…." The teen's thin voice trembled.

"Don't be. I gave you my number so you could use it if you needed to. Is something wrong? Is everything okay with the baby?"

"Yes, the baby's growing fine."

"Then are you rethinking your decision about the adoption?"

"I have to. Things have changed."

Abby sat in the closest chair and imagined the anguish on Alicia's pale face, the sadness in her big brown eyes. "But when I left, you'd made up your mind. You were going to keep the baby."

"That was when Cutter agreed to help me raise it."

Abby pressed her fingertips against her forehead. She'd heard this story too many times. "What happened, Alicia? Did he back out?" She hoped not. Alicia's boyfriend had been in trouble with the law a couple of times, but the prospect of becoming a dad seemed to be turning him around.

"No, ma'am." Alicia hiccupped—the prelude to what Abby knew would end in sobs. "He got arrested last night. He st-stole a car."

"Oh, no. That's not his first offense."

"It's his third. He's in jail right now. They aren't going to let him out." Alicia was crying. "I've got no choice, Miss Vernay. I've got to give up this baby. Otherwise my daddy's going to throw me out."

For just a moment, Abby considered that being thrown out of a ratty trailer sitting on cinder blocks on the outskirts of Atlanta might not be a bad thing. But she didn't say that. The single-wide was the only home Alicia Brown had ever known. And other than the group homes Abby sometimes sent girls to—an option Alicia had already rejected—Abby didn't have any other housing suggestions for her and her baby.

"Can you find me a family, Miss Vernay? A good family to take my baby?"

"You're at four months now, right?"

"Yes."

"We've got a little time. I want you to think about this very carefully. You need to use the best decision-making skills you have." Abby realized the near futility of what she was suggesting. When a vulnerable sixteen-year-old girl found out she was pregnant, her world fell apart. Yet that was when she had to make the most crucial decisions.

"I'm just a phone call away, Alicia," Abby said. "We can spend as much time as you want going over your options. I can try to locate a foster home for you. You can apply for work-study programs. I can guide you to some fine state-run child care facilities…."

"I've made up my mind. I don't want to do this without Cutter. And I want a closed adoption."

As many times as Abby had counseled young girls that giving up a baby was a personal and critical decision, as many times as she'd told them they had to make the decision based on their emotions, needs and expectations, she would never advise one of them to choose closed adoption. Even Abby, thirteen years ago, hadn't picked that option.

She approached the issue carefully now. "You know what that means, Alicia? You won't ever see your baby again. You won't know where he's gone. You'll never know what he looks like or what he becomes."

Alicia drew a trembling breath. "It's the way I've got to do this, Miss Vernay. I have to say goodbye to this baby and be done with it. I just need you to find a family. And I need it to be somebody who'll pay my doctor bills. With Cutter in jail…"

"Okay. That won't be a problem. I have more than forty families on my list at the moment."

"You think I'm being selfish, don't you?"

The desperation in the girl's voice almost brought Abby to tears. "No, honey, I don't. What you're doing is one of the most unselfish acts a mother can do for her child. I just want you to be sure." She waited until Alicia's sobs subsided. "I'll have one of the other counselors in the office begin the match for your child and the perfect parents today."

"Thanks."

"But there's time. If you change your mind—"

"I won't."

"Are you still going to school?"

"Yeah."

"Okay, good."

"Nobody can tell yet."

"Don't lose this number. You call anytime, day or night."

Alicia disconnected and Abby slid her phone into her pocket. She walked through the house to the front door. Huey had gone upstairs to rest. She should have appreciated the solitude, but the quiet only gave her more opportunity to think about the Alicias in the world.

Abby was getting better about accepting these stories as facts of life. And she was definitely grateful that she had the knowledge to help so many troubled teens through one of the most difficult times of their lives. She was relieved when she watched a birth mother come to terms with her future and take her baby home. She was equally happy when a birth mother agreed to a fair open-adoption plan with eager adoptive parents. Happy endings existed, and Abby considered herself lucky to be able to participate in them.

She hadn't felt so lucky thirteen years ago. And she hadn't experienced a happy ending.

Had she been in Atlanta, Abby would have started to

work immediately on Alicia's plan. In Key West, her home for years, she didn't know what to do, so she walked outside and looked for a diversion, something to take her mind off the place where it so often returned.

In a few minutes a 1965, canary-yellow Mustang convertible pulled in front of Vernay House. Abby ran down the steps to the car and popped open the passenger door. "Mom!"

Loretta jumped out and enclosed her in a fierce hug. Wrapped as tightly as a twisted ficus tree, the two women swayed together, giggling and sniffling and carrying on as if they hadn't spoken to each other in years, when in reality they'd talked twice last night. Through Abby, Loretta had gotten Reese's interpretation of Huey's injuries, and had in fact supported his theory.

Finally, she stepped back to get a mother's-eye view of her baby. "You look wonderful, sweetie…considering."

"Right. Sure I do."

Phil Vernay came around the front of the car and gave her a peck on the cheek. "How you doin', cupcake?"

She squeezed his hand. Phil was a good man. While she was growing up, he'd been a supportive and loving uncle. It had taken a few years, but Abby had slowly accepted Phil in Loretta's life, and now she appreciated how happy he made her mother. She couldn't resent Loretta's decision to leave Huey. Happiness was hard to find, and Loretta and Phil had made a life together. Unfortunately, Huey had never let the past go.

"I'm doing okay, Uncle Phil," she said. "How's everything over at the Pirate Shack?"

"Same as always," he said. "Thank the Lord."

Loretta jutted her thumb toward the house. "Has the bear wakened yet?"

"Oh, yeah. We've already had a close encounter of the Reese kind this morning."

Loretta grabbed Abby's arms and looked deep into her eyes. "Oh, honey, running into Reese can't be easy for you."

"It's not so bad," she said. "In fact, it was probably good that he showed up at the hospital last night. At least this morning I'd already gotten over the initial shock of seeing him. I didn't fall apart, and a few minutes ago Poppy didn't shoot him."

Loretta pointed to the porch. "Speak of the devil."

"For Pete's sake," Huey hollered. "Can this day get any worse?" He stomped down the steps and stood with his fists on his hips. "Doesn't the *good brother* have some kegs to tap and fritters to fry?"

Abby winced. She knew Uncle Phil was here to please her mother. This reaction from Poppy would only antagonize Phil.

"Nice shiner, Huey," Loretta said.

Phil, a younger, softer, beardless version of his brother, leaned on the hood of the car he cherished, and glared. "It's not ten o'clock yet, Huey. Even the worst of the worst on this island don't start drinking this early."

"Then get off my land and go irritate somebody else until it's time to fire up that week-old grease."

Phil shook his head, walked around the front of the car and got in. "Come on, Loretta. We're leaving." He smiled at Abby sympathetically. "Sorry, cupcake. I'll see you later—someplace where the air's a little easier to breathe."

Loretta tugged Abby toward the car. Before getting in, Loretta whispered, "So what did you think of Reese? How did he look to you after all this time?"

"Don't ask, Mom. I'm just glad I'm not stupid and eighteen again."

Loretta glanced up at Huey, who was tapping his foot impatiently. "Oh, sweetheart, even when we grow up, we can still be stupid."

AN HOUR BEFORE SUNDOWN, the migration toward Mallory Square began. Cars, bicycles, motor scooters and pedestrians headed along the narrow streets of Old Town toward the harbor to enjoy the decades-old celebration of sunset in Key West. And Huey roused himself from the ancient wicker rocker on the veranda and went inside to get his keys.

"I'm going with you," Abby said, grabbing a ball cap from the hook by the front door.

"You don't have to. I feel fine, and I'll only be two or three hours, depending on the crowd. I'll call when I'm through, and you can meet me at the Bilge Bucket for supper. My treat."

"The Bilge Bucket idea is fine, but I'm still going with you. I just brought you home from the hospital last night."

"I don't need any help. I've been selling the same crap for years. Having you alongside me won't change the profits any."

Abby wanted to argue that point. Considering Huey's usual personality, she thought a friendly smile at his vendor's cart might increase revenues. He soon had to pay the fines for starting the fires, and she suspected he didn't have the money for it. "I'm not taking no for an answer," she said, holding the front door open. "After you."

To save time, they took Whitehead Street instead of tourist-packed Duval, and pulled into a small private lot next to the old Customs House, where Huey had enjoyed

free parking for years. Thank goodness the Vernay name still drew some perks. There were probably days when Huey's entire profit from sales would barely cover the fee at the public lot.

They walked the short block to the local theater building and located his mobile cart. With its large pair of wooden wheels and center post for stability, the sturdily built conveyance resembled a gypsy's wagon. Years earlier, Huey had skillfully painted the sides with bright, tropical colors meant to look like waves crashing along the shore. Now the designs were barely recognizable and the paint had faded to muted blues, yellows and pinks. The sign in the center of the whimsical peaked roof was still legible, however: Tropical Delights of the Conch Republic.

Huey released the padlock securing the cart to a fence post and hung the chain on a hook at the back of the cart. Then he lifted the twin posts on the front, one in each hand, and, rickshaw-style, strutted briskly toward the square, with Abby keeping pace. His inventory, secured behind locked side panels, rattled and clanked as he moved.

The harbor area teemed with activity as they approached. Crowds gathered in semicircles along the wide paved dock, where street performers with animal acts, comic routines and acrobatic skills vied for the attention of tourists with fat wallets. The entertainment was free, but each performer had baskets set up around his designated "stage," clearly indicating that tips were appreciated.

Reese had been right. Town maintenance crews had turned the square into a holiday wonderland. Streetlamps, curved at the top, had been wrapped with red and white ribbons to resemble candy canes. Lights decorated all the hotels, and fences and patio umbrellas displayed a riot of

traditional Christmas colors. Nothing about Key West at this time of year even hinted of understatement. During the holidays every public building twinkled with multicolored bulbs and flashing signs that screamed, in case anyone should doubt it, This is Key West, and We're Making Merry.

Huey set his cart in his usual spot, back from the performers where mobile vendors like himself offered everything from Key West lemonade to handcrafted jewelry. He unlocked the panels of his wagon, exposing merchandise on both sides. Then he dropped the wooden boards, creating a level surface where more items could be displayed.

As her father sorted through chipped goods and threw them in a trash bin, Abby arranged the varied and colorful assortment of "stuff" that Huey offered for sale. Hanging from the roof on one side of the cart were dozens of fuzzy coconut heads, painted to resemble scowling, one-eyed pirates. Each was marked Made in China and priced from three dollars to five, depending on the detailing. Shell wind chimes hung from the other side, their hollow-sounding clackety-clack drawing attention in the breeze.

The rest of Huey's inventory was equally garish and also entirely foreign-made. He set up brightly painted ceramic blowfish, ocean-theme salt and pepper shakers, stuffed flamingos, palm tree mugs and conch-shell bells. Six-inch ceramic figures of chubby beachgoers carrying umbrellas and sand buckets added to the eclectic inventory.

Nothing on Huey's cart was priced higher than five dollars. Abby's hopes of improving her father's bottom line plummeted. But when families with children actually stopped and examined his goods, she became encouraged. Perhaps a market for Huey's goodies existed among young parents, who could only afford inexpensive souvenirs.

Unfortunately, her hopes were dashed again when Huey took a rickety folding chair and a pair of binoculars from the back of the cart. He opened the chair, plopped himself in it and held the binoculars up to his face.

"What do you need those for?" Abby asked.

"I use them every night," he said. "I keep thinking something interesting might happen. Hasn't yet, but you never know." He hung the binoculars around his neck and popped up a hat shaped like an umbrella, which he jammed onto his forehead, virtually hiding his eyes. Taking a deep, relaxing breath, he snapped open a newspaper. So much for watching the world. And so much for salesmanship.

Abby walked around the cart, stared down at her father and attempted to be diplomatic. "Ah, Poppy, don't you think you'd sell more if you showed more enthusiasm?"

He glanced up at her. "They'll ask if they want something."

All around them, merchants were hawking their goods, performers were drawing crowds and food vendors were offering free samples. Mallory Square at sunset was an entrepreneur's playground. Yet Huey sat, uninspired and totally uninvolved. Abby frowned. No wonder...

There were more ways to finish that thought than she cared to contemplate.

She tried to fill in the obvious gap in her father's merchandising technique. When browsers approached the cart, she offered to show them individual items. She even sold one little girl a flamingo—a sale that wouldn't have happened had Abby not placed the furry creature in the child's hands. Meanwhile, Huey read the newspaper.

A tense moment occurred when a boy no older than four came up to the cart and tugged on Huey's shirtsleeve. With

bright, inquisitive eyes, he pointed to Huey's white beard and asked, "Are you Santa Claus?"

Anticipating a brusque reply, Abby prepared to soothe the child's hurt feelings. Her dad, however, merely dropped the paper to his lap, leaned forward and said, "You think every man with a beard is Santa Claus?"

The little boy smiled and said, "Yes. But why does Santa have a sore eye?"

Huey grunted. "Good question, kid. Reese, the Red-nosed Reindeer, punched me."

The boy giggled. "I thought his name was Rudolph."

Huey gently jabbed the boy in the center of the cartoon on his T-shirt. "Haven't you ever heard of anyone changing his name to protect the guilty?"

"No. What does that mean?"

"Don't worry about it." Huey grabbed a coconut head from a hook and handed it to the boy. "Here. Merry Christmas."

His mother nudged him forward a couple of inches. "What do you say, Trevor?"

"Thanks, Santa." Mother and son headed off toward a performer putting his trained cats through their paces.

Abby stared at Huey for several seconds before saying, "You know something, Poppy?"

He picked up the newspaper again. "Don't go getting all sentimental on me," he warned.

She kissed his cheek. "Okay, but your soft spot is showing."

He placed his hand where her lips had been. "Is not."

She smiled and stuck another head on the empty hook. And then she saw a patrol car slowly pull up to the edge of the harbor. Enough sunlight was left for her to determine

that Reese Burkett sat behind the wheel. And he wasn't alone. Someone was in the passenger seat.

A shiver of anticipation, or dread, or maybe even disappointment, worked its way down her spine, and Abby stepped around the side of the cart to be out of sight. But she knew Reese had seen her. She sensed him watching Huey and her, felt his attention by an involuntary curling of her toes in her sandals.

"What are you hiding back there for?" her dad asked.

"I'm not hiding." She pointed. "Isn't that Reese?"

Huey turned in the chair just enough to glance over his shoulder. "Yep. Probably hassling citizens for fun. He ordinarily doesn't work at night, and never at the sunset ritual."

Abby feigned an interest in fuzzy stuffed dolphins and peeked at the car. "Who's with him? It looks like someone with long blond hair."

"You need glasses, Abigail," Huey said. "Long blond ears is more like it."

Abby couldn't resist; she came around the cart for a closer look. Reese was out of the car and coming toward them. A big yellow dog on a short leash trotted obediently beside him.

The twosome stopped at the cart and Reese smiled at Abby. "I thought you might be here with Huey," he said.

Huey made a show of rustling the newspaper. "You're an investigative genius, Burkett," he said. "No wonder you're captain of this illustrious police department."

Reese scowled down at him. "I see you're feeling better."

"You want me to really feel better?"

Reese seemed to think about it before saying, "Sure."

"Tear up your copies of those worthless citations. Then I'll know you mean it."

When Abby nudged the back of his chair, Huey mumbled something she was glad she couldn't hear.

Reese turned his attention to her. "How's business?"

"Fine. Great," she lied. "You were looking for us?"

Reese patted the animal's head, and the dog gazed up at him with huge, adoring eyes. "Just doing rounds."

She couldn't help smiling. The dog was overgrown and clumsy-looking, a definite hug magnet. "Is he yours?"

"Yep."

"What kind is he?"

"A Lab mostly. Name's Rooster."

"Rooster?"

"Yeah. I found him outside one of the restaurants in town. He was chasing after some of the chickens that run over the island. All that squawking and barking was upsetting the business owners."

"That's what I've always said about you," Huey muttered.

Abby shook her head. "Seems like a nice dog."

"He is."

"Well, see you," she said, with a wave of her hand. Only Reese didn't leave.

"Tomorrow's Saturday," he stated. "I'm off on weekends. Would it be okay if I stopped by your place in the morning?"

"Why would you do that?"

"I'd like to talk to you about something."

"What's wrong with right now?"

He glanced down at Huey, who was arguing with a few customers over the price of a plastic beach ball. The pregnant woman and her two kids seemed to be winning.

"We should keep this between the two of us."

Abby shrugged with an indifference she didn't feel. What

could Reese possibly have to say that concerned the two of them? Masking her curiosity behind a flip remark, she said, "I guess this means you're not canceling Poppy's fines."

Reese smiled again, this time an indulgent pull of his lips. "I'll see you tomorrow."

"Make it early," she said. "I've got errands to run."

He tugged on the leash. "No problem. I'm an early riser."

The yellow dog padded alongside him back to the patrol car, jumped in and took his seat as the passenger. Abby watched them leave the parking lot. She was a long way from admitting to herself that she was relieved that Reese's "date" had long blond ears.

CHAPTER FIVE

AT NINE O'CLOCK SATURDAY morning, a black Ford pickup turned onto Southard and stopped in front of the house. Abby increased her efforts to sand the decorative wrought-iron fence at the sidewalk. She was aware when Reese got out of the truck, but she decided not to acknowledge him right away. Big deal. He'd shown up. He obviously had an ulterior motive.

He strode up to her. "Hey."

She glanced up and continued working. "Hey, yourself."

He held out a tall mug and a plastic pack of accessories. "I brought coffee."

Noticing the trademark *M,* she took the mug and stirred in two sugars. "Martha's. Thanks."

He leaned against the fence. In tan cargo shorts and a green-and-orange University of Miami T-shirt, he was decidedly uncoplike and more like the young college grad who'd brought his reckless behavior and invincible attitude back to the island. The same young man who'd suddenly joined the navy and left Key West without telling her he was going. Not that he'd felt he owed her an explanation back then. He'd made that clear by not calling her after she'd met him on the beach for the encounter that changed her life. After two weeks, she'd given up hoping he would.

"You planning to paint that?" he asked, gesturing at the fence.

"You think it needs it?"

He smiled. "It has for the seven years I've been back."

"Actually, I thought I could talk Poppy into painting." She wrapped sandpaper around a pole and scraped. "I told him I'd rough it up first."

Reese stared at the front door of the house. "So I should expect him to come out any minute and start yelling at me?"

"Nope. He went for doughnuts." She sipped her coffee. "If you have something to say, you'd better get to it."

"Can you stop working on that fence for a minute?"

She stood up, dusted her hands on her shorts. "I'm all yours. Is this going to take longer than the five minutes I gave you at the hospital?"

He crossed his arms. "Great. I'm on the clock again."

She managed a small smile. "Let's sit on the stairs."

They settled side by side on the top step. After a few moments of silence, Reese said, "Abby, I discovered something yesterday—"

She held up her hand, interrupting him, and looked toward the corner. "What's that noise?"

He nodded, indicating he was familiar with the chug of an engine and the now-amplified chirpy voice that filtered through a speaker. "It's the Conch Tour Train," he said. "You remember that."

The Conch Tour Train, famous as *the* way for visitors to see the island and hear its history, rolled onto Southard. The engine, a cross between a kids' amusement ride and an old steam locomotive, pulled five passenger cars down the narrow street. A Christmas wreath blinked from the

decorative smokestack. Each open-air tram, trimmed with colorful awnings, was packed with tourists pointing and waving and ignoring the driver's warning to keep their hands safely inside the vehicle.

"A cruise ship docked at Mallory Square this morning," Reese explained. "The tour trains will be steady all day until the passengers reboard."

"What are they doing on this street? We're not part of the tour, are we?"

Reese shrugged. "I really don't know. The guides pick the sites. They drive around to all the spots they think are important because of local color or historical significance." He gazed up at the house. "This *was* the home of Armand Vernay. Your ancestor had quite a reputation during the island's shipwrecking days."

Not this again. While she'd lived in Key West, Abby had struggled to live down the horror stories about her ancestor's misdeeds. And when she wasn't defending the family name for her great-great-great-grandfather, she was defending Huey's reputation as the island's ambitionless eccentric. She cringed when the tour guide spoke.

"Ladies and gentlemen, I urge your attention to your left, to the faded Classic Revival residence nearly hidden behind that pair of old banyan trees. This is Vernay House, built in 1857 by the infamous Armand Vernay. The house, with its interesting and colorful history, has remained in the hands of his descendants since that time."

Enough, Abby thought, mentally waving the guide on. It wasn't to be.

"Armand Vernay was a notorious salvager who braved Atlantic storms to aid vessels that became grounded on the treacherous reefs that border our island. In the 1850s, when

Key West was the richest city per capita in the United States, salvaging was our most profitable industry. The rules were simple. The first wrecker to reach a foundering ship had rights to its cargo, which could be anything from gold, to porcelain, to the finest European leather goods."

Abby's stomach clenched. She stood. *Here we go. More talk about Armand's wicked ways.*

"I didn't know your place was on the tour, Abby," Reese said. "But I'm not surprised. The legend of Vernay House is a good story."

The tram guide waved to him. "'Morning, Officer." He droned on as the train crept by the house like a lazy caterpillar, its passengers staring avidly. "Most of the wreckers were honest men who abided by the laws of salvaging at the time." He chuckled. "Unfortunately, that cannot be said of old Armand."

Abby took a determined step toward the little locomotive. Reese pulled her back.

"Let me go!" she said.

He didn't. "Just cool it a minute. They'll be gone soon."

"A wrecker's first obligation was to save passengers," the guide explained. "Recorded history tells us that the original Vernay was more concerned about rescuing the riches from the hold. He died with the blood of many hapless people on his hands."

Abby seethed with anger but remained in Reese's grasp.

The guide's voice faded as the tram continued down Southard, but she heard the last of his spiel. "They say Armand died a tortured soul in this very house, haunted by the spirits of those he condemned to a watery grave. If you look real close at the windows on the first floor, you might see Armand's great-great-grandson, Hugo Percival Vernay,

who lives to this day in a house many people claim is still home to the very first Vernay male."

Abby was thankful Poppy wasn't here. Yet he had to have heard this embellished tale countless times.

The train turned onto Whitehead Street. "Next stop Hemmingway House, home of our most famous former resident…"

Abby drew several deep breaths, but wasn't successful at easing her anger. "I'm surprised Poppy hasn't pointed that stupid shotgun at the tour guides," she said to Reese. "Even *you* wouldn't arrest him for defending his reputation."

Reese grinned. "Well…"

"Don't these guides care about people's feelings?"

"In all honesty, Abby," he said, "I don't think the guide had Huey's feelings in mind. And I doubt he realized you're a relative."

"Still, it seems these tour companies are only interested in making a fast buck."

"Money's a definite motivation," Reese agreed. "But I have to tell you, I've heard that story about Armand's wrecking business since I was a kid. I'm not sure it doesn't have a basis in fact."

"That's ridiculous! What sort of man would let people die while he filled his pockets with booty? Why, Armand would have to have been heartless, thoughtless, selfish…."

Reese's lips quirked. "Yeah. It's hard to imagine a Vernay with those traits."

Abby bit her tongue to keep from calling him a smart-ass. She could understand a lot of Huey's resentment. He had lost his wife to his own brother, a man people on the island liked and respected. He had failed at several jobs. And he lived alone now, wandering around a big old house

that, according to legend, was inhabited by ghosts. Not that she believed in spirits, but the idea was a creepy one. "Poor Poppy," she said, giving Reese a pointed glance. "Between the cops bugging him and his poor sales at Mallory Square, he's really gotten himself into a mess."

Reese didn't say anything, but his expression suddenly became almost grave.

"Why are you staring at me like that?" she asked.

"Abby, we need to get back to that talk—now, while Huey's away."

Her instincts warned her that whatever he had to say, she wasn't going to like it. "Okay. Guess there's no avoiding this."

He walked her back to the porch steps. She sat rigidly. "So, out with it."

Reese settled stiffly beside her. "I found out something disturbing. My mother told me she'd heard it, but then I checked the facts for myself."

Abby threaded her fingers together. "What facts?"

"Your father owes back property taxes for last year. Part of the total was paid, but what's left amounts to quite a bit of money. Taxes in Key West have been steadily rising."

Abby knew Huey had no mortgage responsibility for Vernay House. He'd inherited the deed free and clear when his father had died, while Phil got the land where the Pirate Shack stood. But of course, there were other expenses related to owning property. "How much?" she asked, and held her breath, waiting for the answer.

"He owes close to four thousand for last year and the year before, and he'll probably owe a little more than eight thousand for the one coming up. That's a total of—"

"Twelve thousand dollars!" She looked over her shoulder. "For *this* house?"

Reese nodded. "I admit it doesn't seem like much in its present condition. But besides the historical significance of the house, the property it sits on is a valuable piece of real estate." He gazed down the tree-lined street. "Anything in Old Town is worth a lot of money."

Abby immediately began scraping together piles of cash in her head. She had about twelve hundred in her savings account. Uncle Phil probably had a few bucks…. Yet he would never give any of it to Huey, and she couldn't remember one true friend Huey still had in Key West who might offer a loan. "Is Poppy aware of this?" she asked Reese.

"He should be. Several statements were sent to him about his failure to pay the debt. And he should have received a notice about the current amount, due the first of the year. But truthfully, Abby, I suspect Huey lives in a state of altered reality. I don't think he believes anyone would actually take his house away."

"Are you saying he's crazy?" Her antagonism against Reese flared. Just saying those words hurt.

"No, not the way you're imagining. He's competent enough day by day. I just think he refuses to admit that his problems have escalated to this extent. If he doesn't acknowledge the basic facts, then maybe they don't exist."

Abby recalled the stacks of papers, bills, circulars, all sorts of junk mail she'd seen scattered on nearly every piece of furniture inside. Many of the envelopes had never been opened. "Tell me exactly what will happen if he can't pay," she said.

Reese looked at his hands, clasped between his knees. "He'll lose the house. He could have had it taken away by now, but a chunk of the amount owing—a few thousand dollars—was paid in May, and some citizens petitioned the

county revenue collector to give him more time." Reese shifted his attention to Abby's face. "The Vernay name still means something around here," he said. "Huey's right about his family's historic connection to the island. But eventually—"

She held up her hand. "I know. I get it."

"Look, Abby, I hate being the one to have told you this. But someone had to."

"Sure. You're just the innocent breaker of bad news."

"Something like that. And there's something else."

Oh, wonderful. "What?"

"There's a committee in town, the Community Improvement Board. They've been urging Huey to fix this place up."

"Urging? I'll bet."

"They even offered to buy the house from him and put it in the hands of the board. The folks on the committee want to restore the place before it's too late, open it to the public."

About this Abby was certain. "Huey would never sell to them."

Reese acknowledged that truth with a nod. "And that's part of the problem. He's not creating a lot of goodwill."

She stood again, her frustration too great for her to remain seated. "For heaven's sake, Reese. This is his home! No one has the right to drive him away from it."

Reese cast his eyes around the yard. "If he doesn't keep up his obligations, then that's not true, Abby."

She paced back and forth in front of the house. Didn't it just figure that Reese Burkett would be the one to deliver this blow?

Mechanically, instinctively, she placed her palm over her flat stomach, as she'd done many times in the past thirteen years. Reese didn't know he had fathered a child.

He hadn't cared enough about her to even call her after that night. He'd never said goodbye. Once he'd left for his tour of duty in the navy, once that one night had been nothing more than a fleeting memory of a drunken binge…

Abby rolled her shoulders, releasing familiar tension. That night had turned out to be Reese's way of dealing with the aftermath of smuggling refugees into Key West. He probably never thought of Abigail Vernay again, except perhaps as she related to her troublesome father.

She'd tried to tell Reese she was pregnant. That her life should be interrupted while he followed his plans, blindly ignorant, wasn't fair. Besides, she'd thought he ought to know. And she'd desperately wanted him to care. But when she went to his house, he was already gone.

What did the Burketts know of adversity, of pain and loss? The Burketts with their successful business, their status in a town that had always accepted and respected them. True, Reese had gone through a divorce, but did that compare with giving up a child? Abby didn't think so. Every day of her life she experienced the anguish of that decision. Every time she received a photo of Jamie from his adoptive parents, she relived the moment he'd been taken from her arms, hours after his birth, by a nurse, and whisked off to someplace in the hospital she'd been advised not to go. Now she didn't know if she believed what adoption counselors like her were urged to tell birth mothers—that it was better to at least say hello before you said goodbye.

She flinched when a pair of hands clasped her shoulders, stopping her from wearing a path in what little vegetation grew in the front yard. Shrugging out of Reese's hold, she spun around to face him. Maybe he wasn't responsible for her father's current problems, but he was at least guilty of

harassing him. And he sure as hell wasn't blameless for the heartache in her past.

She stared up into his face. "You told me what you came to say, Reese. Your duty is done. You can go now."

"Look, Abby, if you need to talk, if I can help you clear this up—"

"I don't want your sympathy. I'll handle it," she said.

Abby squared her shoulders when she saw Huey's truck round the corner. She waited for Reese to take his cue and leave. After an uncomfortable moment, he got in his own truck and drove away, passing Huey.

Abby suppressed a sob. *Damn it, Reese,* she thought. *Will I ever get over what happened between us? More to the point, will I ever get over you?*

She picked up the sandpaper and went back to work, determined not to think about him. She had to figure out a way to save this house. Waving to her dad as he pulled into the drive, she muttered, "Merry Christmas, Poppy." The words disappeared into the rasp of sandpaper on metal.

REESE HEADED TO HIS favorite convenience store, on Truman Avenue. He intended to buy a six-pack, run his truck through the car wash so it was clean for his date tonight, then maybe treat Rooster to a romp at the beach. Once he'd established a plan for the rest of the day, he let his mind wander back to the half hour he'd just spent with Abby.

He especially wondered how he could have softened the blow he'd given her. "How do you tell someone they have to cough up twelve thousand dollars or lose their house?" he said to himself.

He didn't really blame her for resenting the messenger. He and Abby had a history, though Reese didn't know how

much she remembered about that night. But he figured that the time they'd spent on the beach couldn't have been any girl's dream of a romantic encounter. He regretted what had happened between them, more so now that he'd seen her again. Despite the obvious chip on her shoulder, he liked her. She had the same innocent appeal of the girl he'd watched change through high school, plus the maturity and sensuality of a woman. Little Abby had definitely gotten better with age.

He pulled into the convenience store parking lot, and had just cut his engine when an island patrol car whizzed past, its light bar flashing. The siren wasn't going, so a major emergency wasn't in progress. Probably one of those incidents that were typically Key West. Reese looked at the store entrance and back at the speeding car.

He cranked over his engine again. He wasn't in uniform, and no doubt the officer could handle the problem, but what the heck? Reese wasn't feeling particularly good about the way his meeting with Abby had gone. He could use a diversion. So he left the lot and followed.

The fast-traveling patrol car soon outdistanced him, but when he observed it turn onto South Roosevelt, Reese figured it was headed to Smathers Beach. Minutes later he saw the cruiser parked alongside the beach road, its lights still flashing. He pulled in behind, got out and caught up to the officer trudging through the sand. "What's up, Mark?" he asked.

The officer slowed down, acknowledging Reese's presence. "Creative volleyball," he said.

"Oh." Reese understood. "Clothing optional."

Mark Groves smiled. "It's your day off. Why are you here?"

"Nosy, I guess," Reese said. "I saw you go by, and you know how it is. I hate to miss out on something this exciting." As they approached the volleyball net set up at the far end of the beach, eight young men stopped playing and stared at them. "I think we've been spotted," Reese murmured.

"Yep, here come the killjoys."

A ten-year veteran on the force, Mark followed procedure. He introduced himself first and then Captain Burkett.

"You fellas know how to read, right?" Reese said.

"Sure."

"Then you must have missed that sign over there." Reese pointed to the very legible list of rules for Smathers Beach that stood by the road. "Check out the rule that says, 'No Nude Bathing.'" He stared down at a cooler outside the volleyball court boundary. "It's right under the regulation that prohibits alcohol."

"That's just orange juice," one of the boys said.

"Sure it is. I think I'll have some."

The boy didn't offer. "Come on, officers," he said. "This is Key West, man. Cut us some slack."

"Yes, it is Key West, man. But rules are rules, and you guys are in violation of public decency regulation number…" Reese spouted off something official sounding, since he didn't have any idea what the exact numbers were. "This is a family beach," he added.

"It's early, man," the spokesman said. "And we're way at the end. You see any kids out here?"

Reese didn't. But he did notice a few senior citizens' attention had shifted from health regimens to sightseeing. "Game over, boys," he said. "Get your clothes on and get that cooler off the beach. If I catch you guys down here

again, you'd better be sporting some wild Hawaiian knee-length trunks and be chugging smoothies."

"Okay, okay," the young man said. "But what about now? Are you going to ticket us?"

"We'll let it go this time," Reese finally said. "But I'm warning you…"

The boys scrambled for their clothes and cooler. "No problem," one said. "You won't have any more trouble from us."

"Good. Now get going."

Within a minute, every trace of the Florida Keys Nude Volleyball Team had vanished. Reese and Mark headed back to their vehicles. "I'd have ticketed them," Mark said. "Easiest revenue we get in this town other than from parking tags."

"I know, but I can't help comparing these guys with the kind of kid I was way back when." He smiled. "Don't get me wrong. I didn't run around the island shooting moons."

Mark tossed his clipboard onto the passenger seat of the patrol car. "The guys say you're a softy when it comes to our weekend rowdies. They say it's because of the trouble you used to get into."

"The guys would be right. Just ask my dad. He bailed me out a couple of times. Me, the son of a former cop."

"Isn't that always the case?" Mark said.

"Yeah, cops' kids are notoriously rebellious." Reese rested his elbow on the top of his truck. "But I think the reason I got in so many scrapes was that my dad *quit* being a cop when I was thirteen."

"I heard he was a good one," Mark said.

"The best. And he loved it. Wore the uniform with pride." Reese paused, shook his head and then got in his

truck. He stopped just short of admitting that he'd never really gotten over his father knuckling under to Ellen's demands. When Frank stopped being a cop, he'd also stopped being the man Reese looked up to unconditionally. Reese loved his dad. And there were a lot of qualities to admire about Frank Burkett. But sticking to his principles, leading the life he wanted, wasn't one of them.

Reese went back to Truman Avenue, picked up that six-pack and drove through the quickie car wash. A few minutes later, he walked into his kitchen and popped the tab on the first beer. Taking it outside, he let Rooster sniff around familiar backyard territory and pick his spot. Then Reese punched in Belinda's phone number at the chamber of commerce office. "Hey, we still on for tonight?"

"I'm planning on it."

They discussed possible destinations and finalized the time. "Oh, one more thing," Reese said. "As a chamber member, you should have been out at Smathers Beach this morning. As a woman, you probably would have appreciated the view. It was definitely a photo-op moment."

"Sounds interesting. Details later, okay? I've got an office full of tourists."

He disconnected and thought about Belinda. Theirs wasn't a serious relationship, but she was fun. And happily independent, just as he was. He'd taken the marriage route once in his life and vowed to be very careful about following the same path again. When a marriage was working, it was great. But when it ended badly, two people were left with lifetime scars. And a blame game that never really had a winner.

He was on his sofa and in the middle of his second beer when he realized that sometime in the past few minutes his mind had switched gears, and he was back to thinking

about Abby and that one night they'd spent at the beach. He drank the rest of the beer and tried to recall the details of that encounter. But even two weeks after it had happened, when his life had changed so quickly and decisively—when he sat in the marina van as his father drove him to the Key West airport to catch his flight to Pensacola—his brain had been foggy.

Now, since seeing Abby again, he recalled more than he had then. He remembered that she'd looked unbelievably sexy, with her blond hair waving below her shoulders, sort of the way it did now, only longer. She'd been wearing a cropped blouse that showed a slice of soft pink skin above the hip-hugging waistband of her cutoffs.

She'd been too cute for her own good, and far too sexy for his. He recalled how she'd leaned into him, shyly at first, then with a boldness he'd never have imagined. He'd been wasted, but he knew he'd asked her if she was on the Pill. And he'd asked her age. She told him she'd just had her eighteenth birthday. He'd been relieved. Considering the trouble he was already in, he didn't need to add morality charges to his crimes.

She'd been so willing. Reese had never forced a woman to do anything she didn't want to. And Abby had seemed to want to do it. She'd been sweet-smelling, warm and pliant in his arms. So unlike the girl who'd always come across as cool, aloof, too brainy to associate with mere mortals like the crowd Reese hung out with. It was almost as though she'd been driven to get away from Key West and people like him.

More than a decade had passed since he'd seen Abby. Maybe her resentment to him the past couple of days was due in part to her hatred of him for what they'd done that

night. But he sure as hell didn't feel any resentment to her. In fact, if they hadn't gotten off on such bad footing with these problems with Huey…

"What?" He posed the question aloud. "You'd apologize for something that happened years ago?" He scoffed at his own foolishness. "It's way too late for that. She'd see right through a lame attempt to make things right now."

Reese went into the kitchen, set his can on the counter and reached around the back door where he kept Rooster's leash on a hook. "Let's go, boy," he said. "I find myself needing to walk off some frustration all of a sudden, so I hope you can keep up."

CHAPTER SIX

ABBY WAS SHOWERED and dressed by five o'clock, the time Huey had told her he'd be ready to leave for Mallory Square. Saturday was the biggest tourist night of the week. She thought it best not to distract him from making sales by telling him Reese's news about the taxes.

They'd just left the driveway in Huey's truck when Abby's cell phone rang. Since she'd spoken to Alicia earlier in the day and given her the name of the counselor assigned to her case, Abby didn't think this call would be from her. But it could be from any of the other pregnant teens who'd phoned since she'd been in Key West.

Relieved to see she wouldn't be involved in a lengthy counseling session, she connected. "Mom, what's up?"

"Abby, I need you to get over here to the Pirate Shack right away."

"Why? What's going on?"

"Are you with Huey?"

Abby glanced over at him. He was concentrating on his driving and swearing about the traffic. "Yeah."

"Then I can't talk now. Just get over here."

"But we're on our way to Mallory Square."

"I don't care if you're on a mission to the moon. You need to stop at the Pirate Shack. Alone."

That wouldn't be a problem. Huey never stepped over the threshold of his brother's business. "Okay. I'll have Poppy drop me off.

"That was Mom," Abby said after she'd clicked her phone shut.

"What'd she want?"

"She's asked me to stop at the Shack. I'll just be a few minutes, and then I'll walk the rest of the way to the square."

He drove the block off Duval and pulled up in front of the restaurant. "Do you want me to get you something to eat?" Abby asked.

He gripped the steering wheel and stared straight ahead, as if even looking at the establishment would cause him indigestion. "Not unless Phil's giving something away free. I won't put any of my money in his pockets."

She climbed out of the truck. "Suit yourself. We'll eat later."

He left and she went inside. The Shack was nearly empty—not unusual, since the dinner rush hadn't started. In a few hours the restaurant would be packed with mostly locals out for a good time.

Loretta came over immediately and took Abby to a back booth.

Abby sat. "Good grief, Mom, what is this all about?"

"No one will bother us here. Not even Phil. I told him we were discussing girl topics. I've never known a man who didn't cringe at the thought." She motioned to Nick, the bartender. "Can I get you a drink? A beer?"

Suddenly, that sounded like a great idea. "Sure. Whatever's on tap."

Loretta ordered in code by putting up two fingers. Nick

brought two tall frosted mugs. Abby took a long swallow from hers. "Okay, spill," she said.

"I got some bad news about Huey today," Loretta told her. "And guess where the rumor started."

Since Abby knew only a handful of Key West residents these days, and since she herself had heard disturbing news from one of them, she politely offered her suggestion. "Reese, maybe?"

Loretta looked shocked that such an idea could pop into Abby's head. "No. Of course not. Reese would never spread gossip. But you're close. The news came from that bitch who calls herself his mother."

"Oh. Ellen."

"Mrs. My-husband-owns-the-biggest-marina Snoot Nose," Loretta said.

Already sensing the answer, Abby asked, "What did she tell you?"

"*She* didn't tell me anything. Ellen Burkett wouldn't tell me if my clothes were burning."

Obviously, the animosity between the two women hadn't diminished much in thirteen years. "I get the picture," Abby said. "So someone who heard from Ellen told you this news."

"Right." She waved a hand dismissively. "Doesn't matter who. What matters is what."

"And that is…?"

"Your father's going to lose that damn house."

When Abby's expression didn't change, Loretta leaned over the table and studied her eyes. "You know already!"

"Yes. I heard from the saintly Reese, who never gossips."

"If Reese told you, then he was only trying to help."

Abby conceded that point. "He was giving me a heads-up on possible outcomes for Poppy's future."

"Did he tell you how much Huey owes in back taxes?"

Abby nodded, took another swallow of beer.

"Something like twenty-five thousand dollars?"

Abby nearly choked. "Good heavens, no! Now, *that* is gossip. He owes around twelve thousand. Bad enough, but not that bad."

"And I'm guessing Huey hasn't talked with you about this."

"No."

"Is he even aware of the problem? I mean, Huey's always been stubborn about pretending bad news doesn't exist."

"Hmm…your analysis of Poppy is strangely similar to Reese's," Abby said. "I would bet that Poppy doesn't know how bad the situation is. According to Reese, he should have received notices, but Poppy's record-keeping is… well, let's just say his filing system could use a major revamp. I'd bet he hasn't even opened the envelopes."

"Still, Ab, he has to know taxes are due. He's lived in that place his entire life. He must have made payments all along."

"I'm sure he did, when the bills were less. And apparently, one payment was made last May. But his business isn't going well. He's just making living expenses."

"Do you have any idea how much he has in the bank to apply to that bill?"

Abby gave a sarcastic chuckle. "It's my opinion that Poppy is flat broke." She blinked when tears started to form.

Loretta patted her hand. "It's a shame that you're here just when this news breaks," she said. "Even I feel sympathetic to Huey about this one. And I've always maintained that he's a big boy and should solve his own problems." Loretta looked sad, as if she was remembering the past. "Only, he never did," she added.

"Does he have any resources we don't know about?" Abby asked.

"I can't recall any hidden gold mines." Loretta sat back in the booth and blew out a breath. She tapped her fingernail against her mug. After a moment, her eyes widened and she said, "The hell I can't."

"What do you mean?"

"Huey's living with his resources. He's sitting on them, stacking useless junk on them and letting them collect dust."

Abby waited for her to explain.

"That mausoleum is crammed with resources." Loretta grinned. "All we have to do is convince him to part with some of them."

Abby was beginning to follow her mother's line of thought. "You mean sell his belongings?"

"Absolutely. Some of those pieces could be worth a small fortune to the antique dealers who have settled in this town recently. And who knows what's moldering away in the attic."

Instantly absorbed in the plan, Abby smiled. "This is a great idea, Mom. But will Poppy go for it?"

"Not if I suggest it. If you do, though, we've got a shot."

"Okay, I'll do it."

"I can't help you with this, Ab. I've got to work, and Phil would have a fit if he knew I was doing anything that would benefit Huey. But I was thinking, if you need a hand moving things around, Reese would probably be willing—"

"Stop right there, Mom. Forget it. I'm not asking Reese to help with anything. Poppy wouldn't like it, and I don't want to owe Reese any favors."

Loretta sighed. "You know, honey, you've got a bitter side to you that isn't very pleasant."

"What? Mom, this is Reese we're talking about."

"Yes, and I still regret that he didn't handle things differently back then. But he's a good man, Abby. He cares about this island. He's fair and honest—"

"Oh, please." Abby turned on the bench and stared across the empty Pirate Shack. She couldn't believe her mother was listing Reese's virtues.

But Loretta wasn't about to let up. "And I regret that you and I didn't try harder to reach him. We did what we thought was best at the time, and God knows, Jamie has a happy life…."

"Enough, Mom. I am not going to go over this territory again."

"I know you don't want to. You've lived your life pushing this incident to the back of your mind, but, honey, you have to admit that it won't stay there. It comes into your thoughts all the time. I don't want to make you feel bad, but since you're going to be in Key West for a while anyway, I think you should consider telling Reese the truth."

Abby reconnected with her mother's soft blue eyes. "What? Thirteen years have passed. Jamie is twelve years old, and you believe I should tell Reese about him *now*?"

Loretta was resolute. This wasn't the first time she'd thought about this. "Yes, I do. For your sake more than Reese's."

"Are you crazy?"

Her mom smiled. "Some people might argue that I am, but no, I'm not. Consider this from Reese's perspective first. He never had a say in the decision to give Jamie up for adoption."

"I tried…."

"Yes, you did. But Reese was a victim of his mother at

the time. She's never happy unless she's controlling the lives of the men in her family. She would have built a moat around that house of theirs to keep her precious son from hooking up with a Vernay."

Abby scowled at her. "I'm not going over this again. It was my decision. I had plans back then, plans that didn't include a baby. I wanted to go to college, to make something of myself away from this island."

"Of course you did, and I don't blame you. I'm proud of what you've accomplished."

Somewhat mollified, Abby tried to relax. How many times, and how carefully, had she gone over her decision to give up her baby? Now her mother was acting as if that decision hadn't torn her heart in two. "I wasn't in any position to raise a baby," Abby said. "And, Mom, neither were you."

Loretta nodded. "I considered keeping him. I really did. But things had started to sour between Huey and me years before. Ours wouldn't have been a healthy situation to bring an innocent child into."

Abby agreed. "And besides, people on this island would have looked down their noses, saying, 'How like a Vernay to get knocked up. Even the brainy Abigail, who always thought she was better than her family, better than everyone, found her level.'" Loretta's features softened. "I knew, Mom," Abby said. "I knew what people said about me back then."

"Words don't mean a damn thing, Ab. I would have pushed that baby in his stroller down Duval Street as if he were my own, if I could have brought him into a house of love. And I would have paraded him in front of Ellen Burkett's fine stilt home until she closed every expensive drapery in the house."

Wow. There was some bitterness in Loretta, as well.

"But that brings us back to Reese, and you telling him," Loretta said. "I'm not suggesting this for Reese's benefit, although I think he has a right to know the truth. This is for your benefit, so you can cleanse the past of the pain and the guilt." She held up her hand when Abby started to protest. "I understand your guilt, sweetheart. It's been eating you up for years, and it's time to rid yourself of this burden."

Abby swiped at a tear that fell onto her cheek. "No."

"Abby, what do you tell the teen girls you counsel?"

"I tell them that the future of their baby is their decision. Theirs! What matters is what they want and what's best for the baby."

"You mean you never advise them to tell the father?"

Loretta had her there. "Of course I do. Unfortunately, far too often the father doesn't want any part of fatherhood, so it's a moot point."

"But you tell them to involve the father, because then they know they have truly analyzed all the options honestly and openly, isn't that so?"

Abby remained silent. Her mother was right.

"You've learned a lot since you were faced with this decision yourself. You can't change what happened then. But you can certainly help yourself now, just like you're helping all those girls you counsel."

Abby finished her beer and stood. "I have to go. Poppy's waiting for me."

"Okay. You don't want to talk about this anymore. I can see that. But I still think—"

"I know what you think, Mom," Abby said. "Now, give me a chance to do some thinking of my own. As if I haven't been doing just that since I got back to Key West!"

Loretta smiled. "Anyway, you're going through with trying to sell some of Huey's things?"

"Yes. I'll call antique dealers."

"Fine." Loretta slid out of the booth and picked up both beer mugs. Then she kissed Abby's cheek. "I meant what I said. I really am proud of you."

Abby smiled. "In that case, I'll let you pay for my beer."

ABBY WALKED BRISKLY DOWN Duval Street, her thoughts on the past half hour. Was Loretta right? Her mother's instincts were often perfect. But how could Abby confess everything now? Maybe Reese was a decent man. Abby had seen evidence of that herself. But how would this "good man" react if she told him she'd given up his son for adoption?

With Mallory Square just ahead, Abby increased her pace. No. She couldn't tell him. She'd learned to live with the guilt over keeping this secret, and would continue to do so. Once these problems with Poppy were solved, she'd return to Atlanta, to her life, and try to forget that she'd seen Reese face-to-face. She'd push him to the back of her mind, where he belonged. Only, her mother was right about that, too. Reese refused to stay there.

Abby reached the last intersection before crossing over into the crowd gathering at the square. Satisfied for the moment with her decision, she waited at the crosswalk for the pedestrian sign to change. A familiar black pickup stopped beside her at the light. Reese was behind the wheel, and this time he definitely had a woman in the passenger seat.

Abby tried to look away before he noticed her, but it was no use. He focused on Abby and raised his hand from the steering wheel in a little wave. Abby nodded. The woman,

an attractive brunette, checked her out. The light changed and Abby crossed the street.

She imagined Reese continuing on his way, smiling and talking, his attention back on his date. And why shouldn't it be? He lived here. That meant he had friends, a social life with people who didn't ask him to get off their property. Abby had Huey, and at the moment he was her priority. She walked toward his cart, determined to forget Reese and concentrate on selling ceramic trinkets.

ABBY AND HUEY STOPPED FOR take-out chicken dinners on the way home from the sunset celebration. The bill was under ten dollars and he paid. "Pretty good night," he said, sitting across the kitchen table from her. Chicken Hut sacks stood between them. "Sold nearly eighty dollars' worth."

That, along with the thirty dollars he'd brought in the night before, gave him a one-hundred-plus two-day total. Enough, if he didn't blow any of it, to pay his illegal-fire fines. Since they'd just discussed money, Abby figured now was as good a time as any to bring up the subject of the property taxes.

"Of course I knew about it," he said after she'd told him what she'd learned from Reese. "But I don't appreciate Burkett or any other government employee butting his nose into my business."

"Does that mean you have a way to pay the bill?" Abby asked.

"I've started saving up," Huey said. "I've put away a little from each social security check the past six months."

"How much is 'a little'?"

"I couldn't tell you off the top of my head."

"Estimate."

He frowned at her. "I've got maybe three hundred fifty saved."

Abby's dinner threatened a revolt. The amount was about what she'd expected, but certainly not what she'd hoped. "After the first of the year, the bill could be nearly twelve thousand, Poppy. And it's only because some of these bureaucrats you hate so much showed some consideration that the house hasn't been seized already." She gave him her most serious look. "But time's up. You've got to pay."

He sat silently for a moment, then rose and carried their take-out sacks to the waste can. "We have ice cream for dessert."

She stood and followed him. "I talked to Mom today. We have an idea that could save the house."

He frowned. "I'm not deeding the place over to Phil."

"No one's asking you to."

He glared over his shoulder. "Good thing, because I'd burn it first."

"That would accomplish a lot."

He snorted, then began rinsing the dishes.

"Tomorrow you and I are going through the things stored in the attic and the carriage house. I'm hoping we find enough of value to sell to one of the antique dealers."

He stopped rinsing. "You're suggesting we sell everything?"

"Not everything, but enough to get you out of this current jam."

He shook his head decisively. "No. I won't sell anything to the robbers in this town."

She sighed. "I don't see any other way."

He stacked a glass in the drainer. Then he stared out the window toward the faded brick outbuilding that used to be

Armand Vernay's summer kitchen. "I guess I could let some of it go," he finally said. "For the right price."

Abby went to the refrigerator. "Good decision. Now, can I get you a couple of scoops of Rocky Road?"

CHAPTER SEVEN

HUEY BLEW THE DUST OFF a top hat he'd just found in a steamer trunk he and Abby had carried from the attic. "I can't sell this," he said. "It belonged to my great-great-grandfather. Came all the way from France."

Abby took the hat and set it on top of his head. "It's dashing, Poppy. You should keep it. But we need to air it out."

She was pleased with their progress. So far, just from one trunk, they'd accumulated several interesting artifacts. Huey had been persuaded to sell old tools, a collection of liquor bottles and flasks, grooming supplies and clothing, as well as jewelry and lacy handkerchiefs. Studying each item, Abby learned that Vernay men had chosen fashionable ladies for their brides.

Huey had also agreed to sell several pieces of furniture, including small cabinets, a wine rack, a pair of intricately carved étagères, even a spool-leg William and Mary buffet with Armand Vernay's initials carved in the back—a detail that Abby hoped would add to the piece's value.

"What do you know about Armand, Poppy?" she asked later, when she and Huey were having sandwiches on the back patio. "It's not true what the tour guide said about him, is it?"

Huey only grunted and took a swallow of iced tea.

"Well? Is it true or not?"

"I can't say for sure," he said. "Could be, I suppose. There were a lot of disreputable wreckers in those days, especially before Congress sent federal judges to control their behavior."

Huey sat forward in an old wrought-iron chair and stared out at the overgrown yard. "I can tell you that Armand was the richest of the Vernays. He built this house from Honduran mahogany. The original draperies came from Belgium. The chandeliers are Austrian crystal." He jutted his thumb at the old carriage house. "You remember that buggy in the shed?"

A decrepit conveyance of some sort had been stored there for as long as Abby could remember. She never paid much attention to it, since the upholstery was covered in bird droppings and the fittings were badly tarnished. "Yes, I know the one you mean."

"It's called a French dog cart, small but elaborate in decoration. Armand had it made in Paris and shipped over here. Quite an extravagance, if you ask me. On an island less than six miles square, what need does a man have for a horse and carriage? But Armand would hitch his Arabian stallion to the cart on a Sunday afternoon and trot about town, showing off his good fortune."

"Apparently, he didn't have much humility."

Huey chuckled. "Right. As to whether he was strictly honest, let me just say that if a man could amass all these possessions by never bending the rules, I might have gone straight years ago." He held up one finger. "But I will admit this, Abigail. I never saw a ghost or a spook in this house. So if Armand died a tortured soul like those guides say, the ghosts went with him to the Great Beyond."

Abby laughed. "That's good."

She followed her dad into the house. Dusk had settled, and the interior was gloomy—which was fitting, considering their last conversation. Abby wandered into the parlor, where the items for the antique dealers sat in the shadows, and she suddenly experienced an overwhelming melancholy being amid all the mementos of the Vernays. Selling her heritage was proving almost as difficult for her as it was for Huey. But necessary, she reminded herself.

Maybe she would walk down Duval Street and spend a few minutes among the tourists remaining on a Sunday night. She could listen to music coming from one of the local bars. She certainly wouldn't think about Reese and the woman in his truck last night. Abby would focus on the sounds, the sights, the lights….

The lights? Abby's gaze was drawn to the front window, where a white glow flickered near the base of the balustrade. She walked over. Tiny lights jerked crazily, as if controlled by an unseen hand. "Poppy," she called. "Come here. Something weird is going on."

He stepped into the room, saw the strange phenomenon and rushed out the door. "Oh, for Pete's sake, it's Burkett," he hollered back to her. "What the hell are you doing now, Reese?"

Abby scurried after him to find Reese, looking up at them with a wide grin on his face and a string of Christmas lights dangling from his hand.

"It's the holidays, Huey, and this old monstrosity of a house is about as Christmas-y as the hull of a clipper ship on the floor of the ocean." He stretched the string across a portion of the veranda railing and fixed it in place with a staple gun. "Surely even you can't object to a little Christmas cheer."

REESE DECIDED THAT adding holiday spirit to Vernay House, and seeing Abby's face while he did it, was a lot more satisfying than stringing decorations across the front of his own place. He paused in his work and took a moment to appreciate the surprised expression on her face. "'Evening, Abby."

Her mouth opened, but a few seconds passed before she said, "Reese, why are you doing this?"

He resumed decorating. "I figured you wouldn't ask me to leave if I was making your house merry." He held up his hand to stop her from protesting. "I'm aware you don't need my help, but I had a few extra lights, and Dad had some things in his shed, so why not put them to good use?"

"It does look good," she said.

Huey stomped down the steps. "What's all this crap going to do to my light bill?"

Abby followed him into the yard and stared back at the house. "It'll add a few bucks. But you shouldn't care. It's worth it."

A bark erupted from the black truck parked at the curb. "You brought your dog," Abby said.

"Yeah." Reese nodded toward the cargo bed. "Do you mind? He's kind of excited about Christmas."

"I don't mind."

Reese whistled and Rooster bounded out of the truck, his big feet scrambling for purchase on the lawn. He ran first to Reese, then galloped over to Abby.

"Tell that beast not to leave any presents in my front yard," Huey said.

Reese snapped his fingers and Rooster squatted in front of him on his haunches. "You heard the man, Roos. He doesn't want any presents this Christmas."

"I found an outlet, son," Reese's dad yelled from the side of the house. "I'm plugging in."

Three small wire deer outlined in white lights began bobbing their mechanical heads at the side of the yard.

Huey squawked. "Oh, Lord, it's Frank. One Burkett isn't enough? You tell your father—"

Reese smiled at Abby. "I know. Dad, Huey doesn't want you to leave him any presents."

Frank strode to the middle of the yard. "What's that?"

Abby walked over to him. "Never mind, Mr. Burkett. It's nice to see you again." She extended her hand as if she truly meant the sentiment. Reese wasn't surprised. Frank was nice to everyone, and he and Phil Vernay had been friends for years.

"You, too, Abigail," Frank said. "Hope you don't mind us livening the place up. Reese called and asked me to give him a hand."

Abby glanced up at the house, a smile on her face. "It's amazing what a few lights will do."

Finished, Reese handed the stapler to his dad. "Do you want them to twinkle or stay on permanently, Abby?"

"Twinkle," she said. "Just the way they are now."

"This house looks almost good enough to give Mrs. Howell a run for the ribbon," Frank said, nodding toward the neighbor's immaculately preserved century home. "And she's gotten awards from the Home and Garden Club for her decorating."

Abby hadn't bothered to walk by Mrs. Howell's place, but now she stepped around the shrubbery to get a look. Reese followed her. The neighbor's yard was filled with lit palm trees and an animated flashing train. Huge stars blinked from her porch eaves, and a giant snow globe sat

in the center of it all, with Mickey Mouse riding a dolphin amid a flurry of plastic flakes.

"Edna will get the ribbon," she said over her shoulder to Reese. "But our house is understated yet elegant."

"Maybe the tour guides will forget about haunted spirits when they drive by," he mused.

"This was nice of you, Reese," she said. "I've been so caught up in Poppy's problems that I'd just about forgotten Christmas is on its way."

"Don't mention it. I haven't made things easy for Huey...." He paused before adding, "Or vice versa. But I never intended for him to get hurt the other day."

She sighed. "Unfortunately, you probably shouldn't expect Poppy to thank you for doing this."

"That's all right. I did it as much for you as for him."

"You did? Why?"

"Because things haven't been easy for you, either, since you returned."

She shrugged noncommittally. "I didn't expect this to be an easy trip," she admitted.

Reese hollered to his father. "Will you take Rooster home for me, Dad?"

Once he'd agreed, Reese said, "Abby, you and I are going to have a talk, one we should have had a lot of years ago."

Her eyes widened with what he hoped was eagerness, but he wasn't certain until she said, "It's probably not a good idea for us to go over—"

"A half-hour walk downtown," he interrupted, checking his watch. "I'll have you back by nine-thirty." He waited a moment, then added, "It's just a walk."

Right.

He pointed his index finger at her. "You're coming. No

arguments." Softening the order with a smile, he stated, "It's time to clean the slate."

He had no idea how dirty that slate was.

Apparently assuming her silence was agreement, Reese went to his father's truck, opened the door and whistled, and Rooster jumped in. Man and dog drove off, Frank waving out his window. "Merry Christmas, Huey."

Huey's answering wave was more a "good riddance" flip of the hand.

Abby came up beside him. "I'm going for a walk with Reese," she said.

"What for?"

"Because he invited me, and since he just strung all these lights…"

"You don't owe him for that. No one asked him to do it, and besides, I'll probably have to take them down."

Abby struggled to control her temper at her father's behavior. She glanced over at Reese to see if he'd heard what Poppy had said. If he had, his expression reflected un-believable patience. "I'll only be a short while," she said to her dad, then joined Reese on the sidewalk.

Her nerves were on edge. Neither of these men under-stood the pressure she was feeling. Reese didn't know why she was feeling it, and Poppy didn't care that his resent-ment of the Burketts made her uneasy.

She started walking. "Do you have a destination in mind?"

"What do you say to Celia's Wine Bar?" Reese sug-gested. "The place shouldn't be too busy, and it's a nice night to sit outside."

They turned the corner and entered an island-style winter wonderland. Lights twinkled from every store window. Artificial trees decorated with everything from

clam shells to pirate hats framed doorways. Reindeer peered down from rooftops. Even a twelve-foot stuffed marlin over the entryway to the Big Catch Saloon sparkled with blue lights.

Abby looked up at Reese and asked the question that had her heart pounding. "So what are we going to talk about?"

He steered her to an empty table on the restaurant patio. "Old times," he said with an easy smile.

She felt the first grip of panic squeeze her chest. Maybe she could steer the conversation away from that night on the beach. Or maybe he had another topic in mind, although she couldn't think of anything else about the past that they could possibly discuss. After all, despite what they'd done, they were practically strangers now—although, ironically, connected in the most profound way.

SENSING ABBY'S ANXIETY, Reese ordered a carafe of wine and poured them each a glass. Abby sipped hers, then ran her tongue over her upper lip. He fixated on the moisture glistening there and tried to remember how those pink lips had felt against his when he'd kissed her. He'd bet they'd felt darn good.

Damn. This was an awkward situation, and Reese didn't do awkward very well. He was direct, open. Most cops were. There were definite lines a cop wouldn't cross. They saw things as good and bad. Legal and not. Even when he'd gotten his divorce, the final decision to end his faulty marriage had boiled down to a basic lifestyle choice. After his wife had had two miscarriages, and blamed both on him, he'd still wanted kids. She hadn't. He'd come to the only conclusion that was sensible, though not without a boatload of regret about lost love, misplaced trust, wounded pride.

And Reese had other regrets, as well. About his past, the laws he'd broken by falsely believing in his own invincibility. About the path his father had taken and the fact that Reese hadn't even tried to talk to him about it. And about Abby. Regrets that had recently begun niggling at his conscience again.

He liked her, admired her stubbornness, her loyalty to Huey. He wanted to know more about the woman she'd become. Even though he hadn't thought about her too often in the years since they'd both left Key West, he'd been thinking about her plenty since she'd returned. He wanted to make things right between them, maybe alter some of those notions she still held about the kind of guy he used to be. He couldn't change anything about his past, but he could try to change Abby's opinion of him in the present.

He swallowed some wine and studied her across the table. She was lovely. The glow from the candle in the center of the table caught the sunlight color of her hair, the pink in her cheeks. She still had that fresh, natural beauty he remembered, but now those tomboyish teen angles had smoothed into sensuous curves.

Reese smiled to himself as he realized that the young woman who'd tempted him at the beach still appealed to his most elemental instincts. If they were at the beach now…

"What made you become a police officer?" she asked.

He blinked away the image of him and Abby alone in the moonlight, a scene that, until the past few days, he'd nearly forgotten. Only they were doing it right this time….

"My career choice must seem like a stretch, considering that much of my past was spent avoiding the cops," Reese said with a chuckle.

"Well, there were rumors about you."

"I wish I could tell you that most of the stories weren't true, but you know better."

She smiled. "So?"

"I guess I followed in my father's footsteps." There was no need to tell her that he'd joined the force hoping to be even half the man his father was before Ellen changed him.

Abby seemed surprised. "Oh, that's right. I remember Frank was a policeman before he opened the marina." She drank more of her wine. "He's done well there. At the marina, I mean. Did he ever regret giving up law enforcement?"

Only every day of his life. Reese answered vaguely. "I don't suppose any of us make important decisions that don't involve some regret."

She held her glass in the air and looked at him over the rim. Her eyes were vividly blue in the soft light. "I suppose not," she said.

"And what about you? I hear you're doing social work." Recalling what Loretta had told him a while back, he added, "Working at an adoption agency, right?"

She nodded, set down her wine.

"Why did you choose that career?" he asked.

She stared into the glass. "It just seemed right for me at the time. Placing kids with adoptive parents is rewarding."

"I'm sure it would be," he said. "It's a situation where a person in your position can guarantee that everybody wins."

She blinked several times. "I don't know about guarantees," she said. "Life doesn't come wrapped up in a big red bow."

"No, it doesn't." Reese sensed he'd somehow made her uncomfortable. He changed the subject—not that this one would make her more relaxed. "Abby, how much do you remember about that night?"

For a moment, he thought she hadn't heard his question, but then she looked up and said, "Not much. It was so long ago."

"Yeah, but I sense this connection between us because of it." He smiled, trying to put her at ease. "Maybe resentment is more like it. At least on your part."

"Don't assume anything, Reese. We met that night. Things got out of hand. That's pretty much all there was to it."

He smiled. "I find that hard to believe. If it makes you feel any better, what memories I have are all good."

She glanced up at the sky. "Reese, as I said before, I don't know that we'll accomplish anything by rehashing what happened years ago."

"This isn't *re*hashing, Abby. This is first-time hashing. And now seems like the perfect opportunity. There's a lot going on with you. I'd really like to see Huey stay in his house…." He smiled again. "And out of jail. I believe that getting things out in the open is the way to go. Don't you feel the same?"

She shook her head, as if the concept was somehow confusing. "Well, sure," she said after a moment. "Generally speaking. But there can always be extenuating circumstances."

"Not in this case, I don't think. If what occurred that night is standing between us, and we can clear it up with a conversation…"

"We can't."

She said the words so quickly he sat back. "Why not?"

Her gaze unwavering, she stated, "The time to discuss this was thirteen years ago."

"No doubt. But I left soon after."

Her lips pulled down at the corners—not despair ex-

actly, but definitely an expression of sadness. "You certainly did. You'd just come out of college, and you signed up for the navy." She traced a line along the base of her glass with her fingertip. "That was a rather sudden decision."

"It was. I enlisted at the recruiting office at the naval yard the same day you and I…got together, and I went for basic training in Pensacola two weeks later."

"I remember," she said. "I heard you'd gone."

"Yeah, I was in trouble. That decision to smuggle those Cuban immigrants onto the island wasn't the smartest choice I ever made in my life. Which might explain why I wasn't exactly myself the night I met you at the beach. I had some pretty serious consequences hanging over my head, and I was using a bottle to forget for a while."

She closed her eyes and released a quick breath of air—a seemingly subtle reaction, but he realized how his words might have hurt her. "I didn't mean that the way it must have sounded. I don't want you to believe that what I did, what *we* did, was just me being crazy."

"No, we were both being crazy."

"Maybe, but I never intended for you to be part of the madness."

"You weren't solely responsible for what happened."

He felt that he was. She'd been a sweet, innocent kid, barely eighteen. He was a twenty-one-year-old man who'd gotten himself into more fixes than he cared to remember.

But when she'd padded across the sand in her bare feet and sat beside him, she hadn't seemed like the untouchable Abigail Vernay. When she'd rested her cheek against his shoulder and curled her hand over his thigh, he'd lost his head. When she'd let him kiss her, when his hand had

snaked along that tempting slash of skin above the delicate dip of her naval…when she'd leaned in, pressed her breasts against him, he'd forgotten all sense of right and wrong. He shouldn't have, but "shouldn't have" had been the mantra of his life for a lot of years.

She took a long sip of wine now and fixed him with a gaze so penetrating he felt it in the pit of his stomach. "I heard you were at the beach that night," she said. "I looked for you. I wanted to find you."

He inhaled a long, slow breath to give his brain a chance to process what she'd just said. Did she mean what he thought she did? This was the last thing he'd expected to hear from her. Abby Vernay, the girl who always held herself to a higher standard, had intended to seduce him, the bad boy of Key West.

She gave him a tentative smile. "You're surprised."

"A little." He should have gagged on the understatement.

"I wanted you to kiss me, to find me attractive."

Oh, he'd found her attractive. And if the number of times she'd entered his head in the past few days indicated anything, he still did. He couldn't tell her that. He wasn't drunk. He'd changed and she had, too, in ways he still didn't know, which was why anything he could say now would sound lame and insincere.

So he said something that was at least true about what had happened after that night. "I thought about you. If I'd stayed in town, I would have called." He smiled. "I figured you would have hung up on me."

Her eyes clouded with something he couldn't identify. Regret? Suspicion? "But you didn't call…in those two weeks, or ever."

"Once I left here, I got caught up in the whole military

thing." He paused, realizing that what he'd just told her probably sounded like a flimsy excuse. "I couldn't come back here. The details of my enlistment were all over town. It was a deal my parents and I made with the judge to keep me out of jail."

"I heard someone spotted you the night you picked up the immigrants, and turned your name in to the police."

Right. Huey Vernay, to be exact. But Reese wasn't going to tell her that. He held up the carafe. She shook her head and he poured the last few drops into his glass. "We aren't the people we were back then." He drained his glass and called the waiter over. "That's a good thing in my case."

"You've become Mr. Responsible," she said. "My mother says you're admired by everyone on the island."

He slipped a few bills to the waiter and stood. "I don't know about that. I'm still trying to impress the Vernays. Huey doesn't admire me. And I've only started working on you."

"IT'S STILL EARLY," Reese said when they left the restaurant. "Care to walk off that wine?"

She should decline. His conclusions about her job, his admission of regrets had left her anxious, her stomach feeling as if the wine had turned to vinegar. She could almost convince herself that he knew her secret and his comments were aimed directly at her heart, that part of her that had carried the guilt for so long.

"For a few minutes, I guess," she heard herself say, and realized at that moment she would never be over Reese. Once again, she refused to play it safe and just go home.

They strolled down a side street. He took her elbow whenever they stepped off a curb or hit a patch of uneven

sidewalk. He was almost gallant. She was practically giddy. And she hated herself for it. Especially when her mind wandered, as it so often did, to that night.

When she'd seen him at the beach, something inside her had snapped. She'd experienced a need so strong it had frightened her even as it gave her courage she hadn't known she had. She'd just left a graduation party, where she'd had too much to drink. She'd parted from her friends and headed to the beach, thinking, hoping, to find him. She told herself later that the beer was responsible. It had unleashed a bold, spontaneous side of her personality that refused to be denied.

The truth was she'd had a crush on Reese for years. He'd filled her thoughts and invaded her dreams, and was the stuff of all her fantasies. Older, confident, popular, he'd been nice to everyone, even a quiet, proper girl three years younger than him. And there he was that night, sitting alone and apart from his buddies, gazing at the ocean as if waiting for something. Taking a totally unfounded leap of faith, Abby had convinced herself he'd been waiting for her.

But in the next two weeks she'd discovered that he hadn't been.

Reese pointed down the street to where a crowd had gathered in front of an old theater. A tall man in a black cape and tricornered hat seemed to be in charge of the group. "How do you like his outfit?"

"Is he supposed to be a ghoul or a pirate?" she asked, grateful Reese had brought her back from the past.

"A little of both, I imagine."

Abby remembered one of the tourist activities the island was famous for. "Is he conducting one of the ghost walks?"

"Yep. He calls himself The Undertaker."

The man gestured toward the theater and spoke about its supposedly haunted past. Cameras flashed. The Undertaker turned, caught sight of Reese, took off his hat and bowed. "'Evening, Captain Burkett," he said. "We're being law-abiding ghost hunters."

Reese gave him a little salute, and the crowd moved on.

"I see the ghost tours are still popular," Abby said.

"You bet. This island has a few ghoulish tales to offer up for the price of a few bucks."

Abby smiled. "So I heard. One of them involves Poppy's house."

They continued down the block until they stood where the paying customers had been, across the street from the theater, which was illuminated by a single light beside its double doors and another in its upper story. "How long since a business has operated here?" Abby asked.

"Years. Maybe the building's not inhabited by ghosts—although anything's possible, I guess—but the fire that destroyed the interior was real enough, and people did die. And no business has made a go of it since then. It's like the place is jinxed."

Abby sighed. "I remember hearing about that fire."

Reese wrapped his hands around her arms. "I didn't mean to make you sad." He smiled. "It's the holidays and you're in paradise."

Key West hadn't been a paradise to her for a long time. "Is that how you think of this island? That it's a paradise?"

"Absolutely."

She envied him. How nice to feel totally relaxed in an environment, to belong. "Why?"

He thought a moment. She figured he was going to give her the pat answers—sun, sand, moonlit sails, margari-

tas…the stuff that filled the tourist brochures. Instead, he tightened his grip on her arms and pulled her a fraction closer. Her heartbeat accelerated.

"What's not to like about a beautiful Sunday night in Key West, Abby?" he said at last. He glanced up and down the dark street. "I'm alone with a pretty girl, and for once her father isn't glaring down at me from his front porch. A guy would have to be nuts not to consider this paradise."

A ribbon of anxiety fluttered in her stomach. For a moment she thought, maybe even hoped, he was going to kiss her, though she couldn't let that happen. She looked away and concentrated on the building with the sad history. "Yeah, and a haunted theater makes for a perfect addition to your image of paradise."

He laughed. "Well, there is that." He brushed her hair from her shoulders and placed his hands on either side of her neck, bringing her attention back to his face. "But I'll protect you!"

The fluttering increased. Abby's breath hitched. "But what if I don't need protecting? I don't believe in ghosts."

"Doesn't matter. Haven't you heard? Men like to role-play."

He lowered his face. She leaned away from him, but not fast enough. His lips claimed hers for a quick, warm kiss. She backed up as if she'd caught fire. "Reese, we don't want to do this."

He still held her. "We don't? I do."

She said the first thing that came to her mind. "I saw you with a date last night."

"Oh. You got me there. But I'd probably be right if I assumed you had dates in Atlanta."

She didn't respond. Of course they both dated. And this

was just a kiss. Anything she would say would paint her as an uptight woman who placed more emphasis on a kiss than it deserved. Anything except the truth.

"I have to get back. Poppy's expecting me."

He waited, as if debating his options. After a moment, he dropped his hands and walked toward Duval Street. They were soon lost among the tourists still roaming from shop to shop, bar to bar. When they reached Southard, Reese stopped at her house and said, "What if you were my date? My official date? Would that make a difference?"

The porch light was burning, and Abby went toward it. When she'd put distance between them, she turned back. "I don't know."

He grinned. "That's the way we should handle this. I'm not going to let you hide out in that house this time."

CHAPTER EIGHT

ABBY WAS IN BED BY eleven, but a long way from falling asleep. When her cell phone rang, she set down the book she wasn't reading, and connected. "Mom?"

"What were you doing strolling down Duval Street a while ago with Reese Burkett?"

"How did you know about that?"

"This is Key West. I work at the Pirate Shack."

Abby didn't resent her mother's interference this time. She wanted to tell her what had happened. "Mom, he kissed me."

"Hmm…nobody mentioned that part."

"I stopped him before it went too far."

"I'm sure you did. How was it?"

"The kiss?"

"Yeah."

"Inappropriate. Uninvited." Abby waited a moment before adding, "Spectacular. But Reese and I can't have that kind of relationship. We have a history. I'm here for Poppy, to make sure Reese doesn't take advantage of him, that's all."

"I realize it's complicated, Abby."

"It's more than complicated. He has a son he doesn't know anything about."

Loretta exhaled. "Abby, if you're going to allow a relationship to develop…"

"I'm not. The kiss was wrong. It shouldn't have happened."

Loretta continued as if she hadn't spoken. "Then you have to tell him."

"I should stop seeing him. I managed to avoid him for thirteen years. I can do it again."

"What do you want me to say, Ab? Do you want me to agree with you so things will be easy? I won't do that. You made your decision back then based on your goals and your situation at the time. But now you're a grown woman. Your situation has changed. You need to make amends so you can get on with your life, and maybe, believe it or not, even find a place for Reese in it. Besides, I like him."

"So you've told me often enough."

"And I think you like him, too. You always hoped that if you ran into him you wouldn't, but you do. And you've never quite forgiven yourself for giving away his son."

This was the crux of the issue. In Atlanta she managed to block out reminders of what she'd done for hours at a time. But now, back at the scene of the haunting memories, she was forced to face the horrible consequences of her choice over again.

"Abby, back then we did what we thought was best for that baby, and for you," Loretta said. "We can't second-guess ourselves now. That doesn't help anyone."

"I know that, but…"

"You should tell him."

"But what if this kiss was just Reese acting in the moment?"

"What if it wasn't?"

"I saw him last night with a date."

"Redhead or brunette?" Loretta asked.

"He dates one of each?"

"He's a good-looking guy, Ab. And even with men out-numbering women on this island, he still does pretty well for himself."

"Obviously."

"Anyway, what difference does that make? You are never going to move past what happened until you tell him. Trust me. I know something about the cleansing power of truth."

Abby remained silent, contemplating her mother's analysis of a complicated problem. Loretta was right. She'd faced a powerful and difficult truth in her life, lived through it, and was happier now for revealing it. There could be no future with Reese unless she told him. But how could there be a future with him anyway? Abby was going back to Atlanta, where she helped girls who reminded her of herself—confused, uncertain. Reese would stay here, being admired and respected and dating redheads and brunettes. No. There couldn't be a future with him, even one that lasted only as long as Christmas.

"I'll think about it," she said, and disconnected.

BY WEDNESDAY AFTERNOON, Abby had avoided Reese both times he'd stopped by the house. She'd gotten Huey to participate in her white lies by telling Reese she was out shopping or down at the Pirate Shack. Loretta refused to lie for her, insisting that Abby was being childish. She was. And she was miserable. She was flattered by the attention Reese was paying her, and didn't enjoy denying herself the pleasure of being with him.

Huey looked over at her from the sink, where he was mixing a pitcher of iced tea. "How are you doing with re-checking that total, Abby?"

She concentrated on the stack of bills on the kitchen table and layered the twenties on top of the hundreds, counting as she went. "It's correct, Poppy. Six thousand five hundred. That's a great start toward paying the taxes."

He scowled down at the money. "It's a pittance for all that stuff. I expected twice that amount."

Abby could only marvel at his view of what she considered fair and honest offers by the dealers who'd bought the things up for sale. "Some of those pieces weren't in the best condition," she reminded him. "The roof leak in the attic from the last hurricane ruined a lot."

"Nothing that couldn't have been made like new again with a bit of effort."

What did he call effort? Abby's hands were sore from polishing and varnishing. Her skin was chafed from hours of hand-washing the linens they'd sold.

Oblivious to her feelings, Huey picked up the stack of money, folded it in half and stuck it in his pocket.

"What are you doing?" she asked him.

"Keeping it safe." He patted his pocket. "I'm not putting it in the bank. It's better right where it is."

"Poppy, you can't keep the money. You have to use it to pay your fines and your tax bill."

He shot her the coy grin she'd learned never to trust. "In due time, Abigail. In due time."

"No. Now. And that reminds me. I've been meaning to ask where you got the money you put down on last year's tax bill."

His brow furrowed. "What are you talking about?"

She scattered papers over the tabletop, looking for the

right one. When she found the statement, she handed it to him. "Three thousand was paid in May, apparently after you received a couple of overdue notices."

Huey studied the statement. "What the hell? I didn't pay this."

"But you must have."

He hooted. "Hot dog, Abigail, this is the first time the government has made a mistake in my favor."

She could only stare at him. "You don't really believe that."

"I didn't pay it. I believe *that*."

She reached for the statement. "Obviously, we have to check into this."

He crushed the paper to his chest. "Not on your life! I'm paying these greedy bureaucrats enough without doing their job for them. It's not my place to point out the mistake some fool bean counter made in record keeping. Besides, it's time fate gave me a break."

Abby couldn't understand the rationale in continuing this argument at the moment. "We'll talk about it later." She held out her hand. "For now, give me the cash from your pocket. We'll take it to city hall right away. This amount doesn't solve your problem, but it should stall them until we can come up with other ways to make money."

He reached in, withdrew the wad and made a great show of reluctantly putting it in her hand. "You're just like your mother. Domineering, bossy…"

Abby closed her fist over the money. "Don't forget *right*."

"Even a hopeless nag can get lucky once in a while."

She tucked the bills into her purse. "Are you coming with me to city hall?"

"Hell, no. You're a signer on my bank account. You deposit the money and write both checks. At least I can save myself that humiliation."

She smiled. "Okay. What are you going to do?"

"I'm heading down to the square in about an hour. See you there?"

"Yep. I'll be along." They hadn't been to the sunset celebration in a few days. Poppy participated only five days a week, Wednesday through the weekend. Since she believed she was helping increase his sales, Abby didn't want to abandon him now, even if being in public meant she might see Reese. Besides, she was through acting like a child.

As if reading her mind, Huey said, "I appreciate your help, Abby, but what if you run into Captain Buttinski down there?"

"Don't worry about it. I'll handle Reese if he shows up."

"I'll bet. About like you handled him thirteen years ago. I should have taken care of Reese back then, for all the good you did."

Abby's jaw dropped. Huey had voiced the forbidden topic. Several times when Abby had visited Key West, her dad had reminded her that she should have let him handle the problem with Reese. She'd never once considered that an option. At first, she'd been forced to listen to Huey's vitriolic tirade about Reese leaving squarely on her shoulders the situation he'd created. Even after Abby had repeatedly reminded him that Reese didn't know she was pregnant, Poppy hadn't let up. Finally, she'd threatened never to come back to Key West again if he didn't promise to drop the subject.

He'd abided by her wishes for the most part, only referring to Reese in generally unpleasant terms, never zeroing in on the specific incident that had changed all their lives.

Apparently, he had decided today that he could no longer maintain his silence.

"Don't bring that up, Poppy," she said, not even trying to mask her anger.

"Why not? You talk to your mother about what happened, don't you?"

"That's different."

"Why?"

"Because she doesn't harbor an irrational hatred against the Burketts."

His eyebrows came together. "She damn well should. They ruined her life, too."

"Nobody's life was ruined—at least not by the Burketts."

"The hell. Your mother wouldn't have left me for Phil…."

"The Burketts aren't to blame for your failed marriage."

"You wouldn't have fled the island in disgrace…."

This pointless game of verbal ping-pong had suddenly gotten wicked. Abby squared her shoulders. "Poppy, you don't want to continue this conversation."

But obviously, he did. "I told you to have an abortion. It was the only thing that made sense once Reese took off. I said I'd drive you off the island to a clinic in Miami. But no, you insisted that you were going to have the baby."

"And I've never once regretted that decision." *Though I've suffered in countless ways because of it,* she silently acknowledged. But she knew she would do the exact same thing again.

"You let Reese Burkett drive you away," Huey said. "I lost you all those years ago because he didn't live up to his responsibility."

"He wasn't aware he had a responsibility, Poppy. You know that."

"You should have told him, or let me go over to that fancy house they live in. I'd have made those Burketts do the right thing by you."

"It was my choice and I made it," she said. "I couldn't ruin Reese's life. Or mine. I'd been working for years to go to college."

"Here in Key West at the community college."

"To start, yes, but I would have eventually gone on to a university. That was always my plan, and I didn't want to give that up." She sat heavily on the nearest kitchen chair. "I've never once been sorry I got that education."

She and Huey had avoided talking about this issue for so long Abby had convinced herself that the two of them had come to a sort of truce. A strained one, maybe, but at least a silent acceptance of the events of the past. Apparently, that wasn't the case anymore.

There was no question now that her father still felt a great deal of resentment. The truth was Abby *had* left the island to cover up her pregnancy. And to protect Reese from leaving his basic training and ending up in jail. Ultimately the education she'd received at the University of Central Florida was the fulfillment of her goal, one she might not have achieved had she not left Key West. Not all the consequences of that one foolish act had been bad.

Loretta had gone with her to Orlando to wait for the baby's birth. In a way, Huey was right. He'd lost both of the women in his life after that night on the beach. Abby hadn't returned, and when Loretta had, she'd stayed with him only a few months. She'd decided she couldn't live with Huey's constant accusations, both silent and spoken. And she'd turned to Phil, the man who claimed to have loved her for years.

Abby looked into her father's eyes now, fully expecting her anger to boil over. Huey had done the unthinkable and opened the Pandora's box that he'd sworn to leave closed. But the sadness in his eyes told her he truly loved her, and in his mind he'd lost her. She reminded herself that she'd come back to Key West to help him. She couldn't make his misery worse.

She stood and walked over to him. "Poppy, you never lost me. And you never will. My life is in Atlanta now, but part of my heart will always be in this house with you."

He looked her square in the eyes. "Having part of your heart is good, Abigail. I'm grateful for that, and Lord knows your heart's big enough to go around. But I want more."

She clutched his hand. "You've got to accept things the way they are, because I won't live here again."

He opened his mouth as if he might argue the finality of her statement. But instead, he pulled his hand free and headed toward the parlor.

She called to him. "Poppy?"

He stopped, his back to her.

"You've always kept your word," she said. "You never told Reese about the baby. I need to know that you will still honor that vow."

He rolled his shoulders, straightened his spine with the stubbornness that defined him. "I won't tell him. My word to you is more important than anything Reese Burkett has ever done or will ever do." Huey took a step forward, then turned back to her. "But if you want me to threaten him with the shotgun, I'm ready and willing."

She smiled. "I'll remember that."

He strode to the door. "Meet you at the square."

THE MONEY TRANSACTIONS went smoothly. Abby deposited the cash into Huey's account at the bank, walked the block to city hall, paid his fines and then proceeded to the tax collector's office. Her former high school civics teacher was behind the counter.

"Mr. Haskins," she said. "Are you collecting taxes these days?"

"Well, I'll be. Abigail Vernay. How are you?"

"I'm fine. Surprised to see you here."

The man explained that he'd retired early from teaching and discovered he didn't have enough to do to keep busy or to prevent his wife from complaining that he was around too much. So he'd applied for this job, and was now happily employed as a public servant. He took the check Abby slid across the counter. "I'll bet this is about Huey's tax bill," he said.

"Yes, it is. I guess everybody on the island knows about my father's debt."

"It's pretty much common knowledge now, Abby. But we're all pulling for him."

"Thanks." She waited for Mr. Haskins to read the amount on the check. "What do you think? Will that buy him a little time?"

"Oh, you bet. But just remind him that the rest of the money will be due after the first of the year."

"I will." Abby said goodbye and proceeded down the hallway to the front entrance of the building. At the reception desk, she noticed a signboard listing upcoming town business meetings. One in particular caught her eye—the meeting of the Community Improvement Board that very evening. The board members were mentioned at the end of the announcement. Abby walked closer and read the names. And gulped back her surprise and anger. "How could he?"

"Hey," a voice called from over her shoulder. "There you are."

She spun around to face Reese in uniform.

"I've been looking for you," he said. His easy grin faded as he studied her face. "What's the matter?"

She pointed a trembling finger at the board. "And there *you* are," she said.

He leaned in close. "What are you talking about?"

"Your name! You're on that stupid Community Improvement Board that bugs my father every other day."

He peered. "Impossible. I'm not a member."

She steadied her hand and tapped the glass.

His eyes widened. "What the hell? How did my name get there?"

She dropped her arm and glared at him. "Oh, I don't know. This is small-town politics. Maybe you paid to have the honor. Maybe you tore up a couple of tickets for somebody. Maybe you wrote a letter to the editor about putting a poor old man out on the sidewalk. Anyway, there you are, right under your mother's name!"

WELL, THIS WAS embarrassing. Reese raked his hand through his hair. "Honestly, Abby, I don't remember…."

He paused, thinking back, and recalled a quick meeting with the chief of police at least a year and a half ago. It wasn't even a meeting. It was more a two-sentence edict delivered in the hallway of the police station. Ray Fitzpatrick had said the town wanted someone from the force on the CIB. Reese had asked how that affected him, exactly, and Ray had stated, "I've decided you're it."

Recalling those words now, Reese wished he'd have fought harder to get out of that stupid assignment. But Ray

had pointed out that since Reese's mom was on the board, it only made sense for Reese to be the representative from the force. "Besides," the chief had told him, "you won't have to go to any meetings."

And he hadn't. Once he'd told his mother the next day that he was a member in name only, he'd forgotten about it.

Reese tried to explain all that to Abby now. She listened alertly, as if evaluating every word.

"I know how this must look to you," he finally said.

"Really? It seems like you're a two-faced liar. With one breath you say you don't want to see Huey thrown out of his house. With the next you admit you're part of the Key West vigilantes who send him notices all the time that he should clean up his place before you sic the authorities on him."

Reese tried not to smile, but felt his lips twitch. "Vigilantes, Abby? Isn't that a little strong?"

She held her ground. "No. I wouldn't be surprised if your pals somehow increased his taxes to this ridiculous level so he'd have to move out."

"We're a powerful force in this town," Reese said, unable to conceal his sarcasm. "But I don't think even the CIB can control property taxes. However, if it makes you less inclined to hate me, I'll resign my post just as soon as they can find a replacement." He smiled. "Believe me, I won't be missed."

She stared at him as if judging his sincerity. Then she tucked a strand of hair behind her ear and said, "Fine, let me know when you've done that." She turned abruptly and started for the exit.

"Hey, wait a minute." He caught up to her on the steps. "Aren't you curious about why I've been searching for you?"

She stopped, gave him a look that was part curiosity and part exasperation. "Okay. Why?"

"I wanted to ask you out. On that date I threatened you with the other night." He pointed to the photographic representation of Georgia's Stone Mountain on the front of her T-shirt, and back at his own chest. "Just you and me."

"A date?" she squeaked, as if the idea had come from the musings of a lunatic.

"Yes. For the annual Christmas parade this weekend. What do you say?"

She thought much too long for his comfort. "This isn't an invitation to bungee jump," he said. "It only requires a simple yes or no."

"I might go," she said.

"Great. I might pick you up Saturday at six forty-five then."

"Fine." She headed down the steps.

"I could see you later," he called after her. "I'm working a double shift today. Are you going to be at Mallory Square?"

"I am," she said. "So, you're right. You could see me."

She got into her compact car and drove off.

Reese smoothed his hair back and put on his cap. Then he shook his head. Who would have ever thought that damn committee would turn out to be a bullet he'd have to dodge months later? But at least he had dodged it. He hoped.

CHAPTER NINE

WHEN ABBY SHOWED UP at Mallory Square a few minutes later, Huey had set up his cart and was reading the newspaper. The sun was nearing the horizon. Street performers were beginning to draw crowds.

She placed her hand on Huey's shoulder. "I'm sorry we had words, Poppy. I don't want to argue with you."

He squeezed her fingers. "Forget it."

She rearranged a few of the items on his cart to look more appealing. "You're running low on these beach baby ceramics," she said. "And I was thinking you might add some turtles. I imagine the Friday-night turtle race over at Turtle Kraals is still as popular as always."

He nodded. "Oh, yeah, folks are still blowing their hard-earned dollars on which damn reptile will reach the finish line first. But turtles might be a good idea for my cart. I have to run up to Miami next week to restock at the wholesaler. I'll see if he has any."

Hoping to attract attention, Abby smiled at customers as they walked by. She even sold a few things.

An hour or so later, Reese showed up. He'd changed into blue shorts and a white knit shirt with the police department's logo on front. He was on a bicycle, so obviously whoever he was filling in for was a bike patrolman.

Reese stopped next to the cart, looking all tanned and pressed and gorgeous. "How's it going?"

"Not bad," Abby said.

Huey stared up at him. "I haven't seen you at the sunset celebration twice in seven years, and now, all a sudden, you're haunting the place."

He grinned at Huey. "I just need to make sure that honest businessmen like you aren't hassled by petty thieves."

Huey grunted, picked up the binoculars he always brought with him and stared through them. "Fine. I feel safer just having you hovering over us." After a moment, he said, "As long as you're here anyway, you can watch my stuff while I focus on the real troublemakers."

Reese leaned over him. "Is something out there?"

"One of those damn go-fast boats. There ought to be a no-wake policy this close to shore."

Reese squinted into the setting sun. "It's not that close. The driver's not breaking any law that I can see."

Huey jumped up from his chair. "You might want to rethink that, Captain Courageous. He just dumped something off the side of his vessel."

Reese reached for the binoculars, tugging the strap at Huey's neck. "Let me see."

"It's too late now. Whatever he threw off is already in the drink. It might have been a body."

Abby peered out to sea. "What?"

Reese fiddled with the lens adjusters. "Are you sure, Huey?"

"I can certainly tell if something as big as a duffel bag is tossed overboard, Reese."

"There *is* something floundering around out there," Reese said.

Abby grabbed his arm. "What are you going to do?"

He dropped the binoculars onto Huey's chest with a thud, then hit a button on his shoulder mic. "This is Reese. Send a patrol boat to Mallory Square." A short pause followed, during which Abby tried to understand the muffled response. "Yes, immediately. I'll be at the seawall. And tell whoever's driving to make sure the lifesaving equipment is easily accessible."

He reached for the strap at Huey's throat. "I need to borrow those binocs."

"Be my guest."

Reese took off at a sprint toward the dock. "Be careful," Abby called after him.

In less than a minute, she saw the flashing blue lights of the Key West police boat. Reese jumped on board, and the *Whaler* headed toward open water, leaving a trim, foamy wake in its path.

HIS HEART POUNDING, Reese gestured toward a channel marker he'd pinpointed next to the site where the object had been jettisoned from the cigarette boat. He was happy to see Chuck Lewis commanding the police craft. Chuck didn't mind putting the throttle full forward, and he was the best driver on the force.

"What's out there?" Chuck asked above the roar of the twin, two hundred horse Mercury outboards.

"I don't know. Huey Vernay said something was thrown off a passing boat." The go-fast was already lost on the horizon, and Reese knew catching it would be impossible. All they could do now was try to save whatever might be struggling to survive in the Gulf.

Reese shielded his eyes against the sun sinking rapidly

toward the blue water. What was left of the famous Key West sunset was the one chance they had of spotting whatever might be floating out there. Once night fell, it would be too dark to see.

"Over there!" Reese said. Something was definitely moving, creating ripples on the otherwise smooth surface.

Chuck steered closer. Reese hung over the side of the boat. They were in time. It was paddling, struggling to stay above water…. Reese spotted a tinge of auburn in the shadowy Gulf. A person with red hair, perhaps. "Hang on," he shouted. "We'll get you."

Chuck cut the engines, drifted the last few feet. The sun was almost down. Reese braced himself and extended an arm into the dark sea. He made a few passes with his hand, hoping to grab something solid.

A growl came from the murky waters. Reese almost withdrew his hand when his fingers connected with something coarse, like the bristles of a brush. It certainly wasn't skin or clothing. "What the…?"

"Whatever it is, it's not human," Chuck said. "Don't let it bite you."

Reese darted a glance at his friend. "Thanks for the advice. That makes me feel great." He grabbed hold of something thin and bony. The creature writhed in his grip, trying to get free. "Stay still, damn it," he said.

Chuck shone a light off the side, and Reese finally saw the object of their frantic rescue attempt. His gaze connected with a pair of round golden eyes, wide and frightened. A large mouth yawned, revealing sharp teeth. Canine teeth. "Holy shit," Reese said. "It's a dog."

He wrapped both arms around its torso and pulled the waterlogged animal into the boat. He ordered Chuck to

head back to the dock, and then tried to assess the creature's condition. The poor dog wiggled around on the deck and made several valiant attempts to stand. Each time, exhaustion and slippery floorboards sent it sprawling again.

Reese spoke in his most soothing voice. "Take it easy, fella. We're here to help." Finally, the animal lay prone, his chest convulsing with the effort to breathe.

"He's not going to make it," Chuck said. "Must have swallowed gallons of salt water."

"Step on it," Reese replied. "We've come this far. I'll be damned if I'll just watch him die."

A crowd had gathered at the seawall. The performers had suspended their shows. An ambulance, lights flashing, waited to take the victim to the hospital.

Abby and Huey pushed through as the boat drew next to the embankment. Shouting that he'd been the one to witness the possible tragedy, Huey stationed himself at the edge of the dock and refused to be jostled away. He fired questions at Reese and Chuck. "What'd you see? Did you save him?"

"Get back, Huey," Reese hollered. He lifted the dog from the bottom of the boat. A collective gasp rose from the crowd.

"Who would do such a thing?" one woman asked.

Another person voiced the obvious. "It's a dog."

With Huey's help, Reese lay the now-unconscious animal on the concrete and jumped up beside it. A paramedic rushed over, looked down and simply stared.

Do something, you damn fool," Huey said. "You're in the business of saving lives, aren't you?"

The medic dropped to one knee and began pumping the dog's chest.

A wisecracker from the crowd commented, "He needs mouth-to-mouth."

"You're the dog lover," Huey said to Reese.

"I don't know how to revive a dog." Reese rubbed his hand over his dry mouth. "But I suppose I could try."

"Oh, hell." Huey pushed the medic out of the way and crouched beside the animal. He cupped one hand over the snout and opened the jaw with the other. Looking up at Reese, Huey said, "If he bites me, have us both tested for rabies."

Reese, his soaked shirt matted with dog hair, gawked in wonder along with a hundred tourists. All two-hundred-plus pounds of Huey Vernay covered the dog as the self-proclaimed descendant of French aristocracy locked lips with a mangy mongrel. For a full sixty seconds, Huey puffed, released, puffed again, blowing life into the animal.

Reese didn't believe in miracles, but he was pretty certain he witnessed one under the twinkling Christmas lights on Mallory Square when the dog began belching up seawater. Huey rolled the animal onto his side and stroked his wet fur. When the dog's breathing approached normalcy, Huey stared up at the crowd. "That's how it's done, folks," he said.

Abby knelt beside her father and hugged him. Reese patted his back. "Good job, Huey." Even the dog, too weak to do much more than flip his tail in gratitude, seemed to regard his savior with something almost like worship.

"What happens to him now?" Huey said.

"I'll call animal control to come get him," Reese said. "If he needs further medical attention, they'll take care of him at the vet's."

"And more than likely gas him," Huey said.

"Not necessarily so," Reese said. "He'll probably be adopted, especially once this story hits the newspapers."

He took in the large group of people snapping photographs. "Which is quite sure to happen."

"Still, let's not take the chance," Huey said.

Abby petted the dog's large head. "What are you saying, Poppy? Should we bring him with us?"

Huey grimaced. "I don't recall uttering those words, Abigail."

"You don't even like dogs."

Huey looked up at Reese. "Okay, dog expert. What kind is he?"

"I don't believe he's any specific kind," Reese said. "But I'd say he's got a lot of Irish setter in him."

"I don't care much for the Irish," Huey said. "They're basically a lazy lot. Don't like to work for a living."

Reese started to point out the obvious similarity to a certain Frenchman, when Abby shot him a warning glare. Instead, he said, "It's my belief that stereotypes don't necessarily apply to mixed-breed animals."

Huey considered. "I suppose you're right. I guess I could bring him home awhile, since nobody else appears to be on his side right now." He glanced at Abby. "Do you mind?"

"It's a wonderful idea."

"Okay. Just for a few days. I'll make sure he's okay, give him a bath and fatten him up some. Reese, lend me a hand getting him to my truck."

A couple of other police officers parted the crowd, and Huey and Reese, each supporting half of the weight, carried the soggy animal to Huey's vehicle and carefully set him in the cargo bed.

Huey looked from Abby to Reese. "You two stay with him while I close up my cart. Keep him quiet. Don't let anybody point any cameras at him. The flash might upset him."

As he walked away, Abby regarded Reese, who shrugged at the mysterious workings of the universe. "Who could have predicted that?" he said.

She grinned at him. "Yeah, and who would have thought that I'd be keeping company with two real-life heroes this evening?"

Reese looked away, suddenly struck with an unexpected rush of humility. That comment from Abby felt even better than the sandpapery lick a long canine tongue was applying to the back of his hand.

THE NEXT MORNING, Abby awoke to the ringing of a telephone. She glanced at her travel alarm and had a moment of panic. She should have been to work forty minutes ago! She'd already missed appointments.... And then she remembered where she was.

She hadn't slept this late in weeks. Maybe her old room, with its faded ivy wallpaper and tea rose curtains, was starting to feel like home.

The phone rang a third time. Abby scrambled out of bed. "Poppy, are you getting that?"

When he didn't answer, she began a mad search for the telephone on the top of every table in the wide hallway. No luck. "Poppy, where's the phone?"

"What's that?"

She ran to the open window at the end of the upstairs hall and looked out on Huey and the dog in the backyard. "Can't you hear the phone ringing?" she hollered down to him.

"Yeah. So?"

She rolled her eyes. "Where is it?"

"Under my nightstand, maybe."

She raced for his room, tripped over the threshold and

landed next to the bed on her fanny. But at least she was near the phone. Whoever was calling was persistent. She'd counted eight rings. She put the receiver to her ear, thinking this was the first time her father's phone had rung since she'd arrived a week ago. "Hello."

"Hi. You sound out of breath."

Well, I am now. "Reese. What do you want?"

"I called to see how the dog is after his big adventure last night."

Abby stood, massaged a slightly painful spot in her ankle and hobbled to the window. "He's—" *eating a doughnut?* "—fine. Having breakfast."

"Tell Huey not to give him too much at once. And use good sense with the menu. The salt water could still be affecting his stomach."

She watched Huey pull apart a cruller and feed a portion of it to his new pal. "You mean only give him dog food, right?"

"Well, sure. That's all dogs should eat, anyway."

Poor dog. Although upon inspection, Abby decided he looked quite satisfied with his unhealthy meal. Just like Huey. "I'll tell Poppy," she stated.

"Hope you have a nice day," Reese said.

"Thanks. You, too. I suppose Huey and I will be watching for what people throw off boats going by Mallory Square tonight."

"Hang on." Reese spoke to someone in his office—the dispatcher, Abby guessed. He ordered a unit to head to Roosevelt Boulevard. "I have to go, Abby. One of the school bus drivers just reported a guy weaving over U.S. 1 with a beer bottle to his lips."

"At this hour? And around kids?"

"No, the driver had already dropped them off. We've got the tag number and a description of the car."

"Be careful."

"I'll be fine." She heard labored breathing as he rushed to his car. "In fact, I already have an idea who it is. He's a night watchman who claims he only has a few drinks when he gets off work. Unfortunately, his clock doesn't coincide with most of the others on the island! I may have to give him a stronger reminder now."

A car door slammed. "Till Saturday," Reese said, and disconnected.

Experiencing a totally unexpected, and certainly unwanted, euphoria, she returned to her room and dressed for the day. Reese had called just to chat—something couples did when they were establishing a relationship. Something married couples did. "Don't be ridiculous," she said to herself as she went down the stairs. She met her dad and the dog at the back door. "Hey, fellas," she said. "How's the patient?"

Huey beamed down at his companion. "Show her how you are, sport." He held up a finger and commanded the dog to sit. The animal stared up at him with unabashed adulation, and did nothing. "That's what I like about this dog, Abigail. Got a mind of his own. Doesn't dance to any tune but the one in his head."

Abby leaned against the counter and reached for the pot of coffee and a mug. "I can't imagine why you'd find that such an appealing quality."

Ignoring her, Huey rubbed under the dog's jaw. "I might even take him down to Fort Zachary Taylor Park today so he can show off his independent streak in front of the other animals."

Abby was about to comment that the dog would like that, when she heard the familiar rumble of the Conch Tour Train turning onto Southard. "Great. The stupid tour again," she said to Huey.

They went to the front entrance and stood just inside the door. The guide's voice carried across the yard. "On your right, folks, is one of the oldest houses on the island, the home of four generations of Vernays—"

"Blah, blah," Huey said. "Here we go again."

"Shh, Poppy. Listen." Abby sensed the speech was different today.

"Key West's latest hero lives in this house, Hugo Percival Vernay, the man who just last night saved a poor old dog that had been cruelly tossed into the sea. The way I hear it, Hugo used mouth-to-mouth on that animal right on Mallory Square, bringing the near-dead creature back to life."

Abby spun around to her father. "Do you hear that, Poppy? I'm not the only one who thinks you're a hero."

This time Huey shushed her. "He's still talking, Abby."

"…claim this house has a supernatural history," the tour guide said. "I don't doubt it. Some of the locals have decided to call the miracle dog Snowflake because Christmas is almost here, and last night that animal had about a snowflake's chance in Key West of surviving his ordeal. If you look sharp, you might see ol' Hugo and Snowflake in the window, sharing what can only be called an unearthly bond."

The train chugged by, leaving Abby and Huey speechless. After a moment, she said, "They want to see you, Poppy, for a good reason this time."

He tugged on his beard. "Damned if they don't. I might give them a peek one of these days. But I don't like that name."

"What? Snowflake?"

"It's a sissy's name. That dog's no sissy."

She smiled at him. "Just call him Flake. Somehow it seems fitting for any creature who'd live in this old haunted place."

Huey laughed. "I'll have you know, Abby, four generations of Vernays are taking exception to that little comment…." He looked down at the dog, who'd appeared at his side. "I might have to keep this animal, Abby. I think I'll repaint the cart, add a whole new island theme to the side of it. Instead of Tropical Delights of the Conch Republic, I'll change it to Hugo and Flake's Tropical Delights. Now that we're famous," he added.

Abby smiled. It was a fitting Key West name.

CHAPTER TEN

EVERY COUPLE OF MONTHS Reese forced himself to review the department-mandated materials in the trunk of the patrol car. Late Friday afternoon, after he got off work, he dressed in shorts and a T-shirt and released Rooster to the fenced backyard. Then he popped a beer and opened the trunk. Talking to himself, he checked off items according to a printed list provided by the department. "Flares, blankets, first-aid kit, ballistic shield…" He smiled. He'd never once used that awkward thing and prayed he never would. "Stun gun, ammo, crime scene tape…"

He was down to the spare tire when he heard a car pull into his drive. The burgundy Chevy Impala stopped a few feet behind the patrol vehicle.

Reese walked to the driver's door. "Hi, Mom. What are you doing here?"

Ellen Burkett, looking crisp and cool in white shorts and a blouse embroidered with martini glasses and beach umbrellas, got out of her car. She leaned in for Reese's peck on her cheek, before removing a baking dish from the backseat. "I thought you might be hungry for my chicken Alfredo. You never eat right."

Reese lifted the aluminum foil and sniffed appreciatively. "Smells great. Thanks."

"I'll just pop this in the fridge." She went into his kitchen and returned a few seconds later. "Did I catch you in the middle of something?"

"Nothing important, unless you ask Ray Fitzpatrick. You want a drink?"

"A glass of wine would be nice."

He got himself another beer, handed the wine to his mother and sat next to her on a lawn chair.

"I had a call from Belinda," she said.

"Oh?"

"She said you weren't taking her to the parade tomorrow."

Reese had spoken to her yesterday and told her he was escorting an out-of-town visitor to the event. She hadn't seemed upset. "That's right. I'm not," he said.

"Do you have plans for tonight?"

"Yeah. My softball league has games scheduled."

"That's all you're doing? Playing softball?"

"I imagine we'll go out for a few beers later. We always do."

"So, are you going to the parade alone?"

He stared at her quizzically. Other than a few occasional questions about his social life, his mother rarely insinuated herself into his personal matters. "Why do you ask?" he said.

She sipped her wine and smiled. "Reese, honey, if you're cooling off on Belinda, that's fine with me. As you know, I have my reservations about her."

Now that he thought about it, he recalled his mother saying a few negative things. He'd ignored them at the time. Who he dated wasn't his mother's business.

"Have you met the new woman just hired at Bremerton Art Gallery?" Ellen asked.

Suspecting where this conversation was headed, Reese shook his head. "No, can't say that I have."

"I met her at the garden club. She's delightful. A year older than you, but she looks much younger than her age— not that thirty-five is old."

Reese shrugged.

"She's cultured, dresses well, comes from a good family in Connecticut…."

"Mom, are you trying to fix me up?"

"Would it be so bad if I was? You haven't settled down since that disastrous marriage. You're alone every night. That's not good for a man. I worry about you."

He sighed audibly. "In the first place, you don't know what I do every night, so drawing the conclusion that I'm alone is based on guesswork, not investigation. At least, I hope you're not investigating me."

"Don't be silly."

"And second, I can meet women on my own. I have done so quite a few times with a certain measure of success."

Her back stiffened. "Surely you're not opposed to a suggestion from someone who only has your best inter-ests at heart."

Ignoring that comment, he continued. "And third, I already have a date for the parade."

That perked her interest. "You do? Who?"

"Abby Vernay is going with me."

Her glass stopped halfway to her dropped jaw. "Not really?"

"Yes."

"Why her?"

"Why *not* her?"

"Because I just told you a week ago that you should avoid getting mixed up with that family."

"Yes, I remember that you did. And your point now is?"

Her voice hitched. "Don't be flip with me, Reese Burkett. I'm watching out for you. You don't need to make another mistake."

"I'm not asking Abby to marry me, Mom. I'm only taking her to the parade. Besides, what do you have against Abby? She's a nice girl."

"How would you know that? She's been gone for years."

"I remember her from before. She was sweet and smart. And I thought she was cute."

"I know darn well why you remember her, Reese. And it doesn't have anything to do with cuteness."

Reese nearly spat out his last gulp of beer. "What are you talking about?"

Ellen rolled her eyes. "Don't be naive, Reese. A mother hears things."

"Unfortunately. Things that are none of her business. Anything that may or may not have happened between Abby and me is none of your concern."

"That's easy for you to say now, Reese. Your life's on track, sort of. But back when you were in trouble, you were happy to let your father and me intervene with the judge on your behalf. We used our influence to save you from a jail sentence."

He couldn't argue that. But what he found disturbing after all this time was that his mother was bringing it up now. Was she that determined to keep him away from Abby? Surely she was aware that Abigail Vernay had made a success of her life. His mother's old prejudices didn't make sense anymore. In fact, they never had.

He stood up, reached for her glass. "Are you finished?" She reluctantly handed it over.

"This conversation has ended," he said. "What I do and with whom is off-limits to you. I'm grateful for what you and Dad did for me thirteen years ago when I screwed up big-time, but it's history. And for your information, I'm not proud of myself for helping Manny that night, but I'm not sorry, either."

"False nobility isn't a good trait," Ellen said. "Especially when you seem to conveniently forget that Huey Vernay was the person who turned you in to the police."

"I remember. But no point dwelling on it now. He was doing his civic duty."

Ellen chuckled with poorly concealed bitterness. "Civic duty? Hardly. You have no idea of the consequences of your poor judgment in helping smuggle those immigrants."

Reese sucked in a breath. "First of all, I don't regret helping those people to freedom. And we all know the consequences. Manny spent a year in jail. Half the immigrants got sent back to Cuba. And I got off scot-free by cutting a deal with the judge and joining the navy. It worked out pretty well for me compared with the rest of the people involved." He stared at her. "So what other consequences were there? And what does any of this have to do with Abby?"

"Not Abby," she said. "But you're forcing my hand, Reese. You're forcing me to tell you…"

"Tell me what?"

"Huey Vernay only turned you in to the police when his attempt to blackmail your father didn't work."

"Huey blackmailed Dad?"

"He tried to. He asked Frank for two thousand dollars

to keep quiet about what he saw. Your father wanted to give it to him. I wouldn't allow it. If we'd handed over the money, he would have only asked for more."

"And when you didn't pay up, Huey told," Reese murmured.

Ellen nodded. "That's why I don't like him, and why I don't want you to have anything to do with that family."

Reese was certain Abby didn't have a clue that her father had been the eyewitness to the crime that night. But all at once, this animosity between his mother and the Vernay family was making sense. Could the fact that Huey had asked the Burketts for money explain his longtime resentment? Was he ashamed now because he had asked? Or because he had followed through on his threat to turn Reese in? But the thing Reese found most puzzling was his father's lack of resentment toward Huey, now or at any time that Reese could remember.

"Why doesn't Dad feel the same as you do about Huey?" he asked his mother. "Dad doesn't hate him. He even tries to make friends."

"There's something you should know about your father," Ellen said. "He's not a strong man."

Oh, Reese knew that. Ellen had stripped her husband of his pride and now Frank was stuck in a business he didn't even enjoy.

"I've always been the one to make the tough decisions in our family," Ellen explained. "And look at how successful Frank is today." She walked around Reese and headed to her car. "You'd do well to heed my advice about Abigail."

He stopped her. "I have a little advice for you, Mom."

She turned around. "Well?"

"I don't believe Abby's aware of all this history between you guys and Huey, but I advise you never to tell her."

Ellen smiled with a cunning he found irritating. "Don't worry, Reese. I don't expect to be having much interaction with Abby anytime soon." She placed her hand on his cheek. "I'm only thinking about you."

Ellen got in her car and left. If she'd intended to cool her son's interest in Abby, she'd failed miserably.

ON SATURDAY EVENING, Abby dressed in the only outfit she'd brought from Atlanta that might be considered festive—a short-sleeved red sweater and white jeans. A date. She was going on a date with Reese Burkett. After all these years, after they'd had a child, she was dating him. She looked at her flushed face in the mirror. "You must be nuts. This will change everything."

As if the image talked back, she told herself, "One date could lead to more, and then you're in a relationship, and then…" She added a swipe of blush she didn't need, her skin was so heated. "Who knows where this will lead? Certainly to the truth."

When she heard Reese's pickup, she went to a front window and watched him approach the porch. He appeared coolly civilian in dark green chino shorts and a splashy island print shirt. From the thick dark hair falling onto his forehead to the distressed leather of his boat shoes, he resembled a native—bronzed, relaxed and entirely too sexy. And Abby experienced an instant replay of all those overwhelming girlish emotions she'd felt about him years earlier.

She blotted her lipstick, smoothed her damp palms over her jeans and met him at the door.

"Wow, you look great!" he said.

"Thanks." He held the screen door for her. "I guess this is sort of my coming-out night," she said. "Probably no one remembers me from before, but we'll find out soon enough. This is the first time I've been with a local crowd. You don't see anyone but tourists at Mallory Square, and the only other places I've been are the Pirate Shack a time or two, and city hall."

"I heard you made a payment on Huey's taxes," he said.

She laughed. "This town and its grapevine. But yes, I did. I think the officials were more relieved to see a payment than I was."

"Trust me, Abby, no one wants to have Huey punished for owing money."

Tonight she believed Reese.

He walked beside her down the sidewalk to his truck. "So, how many people will recognize you from high school?"

"My best guess? None. Do many of our classmates still live here?"

"Oh, sure. This island's full of dedicated Fighting Conchs. You'd be surprised. And all of them will be at the festivities tonight."

She wasn't certain if that was good news or not.

Once they were in the truck, Reese crossed Duval, where authorities were setting up barriers for the parade. He took Simonton Street a couple of blocks to historic Eaton and turned into the driveway of a charming white cottage with blue trim. Potted plants decorated the small but lush front yard. A single carriage light glowed next to the centrally located entry door. A wide porch supported by six square columns and framed with a Victorian spool balustrade made the unassuming home appear warm and inviting.

"Who lives here?" Abby asked when Reese shut off the truck engine.

"Rooster and I do."

Whoa. She didn't know what she'd expected, but not this lovingly restored piece of island history. "It's nice. Did you do the renovations yourself?"

"Mostly. When I came back seven years ago, I had some time on my hands, and I got a pretty good deal on this place before the real estate values went up." He regarded the cottage with unmasked affection. "It looks a whole lot different now than when I bought it." He got out of the truck and went around to open her door. "We're barely more than two short blocks from Duval here, so I thought you might not mind walking." He grabbed two lightweight chairs from his side yard. "I'll carry these."

"Great. It's a beautiful night. I'd enjoy the walk."

They soon became part of the crowd migrating down Eaton to Duval. When they reached the old hotel in the center of town, Reese set up the chairs just outside the double-door entrance. Abby noticed a poster on the front window. "This is where the Ghost Walk Tour originates," she said.

"Yep. You can buy tickets in the lobby just after dark. And then The Undertaker, or one of the other guides, leads the group down the dark alleys and even darker history of this island."

"It must make for a fun evening."

"I imagine so." He pointed up Duval. "Just like this one will be. I see the start of the parade."

Abby was thinking how nice it was to view the traditional holiday event again. So far, she hadn't seen anyone she knew, no old classmates who might bring up her abrupt departure from the island.

Just when she was relaxed and enjoying her anonymity, a chirpy voice came from over her shoulder. "Oh, my God, Abby Vernay! Is that you?"

She turned and stared into the smiling face of Key West High School's pep squad leader from fourteen years ago. Only, now the woman was leading a squad of a different sort; she had three children hanging on to her.

"Mary Beth Comstock," Abby said. "You look terrific."

"Me? Heck, I've added three kids and thirty pounds since I last saw you. But you haven't changed a bit." She patted the side of Abby's head. "That gorgeous blond hair still with all those curls. I was always so jealous."

"Not on the frizzy days you weren't." Abby laughed.

Mary Beth grinned. "At least I'm a blond now, too. The bottle variety." She gave Reese a kiss on his cheek and glanced from him to Abby. "Are you guys together?"

"Just for tonight," Abby said.

"Yeah," Reese echoed.

Mary Beth smiled at both of them. "Whatever." She drew her children forward and introduced them, from the youngest, her four-year-old daughter, to the eldest, a son who was nine. "Who does he look like?" she challenged when the introductions were complete.

At a disadvantage, Abby stared at the boy and tried to associate his facial features with a celebrity. Harry Potter, perhaps, since all the kids these days wanted to look like him. "I'm not sure," she admitted.

"Eddie Reiser," Mary Beth said. "Everyone says little Peyton here is the spitting image of his father."

Abby attempted to picture her former classmate. Then, miraculously, she remembered him as a forward on the basketball team. Other than the ball player's six-foot-

four-inch height, she couldn't come up with any identifying characteristics. "So you married Eddie?" she finally said.

"Big surprise, huh? We went together all through high school."

Abby glanced around. If Eddie Reiser was nearby, she didn't want to insult him by not recognizing him. Feeling secure that an especially tall guy wasn't in the vicinity, she asked, "Where is Eddie?"

"He's in the parade. Driving the mayor in our '68 LeMans convertible. Eddie's the chief maintenance officer for the island's official vehicles. You remember how he loved engines."

Abby nodded. She only remembered him loving basketballs, and, now that she thought about it, hot dogs.

"He keeps everything running, from street cleaners to the police cars." She nudged Reese. "Isn't that right, Burkett?"

"Don't know what we'd do without Eddie." Reese stopped pretend-punching Peyton. "Abby, do you want something from the bar? The cops are pretty lenient about the open-container law on parade night."

"Sure. Whatever you're having is fine."

"I'm having a beer."

"Okay."

"Mary Beth? My treat?"

"No, thanks. She patted a backpack slung over her shoulder. "I've got fruit punch in here. That's what Eddie and I mostly drink these days."

Reese tickled both Reiser girls and asked if they were ready for Santa Claus. They squealed that they were. Mary Beth cupped her hand over her mouth and murmured, "I hope Christopher Biggs isn't dressed like Drag Santa this

year. It's hard to explain to the girls why Santa's wearing a red hula skirt, a coconut bra and blue sequined eye shadow."

Reese smiled. "Sorry, but I saw him earlier when I went to pick up Abby. He's added a neon spangled wig under his red hat."

Mary Beth sighed. "I'll have to tell them again this year that he's a very merry elf." When Reese laughed and went inside the hotel, Mary Beth took his empty chair. She spoke to her son. "You watch your sisters. Mommy's talking." She leaned over to Abby and grinned. "So, you and Reese Burkett. How long has this been going on?"

"Nothing's going on, Mary Beth. I live in Atlanta. I'm just here to help out my father. Reese was kind enough to invite me to the parade."

Mary Beth was still smiling. "You sort of had a crush on him in high school, didn't you?"

Had it been that obvious? She and Mary Beth hadn't been close friends. Abby avoided a direct answer by chuckling. "What girl at Key West High didn't have a crush on Reese?"

"True," Mary Beth agreed. "But I'd definitely like to see him get lucky one of these days."

Get lucky? Did she mean that the way it sounded? "I wouldn't count on him getting lucky with me," Abby said.

Mary Beth shrugged. "You can never tell, huh? Reese deserves some happiness. That ex-wife of his—I met her, and she wasn't like all of us here on the island. She was snobbish. You know the type. She came from some *Mayflower* family in Richmond. That's where Reese met her, when he was stationed in Virginia. They only went together for about two months, and got married before he shipped off to somewhere in the Middle East." She lowered her voice. "I don't think Reese really knew her all that well. It's a shame."

Abby couldn't resist the opportunity to get information about Reese's ex-wife. "Did you hear why it didn't work out?"

"Well, sure. From a reliable source. His wife had two miscarriages. She blamed both of them on Reese."

"On Reese? Why?"

"She didn't approve when he re-upped for a second term in the navy. She said if she hadn't been so worried about him serving overseas, she wouldn't have lost the babies." Mary Beth snorted. "It's ridiculous, of course. A good wife doesn't put that kind of pressure on her husband, especially when he's serving his country."

Abby tried to be fair to the former Mrs. Burkett. She helped so many young women that she'd witnessed heartache in many of its forms. "Some women are more fragile than others," she said. "If she missed Reese, if she was concerned for his safety, that might have played a role."

"Whatever," Mary Beth said. "I just see how Reese is with my children. He loves kids. He'd be a great daddy. It's a shame he hasn't had any of his own."

CHAPTER ELEVEN

HEAT CREPT INTO Abby's cheeks. She focused on her lap as the sounds of people laughing and carols coming from businesses lining the street faded. In her heart, she knew Mary Beth's words were true. Reese would make a wonderful father.

He came out of the hotel and handed over a plastic glass. Abby took it without lifting her eyes.

"Hey, you okay?" he asked.

She blinked away blurry images of Christmas lights and raised her face. "Of course."

He pointed to her drink. "Sorry, no umbrella, so if it rains, your beer will get wet."

She smiled. "I'll manage."

Reese and Mary Beth argued over who should get the chair, with Mary Beth convincing him that mothers of young children didn't need chairs anyway, since they were always on their feet. "Besides, we're going up the street so we can be first in line when Eddie shows up." She beckoned her children to her. "Come on. Let's go see Daddy." Before she left, she spoke to Abby. "We have to get together while you're here. On a school day, of course."

"That would be fun," Abby said, and watched her move up Duval toward the head of the parade, which was making

its way down the street. She and Reese sipped their drinks as pirates, mermaids and celebrity look-alikes from one of the nightclubs strutted in front of them. Color and glitz and holiday spirit, island style. They all contributed to helping Abby relax again.

"So, does this make you homesick?" Reese asked her after the Methodist Church choir strolled by, singing traditional carols.

"It's nice, and yes, in a way." She smiled. "I didn't know Elvis and Barbra Streisand would be here."

"They haven't missed a holiday parade since I've been back," Reese told her. "But at least we've got a little of everything." He turned his attention to a souped-up pickup pulling a silver-and-red speedboat on a shiny trailer. "Here comes Dad," he said. "He's got the Fighting Conch cheerleaders in elf costumes."

Abby waved at Frank before pointing to the vintage convertible behind. "There's Eddie."

Grinning and nodding along with the mayor, Eddie motored by at a leisurely pace. "I guess you can see that Mary Beth is a pretty good cook," Reese said.

Abby laughed. "Eddie looks less like a forward on the basketball team and more like a defensive lineman."

The last parade entry arrived in a candy-apple-red Cadillac convertible driven by a man with reindeer horns. "Thank goodness," Abby said, smiling at the jolly, whiskered man in the red suit sitting on the ledge of the backseat. "After seeing that fake Santa in the hula skirt, I was worried the real one wouldn't show."

"He always does," Reese said. "Although I usually feel a lot better when he arrives in traditional costume."

Santa threw candy canes and Mardi Gras–style beads

from a bag in his lap. When he drew alongside Abby, he reached in, took out a big handful and tossed them onto the sidewalk in front of her. "Merry Christmas, cupcake," he called, and winked at her.

She stood up, feeling almost as excited over seeing Santa as she had when she was a child. "That's Uncle Phil!"

Reese knelt to gather her booty and said, "Sure is. The holiday committee picked Phil to play Santa this year."

"I'll bet Poppy doesn't know."

"It's my guess he doesn't. No one would tell him for fear he'd come down here with a paintball gun and blast Santa's suit."

Abby couldn't argue. Huey definitely would do that—or worse. "Uncle Phil makes a great Santa."

"Yes, he does, but your dad would make a better one. Wouldn't need any padding."

Abby laughed. Imagine—Huey as Santa. Once the guest star had progressed the rest of the way down Duval Street, the crowd began to disperse. People walked by, many of them stopping to talk to Reese, a few even staring at Abby for a moment and then recognizing her. She chatted with the local beautician, who still did Loretta's hair, the owner of an ice cream stand where Abby had worked on weekends, and one gangly fellow who'd grown much more handsome since he'd been her lab partner in chemistry class.

By the time Reese folded the lawn chairs, Abby was more content than she'd been in days. Perhaps she could attribute this feeling to a couple of glasses of beer. Or perhaps to the people from her past who accepted her back on the island with grace, even enthusiasm. Or maybe the man smiling down at her was responsible.

Whatever it was, she almost said yes when he asked, "You want to go back to my house?"

She could picture them sitting together on a butter-soft leather sofa. Reese would have leather. He might even light a fire. She'd seen a white brick chimney sticking out of his tin roof. He would offer her something to drink, maybe suggest a movie. It was a perfect evening for two people in love, or even two people who considered the possibility. But certainly not for Abby Vernay and Reese Burkett. Such a scenario wouldn't work for the man Mary Beth had said would be a great father and the woman who could likely break his heart now with one confession.

She looked up at him. "Actually, I think I'm hungry."

She imagined a flash of disappointment in his eyes. Or perhaps it was only his way of reacting to a change in plans. "I could eat," he said. "How about the Pirate Shack? We'll avoid most of the tourists by going there."

The Shack was crowded with locals enjoying the festive atmosphere. Gold garlands hung above the bar. Lights shaped like chili peppers draped from the ceiling. And an eight-foot pine tree sparkling with large multicolored lights and decorated with all sorts of pirate paraphernalia stood in a corner.

Reese stopped to talk with friends. Abby spotted her mother across the dining room and hurried over to tell her she'd loved Phil as Santa Claus. Loretta had three strings of beads around her neck. Abby fingered one of them and smiled. "So Santa made a special stop here."

"No, I took off a few minutes and went to see him. He made an adorable Saint Nick, didn't he?"

"You bet. The kids loved him."

Loretta smiled at her daughter. "Is this an official date?"

"Reese is calling it that."

Loretta smiled. "I've always trusted his judgment."

Abby smirked. "Have you got a free table or not? We're famished."

She led Abby to a table for two near the bar, and waved at Reese. "Hurry up, honey, before someone grabs your seat."

He claimed the chair across from Abby.

"So what'll you have?" Loretta asked.

Reese ordered a grilled chicken sandwich, fries and a beer. Abby ordered a salad and iced tea. A half hour later, Reese popped the last fry into his mouth and washed it down with the remaining ounce of beer in his frosted mug. Abby's plate was still half filled with salad, but she knew she couldn't eat another bite.

Something about sitting across from him, watching the animated play of his features as he talked about his job, his dog, his experiences as a fishing guide, made her think less about food and more about the kind of man he was. Forget handsome. Reese was definitely that, and he always had been. But she was learning now that he was also interesting, adventurous, knowledgeable about many topics.

And Abby was beginning to worry about how she would put the emotional brakes on something that shouldn't be happening at this stage of their lives. Maybe he didn't feel the same about her. But what if he did? Their relationship was based on deception.

Loretta returned to their table. "You guys finished? You want coffee?"

Reese waited for Abby to decline, then called for their tab and laid bills on the table. Five minutes later, after asking Phil if he could leave the lawn chairs for a while, he

escorted Abby to the door. "Again, it's close enough to walk to your house," he said as they stepped onto the sidewalk.

Groups of tourists still meandered down Duval, a block away. Many shops remained open after ten o'clock. *'Tis the season,* Abby thought. *Rake in the bucks while you can.* She couldn't blame the storekeepers. She'd seen the official population of the island on a promo poster at city hall. With only twenty-three thousand permanent residents, Key West businesses couldn't survive without tourist dollars.

She and Reese headed toward Southard Street. After a few steps, he casually draped his arm around her back, his fingers curled over her shoulder. She resisted the urge to lean against him, determined not to let herself become used to the feel of him, protective, caring…and most of all, she reminded herself, temporary.

They reached the house after about a ten-minute walk. Abby stopped at the wrought-iron fence she'd recently sanded, and commented that the outside Christmas lights were still on, as well as several interior lights. "Poppy's home," she said.

"I imagine," Reese stated. "It's nearly eleven."

She kept her attention on the house a moment before facing him. She felt as though she was on a first date again, poised at the front door. Should she duck inside, wait for a kiss, hope for more? "Thanks for suggesting the parade," she said. "I had a great time. It was nice running into old friends."

He held her elbows. "You know what they say—old friends are the best."

They stood like that, in a sort of tentative embrace, neither one moving, neither talking, until Abby said, "Well, good night."

Reese didn't let go. "I've changed my mind about the coffee."

"What?"

"I said I didn't want a cup, but now I do."

"That was back at the Pirate Shack."

"True, but I'm assuming the Shack isn't the only place a guy can get coffee."

She smiled. "No. We have coffee here. I can fix a cup and bring it to you in the backyard. How does that sound?"

"It sounds like what I wanted to hear."

"You go on. I'll meet you." She went in the house, looked for Huey and decided he must have turned in. Relieved, she prepared the coffee and carried it to the yard, where Reese was seated on a wrought-iron bench in the shadow of a thick bougainvillea. The garden was pleasant at night, with the breeze carrying tropical scents, and the darkness hiding Huey's now infamous fire pit.

Reese took the drink from her and slid over, giving her room to sit next to him. "You didn't want a cup?"

"No."

He set the mug down on a table by his side. "Me neither. I never drink coffee at night."

"But you said—"

He put his arm around her and pulled her to him. "I remember what I said. I was desperate."

"For what?"

"I think you know." He lowered his face and brushed his lips over hers.

Abby resisted, as she knew she should. A groan of protest came from her throat. She attempted to push him away. Reese would have none of it. He held her tighter, one hand on the small of her back, the other gently massaging

her side under her rib cage. He deepened the kiss, sliding his tongue over her bottom lip.

And Abby felt as if she'd spent the day on the beach under the hot sun. Her skin warmed, her internal temperature spiked. The sensible voice in her head that had been telling her to stop suddenly became the reckless voice of the teenage girl who had hoped to find her dreams come true on a Key West beach. *Oh, hell, Abigail, you know you want this,* the voice now said. The inclination to argue fled as Abby wrapped her arm around Reese's neck, sighed against his mouth and opened to the thrusts of his tongue.

Reese made a sound that was a combination of a chuckle and a moan, purely male, dominant, playful…and effective. Abby's senses focused on his tongue, his lips, her own heartbeat and finally on the hand that strayed up her midriff until his thumb teased the bottom of her breast. She leaned into him, inviting him to explore every tingling inch of her mouth. He complied, running his tongue along the insides of her cheeks, the ridges of her teeth. He curled his fingers over the scooped neckline of her sweater, his blunt nails tantalizing her flesh.

She gasped, pulled away to catch a breath and allow logic to prevail. "Reese, we can't do this," she mumbled against his warm neck. "We're outside my father's house, for heaven's sake!"

He lowered the red fabric over her shoulder and pressed his mouth into the hollow of her collarbone. "We should have gone back to my house. Rooster minds his own business."

She sputtered, half laughing, half breathless. "What if Mrs. Howell—"

He interrupted, his lips still nuzzling her skin. "Edna

Howell may live alone now, but she has nine grandchildren. I think she'd understand."

Abby gently pressed her palms against his chest. The time wasn't right no matter how good his lips felt on hers. He sat back, his eyes intent on her face. "No, huh?"

"No."

"So what *should* we do?"

There was no kidding herself anymore. Abby was on the brink of a decision that would change Reese forever and permanently alter his opinion of her. The old excuses just didn't work. She liked him. Too much. And more, she admired him. And if she wanted to continue seeing him this way, she had a responsibility to tell the truth. If she didn't, then she had to say goodbye to him. It was the only thing to do, the moral thing to do. And she had avoided the moral thing for too long.

But there was still ground they hadn't covered, and it was time they did. Abby needed answers before she revealed everything. She needed to know Reese to the depths of his soul. It was the only way she could be sure that she could trust him as the guardian of information both intimate and life changing.

"Reese, I heard something tonight," she began.

His eyes widened. "Oh. For some reason this doesn't sound good."

She smiled. "Mary Beth told me a little about your marriage."

His expression sobered. "She shouldn't have. It's not that I have any dark secrets, but if anyone should be discussing that part of my life, it should be me."

"I can't argue that, but now I know, and it makes me curious."

"Okay. What do you want to ask me?"

"About your wife's miscarriages…"

He lowered his gaze to his lap. "Oh. That's not easy to talk about."

"I understand, and you're certainly not obligated to tell me anything. But I am in the baby business, in a way. And as you said the other night, we are connected. I'd like to understand what happened."

He remained silent for a long minute, until Abby began to worry he was shutting her out. Finally, he exhaled deeply and said, "She claimed it was stress. That she lost the babies because she was going through the pregnancies alone."

"Stress is often a major factor in pregnancy. An expectant mother has to consider a lot of things." Abby touched his arm. "Not all pregnancies are happy ones."

He shrugged. "Ours were," he said. "At least, I believed so. Back then I had a hard time accepting stress as the reason we lost the babies. I'm a guy, Abby. Guys deal with stress by swinging a bat harder or waxing their cars."

"I'm glad that works. But women are different. We tend to suffer more physical effects."

A muscle worked in his jaw. He clenched his hands together. "My mother used stress as an excuse once," he said. "She said my dad's career was affecting her health. My father did what he thought a good husband should do. He gave in to her demands." Reese stared over the yard. "I think he's regretted it ever since.

"Rachel didn't want me to reenlist. I did anyway. I wasn't ready to leave the navy. Maybe I was selfish. Maybe I was recalling what had happened to my dad."

Reese shifted on the bench and looked at Abby. "I would do it differently now. I would listen, try to understand. If I

had known that both babies—" He stopped, blinked hard. "I think about them a lot. What sort of kids they would have become. If I thought I was responsible in any way…"

"Sometimes miscarriages just happen and we can't determine the cause," Abby said. "There can be abnormalities in the baby's chromosomes, hormonal problems, any number of reasons."

He didn't speak, but she could tell he was listening.

"Where is Rachel now?" Abby asked.

"Remarried. Happily, I guess."

"Children?"

"Not the last I heard. When she told me she would never endure another pregnancy again, I suppose she meant it." He frowned. "It was the major reason we broke up. I don't believe that Rachel was ever cut out for motherhood."

"And you wanted to be a father?" Abby asked.

His eyes softened. He smiled. "Still do."

Abby's heart squeezed. Her voice trembled when she said, "You'll make a great one."

"Thanks." He grasped her hand. "Need to find someone who'd make a good mother first, though."

"You will."

He leaned over and kissed her gently. "You know, Abby, I never talk about this. It's a part of my past, like a few others, that I always figure is best left hibernating somewhere in my brain. And I'm not a gut-spilling type of guy. But somehow with you, it seems right."

He brushed a strand of hair from her forehead. "Maybe it's the counselor in you." He stared at her a moment and then kissed her again, harder, needier. When he drew back, he said, "But that's not it. Something's going on between us. Do you feel it?"

She touched his face and her fingertips tingled. There was a bond; she couldn't deny it. But most of all she felt the connection in the familiar ache inside her, which had never gone away and was only stronger now. At the same time her heart was expanding every second, finding room for Reese in a whole new way. But to let him in, even if only until Christmas, she had to do what was right. "Yes," she said.

He took her into his arms and kissed her temple. "So, what'll we do tomorrow?"

He was making plans. A smile stretched her lips and she leaned against him. And then the light came on above the small service porch entrance.

"Abby, you out there?"

Reese laughed, withdrew his arm. "It's the curse of a guy's life," he said. "If it's not one damn porch light, it's another."

"I'll be in soon, Poppy," she called. "I guess we'd better call it a night," she said to Reese.

"Right." He got up, strode across the yard and stopped at the side of the house. "I'll see you tomorrow." Then he grinned at her. "But for the record, I'd call it *quite* a night."

CHAPTER TWELVE

SOMETIMES REESE'S neighbors irritated the heck out of him. Like this morning. It was Sunday, his day off. He'd gotten up at nine, walked Rooster, and then driven down to Martha's for coffee and doughnuts. When he returned, he'd phoned Abby and arranged to pick her up at eight. He was giving Rooster a snack when Bud Chambers called. If Huey Vernay was the most stubborn old-timer on the island, Bud was second. And Ralph Fresco was third.

Once, Reese had considered both Bud and Ralph his friends. Now, after two hours of negotiating hell, he didn't figure he was either man's friend any longer. And he wished he hadn't answered the phone.

"I'm not working today," he'd told the elderly man.

"But I need you over here. I don't want just anybody from the police department, Reese. I want you. You've got to arrest Ralph."

Since Reese had known Ralph for twenty years, he drove to Olivia Street to determine what all the fuss was about.

The evidence had been clear. A two-pound brick had broken the window of Bud's classic Victorian five-bedroom house. The damage hadn't stopped there. The brick had landed on an antique parlor table, turning a supposed five-hundred-dollar hurricane lamp into shards of milk glass.

The brick matched ones used in the garden wall of the property directly to the east, which was owned by Ralph, who'd complained for months about the annoying squawks of Bud's valuable Amazon parrot.

Now a damage claim was pending. Bud had threatened to file a civil law suit against Ralph because the brick had come to rest near the parrot's perch, and Bud claimed the creature's health and mental stability would never be the same. The bird hadn't uttered a sound since. Worst of all, Reese had been forced to take sides, aligning himself against the brick thrower.

After extracting promises from both men to behave themselves until he could at least file a report, Reese went home, mistakenly thinking his day might proceed more smoothly. And then his phone rang again. He checked the caller ID and connected. "Belinda, hi."

"Hi, yourself. Did you enjoy the parade last night?" Her voice was flat, the words clipped.

"It was a great parade," he replied. "A chamber of commerce triumph."

"How did your out-of-town visitor like it?"

Figuring there was no point dancing around the underlying issue, Reese said, "So what's really on your mind, Belinda?"

"That was no tour guide act, Reese. I doubt you would have had your arm around someone who just wanted to experience the island at Christmas."

Reese considered a smart-ass answer and passed. He and Belinda got along great, for the most part. She was fun and never placed demands on his time. But he could honestly say that any wounds to his pride would have healed pretty quickly if he'd noticed her on the arm of

another guy. Obviously, she didn't feel the same way. "You're right," he said. "It was a date."

"With someone you've known for a long time," Belinda added, proving that she'd done some investigating before phoning him.

"I used to know her. We went to high school together, but I haven't seen her since before I went into the navy."

"Is it serious?"

"I can't answer that." *Though I hope it could be.* He smiled. That was the first time he'd admitted it, even to himself. "She's only been back a short while and she lives in Atlanta." This was the first time he'd faced that fact, as well. And he didn't like it.

"Look, Belinda, I'm sorry if I've upset you, but you and I have always had an understanding about dating other people."

"I thought the understanding had changed. I've been exclusive with you, Reese."

"I didn't know that." Maybe he was dense, but he'd heard of other guys asking Belinda out. He figured she probably accepted some of those invitations. Maybe he should have been paying more attention.

"Here's a new understanding, Reese," she said. "Don't call me. Have a good life."

When he heard only dead air, he stared at the phone as though it was an alien thing. "I'm just trying to have a good *day*," he said. And he was counting on Abby to make that happen.

ABBY GOT UP Sunday morning with Reese on her mind and the awareness that she was falling in love with him. Not the wild ride of a teenage crush, but a real, last-forever,

total-commitment kind of love. And loving him meant that she had to be completely honest about the past—tonight.

If she spent the day thinking about what she had to do later, she might chicken out, rationalize taking the easy route and keeping the secret she'd harbored for thirteen years. She had to keep busy until the moment arrived. So she decided to follow through on an idea she'd gotten after Huey redecorated his merchandise cart. Once the breakfast dishes were cleared away, and Huey was puttering around in the yard with Flake, Abby left to run an errand. She returned from the lumberyard a short while later and hauled the scraps she'd picked up to the back, where she set them on the porch.

Huey, with Flake, opened the door. "What's all this?" he asked, looking down at the stack of boards. "Did I forget to pay the electric bill? Are we cooking over an open fire tonight?"

She smiled. "No. You're going to paint." She pointed to the lumber, all shapes and sizes. "These are your canvases." She showed him an artist's supply box she'd left on a shelf. "And I found your oils in the back of your closet. You used to produce some pretty nice work."

If he was angry, she couldn't tell it. In fact, he seemed intrigued. "What makes you think I can paint anymore?"

"I saw what you did with the merchandise wagon. Very nice."

He smiled. "It is, isn't it?" He took the artist's box from her hand. "What subjects am I supposed to paint now?"

"This island. The gardens, the old buildings, the Hemingway six-toed cats, even the chickens that roam around downtown. Paint any nook and cranny that strikes your interest."

"So you believe I have talent?"

"Poppy, I believe you're a creative genius. And it's time everyone else around here discovered it. And paid for it."

"You think I can sell these?"

"I do. We're going to add a new board to the wagon." She made an arc with her hand. "Huey and Flake's Tropical Art Gallery."

He chuckled. "Got a ring to it."

She picked up a gallon of red paint she'd also bought, and held it out. "And while you're at it, I want you to think about painting the old dog cart in the carriage house."

"Why would I do that?"

"Because it needs it. We can repair the leather and polish the brass. Restored, that carriage would look great by the veranda."

He stared at the can of paint. "And you want this color?"

"I studied the cart. The side panels have traces of red. So why not? It's Christmas and—"

"Oh, swell." He mimicked a woman's voice. "It's Christmas. Let's all be jolly."

She laughed. "You can start your first painting whenever you want. You'll have the house to yourself tonight."

"Burkett again?"

She shrugged.

"You and Burkett. A dog in my life. My possessions gone to pay taxes. And pretty soon a shiny red dog cart in the yard. What's my world coming to?"

"A new beginning for a new year," she said, and headed for the back door. She stopped before going in, and grinned at him. "Don't forget to sign each painting. I consider these works of art my inheritance."

He leaned over and spoke to Flake. "Poor girl. A Vernay original and a dollar bill will get her a cup of joe at Martha's."

REESE WAS SUPPOSED to pick Abby up at eight. At seven-thirty she checked her appearance in her bedroom mirror. Hair shiny and falling in waves to her shoulders. Makeup light and natural. Splashy sundress hopefully just sexy enough to help her through the toughest night of her life. Brand-new sandals framing newly painted coral toenails. Satisfied she'd primped as well as she could, she went to her car and headed to Eaton Street to waylay her date before he left his house—the place she hoped he'd feel most comfortable.

She pulled into Reese's driveway, relieved to see his pickup still parked behind the patrol vehicle. When she got out of her car, excited barking came from the little house. She ran her hands down the sides of her dress and walked to the porch. She experienced a flash of panic, and even considered an escape plan. She'd wait until she was face-to-face with Reese. Maybe she didn't truly love him. Maybe she was in love with love and had chosen her old crush as a target for misplaced emotions. There was still time to back out of this supposed commitment she'd made to herself.

Reese opened the door before she had a chance to knock. All fickleness vanished. This was no renewed crush. Her stomach dropped; her heart pounded; her hands sweated. Simply put, this felt like love.

"You look fantastic," he said. Desire flared in his appreciative gaze.

She swallowed. *Back at ya, Reese.* He was dressed in a

silky Havana shirt, which hung loosely over dark slacks. His hair was damp. A few strands fell onto his forehead. His smile brightened his entire face. She muttered something that sounded like, "Thank you."

"I was supposed to come to your place, right?" he said, pulling the door wide.

"Yes, but I thought we might change our plans."

His expression was blatantly hopeful. "Really? How so?"

"Do you mind if we stay here and have a drink, and I'll treat you to dinner later?"

He followed her inside. "I'm game."

She stopped in the middle of the living room. He was there, near enough for her to touch, to smell, to feel the heat radiating from his skin. He cupped her chin, tilted her face up and kissed her. "My mind's running away with me, Abby. Does this mean what I hope it means?"

Her defenses crumbled. She wrapped her arms around his neck and returned the kiss. Her desire for him was almost desperate, a blend of her passion and her fear. His hands splayed across her back, and he pulled her to him, their bodies as close as they could get, her breasts pressed against him. The kiss went on forever, deep, hungry, committing them to more.

Somewhere in the back of Abby's mind, a voice broke through the delicious haze to tell her this was wrong. That it was backward. She was beginning where she'd planned to end. She had to talk first. Though she felt dizzy, alive, heavenly, she could no longer kid herself. She'd wanted this to happen since she'd first seen Reese in the yard at her house—and since that night thirteen years ago. But if they were going to make love, which Reese seemed to want as much as she did, she had to be honest first. She

stepped back from him, brushed her fingertip over her moist lips. "Reese, we have to talk."

He blinked. "Not my first choice." His voice was thick, husky.

She took his hand and led him to the sofa by the fireplace. A small Christmas tree twinkled with colored lights in the window nearby. Rooster, his head on his front paws, lay on the soft braided rug covering the hardwood floor. Tears burned Abby's eyes. This was a scene of total contentment. The fulfillment of a dream.

They sat. She swiveled to face him, tucked one leg under herself and clasped her hands in her lap. Reese smiled. "If we're really going to talk," he said, "can I go first?"

Abby drew her bottom lip between her teeth. What was this? Was he going to say something that would change the course of this evening? Had she read the past minutes all wrong? Did he not care as much as she believed he did? Insecurity bombarded her. She tried to smile, but her lips trembled. "Sure, go ahead."

He clasped her hand and gently massaged her knuckles with his thumb. "I ran into Undertaker today. Remember him from the ghost walk tour?"

She nodded.

"We talked for a while. I asked him how business was. He said it was great, but he'd like to have more stops on his tour. When we went our separate ways, I suddenly had this idea that might help solve some of Huey's financial problems."

"You did?" She acknowledged the irony of them both thinking of ways to help Huey today. Of course it was natural for her to want to help her father. But Reese had no such obligation. "What's your idea?" she asked.

"What if Huey became part of the ghost walk tour?

Vernay House could be added to the list of places the group visits. He could wear a costume from the period and pose as the reincarnation of Armand." Reese grinned. "And get a cut of each ticket price."

Abby thought a moment. Would Poppy agree to such a public display of his family's history? She decided he might. She could easily picture him dressed as a prosperous nineteenth-century ship captain in waistcoat and breeches. He could wear Armand's top hat and carry the ebony cane they'd found in a trunk in the attic.

"Huey could stand on the front porch while the tours stopped," she said. "We could add some low lighting, special effects, background sounds. Poppy could moan and appear tortured by his past, repentant and frightened at the same time."

Reese chuckled. "Huey repentant? I'm not sure how that would work."

"He would love it. This would be perfect for him. I'll ask him. What would be the next step?"

"I'll talk to Undertaker. I'll bet he goes for the idea, too. On their brochures they could advertise that an actual descendant of Armand Vernay was portraying the old man. Seems like a win-win situation to me."

"Reese, this is fantastic. Finally, the history of Poppy's house could benefit him. I don't know how to thank you."

He kissed the tips of her fingers. "You don't? A few minutes ago you were already beginning to."

A few minutes ago, when everything was wonderful. Abby withdrew her hand and dropped it to her lap. She considered not going through with her plan. This evening had started out so well, so brimming with hope.

Reese lay his palm against her temple. "Hey, what's the matter?"

"I was just so wrong about you. When I first got here, I thought you wanted to put Poppy in jail. That you wanted to teach him a lesson. I know he can be difficult…"

"Abby, I can't tell you I wouldn't have arrested Huey had he deserved it. But I wouldn't have gotten any pleasure out of doing so."

"I realize that now."

"Then something else is wrong. What is it?"

She blinked, considering her words carefully. "Reese, what I came here to tell you tonight is important. And when you hear it, this relationship we've established in the past days will change."

His brow furrowed with concern. "Okay. Change can be good. Did I do something to upset you?"

"No. I'm afraid it's going to be the other way around." Her language didn't nearly convey the seriousness of what she had to say, or the difficulty of saying it. His gaze was warm and comforting but did little to ease her anxiety.

"Abby, is this about what happened all those years ago?"

She could only nod. Her throat burned with what had to be said.

He stroked her face with his thumb. "I've begun to see that maybe what we did wasn't just a couple of crazy kids together on a beach. That night meant something. And means even more after all this time." He smiled. "In case you can't tell, I'm pretty crazy about you."

She looked into his eyes. "Reese, why didn't you contact me in the two weeks after it happened?"

He glanced up at the ceiling, took a breath, then refocused on her. "I wanted to, thought about it plenty, but

then I knew nothing could come of a relationship between us for a very long time. I was committed to two years of court-ordered military service. You were just out of high school. I'd heard you had a scholarship to the community college." He smiled. "You were so smart, Abby. You were going to make something of your life. I was in big trouble and searching for a way out of here. We were two lives crossing at the wrong moment." His eyes darkened. "I was not, in any way, the man a sweet girl like you deserved."

A sweet girl. Abby closed her eyes and moved away, putting space between them. "I tried contacting *you,*" she said.

"When was that?"

She looked up at him. "Two weeks after that night. I went to your house. Your mother told me you'd left that morning." Abby's voice shook. "I was…surprised."

"Yeah. My departure was sudden." His eyes narrowed. "Mom never mentioned that you'd come by the house."

"She said you would be difficult to reach, that the rules of basic training prohibited a lot of contact with the outside. I waited a couple of days and then I tracked you down in Pensacola. I got the phone number of your barracks."

His eyes widened under arched eyebrows. "You did?"

"The man who answered didn't know you. He said there were over two hundred new recruits. But I left a message for you to call me."

"I never got it." He paused, obviously struggling to remember details. "We had a large corkboard where all phone messages were posted. I'm not surprised that some of them got lost. It wasn't a very good system. What did you want to tell me?"

In his eyes, she saw only a profound regret for the missed communication. Her heart squeezed painfully. At the time, she'd almost experienced relief that he hadn't called back. His insensitivity had hurt, of course, but it also freed her to pursue her plans to go to college and build a new life away from the island.

The question he'd just asked hung in the air. She'd come this far, and had to answer. Otherwise there could be no future for them. But the admission might have the exact same consequences. She swallowed and said, "Reese, I was pregnant."

His lips moved as if he were trying to form words. At first, none came. He stared at her, until he filled his lungs and uttered, "You had a… *We* had a…"

She squeezed his hand. He let her, but there was no warmth flowing between them anymore. The connection had been lost. "There's so much to tell you."

His stern gaze remained on her face. "Did you have the baby?"

"Yes. A boy."

His shoulders sagged, erasing the stiffness of a moment earlier. "My God, Abby. We have a son."

"It's not that simple."

His hand jerked in hers. "Where is he? Is he all right? Healthy?"

"Yes, he's fine."

Reese's lips twitched, as if he might smile through his shock, but then realized he didn't have all the facts yet. She couldn't let him feel any joy in this admission. She raised her hand. "I put him up for adoption, Reese," she said. The decision that had made so much sense thirteen years ago sounded hollow and cold and self-serving tonight.

"You what?" His eyes narrowed. "You gave him away? Without contacting me?"

"I just told you. I tried to. I went to your mother. I left a message…."

"That's it? One conversation with my mother. One phone call."

Her mouth went dry. She swallowed. "Your mother said you couldn't come back here, that you would be arrested."

"Did she know why you needed to reach me?"

Abby shook her head. "I didn't tell her. I never told anyone outside my family. Weeks passed and I had to make a decision. Poppy wanted me to…" She paused. She hadn't considered abortion then, so why bring it up now? "I just needed to get off the island before my pregnancy became obvious. I had to be where I could think clearly."

He listened stoically, but his face was blank, like a stone mask.

"In the end, my mother went with me to Orlando, where we both got temporary jobs. I worked in an office until the baby came. I'd already signed the papers with an adoption agency, so on the day of the birth, my son…the *infant*…was taken away. I enrolled in the University of Central Florida in Orlando, and once my mother knew I was determined to stay there, she returned to Key West."

Abby paused, waiting for his reaction to a story told in a few simple sentences.

"That's all you have to say?" Reese's voice was practically a growl. "Unwanted pregnancy. Girl runs away, gives birth, hands baby over to strangers." He raked his fingers through his hair. "End of story?"

No, it wasn't the end. There was so much more.

"I was able to approve the selection of parents," she said.

"They were wonderful people in their late thirties. The baby was their only child. They'd been trying to conceive—"

He held his hand in front of her face. "Stop it, Abby. Do you honestly believe it makes any difference for you to spout the virtues of the people who took possession of my son? What do you want me to say? Thanks, Abby, for turning my child over to kind strangers instead of monsters?"

She looked away. His scorn cut deeply into wounds that had never healed. "No. I just thought you would like to know—"

"I'd like to know where my boy is." His voice was flat, toneless, frighteningly so. "I'd like to know what happened to my rights as a parent. And mostly, I want to know how I can get my son back."

Abby reached out to him, and he flinched. "Reese, please, just consider a minute—"

"How am I supposed to consider anything when all I can do right now is feel? And let me tell you how I feel. Betrayed. Swindled out of a child. That's what I'm feeling now. And when I do start thinking again, I'm going to try to figure out how to undo what you've done."

The first tears, hot with humiliation, fell to her cheeks. He hadn't had time to sort through the information, but she'd had thirteen long years. And now, added to her own countless regrets, thoughts of the other two children he'd lost filled her mind. Right now he probably didn't consider Abby much different from his wife who'd blamed him for the loss of their babies. But Abby reminded herself that she had felt compelled to be honest with him, so he knew where he stood. "Reese, there's nothing that will undo what's been done."

"The hell there isn't." He rose from the sofa and began pacing. He hurt physically. In the pit of his stomach, in his constricted lungs. He stalked from one side of the room to the other, but the area was too small. He clenched his hands, feeling the skin over his knuckles stretch taut. Something had to give. He was going to explode. Fifteen minutes ago he'd have sworn he loved Abby Vernay. Now he didn't even know who she was.

Her voice penetrated the buzzing in his brain. "Have you ever heard of Florida's putative father registry?"

He stopped, glared at her, trying to connect the image of her face with the one he'd been sleepless over for days. He was aware of the registry, but he'd never dreamed it could apply to him. The putative father registry required that any man who slept with a woman and believed a pregnancy could result must include his name in a statewide database of single fathers. Then he would be notified in case adoption proceedings were initiated.

That was all Reese knew about this ridiculous piece of legislation. As if every guy who slept with a woman would add his name to the database in the unlikely event a baby resulted from careless sex. He doubted one guy in ten would do that. But on the chance he might learn something, he said, "Yes, I've heard of it."

"Then you know that you would have had to register as the father of any child who could have resulted from the one night—"

"That's bull, Abby. The registry is useless."

"No, it isn't. It's designed to protect the anonymity of the mother."

"That and any law can be challenged," he said.

"Reese, thirteen years have passed. The child is twelve

years old. Other men have fought the system with regard to much younger children, without success."

"How do you know so damn much—?" he asked as an undeniable truth hit him with the force of a punch. "Of course," he said, his voice unbelievably controlled. "Your job. You work for an adoption agency. That's no coincidence, is it, Abby?"

She flinched.

"You took a job that would assuage your guilt over what you did. By placing other kids with homes, you tried to compensate for what you did to me."

She didn't speak, but he could see in her wide eyes that he'd hit a nerve, uncovered a truth that maybe she hadn't realized. Well, good. She'd played with his life, and no amount of self-examination would take the blame from her shoulders. "Does Huey know this?" he asked.

She nodded slowly.

Reese stared at the Christmas tree until the lights blurred into a garish concoction of colors. "No wonder he's hated me all these years. I knock up his daughter, take off for the navy and she leaves."

Abby sobbed. "No, no, it's not like that. Huey knows about the baby, but he's aware that I never told you. I swore him to secrecy. Like I said, no one knows except for my family."

"And now the father," Reese said bitterly.

He picked up her purse from the floor by the sofa and handed it to her. "I have to go somewhere and you're parked behind me."

She looked as if she might speak, but wisely didn't. He was in no state to hear anything else she might say. She tucked the purse under her arm and headed for the door.

"Wait a second," he said. "Maybe with all that adoption knowledge you have, you can tell me how to find my son."

Her face paled. "Reese, don't…"

"Well, do you know? Do you know where he is?"

She stood at the door, her eyes downcast, her hand on the knob.

Hell, yes, she knew. "So you won't tell me? You can't do that after what you've done?"

She twisted the knob. "No, I can't." She opened the door and stepped into the darkness.

As soon as Reese heard her car pull out of his drive, he grabbed his own keys and went to his truck. Next stop, the stilt house by Burkett's Paradise Marina. It was late. He didn't care. He had to find out who knew what about the child Abby was determined he would never see.

CHAPTER THIRTEEN

REESE CLENCHED the steering wheel until his knuckles ached. His nerves thrummed with anger and frustration. He needed someone to blame for how he felt. Someone besides Abby, because in spite of hearing the confession from her own lips, he still couldn't believe she'd done this awful thing.

Abby had gone to his mother back then, but she claimed she hadn't told Ellen why she'd wanted to contact him. That didn't mean that Ellen didn't know. Ellen Burkett had radar that defied logic.

The living room lights were on in his parents' Gulf-side home. Reese climbed the twelve steps leading to the front entrance, and knocked on the door.

His mother answered, wearing a pair of silk lounging pants and a knee-length robe. Her dark straight hair lay flat against her scalp, lacking the benefits of whatever product she used to style it. She seemed surprised to see him. "Reese, my goodness. Why didn't you use your key?"

She'd asked him that question countless times since he'd returned to Key West. He only used his key when checking on the place if his parents were on vacation. He maintained a separate address from them for many reasons, privacy being the main one, for them and for him.

"I forgot to get it from the kitchen drawer," he said, to avoid a pointless discussion.

She pulled the door wide. "Well, come in. It's ten o'clock. Is something wrong?"

"You could say that."

The volume on the television lowered and Frank called from the living room. "Who is it, Ellen?"

"It's Reese."

A few seconds later, his dad appeared in the hallway, wearing creased pajamas. Ellen Burkett was meticulous about everything, even ironing clothes no one but her husband would see. "Hello, son. Didn't expect you to drop by at this hour. Everything okay down at the station?"

"Yeah, fine, Dad." He explained that he wanted to speak to his mother, but there seemed no way Frank was going to retreat to the TV screen. "Let's go into the kitchen," his father suggested. "Ellen, you can put on a pot of coffee."

"No, thanks," Reese said. "This isn't a social call."

"Are you in trouble?" his mother inquired. It was a conclusion she'd jumped to often in his youth.

"Not that I know of," he replied.

They all went to the spacious kitchen, where Ellen started making coffee anyway. When the machine gurgled into action, she sat down at the table with the two men. "Tell us why you've stopped by, Reese. You have me worried."

"I've just been with Abby," he said.

His mother frowned. "Oh," she said flatly. "So you chose to ignore my advice."

He didn't respond to that. "She had some disturbing news."

"Has something happened to Huey?" Frank asked.

"No. Huey's fine. This has to do with what happened

thirteen years ago." He stared at his mother. Her lips were pursed. She was already thinking back, deciding whether what he was going to say would affect her.

"Mom," he began, "Abby told me she came to see you after I left for Pensacola."

She finally focused on his face. "Really? I don't recall. Of course, that was so long ago…."

Frank sent her a piercing look. "I remember," he said. "I'm surprised you could forget that visit, Ellen. We'd just taken Reese to the airport, and Abby and Loretta came by that evening. I asked later why they'd stopped by. You said it didn't concern me."

She glared at her husband. "I would think I'd remember that, Frank. Loretta and I weren't friends. We didn't seek out each other's company."

Reese shifted in his chair. "Abby said she asked you how to contact me."

Ellen appeared thoughtful. "Did she? That might have happened. I'm sure I didn't give it much importance at the time."

"So you do remember?"

"Vaguely." She got up, went to a cupboard and retrieved a sugar bowl. "Why does it matter?"

"Do you recall telling Abby that I couldn't be contacted?"

Ellen busied herself with getting cups from the china hutch. "I can't tell you what I did last week, much less thirteen years ago," she replied.

"Mom, you can remember what I wore the first day of kindergarten."

Frank chuckled. "He's got you there, Ellen."

She set a saucer in front of her husband with a clatter. "That's ridiculous."

"Come to think of it, Ellen, I don't know why you were so secretive about that night," he said.

"I don't tell you everything, Frank."

Frank's lips thinned. He sat back in his chair and stared at his wife.

Reese shifted his attention to his mother again. "Do you know why Abby came by that night?"

Ellen picked up the coffeepot and brought it to the table. "I honestly don't remember. My goodness, this sounds like an inquisition."

Frank lifted his cup so she could pour. "Reese is just asking a few simple questions, Ellen."

She glared down at her husband as she filled his cup. "Okay, fine. It's not surprising that I can't recall details about something that didn't seem important. That was an anxious time for your father and me, Reese. We had just moved mountains to get you out of trouble. I didn't see how anything Abby had to say would help your situation."

Reese considered that answer for a few seconds. "Let me add one more explanation," he said. "You didn't want me to have anything to do with Abby, then or now."

"All right, Reese. I won't deny that. But mostly I wanted to protect you. That's what parents do. I had suspected for some time that Abby had a crush on you, and if she wanted to reach you… There was that one night…"

Reese raised his hand. "Mom, don't."

"Fine, but if Abby wanted to reach you about some childish schoolgirl nonsense, I wanted to prevent it. I warned her what would happen if you came back to the island."

Reese tried to imagine how Abby must have felt that night, struggling with an unwanted pregnancy, getting no

cooperation from his mother. Still, that didn't excuse her for the devastating choice she'd made.

"You should have told me that she was trying to get a hold of me," he said.

"For what purpose? The Vernays are opportunists. Always have been. It wasn't enough that Huey tried to blackmail your father—"

"Ellen!" Frank rose, hitting the edge of the table and spilling coffee over the side of his cup. "We agreed that Reese would never know—"

"*You* agreed," she said. "I never did. And the other day I told him. It was time he knew what the Vernays are capable of."

Frank cast pleading eyes on his son. "It wasn't a lot, Reese. Huey had lost another job and he was desperate. I would have given him the money if it meant he could put food on his family's table." He absently wiped up the coffee spill. Force of habit. "I wasn't happy when Huey went to the authorities about what you'd done," he added, "but you actually benefited from your time in the navy." He scowled at Ellen—something Reese had never seen him do. "I've all but forgotten about that incident," he said. "We all should forget about it. Makes no sense to dredge up the past."

Ellen sniffed, sat stiffly at the table again. "You're right about that," she said. Then she spoke to Reese. "Abby left soon after stopping by here. She got away from her family and made something of herself. You both went your own ways. You became a decorated naval officer. Abby had a life in Atlanta."

In his mind, Reese added, *All's well,* and nearly pounded the tabletop.

Ellen rolled her shoulders with an irritating smugness.

"At the time I couldn't imagine that any association you two might have had would be good for you. I assumed Abby was just suffering from a crush that would never have gone anywhere anyway."

Frank shook his head. "Ellen, you should have told Reese about Abby wanting to reach him. He was a grown man by then—"

"One who didn't know right from wrong," she said.

Reese stood, hoping to defuse what was happening between his parents. But he couldn't ignore a small burst of pride that his dad was standing up to Ellen for his sake. "It's okay, Dad. I've heard enough." He walked to the door.

"You can't leave like this," his mom said. "Sit and have your coffee. I have chocolate cake. Besides, you haven't told me what this is all about. Why the sudden interest in something that happened thirteen years ago?"

Convinced that his mother didn't know the truth behind Abby's visit, Reese stopped and shot her a glance over his shoulder. "Doesn't concern you, Mom."

"But…"

The last voice Reese heard was his father's. "Let him go, Ellen. If he wanted you to know, he'd tell you."

Reese gunned out of his parents' driveway. Without thinking, he detoured on his way home and drove down Southard Street. He spotted Abby's car behind Huey's old pickup. She'd gotten home safely.

He slowed as he passed the house. Only one light was on, casting a soft glow through a second-story window. Abby's bedroom, no doubt. He imagined her coming onto the balcony. What would he do if she caught him out here? He was supposed to be angry. Hell, he *was* angry. So why was he crawling past Vernay House so late at night?

He sped up, zipped around the corner. It wouldn't do for her to see him. But as he drove toward home, he realized that the sight of that one lonely light in the house made him feel even worse.

THE NEXT MORNING, early Monday, Abby received a call from Alicia Brown. Abby waited until her voice mail had recorded a message, and then got out of bed and padded to the bathroom to wash her face. She couldn't follow through on her instinct to stay hidden under the covers all day. A few minutes later, she phoned the young woman back.

"How are you doing, Alicia?" she asked when the girl picked up.

"Okay, I guess. Miss Douglas is very helpful."

"I'm glad. She's a nice lady and a good counselor."

"I saw Cutter."

Hopeful, Abby asked, "He's out of jail?"

"No, I went there to see him. He's not getting out for a long time."

"Oh. Sorry."

"He told me I was doing the right thing by giving up the baby."

Knowing that all birth mothers had to be confident and comfortable with their decision and not pressured by outside influences, Abby said, "And you're sure this is what you want to do?"

"Yeah, I am. I can't take care of a baby right now."

Concerned that Alicia might regret choosing closed adoption, Abby asked her again, "And you haven't reconsidered at least a semi-open adoption agreement?"

"No. I know a lot of mothers think that's best. They

don't want to sacrifice their baby completely, but I need to, Miss Vernay. I can't go through life just having pictures and talking once in a while with the adoptive parents. I've got to make a clean break."

Perhaps if Abby had been face-to-face with Alicia, she would have argued in favor of a more open agreement. But the girl seemed certain, and for that Abby envied her. Right now, Abby questioned her own decision to give her baby up. And she was beginning to question her ability to counsel anyone experiencing the same life-altering situation. The choice that had seemed right to her all those years ago was now fraught with doubts. And sadness.

"I'm glad you called," she said to Alicia. "You sound like you'll be okay."

"Yeah. I will. I'll talk to you again in a few days."

TWO DAYS LATER, on Wednesday morning, Abby and Huey sat on the front veranda having coffee. Though he kept studying her as if she might spontaneously combust, Huey drank with his usual gusto. Abby sipped hers cautiously, not knowing how her stomach would react to the caffeine.

Since Sunday night, she had kept pretty much to herself, only emerging from her room to encourage Huey with his painting. Without supplying details, she'd told him that she'd confessed everything to Reese. That wasn't exactly true, though. She hadn't told Reese that she'd been getting school pictures of Jamie every year, a condition of the semi-open adoption agreement she'd signed with the adoptive parents, Ron and Deborah Ingersoll.

If Reese ever spoke to her again, if he even came close to forgiving her, perhaps she would tell him, as long as he

agreed to certain conditions. But she couldn't tell him now. His wounds were too fresh. He'd been too angry, too desperate to reclaim his son. She didn't know how far he would go, and her first obligation was to her child.

Thankfully, on this beautiful Key West morning, Abby was able to push her unhappiness to the back of her mind for Huey's sake. She told him about the possibility of him joining the ghost walk tour.

He leaned back in the old wicker rocker and said, "Is this all Burkett's idea?"

"It is. He thought of it and is supposed to talk to Undertaker about it. What do you think, Poppy?"

"I don't know. If the plan came from Burkett, there must be something seriously wrong with it."

She smiled. "That's just silly."

"All I'd have to do is dress up like Armand and stand on the porch?"

"Pretty much. And I'm sure you could ad lib any way you want. And this performance would be after you sell your merchandise and paintings at the square."

He looked at Flake, who lay with his head over the top step. "Could Armand have a dog?"

"I suppose, if you kept him on a leash. Remember, if Flake bites anyone, Armand won't get sued. You will."

Huey waved off her concern. "Flake wouldn't bite anybody."

"So you're interested?" Abby asked.

"I could be persuaded."

"Well, good. Once we know how Undertaker feels, we can work out the details."

Huey grinned at her. "You don't think anybody'd be fool enough to think I was a real ghost, do you?"

"Hardly. I'm sure Undertaker will tell them you're only a representation of the spiritual being who is rumored to reside in this house." She smiled. "But I wonder… Maybe Armand will get as big a kick out of this as those folks on the ghost walk."

Huey gave her a twisted smile, as if he were seriously considering that possibility. "I guess you could thank Burkett for me, once you two patch things up."

Abby walked over to the balustrade and placed her hands on the rail. "You'll probably get the chance to thank him yourself long before I ever do."

"I'm sorry, baby girl. I wish I could do something to make this easier for you. I always said Burkett was a damn fool, and now he's only—"

She spun around. "This is *my* fault, Poppy. I hurt him."

"And you've been miserable. So what are you going to do about it?"

"I'll be fine."

"Hogwash," Huey said. "Burkett hasn't been around to see you. I guess it'll have to be you that takes the first step. You've got to be honest with yourself, though. You're head-over-heels with our police captain. And you and this situation need fixing."

Poppy was so right. "There's nothing I could say to him now."

Her dad got up from his chair. "Get your purse or whatever it is you ladies need to leave the house."

"I'm not going anywhere."

"Yes, you are. You and I are going to the Pirate Shack."

"What? You don't go to the Shack."

"I do if your future's at stake." He checked his watch. "It's nearly ten. Phil ought to be breading fritters by now."

She stared at her father a moment, decided he wasn't going to back down, and said, "If you're driving, I don't need my purse."

He let Flake in the house, grabbed Abby's hand and practically dragged her behind him to the driveway. Before she knew it, they were in his truck and on their way.

At 10:00 a.m., only two customers, die-hard local fishermen, were in the Pirate Shack, talking to Nick, who was behind the bar. When Huey and Abby came in, one of the men said, "Huey?"

"Yep, it's me."

"What are *you* doing at Phil's place?"

"None of your business." Huey spoke to Nick. "Where are—" He paused, almost as if speaking the names of his ex-wife and brother were too much for him.

Nick smiled oddly and nodded toward the kitchen. "Back there."

Huey strode to the swinging door, Abby following. "Are you sure you want to do this, Poppy?"

He pushed the door open. "No."

Phil and Loretta stopped working and stared in obvious shock. "Is something wrong?" she asked.

"What the hell?" Phil said.

Huey stood with his arms crossed. "Tell them, Abby."

"Tell them what?"

Loretta approached with a mixing bowl in her hand. "What's going on, honey?"

"I'll tell you what's going on," Huey said. "*Your* daughter is in love with Reese Burkett!"

Loretta smiled, visibly relieved. "Oh, that."

Phil walked around the food prep counter. "Really, cupcake?"

Abby stammered an answer. "I—I suppose I could be, but there are problems…."

Loretta leaned the spoon she'd been stirring with against the side of the bowl. "Has he contacted you since Sunday night?"

Abby shook her head.

"That idiot."

"Do something, Loretta," Huey said. "You're the one who let this get out of hand."

"Me? What do you think I can do?"

Abby answered for him. "Nothing! Nothing should be done. I live in Atlanta. I'm going back right after New Year's!"

Loretta set the bowl down and reached for Abby's hand. "How far has this progressed, honey? Have you and Reese…?"

Abby's skin heated to the roots of her hair. "Mother!"

"I don't mean to be nosy. It's just that sex complicates everything."

Huey held up a finger. "No talking about sex," he stated.

"No talking about any of this," Abby decided. "My rotten life shouldn't be a topic of conversation for all of you."

Phil stepped forward. "Cupcake, I love you—you know that, don't you?"

"Yes."

"Okay, then listen up. The four of us in this room, and now Reese, are the only ones who know what happened thirteen years ago. We suffered with you…" he glared at Huey "…each in our own way. We tried to support you. We went along with your decision and kept your secret. But if you've got feelings for Reese, if they're serious feelings, then you've got to make him understand. You have to show him how you felt back then. You can't give up and just quit trying."

Loretta smiled at Phil before speaking softly to her daughter. "How strong are your feelings for Reese, honey?"

Abby sighed deeply, used her thumb to wipe moisture from under her eyes, and admitted the truth. "They're pretty damn mind-blowing."

Loretta smoothed her hand down Abby's hair. "Then Phil's right. Go to Reese. Make that man open his eyes and see you for the wonderful woman you are. When are you going to meet up with him again?"

"I'm not sure. Maybe Saturday night, at the Christmas boat parade. We'd talked about going together, but that won't happen now."

Loretta smiled. "But you'll see him there. He's going to be a judge this year. And if you need any of us to go along with you to convince him…"

Abby gave her a small smile. "Heaven forbid."

Huey cleared his throat. "Have we got this settled now? Abby's going to quit sitting around the house and take action? Because I've got things to do."

Phil looked at Loretta. She shrugged. "You want a beer, Hugo?" Phil asked. "It's early, but you've earned it."

Huey's eyes narrowed. He opened his mouth and shut it again. When he answered, his voice was calm. "Sure. Why not? You're paying."

In that moment, witnessing a small miracle, Abby realized what she had to do. A risk was involved, but the possible outcome was worth it. She was going to make what would probably turn out to be one of the most important phone calls of her life and Reese's.

CHAPTER FOURTEEN

ABBY STAYED WITH HUEY at the dock until darkness had fully settled over the island. Then, after congratulating him on the sale of three paintings, she followed the trail of Christmas lights on every building from Mallory Square to the island's Historic Seaport Harbor Walk.

She passed unique decorations that made her smile. The statue beside a seashell store, a six-foot man composed entirely of sponges, blinked with red and green lights. Blue bulbs wound around a marlin above a local seafood restaurant. Someone had set a Santa hat on the metal sculpture of a seaman in the center of the harbor entrance. A large anchor by his feet glowed with red tube lights.

Weeks, maybe months, might pass before Abby managed to shake off the melancholy she felt, but for now, it was Christmas in Key West, and no place on earth quite equaled it.

She found a few inches of space among the crowd gathered along the rear patio of the Schooner Wharf Bar, the official viewing site of the boat parade. The judges and media people would be on the second-story deck alongside the bar, where they could get the best look at the boats floating by. Had plans gone as she'd anticipated, Abby

would have been up there with the parade dignitaries. Now she would have to be content with watching the pageantry from sea level.

A master of ceremonies spoke through a PA system to those gathered below. He announced the arrival of a beautiful nineteenth-century, tall-masted sailing ship, one that regularly took tourists on sunset cruises around the island. Passengers and brightly lit animated figures waved to the onlookers. Christmas carols played from onboard speakers. Every mast was entwined with white lights. The MC read a short history of the proud ship and acknowledged the skilled captain at the wheel.

Abby stepped away from the throng long enough to glance up at the deck over her head. She spotted Reese immediately. Sitting next to a cameraman from a local news show, he appeared deceptively relaxed in a ball cap and island shirt. As the clipper ship pulled away, he wrote something down—his evaluation, Abby assumed. Then he peered over the water, waiting for the next entry to arrive.

Abby slipped into the crowd again, resuming her anonymity. She ordered a glass of wine, spoke to a few people she recognized, and watched the rest of the parade. She stayed to the end and cheered along with everyone else when the top three winners were announced.

Once the judges were thanked and details of next year's parade were given, she went around the side of the bar to wait for Reese. She spotted him with a group of friends in front of the building. When the group broke up, she approached, feeling as awkward around him as she had in high school. Her palms grew sweaty. She hoped the darkness hid the sudden flush to her cheeks.

Fine lines around his eyes suggested he hadn't been

sleeping any better than she had. He stared down at her, his expression unreadable. She didn't know what she'd expected, but not this awful silence. But then, she'd turned his life upside down. She clenched her hands at her sides to keep from reaching up and touching his face. She'd hurt him, and knew she wouldn't be the one he'd want help from now.

"The parade was nice," she finally said.

"I didn't expect you to come."

"I was with Poppy at the square, and figured I'd walk down to see which boat won."

"Oh. It was Bill Peterson again."

She nodded.

Another silence stretched uncomfortably until he said, "Since you mentioned Huey, I should tell you I spoke to Undertaker."

She covered her surprise with an attempt at a smile, though she should have realized that Reese was a man of his word. "What did he say?"

"He loved the idea. Wants to start next weekend, if Huey agrees. The few days before Christmas are always big tourist nights."

"That was nice of you, Reese…." She thought a moment before adding, "After everything." She kept her tone matter-of-fact, not wanting to appear needy or pathetic. "I'll tell him. I'm sure he'll agree to it."

Reese pulled a card and pen from his shirt pocket. "I'll write down Undertaker's phone number. You can speak directly to him."

And leave me out of it, Abby ended for him. She put the card in her wallet. "I'll do that. Thanks again."

They both stood there like snowmen in the tropics, about to melt away and never see each other again. These past

moments had been awkward but not unbearable. Not sure how to proceed, she said, "I guess I'll be going then."

He stopped her. "Abby…"

The deepening anguish in his eyes broke her heart.

"I haven't exactly gotten a handle on my feelings about what you told me," he said. "I keep thinking of him…."

"I understand."

"And I can't let this go. I need to find out about him. What he looks like, what he does for fun."

She released the breath she'd been holding. Her decision to make that phone call was the right one. Reese was calm. Not exactly accepting of what had happened, but ready to hear more. Maybe even to try to understand. She nodded. "There might be something I can do, Reese. I'll be in touch."

A few days later, by Wednesday afternoon, Huey had a growing stack of paintings to sell and a regular gig with the Key West Ghost Walk Tour. He and Abby had painted the dog cart. And Abby had received a response to the call she'd made on Sunday afternoon. Now all she had to do was tell Reese.

ABBY WALKED IN THE front door of the Key West Police Department and approached the reception desk. "Is Captain Burkett in?"

Four words. Easy to say. Ordinarily. But on Thursday afternoon, when she said them to the desk sergeant, a middle-aged woman who smiled professionally, Abby's throat was dry. Her voice cracked.

"He sure is. Just got back a few minutes ago." The sergeant pointed over her shoulder. "Through that door and down the hallway. His office is the last one on the left."

Abby shivered in the ultracool temperature produced by

powerful air conditioners. She passed several large squad rooms with numerous desks, some of which were occupied by uniformed officers. Reese's office was across from the one labeled Chief of Police. The door to that room was closed. At least her conversation wouldn't be overheard by the head of the department.

She stopped in the open doorway. His back to her, Reese mechanically slid files into a cabinet.

After a moment, he turned. "Abby," he said simply.

"Sorry. I didn't mean to sneak up on you."

"No, no, that's okay." He came around his desk. "What are you doing here?"

"I have to tell you something."

He pulled a chair away from the wall. "Do you want to sit?"

Since her knees were shaking, she should have said yes. Instead, she said, "No, this shouldn't take too long."

He, too, remained standing. The height difference, which just days ago had made her feel secure, now made her anxious. She should have sat. "I've come to offer you a proposition, a way to learn something about your son."

His eyes narrowed. "You have?"

"I've recently had a conversation with our son's...the baby's adoptive father."

His features registered his shock. "You know him?"

"I didn't tell you that before, but..." She eyed the chair as a wave of dizziness swamped her. "I've changed my mind. I'd like to sit."

He took her elbow, led her to the sturdy metal office chair.

"Anyway," she said after a moment, "you should know something else. I've kept up on the progress of our child. I have a few photos—school pictures, mostly. And..." She

admitted the truth that she hadn't even told her mother. "I've seen him on two occasions."

Reese leaned against his desk. "When? Does he know who you are?"

"No, he doesn't. I've never met him. Remaining out of his life was a condition of the adoption agreement I signed. But as I said, I've kept track of him. Contact with his parents through a third party is in accordance with the agreement. Personal contact with him is not."

A muscle clenched in Reese's jaw. "His parents?" Bitterness tainted the two words. "And you're prepared to let me in on this now?"

"Yes. But with certain conditions."

His face reflected skepticism, but his attention didn't waver. "What conditions?"

"First of all, you have to understand what my relationship has been to the family. I met and interviewed the potential parents as part of the adoption process. What it really amounts to is I chose them. When I signed over…"

She stopped, breathed. This seemed so callous. "In our contract, the adoptive parents agreed to send me periodic pictures and letters. And I agreed not to contact them on a personal level with either phone calls or visits."

"But you have? Contacted them, I mean."

"Yes. Several years ago."

"How did they react?"

"They were alarmed at first. Worried. Defensive. But I assured them I had no intention of violating the adoption terms by insinuating myself in the boy's life. I said I just wanted to meet with them again. I wanted them to know me."

"And so you got together?"

She nodded. "When Jamie—that's his name—was eight years old, I had a short face-to-face meeting with his parents in a restaurant."

Reese repeated the name softly. "Jamie. It's nice."

She tried to smile past a lump in her throat. "That was four years ago. Since then I've seen him twice. Both times I told the adoptive parents."

Reese pushed away from the desk and came toward her. "Where did this happen?"

"I watched him play in a Little League game. And two years later I saw him in a school presentation. The auditorium was crowded. I was merely one of the audience."

"He plays baseball?"

"Yes." Abby remembered that Reese had been on the Fighting Conchs baseball team in high school. That fact made her ache for him now. "I wanted to see more of him, but, well, you can imagine how strange…" She couldn't continue, so inhaled a deep breath and waited for Reese to react.

He took another step toward her. "And Jamie's adoptive parents—they were okay with this?"

"They were cautious. They still are. But I promised them I wouldn't interfere in Jamie's life in any way. I explained the circumstances that had prompted me to give him up, and that I just needed to see him."

"They must be understanding people."

"They are. They're terrific." After blinking tears from her eyes, Abby continued. "They trust me, Reese. I told them I would never violate that trust, and I meant it. They can reach me in the event Jamie asks questions about his biological parents, if he becomes curious. That was important to me—for them to know I wasn't some mental case. They've agreed that Jamie can seek me out if he ever wants

to." She stared at Reese so he would have no question about where she stood in her relationship with the Ingersolls. "But they are confident that I would never attempt to meet their son on my own."

"Their son," he repeated, but without scorn. Only sadness. He waited. Forever, it seemed. His expression had changed in a matter of moments from one of tentative hope to confusion. "Where does this leave me, Abby? Where do I fit in? He's my son, too."

"Of course. And that's why I called Mr.—" She broke off, withholding Ronald Ingersoll's name for the time being. Even at this stage in her relationship with Reese, she couldn't trust him with the identity of his son's adoptive father. Not until she had Reese's cooperation. He was too hurt, too raw. The news was too fresh. He had too many investigative resources at his disposal. "Jamie's father," she amended.

Reese ran his hand down his face. "And?"

"He's agreed to meet with you. With us. Just the four of us, not Jamie."

Reese frowned. "Is this to determine if he approves of me, as he has you?"

The words sounded cold, but they were true. "Yes, Reese. Jamie is his responsibility. He only wants to protect him, as any father would." Realizing how that must sound to a man who had missed out on protecting his son, she quickly elaborated. "He understands that I've, well, reconnected with you. That puts you in the picture in the event Jamie asks questions about his birth parents."

"And how did he take the news that you'd *reconnected* with me?"

Abby couldn't lie to Reese. Telling Ronald that Jamie's

father had discovered the child's existence had been difficult. She'd promised him four years ago—prematurely, as it turned out—that the biological father would never be a factor in Jamie's life. She intended to keep that promise today any way she could. But Reese was a determined man. "He was surprised," she said. "Guarded. He asked what it meant, if you had any legal rights."

"And you told him I didn't?"

"Reese, you don't. Florida law is clear."

"Unless I choose to challenge it. Fathers have rights these days, Abby. There are lawyers—and I should tell you I've contacted one—who work to establish a legal basis for men like me, men who were never told, to prove paternity and all that that entails."

She did know it. Many of those lawyers worked pro bono, they were so committed to advancing the causes of fathers who'd been left out of their children's lives. Reese certainly qualified.

She sat forward. "This is the first step. I can't tell you if there will be others. You can't blame Jamie's adoptive father for being frightened of the future right now."

"For being scared of me, you mean."

"Yes. You're a very real threat. By agreeing to meet with you, he's hoping to reduce the size and impact of that threat. And if you meet him, I believe—I *hope*—you'll come to accept him as I do, as a kind and decent man." She glanced down, unable to look Reese in the eye. The sad fact of this situation was that both Jamie's fathers fit that description. Both were kind and decent.

"When did you tell him we'd meet?"

Sensing Reese was ready to agree, she lifted her face. "He set the date and the place. Amazingly he suggested

seeing us at their home so you can get a better sense of Jamie's life."

"That is pretty amazing," Reese said. "Of course you probably have the address anyway and the family knows that."

She did, but Abby didn't comment. "They live in Ocala. It's a nine-hour drive. Or we could catch a flight. We would meet with Jamie's parents in the afternoon. Stay over in a motel, if you'd like, or turn around and head back. If we drive straight through, we can share the time at the wheel."

"And where will Jamie be?"

"That's why this date was chosen. Jamie will be on a three-day camping trip with members of his church. Apparently, it's a yearly tradition, something to keep the kids occupied these last days before Christmas. Anyway, we'll be able to get together without him knowing."

Reese stared out the window. After remaining silent for a long time, he rubbed his nape and let out a deep sigh.

She got up and went to stand beside him, resting her hand lightly on his back. "It's the best I can offer you, Reese. You'll see pictures of him, visit his home. Maybe gain some peace of mind, something concrete to visualize when you think of Jamie, as I know you will every day of your life from now on, just as I've thought of him every day for the past twelve years." The muscles in his back contracted under her palm. He was suffering. He always would. And she'd brought this sadness upon him.

She dropped her hand and waited. Looking at his resolute profile, his taut veins, his grim mouth, she felt about as miserable as she ever had in her life. This moment hurt almost as much as the one when her baby had been taken away. And she understood. She loved them both,

always had. Always would. But loving was no guarantee of happiness. Sometimes the awful weight of caring could almost be too much to bear.

He turned toward her. "I'll go, Abby. And I'll accept your terms for now. But I'm not saying this will be the end of it."

His implied threat didn't frighten her. He knew the rules. He'd given his word and she trusted him.

HUEY SIPPED WHISKEY from his glass and set the porch rocker into motion. "What time do you suppose it is?"

He and Abby had been sitting for so long she'd lost track of time, but she guessed. "I'm thinking it's near midnight, so that would make it very late Saturday or very early Sunday."

Huey nodded. "I'm sticking with Saturday. That way I can still say it's been a good day. Sold two more paintings and scared the heck out of three dozen tourists."

She smiled. "Scaring people would be a good day for you, Poppy." She held up her glass, which had been refilled twice now, and made a toast. "Here's to the magnificent reincarnation of Armand Vernay."

"So I did okay?"

"Poppy, if the real Armand does still live here with us, and if he was watching tonight, he must be jealous. There's no way he could be a better him than you were." She laughed. "You understand what I'm saying, don't you?"

Huey clinked his glass against hers. "I do indeed, baby girl. This could open up a whole new line of merchandise for me. Armand top hat thimbles. Armand bobblehead dolls. Armand—"

Abby raised her hand. "Stop right there. I don't mind getting a little pie-eyed with you, but let's be realistic. You promised to upgrade the items on your cart, remember?"

He chuckled, drank more of his whiskey. "That was something when your mother showed up tonight, wasn't it?"

Abby laid her head against the back of her chair. "For sure."

"Why do you suppose she did?"

"Honestly? I think her reason for stopping by was twenty percent for you and eighty percent for me."

He feigned a hurt expression. "I only rate twenty percent?"

"Yeah, sorry. But she's worried about my trip with Reese on Monday. She wanted me to know she was behind our decision to see Jamie's parents."

Huey shrugged. "Okay. Still, it was nice, getting that twenty percent of her attention, all things considered." He remained silent a moment before adding, "You know, Ab, I was never much of a husband to Loretta."

"No?"

"I didn't really like the job—being a husband. I wasn't good at it." He stared across at her. "I was a damn good father, though, wasn't I?"

She smiled. "The best."

"I liked that job. Always did. It's easier to assume the responsibility for someone who already believes you're pretty great than to try to measure up all the time. That's how I felt about your mother. She always wanted me to measure up, and I never did. You just loved me."

Abby raised her glass again. "Still do."

Huey leaned forward, pointed down the block. "Take a gander, Ab. It's that pickup again, going down Duval Street at a snail's pace."

She stared around him. "It's black, like Reese's truck."

"It's him, all right. The past few nights he's been casing our house pretty regularly."

"Don't read anything into it, Poppy. It's Reese's job to check out the neighborhoods."

"Not this one so much, and Burkett doesn't work on the weekends. So I doubt he'd bother with us unless old lady Howell called up the station with some complaint, which she'd have no reason to. Yessir, Burkett's been giving our street extra attention."

Abby allowed herself to hope. She'd noticed Reese driving by a couple of times, and resisted the urge to go outside and see if he'd stop. The only communication she'd had from him was a message on Huey's phone. In as few words as possible, he'd announced that he'd pick her up Monday morning at six o'clock.

Huey shook his head. "Poor guy."

She sat forward. "Who, Reese? Why?"

"'Cause he's crazy about you and mad at you at the same time. Not an enviable position to be in. I ought to know."

Abby snorted. "It's true he's mad at me. But I don't believe he's suffering too much over the crazy part." Huey smiled wryly. Changing the subject, Abby said, "How much money have you saved up in the past couple of days?"

"Some. I'm making a payment tomorrow on that property tax debt."

"Good. I'm proud of you."

He grinned. "Got to be sure you'll have something to inherit when I'm gone. Might as well be a house filled with spooks."

CHAPTER FIFTEEN

ABBY WAS OUTSIDE AT five fifty-five Monday morning. She'd slept fitfully, waking every couple of hours to cope with her own anxiety over meeting the Ingersolls again. She hadn't seen Jamie in almost two years, and she'd never been to his house. Being there, around his things, wasn't going to be easy for either her or Reese. Jamie's presence would be felt everywhere.

Reese pulled up in front of the house at exactly six o'clock. Abby retrieved her overnight bag from the floor of the porch and walked to his car. When Reese stared at the bag, she said, "I didn't know if you would want to stay over, so, just in case…"

He got out and opened the door to the cab behind the front seat. "It's fine." He tossed her duffel in the back, next to his. "I left Rooster with a friend and arranged two days off from work." He waited for her to get in the truck before he said, "We'll decide later whether we want to drive back tonight."

Reese followed Whitehead Street to Truman Avenue, a major thoroughfare through town that eventually turned into U.S. 1, which ran north through Florida and several states bordering the Atlantic Coast. For Reese and Abby, the trip would start with a three-hour drive over numerous

bridges spanning several islands, before they officially reached the mainland of Florida.

There was no traffic. Truman Avenue was quiet. Abby rolled down her window and let the cool, sea-scented breeze wash over her.

They didn't talk. After an hour, he stopped at a bakery in Marathon and bought muffins and coffee. Then he suggested she choose a couple of CDs to listen to.

By midmorning, they'd put almost half the distance behind them. They'd managed to discuss a few safe topics, such as the baked goods from the coffee shop, Huey's stellar performance as a supernatural celebrity and the good fortune they'd had to encounter little traffic.

Reese drove up a service plaza ramp along the Florida Turnpike and parked. "Pit stop," he said.

They used the facilities then purchased more coffee and an order of fragrant cinnamon buns with icing. Once back in the truck, Abby searched in the wallet for another CD. Reese placed his hand over hers. The unexpected contact sent a zing of electricity up her arm. She looked over at him. "What?"

"Tell me about your decision," he said. "What you went through when you chose to give up the baby."

He had to realize this was a difficult topic for her to discuss, but he had every right to learn the specifics. "Choosing to give up a baby is the most difficult decision a young woman can make," she began. She smiled at him but he was focusing on the highway. "Next to telling the birth father years later."

Reese nodded.

"I made my decision based on a number of factors. One, I was unable to care for a baby. I had no income. My

family, as you know, was stuck in financial quicksand at that time. My parents' marriage was breaking apart. Huey would have offered to help, but he wasn't the most, well…" She paused. Reese could finish the thought about her father's unreliability.

"Two, I had ambitions. I'd worked all through school to maintain an average that would get me off the island. My goal was a college education, a scholarship, a ticket away from Key West.

"And three, I truly believed I was making the best choice for the baby." She gazed through the side window, sucked in a deep breath and confessed the truth that had made her feel like such a failure at the time. "I wouldn't have been a good mother, Reese. Not then. I tried not to feel resentful of the timing, my own stupidity…" She risked a glance in his direction and added, "Your lack of attention. I felt alone, and I knew a baby wouldn't fill the void." Trapping a sob in her throat, she said, "I'm sorry, Reese. I've been sorry for so much over the years."

His gaze remained on the road, but a muscle in his jaw worked. "And what about the adoption? How did you go about establishing this agreement you made with the adoptive parents?"

She explained to him about open and closed adoptions, and the one she eventually chose, a compromise between the two. "At first my correspondence with Jamie's parents was handled through a third party. I didn't know where Jamie lived. Even the photos were sent through someone at the adoption agency." She sighed. "For the longest time I tried to convince myself it was enough. Jamie was thriving. But I was only kidding myself. So through my connections, I found him."

"And has it been easier for you since you've spoken to his adoptive parents?"

"Yes, it has. And strangely, it's been easier for them, too. They trust me. They no longer fear that someday I'll show up and lay claim to their child."

He drove for several miles without speaking, but Abby could tell he was digesting everything she'd told him. "So what should I know about these people?" he said after long minutes had passed.

"He's a dentist. She's a former hospital administrator, now a full-time mom."

"What else?"

"They belong to a church. He's active in the community, the Rotary Club or one of those service groups. She commented once that she likes to create things, crafts, needlework."

"Do *he* and *she* have names?"

There being no reason to keep their identities to herself any longer, Abby said, "Ronald and Deborah Ingersoll."

Reese flexed his hands on the wheel. "Considering what we have in common, those names should strike some kind of a chord with me."

Abby didn't respond. Maybe after today, he would feel a bond with them, as she did.

"Did they pay for Jamie?"

The question came at her from out of nowhere. She swiveled toward him. "What?"

"I've heard about money being exchanged in adoption proceedings."

She tamped down a flash of anger. "No, I didn't sell the baby. The Ingersolls did help out with medical expenses,

but that's standard in most adoptions, especially when the birth mother is young and without means."

He had the decency to appear repentant. "Sorry. I had to ask. So they paid nothing but that?"

Abby went over adoption costs every day in her job, knew them by heart. "They paid quite a bit. I work for a nonprofit adoption agency and still the fees are high. I've never handled an adoption that didn't cost over ten thousand dollars."

He whistled through his teeth. "Wow."

"There are application fees, home visitation costs, employee salaries, court costs. But the government will help those who need it. In my case, aside from medical help, all I asked for was the opportunity to choose the family."

"Were the Ingersolls the only ones who applied?"

"No, they weren't. We have many couples seeking children on our list all the time. Adoption is a long and complicated process. The Ingersolls had been trying for six years." She stared out the windshield. "I truly believed they were the best candidates for the baby of all the ones applying. I still do, after meeting them a second time," she added, with what she hoped was a sense of finality.

He took a sip of his coffee. After a moment, he said, "Would you mind opening the cinnamon buns? The smell is making my mouth water."

She complied. They munched on sugary dough for a few minutes until Abby said, "You ready for more music?"

"Sure. Make it something peppy. There's a Mountain Goats in there somewhere."

She found the CD and put it in the player.

Before the music started, Reese looked over at her and said, "Thanks for being so honest, Abby."

She rested her head against the window. For the next

couple of hours, she watched billboards race by, advertising amusements in Orlando. Fun places. Big resorts that catered to families. She couldn't help thinking that she and Reese would never take their son to Disney World.

AT TWO-THIRTY, Abby removed the handwritten directions from her purse. "The next exit is ours," she said to Reese.

He pulled off and headed west as she told him to. Abby glanced up at the sky, which had become threatening in the past few minutes. "It's going to rain," she said.

They passed a convenience store, a tack shop and feed-and-grain supplier.

"You can tell Ocala is horse country," Reese commented.

"Yep. It's a couple of miles before we reach the Ingersolls' development."

Reese let his gaze wander over gently rolling hills, green pastures and stands of live oaks. Paraphrasing a line from *The Wizard of Oz,* he said, "We're not in Key West anymore, Toto."

Abby smiled. "No. Not an ocean in sight and lots of open space."

They pulled into Grand Oaks, a residential area of large homes on one-acre sites. A clap of thunder rent the air, and the first fat drops fell on the windshield. "Timing is everything," Reese said, glancing up at the sky. "I hope we get there before the clouds open up."

He navigated the turns, his eyes widening as he viewed the impressive houses set back from the road. "I have to say the kid lucked out as far as digs are concerned," he said, his voice thick and raspy.

Grand Oaks was nothing like Key West. In Old Town, where Huey and Reese lived, property was at a premium,

and people treasured their few square feet of lawn. Here, grass resembled plush carpets that stretched endlessly. "Maybe so," Abby said, "but I haven't seen any guys with parrots on their shoulders on the side of the road, or even one old Chevy pickup converted to a traveling porpoise. So we're not without our charms."

"True enough," Reese said.

Abby wondered if his heart was pounding, as hers was. The past minutes of almost pleasant conversation had to be masking a heightened tension in both of them. She pointed to a two-story Colonial brick house with a three-car garage attached. "This is it."

Reese drove up the paved driveway and parked in front of the double-door entrance to the house. The impending storm had darkened the sky enough that the hundreds of Christmas lights decorating the place were on even in the daylight. Two massive evergreen trees framed the front doors, their branches heavy with white twinklers.

Reese shut off the engine. "I feel like I'm in a magazine spread," he said.

Abby gave him a smile of encouragement. "I know. I feel the same way. But don't let the opulence influence you. The Ingersolls are really down-to-earth."

The rain began to fall harder. A streak of lightning zagged across the sky a few miles away. Reese rubbed his palms down his jeans. "It's now or never," he said. "Let's make a run for it." He opened his door, stepped out and waited for Abby to slide across. He grabbed her hand and they raced up the steps to an overhanging portico. Reese drew a deep breath before raising his hand to ring the bell.

He needn't have bothered. Ron Ingersoll appeared at the entrance without waiting for them to announce themselves.

He looked pretty much as Abby remembered, except for the expanding bald spot on top of his head. However, he seemed shorter than she recalled, no more than five foot seven. Or perhaps his short stature was more apparent compared with Reese's above-average height. Ron smiled, but the expression seemed forced.

"Come inside before you're soaked," he said, pulling the door wide open. "Nasty day."

They stepped into a two-story foyer with a ten-foot Christmas tree blinking next to a sweeping staircase. A grandfather clock ticked soothingly near a side table holding several family portraits in gold frames. Abby noticed Reese staring at a picture of a young boy with dark hair and deep green eyes.

"Can I get you a towel?" Ron said.

Abby checked her rain-spotted slacks. "No, we just got a few drops." She extended her hand. "Thanks for seeing us, Ron."

He shook it and then gripped Reese's as she introduced them. The two men eyed each other warily, almost like combatants on a field of battle.

"Let's go into the living room," Ron suggested, leading the way. A fire crackled pleasantly, replacing the chill that had blasted Abby when she'd exited Reese's truck. Three stockings hung from the mantelpiece, each hand-embroidered. Abby could imagine Deborah Ingersoll stitching the names.

"Make yourselves comfortable," Ron said, indicating a pair of dusky blue wing chairs. Despite the impossibility of his suggestion, Abby and Reese sat. Reese was stiff, his spine inches from the back of the seat as he crossed and uncrossed his legs.

Ron called his wife's name, and soon Deborah, wearing

a dark plaid skirt and silk blouse, her brown hair pulled back with a clip, entered the room and set down a silver tray. She greeted Abby, and then Reese.

"I was going to serve iced tea," she told them, glancing out a window. The rain was falling in thick sheets. "But I switched to hot drinks because of this nasty weather." She offered a delicate china cup to Reese. "Coffee or tea?"

"I'm good for now," he said, frowning at the paper-thin porcelain. Abby figured he didn't want the responsibility of hanging on to an Ingersoll family heirloom, under the circumstances. She accepted a cup of tea with a polite smile.

The Ingersolls sat on a sofa. "How was your drive?" Ron asked after a moment. "Long way from Key West."

"No problem," Reese said.

Abby put her cup on a parlor table. She'd navigated situations like this many times in the course of her work at the agency. She'd advised countless adoptive couples and encouraged many young women facing unplanned pregnancies. But today's circumstances were unique. Here, she participated as both counselor and birth mother.

"Well," she began. "You already know my background, the reasons I chose to give Jamie up for adoption. You must understand that nothing happening today affects your status as Jamie's parents." She looked from Ron to Deborah. "You should feel secure in that knowledge before we proceed."

The lines at the corners of Reese's mouth deepened, but he kept silent.

"As I explained over the phone, a series of events resulted in my returning to Key West around Thanksgiving," Abby said. "I encountered Jamie's biological father again, and he learned the truth about the birth."

Ron's eyes narrowed. He cleared his throat. "How did he find out, exactly? My wife and I were assured that you would maintain anonymity, that there was no reason to tell the father." He leveled a serious stare at Reese. "Sorry, but that's what we were told."

Reese didn't blink. "Things happen. Late, but they happen."

"I told him," Abby said. "I had my reasons, but I won't go into them today. The important thing is that we move ahead from here. Reese needs to know about his son. Ideally, he'd like to believe that if Jamie should ever ask about his biological parents, you would feel as comfortable telling him about Reese as you would revealing my identity. The final decision to do that is still yours, however."

Ron sat back in his chair and looked long and hard at Reese. "What is it you want to ask?"

The floodgates of curiosity opened for Reese. "What's he like? What are his hobbies? Is he a happy kid? Is he good in school? What are his goals?"

Ron sighed. "Deborah, this part is up to you. You have to feel comfortable with whatever you reveal. Do what you think is right and fair."

Abby sensed an undercurrent of animosity, as if Ron had cautioned his wife not to feel bullied. Such a reaction was justified. Surely the couple had discussed their options well in advance of this meeting.

Deborah rose and went to a bookcase in the corner of the room. After taking out a thick album, she returned to the sofa. "These are our family photos. The album doesn't contain all the pictures we have of Jamie, but it does a pretty fair job of chronicling his life." She handed the book to Reese. "If you have questions, I'll try to answer them."

She resumed her seat next to her husband and folded her hands in her lap. "But be aware, Mr. Burkett, I am appraising you as carefully as you're obviously appraising us. Our primary goal is to protect our son. A great deal of research and consideration went into our decision before we agreed to let Abby into Jamie's life, even to this limited extent. Just as much, if not more, will go into our decision about you. And, of course, any relationship you might establish with Jamie in the future is dependent entirely on his desire for that to happen."

Reese nodded, with what appeared to be a grudging admiration for Deborah Ingersoll, and opened the book.

An hour later, he had viewed all the pages. He'd asked many questions. He'd smiled, frowned. His eyes had lit with pride in the accomplishments of his son. He'd even managed to drink two cups of coffee from Deborah Ingersoll's very breakable china. He'd suffered, yes. So had Abby. But the pain they both were feeling was a cleansing kind.

Abby was confident that her decision to bring Reese here had been the right one. At least when they left, he would know who Jamie Ingersoll was. He would be convinced the child was safe and loved. And he would have initiated the first step to perhaps someday being a part of Jamie's life. Reese's emotional connection to the boy showed in his face, in the light in his eyes. In the way his fingertips brushed the plastic coating of the photographs.

The only thing Abby couldn't determine was whether Reese had started to forgive her.

He eventually handed the album back to Deborah. "Thanks," he said. "I appreciate the time you've given me." He stood up. A peace seemed to have settled over him, over the entire room.

And then the front door opened, letting in the sound of the relentless rain battering the stone entry. The door slammed shut and seconds later Jamie Ingersoll appeared in the entrance to the living room. Water dripped from his ball cap, the stuffed duffel bag hanging from his shoulder and the rolled-up sleeping bag under his arm.

"Hey," he said. "Weather's terrible out in the national forest. They told us to go home. Pastor Bob dropped me off."

Reese's skin went ashen. And Abby's heart nearly jumped from her chest.

CHAPTER SIXTEEN

REESE FROZE with what he figured was a dumbstruck expression on his face. He tried to make his jaw muscles do something, smile or speak. But his whole body seemed unable to accept commands from his brain. If he'd encountered a two-hundred-pound criminal with a semiautomatic aimed at his chest, he would have reacted instinctively. Now, staring across an expensive Oriental carpet at his son, he didn't have a clue.

After long seconds, he forced himself to look at Abby. She didn't appear any more in control of her reactions than he was. Her fingers gripped the arms of her chair. Her eyes were rounded; her jaw had dropped. She'd told Reese she'd seen their son twice, both times from a distance. But she was no more prepared for this sudden meeting than he was.

Jamie, displaying the baggy-pants slouch of a typical twelve-year-old, stood in the entrance to the living room and stared at everyone.

Thankfully, Deborah filled the void with motherly concern. She hurried over to her son, took the duffel bag from his shoulder. "You're dripping wet," she said.

He removed his cap, slapped it against his leg and smiled at her from his nearly equal height. "Well, it is raining."

"Oh, so it is," she said.

He walked into the living room. "I didn't know you guys were having company."

Ron rose. He shot a warning glance at Reese. "Jamie, this is…" He trailed off, leaving them all waiting anxiously.

Reese's ability to think and speak returned. He said, "I'm a friend of your father's. A former patient."

"Right," Ron added. "This is Mr. Burkett and his friend Miss Vernay. Folks, this is my son, Jamie."

"Hey." Jamie nodded, having no reason not to accept a perfectly sensible explanation.

"Nice meeting you." Reese grabbed Abby's elbow and helped her rise. "Abby, this weather is getting threatening. We probably should go." What could have been the most cowardly announcement under the circumstances was actually the most courageous. The last thing Reese wanted to do was cut and run. His instincts told him to stretch out the moment until this unexpected twist of fate brought him even closer to his son.

"You might want to wait," Jamie said. "It's really coming down out there." He looked through the big picture window. "It'd be cool if it was snow."

The grown-ups responded with polite laughter at the absurdity of snow in Florida. Reese couldn't take his eyes off the boy. He was tall for his age, slim, with thick dark hair that probably went every which way when it wasn't plastered to his scalp with rainwater. When Reese was that age, he, too, had been unable to keep his hair neat.

A shudder from beside him forced Reese to draw his attention from his son. Reese tightened his hold on Abby's arm. "I really think we should brave the elements while we can," he said to her.

She bobbed her head in answer.

Reese reached out to Ron, shook his hand. "Nice to see you…again."

"Same here," he said.

They were behaving with such congeniality that Reese thought Ron might add, *Come back anytime*. But he didn't. Ron was wishing this agony would end.

Keeping a firm hold on Abby, Reese walked to the doorway. He stopped next to Jamie and the woman the boy called Mom. "Thanks for the coffee, Deborah," Reese said.

She kept her arm around Jamie's shoulders, even though his damp jacket was soaking her blouse. Her eyes were wary. "You're welcome."

He focused on Jamie. "Merry Christmas."

"You, too," Jamie said.

Reese gazed at him a moment longer, knowing he must appear a fool. An odd comparison struck him. At that moment, he figured that studying a great work of art on a museum wall must be a lot like what he was doing now. He wanted to drink in every detail of this little man whose appearance was so like his own. He wanted to memorize each feature, from Jamie's dark eyebrows to his square jaw. What if Reese never saw him again? In that case, how long was too long to keep looking at the boy now?

A quiver rippled through Reese, and he concentrated on the floor to break the visual contact. Abby tugged on his arm. "Thanks for the hospitality, Deborah," she said.

Reese waved off-handedly at the family that included his son. "So long."

He opened the door. The rain had let up a little. He put his arm around Abby and hurried with her down the steps to the driveway. Behind them, the Ingersolls' door closed with what seemed a deafening thud, shutting the two of them out.

Abby climbed in the passenger seat and Reese ran around to the driver's side. He got in, started the truck and pulled away. They were a half mile away from the house before he realized that other sounds were slowly invading his consciousness besides the drone of the engine and the steady ping of rain on the rooftop—Abby's sobs.

Rain streaked down the windshield, the wipers barely keeping up. Their persistent hiss added to the melancholy chorus inside the truck. Reese's own vision was blurred, from what, he wasn't sure anymore. *Damn,* he thought, wiping a finger under his eye. *Get a grip,* he ordered himself.

An hour later, he took a ramp at a turnpike exit. He hadn't spoken a word. Neither had Abby. She sat with her head against the window, her eyes cast down to her lap. The rain was heavy again, the sky unnaturally dark for early evening. Restaurants and hotels bordered both sides of the busy exit, their lights bright and welcoming. This was Orlando, where families came for fun. Reese drove into the parking lot of a large, well-lit motel and jammed the gearshift into Park.

Exhaustion had overwhelmed him sometime during the past ten miles. He knew he shouldn't drive. He knew Abby couldn't. Drawing a deep breath, he said, "I think we ought to stay over."

She nodded.

"This place okay?"

Without checking her surroundings, she said, "Fine."

He drove under the protective arch, glanced into the lobby, where a Christmas tree sparkled with white lights and shiny red ribbons. "I'll sign in," he said. "Two rooms."

She didn't say anything.

He returned a few minutes later and handed her a plas-

tic key card. "We're just down the walkway from each other. They're all outside entrances, so we'll get wet one more time."

She cradled the card in her palm but didn't look at him.

He parked close to their rooms. "There's a restaurant in the lobby. Do you want to go down for something to eat?"

She turned her head slowly, her eyes dull and vacant in the darkening shadows. "Do they have room service?"

"I suppose they do."

"Then if you don't mind…"

"No. Anything is fine." He was relieved. Given their silence the past hour, how could they possibly keep up a conversation in a restaurant? Still, he struggled to shake off what seemed an almost desperate disappointment. He wanted to reach out to her for… What? Hell, he didn't know. She'd caused this heartache in him. But she was here. And she understood it.

She got out of the truck and retrieved her bag from the backseat. Before shutting the door, she said, "You'll want to get on the road early, won't you?"

He didn't know. His mind didn't have space for practical thoughts at the moment. "I suppose," he said.

"Okay. I'll be ready by seven." She tucked her bag under her arm, ducked through the rain and disappeared into her room. After nearly a full minute of staring after her, Reese went into his.

ABBY SHUT THE FOAM BOX that still held half the sandwich she'd ordered from room service. She threw that and an empty soda can into the trash container and settled on the bed with the TV remote control in her hand. It was nearly ten o'clock. She was emotionally exhausted, but her body

wasn't tired. Whenever she shut her eyes, two faces blurred into one—her son's and Reese's.

They had so many similar traits. Reese, too, must have seen them. She wondered if he was curious, as she was, whether he and Jamie were alike in nonphysical ways. Did Jamie love dogs? Did he like to fish?

She punched buttons on the control, and eventually chose CNN. One of the reporters was hosting a special on global warming. She set the volume low and watched, only minimally involved. The steady recitation of scientific data was all her mind could handle right now. The rain continued, pounding the concrete walkway outside her door. Abby didn't care if the storm ever abated. Maybe the monotonous sound would make her sleepy.

After a few minutes, she heard a knock on her door. She jumped up from the bed and peered out the peephole. Reese stood in the glow of her security light, his head bowed. She glanced down at the jersey lounging pants she'd thrown on along with a pale blue tank top, and figured her clothes didn't matter.

She opened the door. A gust of wind pelted her with raindrops. It was so cold, unnaturally so for central Florida, that she wrapped her arms around her chest.

Reese was drenched. Water dripped from his hair and ran down his face onto the front of his light jacket. He shivered, his shoulders hunched.

When he stared at her, she said his name and waited. After a moment, he breathed, "I want… I need…"

"You're freezing," she said, pulling on his arm. "Come inside."

He allowed himself to be tugged over the threshold and to the center of the room. Abby went back to close the door,

wiping her damp palms on her pants as she did so. Turning back, she saw that rainwater clung to his eyelashes. He pushed at the hair hanging over his brow, and the wet strands fell back onto his forehead. At this moment he seemed more like his son than she could have imagined.

"Why are you out in this weather?" she asked him.

"I've been walking, thinking."

"Oh, Reese."

He looked down, as if realizing for the first time that his clothing was sopping wet. He shifted his feet, stepping sideways. "I'm soaking the carpet."

"So what?" She wrapped her hands around his arms, over his jacket sleeves. She wanted to do more for him, to do *everything* for him, but she didn't know what he required, what he expected, and, most of all, what he would resent.

And then he gazed deeply into her eyes and let out a long breath. "It hurts so bad, Abby. You felt it at the house, too. The awful hurt."

She nodded. "Yes, it hurts."

His gaze didn't waver. She kept her hands on him until he touched her waist, his fingers cold and damp against the bare flesh above her waistband. "I don't know what to do. I've never had a feeling like this. The helplessness, as if there's no solution, no way to cope…"

His fingers flexed. She felt the sensation deep inside— a sudden and inexplicable melding of the cold of his skin and the heat of his touch. An undeniable urge flowed through her, making her legs tremble and her heart ache. This was her chance. If Reese couldn't forgive her, then at least she could help him heal. She grabbed his jacket by the shoulders and yanked it down. It fell at his feet and she said, "Wait here."

She went into the bathroom and turned on the shower. When she came back, she unbuttoned his shirt, dragged it down his arms and loosened the fastening of his jeans. He kicked off his shoes and toed his socks off. She helped him shimmy out of his pants and underwear. When he was naked, she ran her splayed hands around his rib cage. Taut muscles below his shoulder blades rippled under her fingertips. His breath caught.

She led him to the shower, slid back the curtain and urged him in. Water cascaded over his shoulders. He raised his face into the spray. Letting emotions dictate her actions, Abby shed her own clothes and got into the shower. His eyes connected with hers through the mist. He smiled slightly and opened his arms. She stepped into them and held on tight, her face nestled into the column of his throat. She murmured comforting words into his ear. "It'll be all right, Reese. Trust me."

He pressed his lips to her neck and left warm kisses along her flesh. She entwined her fingers in the hair at his nape and breathed in the scents of rain and what remained of this morning's aftershave. She wanted to quell his pain, make him think of something besides leaving their son, just as she needed the same from him. He spoke softly. Many of the words she couldn't make out, though she was certain he said, "I'm sorry."

"So am I, Reese. So very, very sorry."

She stood with one leg between his and her fingertips digging into his shoulders. The water sheltered them, enclosing them in soothing warmth. They swayed for moments until he pressed fluttering kisses at the corners of her mouth. She responded with a fierce kiss of her own. His tongue entered her mouth, circled, withdrew and returned to flick against the insides of her cheeks.

When he palmed her breasts and teased the nipples with his thumbs, she shuddered deep inside. His erection throbbed along her thigh. And what had begun as an act of comfort became primitive and needy. Steam rose around them, warming her and exciting her senses. The spray tingled on her skin, spiking her desire to have him complete what could not be stopped. She guided him between her legs. "Now, Reese," she said hoarsely.

"Abby, this is the first I've felt anything but emptiness in days. But are you sure?"

She pulled his head down. "Yes, I'm sure." He plunged inside. Her need spiraled and crested in one blinding flash that obliterated every other emotion but the one she was feeling at that moment. He clutched her tightly, pinned her against his chest as if he were trying to connect with every inch of her body. He jerked convulsively, groaned against her mouth and finally exhaled a long, slow breath. Afterward he held her for precious seconds until their breathing returned to normal.

She reached behind her and twisted the faucet. Water trickled down her body, cooling her heated skin. Reese pulled a towel from the nearest bar and gently patted Abby dry all over, even where she still pulsed between her legs.

He quickly dried himself, tossed the towel on the floor and stepped from the shower. Taking Abby in his arms, he carried her to the bed and threw the covers back. He laid her down and slid in beside her. And with care and exquisite tenderness, he explored her body, nearly bringing her to a second peak. And then he was inside her again, moving rhythmically with steadily increasing thrusts until waves of pleasure rocked her body.

More content than she ever remembered being, Abby

sighed with completion. Yes, the heartache would still be there tomorrow. But she refused to let anything invade this moment. For now, in Reese's arms, she could believe that he'd forgiven her.

THE CNN REPORTER'S VOICE buzzed in the background— accompaniment to Reese's steady breathing. He wasn't asleep, but lay quietly with his arm around Abby's shoulder, his cheek against her hair. She'd waited for him to say something after the lovemaking that had left the sheets tangled around their bodies. But he'd rolled to his back, fitted her securely inside the curve of his arm, and remained silent.

Fifteen minutes passed. He pulled away from her and said, "I'd better go."

She touched his shoulder, not wanting to break the contact. She hadn't expected this reaction. "You don't have to. You can stay."

He slid to the edge of the mattress and sat up. "I should. We'll talk tomorrow."

Feeling suddenly alone, even before he left, she watched him reach for his briefs, which he'd shed next to the bed. He tugged them on, stood and retrieved his jeans. "If you think that's best," she said, her mind struggling to accept his decision.

He zipped the jeans but left the button open. Then he slipped his arms through his shirtsleeves, picked up his jacket and dangled his shoes and socks from his hand. Grasping the doorknob, he turned and said, "Abby, thank you."

Thank you? His voice was even, calm, devoid of emotion, when just a short time ago he'd whispered in her ear with the unabashed huskiness of passion. His simple ex-

pression of appreciation might have seemed appropriate if she'd waxed his squad car or taken his dog for a walk. But not for what had just happened between them. Shame and guilt overwhelmed her, along with the cold blast of wind coming in the open door. She reminded herself that she'd hurt him deeply. Maybe a thank-you was all she deserved. Maybe shame was what she should feel, a punishment for what he'd suffered. Still, she repeated, "Reese, if you don't want to be alone, you can stay."

"No. I'll see you in the morning. Things will be clearer then."

Abby tucked the sheet securely under her arms. She would have buried herself beneath it if she hadn't feared she would reveal too much about how he'd made her feel. What had these past two hours been about? She felt even more distant from Reese than she had before he'd knocked on her door. "Fine," she said. Their relationship was much clearer to her already.

He stepped onto the walkway, but leaned in one more time before closing the door. "Don't forget to lock up."

She didn't look him in the eye. "Right. I wouldn't want a stranger to come in here." After he left, she decided that that was what had just happened.

CHAPTER SEVENTEEN

THOUGH DREAMS PLAGUED HIM, Reese slept through the night. When he awoke, he checked the digital clock by his bed: 6:15. He rose and filled the coffeemaker. While he showered and dressed in clean clothes, he thought about Abby. He didn't regret returning to his own room last night. It had been the right thing to do. If he'd stayed with her much longer, he knew what would have happened—again. Even now, remembering caused an instant physical reaction.

He'd come to her door confused, hurt, and for the first time in years without a direction for his future. The last thing he wanted was for Abby to think he was using her for some sort of temporary gratification to soothe his wounds, though in her eyes, that was exactly what she must believe he'd done. He'd gone to her for comfort and she'd freely given it—to Reese Burkett, the jerk who accused her of betraying him.

He'd left her with a promise. That things would be clearer in the morning, as if he'd planned on divine revelation to tell him what to do about his feelings for Jamie, for her. Now, with the sunrise, all he'd really decided was that he had to honor Abby's pledge to the Ingersolls to stay away from his son. As far as his feelings for her were concerned, they were strong and seemed to be in a constant flux.

Okay, maybe he'd used her last night, but he'd also known that no one else on earth could have satisfied his needs the way she had. Only Abby. And that realization scared the crap out of him. The woman who'd caused his misery was the only one who could help him. Where did he go from here?

After stuffing his still-damp garments into his duffel, he wandered down to the lobby, where he thought he might find Abby. She was there, nibbling on a bagel, part of the complimentary continental breakfast. Reese poured himself another coffee and sat opposite her.

She appeared tired but still beautiful. Yesterday had been hard on both of them. She'd been as blindsided as he was by the unexpected appearance of their son. He tried smiling at her, but realized how ineffectual the attempt was. "You okay?" he asked.

She narrowed her eyes as if she, too, found his forced cordiality out of place. "Sure. Fine."

"You ready to go?"

"I'm packed. I'll just go to the room and get my bag."

"Great. I'll settle the bill. We should be back in Key West by late afternoon."

She gathered her used dishes and set them in the bin provided. "Suits me."

Ten minutes later, they were in the truck, heading down the turnpike in light traffic. Reese set his cruise control, rolled his shoulders to get comfortable. He and Abby should talk. He had a lot to say, which was uncharacteristic for him. But the topics weren't easy, and he didn't have any idea how to start.

His feelings for Abby were complex. He owed her, but also resented her. Bottom line, he wanted to forgive her. But this morning he wasn't sure what to say to her.

She put a CD in the player—a repeat of yesterday's efforts to break the silence. They were definitely back to the tension of the day before. Only, this was worse. Now the anticipation of meeting the Ingersolls was over. Reese had had his shot with them, and he had no idea if he'd measured up. He'd seen his son, been close enough to hug him, but because of the promises he'd made to Abby, he felt as distant from him at this moment as if they were continents apart.

The CD finished. Abby ejected it and reached for another. And Reese thought his brain would explode if he had to listen to one more country singer croon about the misfortunes of life. When she started to pull the next disc from its plastic sleeve, he said, "Don't, please." She looked up at him, her eyes wide, questioning.

He set the CD case on the floor. "Abby…"

She waited. He drummed his fingers on the steering wheel while he searched for the right words to break the tension. Finally, he glanced at her and inquired, "How do you think things went yesterday?"

Her reaction was one of disbelief. She'd obviously expected something else. "At the Ingersolls'?"

"Yeah."

"In my opinion, it was pretty darn weird."

"Mine, too."

"The entire incident was uncomfortable, dishonest and painful."

"Yeah." He held her intense gaze until prudence forced his attention back to the highway. "But before Jamie arrived, what did you think? Did the Ingersolls approve of me?"

She exhaled a long breath. "I can't say, Reese. I suppose they did. You didn't do anything to make them believe you wouldn't keep your word."

He eased into the left lane and passed an eighteen-wheeler. "About that…"

Abby leaned forward to stare at him. "What? You're not going back on the agreement? You can't do that."

"No. But I don't like it."

She sat back in her seat, crossed her arms.

He tried a different approach. "Obviously, they like you."

"No. They trust me. And because of that trust, they're giving you a chance."

"I realize that. But if Jamie ever asks about his biological father, do you think Ron and Deborah will feel comfortable telling him about me? As comfortable as they would about revealing your identity?"

She chewed on her bottom lip. The silence stretched for at least a mile—maybe the longest mile of Reese's life. Finally, Abby smiled. She wasn't looking at him, so Reese assumed it was a generic smile. Still, it helped. "Yes," she said. "I believe they'll be fine about telling Jamie that you're his father…if he should ask."

A torrent of questions flooded Reese's mind. "How might he ask? And when? You know about this stuff. Do adopted kids ask in their teens, or more when they reach adulthood? Are they basically resentful? Will it matter that we all lied to him yesterday? Because that really bothered me. What if—"

She placed her hand on his arm. "Reese, I don't have all the answers. Each case is different. I imagine that all adopted kids are curious, but some never ask about their birth parents. Many do, and often meetings are arranged when the kids are mature and better able to handle the consequences of hooking up with them."

She kept her gaze on his face. "I want to give you the

benefit of my years of experience in this field, but you have to accept that, legally, there is only one set of parents. And for Jamie, they are Ron and Deborah. That will never change."

He understood that, but he wasn't ready to give up all hope. So he said, "But most do ask?"

She shrugged. "Yeah, most do." After a moment, she said, "Here's what I believe might happen. That one day—and don't ask me when—your phone will ring. You'll pick it up, and a bright, young voice will say, 'Hi, remember me? We met that rainy day. I was wondering if maybe we could get together, have a little talk.'"

Reese rubbed his forehead, trying to relieve the anxiety of the past twenty-four hours. Could she be right? Could the reunion happen just that way, as two acquaintances connecting on a vitally intimate level? Should he allow himself to hope? He noticed Abby's smile was still in place, but it was definitely for him now. He nodded, accepting her prediction of a happy conclusion, a promising beginning. "Ya think?" he said. "Really?"

"Sure, why not?" Her hand was still on his arm, and she gave it a squeeze. "He's our son," she said. "For better or worse, he probably inherited my curiosity. It was the trait that made me search him out—made me search you out on that beach."

Reese's thoughts flashed back to that night, as they did so often these days. He smiled to himself.

"And he might very well have inherited your courage to take risks," she said. "Something you do every day on your job, especially with Huey."

Reese chuckled.

"And if Jamie's really lucky," Abby continued, "he got

wisdom from the Ingersolls, because I'm afraid you and I are sorely lacking in that area."

"I can't disagree with you."

"If Jamie does decide to contact you—I mean *when* he decides to—a new chapter in your life will open up," Abby said. She removed her hand from his arm. "But I have no doubt you'll be ready for it. And maybe all this sadness you've been feeling will become just a bad memory."

All at once, imagining facing that day without Abby beside him was hard. "And what about you?" he said. "Will you be one of the characters in the new chapter?"

"Me? No. If Jamie decides he wants to meet me, I suppose we'll arrange for it to happen in Ocala or Atlanta. I'd have to take my cue from him."

Reese paused, letting her answer sink in. He didn't know why it surprised him. She lived in Atlanta, yet picturing her going back there, maybe disappearing again for years, seemed to knock him off his emotional center. "How long are you staying in Key West?" he asked after a moment.

"Through New Year's."

"Tomorrow's Christmas Eve. You're going back in just over a week."

"It's plenty of time to accomplish what I came for. Poppy will make another payment on his taxes from the profit on his paintings. I'll be confident that he's going to be okay, at least for a while."

"And that's all you care about? How Huey will get along after you leave?"

She stared, until Reese felt like squirming because of the asinine, petulant question he'd just asked. He'd sounded like a jealous kid, not wanting to share the spotlight with anyone else. But damn it, that was the truth of it.

"That's why I'm here, Reese," she said. "To take care of Poppy and to make sure you didn't arrest him."

He smiled. "But you wouldn't consider staying, moving here permanently?"

Her eyes narrowed, and when she tapped her foot on the floor mat, he gripped the steering wheel until his hands hurt. "What made you ask that?" she said.

"I don't know." He truly didn't. "You grew up here. It's not such a dumb idea, is it?"

She stared out the side window as if the barren landscape dotted with struggling scrub palms was the most fascinating thing she'd ever seen. After a moment, she said, "Well, it seems like a strange, impractical idea to me."

When she'd confessed about Jamie, and Reese's world had changed, he would have agreed. Now, having Abby stick around was beginning to feel right. Last night he'd completely lost himself in her, forgetting everything but the sweet comfort of her body against his.

Today the feeling was still present—for him, at least. On this monotonous highway, heavy now with truckers and vacationers racing to get somewhere special in the next thirty-six hours, last night could have been a distant memory. But it wasn't. Reese's mind was flooded with sensory data of Abby—the scent of her in the shower, the silky feel of her hair, her warm breath heating his skin.

She was sitting no more than a couple of feet away, her face unreadable, her posture rigid. But all Reese could think of was pulling off the road and gathering her close to re-create what they'd had the night before.

He rotated his neck, relieving tension, and uttered the words he had to. "Are you ready to talk about last night?"

For an uncomfortably long moment, she simply stared at him. And then she said, "No, I don't want to talk about it. Besides, you've already thanked me. What more is there to go over?"

Whoa. He refocused on the traffic, specifically a six-figure rolling castle of a motor home ahead of him, and waited for the monster to move back into the right lane. What did she mean? Of course he'd thanked her last night. He'd been damn grateful. And he'd be just as grateful if it happened again.

"Don't make too much of it," she said. "We were reacting to what happened."

He didn't respond. When the silence in the truck made Abby want to crawl out of her skin, she risked a glance at his face. It was stern.

After a moment, he blinked hard and said, "Has it occurred to you that maybe I want to turn that night thirteen years ago, and last night, into something now?"

Unshed tears burned in her eyes. She wanted to believe him, but in the past week he'd given her no reason to. "Maybe it occurred to me at one time," she said. "But not now. We're just wrong together. You know it and I know it, and nothing will ever make us right."

He looked out his side window. "Not if you don't try."

"Me? I have. But I don't believe you will ever trust me." A horrible, weighty truth broke her heart, yet it had to be brought out. "Maybe you shouldn't forgive me—and if you can't, I don't blame you. But my decision about Jamie will always stand between us."

She closed her eyes to avoid facing the flash of reluctant agreement in his eyes. He had to agree that what she'd just said was a sad but indisputable fact in their lives. "I

don't need that kind of pain, Reese," she said. "Where Jamie's concerned I have enough already."

Neither one of them spoke again. An hour later, it was nearly dark and they were in Key West.

"You want me to drop you off at your house?" he asked.

"That's fine."

He drove the back way to Southard that avoided the traffic on Duval Street. It was December twenty-third, and the main thoroughfare would be packed with tourists.

He pulled in front of Vernay House. The outside lights were on, but the interior was dark. "Looks like Huey's not here," he said. "I'll walk you inside."

She stepped out of the truck and grabbed her bag. "That won't be necessary."

He stared at her. "Nevertheless…"

"Wait. Never mind. There's a note on the gate."

Abby tore a paper from the latch and held it up to the streetlamp. "It's from Huey. He says he's on Duval Street."

"I'll take you. I'm going right by there."

Abby dropped her bag at the foot of the porch steps and got back in the truck. "Thanks."

"No problem. I don't feel much like going home yet, anyway. I might as well hang out downtown myself. The department can use a couple extra hands."

Being with a cop had its advantages. Soon, Reese had pulled into a lot behind a popular nightclub and parked his truck in a loading zone. He and Abby navigated the holiday crowd. "I wonder where Huey might be," Reese said.

"Since he almost never comes here at night, and especially not when it's crowded like this, your guess is as good as mine."

They didn't have to look far. Dozens of people had

gathered in front of the town's largest department store, forming a circle around, of all things, Huey's renovated, bright red dog cart, with its newly polished brass trim and working coach light.

Abby stared in wonder. "Wow, I can't believe what Poppy's done!"

"It's great," Reese said.

The old carriage sat at the edge of the street beside a miniature forest of artificial trees and animated figures. Its metal fittings sparkled. Plus, a string of lights had been draped around the exterior and a Christmas wreath hung in front of the driver's box.

"How did he get it here?" she asked, walking closer.

Reese chuckled. "I'd say Santa Claus drove it."

Reese's height provided him a better view, but when Abby got closer, she saw what had made him laugh. Santa sat in the driver's seat as if he'd just flown in from the North Pole. "It's Uncle Phil," she said, and then noticed Flake beside him, with an elf cap tied under his muzzle. "And he's got Poppy's dog up there with him." So that was why Huey was here. He wouldn't let his brother use the carriage and his dog without being somewhere nearby, watching over his interests.

Reese nudged her forward. "You're missing the best part."

Abby skirted a group of children accepting candy canes and small wrapped packages from Santa, who was pulling everything out of a giant green bag beside him. She looked up to smile at Uncle Phil, and gulped in surprise. The generous Saint Nick wasn't her uncle.

Dressed in the traditional red suit and black boots, but sporting his own natural beard, was her father. He dutifully cautioned all the kids to put the discarded wrappings in the

trash bins, and then explained how Santa didn't always use his reindeer to get where he was going. Sometimes all he needed was a miracle dog with a good sense of direction. The kids ate up every word as if each one were coated with sugar.

Abby sidled up next to the cart and smiled when Huey noticed her. "Aren't you the versatile one," she said. "First, as Armand, you're the ghost of Christmas past and now you're Christmas present. I can't wait to see what you come up with next."

Huey answered with a deep "Ho, Ho, Ho," and reached into his bag. "I might have something in here for you, baby girl," he said, and handed her a colorful box.

Reese put his hand on Abby's shoulder. "Kind of makes you believe in miracles," he said.

"I guess."

"I'm even sorry there's no Mrs. Claus up there with him."

Abby spun around at the sound of her mother's voice. "Mom, what do you know about this?"

Loretta smiled at Reese. "Just that your father and Phil put this whole thing together."

"My father?" he said.

"Yeah." She spoke softly so the kids around them couldn't hear. "He furnished all the candy and toys, and arranged for the kids at the high school to wrap everything. Then Phil went to Huey about borrowing the dog cart. Somehow Phil talked him into playing Santa."

Abby refocused on a refreshingly jubilant Santa. "No way."

Huey leaned over and whispered to her, "I couldn't let one of those Elvis or Barbra impersonators do this. The kids would have seen right through it." Announcing that

Santa was taking a ten-minute break, he climbed down from the cart. "I need coffee, Loretta," he said, hiking up his baggy pants. "You're going to accompany me to the Pirate Shack."

Loretta put her arm through his. "Absolutely."

They started to walk away, but Reese stopped them. "Wait a minute."

Huey turned around.

"You and my dad are partners in this deal? How did that happen?"

Huey shrugged. "Frank and I have always been victims of our women," he said, grinning first at Abby and then Loretta. "Either that or it's been about money. Let's just say we came to terms. Have you been in the house since you got back?" he asked Abby.

"No."

"Don't be alarmed. There's a bunch of supplies in the kitchen."

"What do you mean?"

"I had to buy some food and plates and stuff."

"What for?"

"I lost my head earlier and invited people over for Christmas Eve dinner. You and I have to straighten the place up in the morning."

Dumbfounded, Abby said simply, "Okay."

"I'm going to deep-fry a turkey," Huey said. He laughed at the expression on Reese's face. "Don't get your briefs in a twist, Deputy Do-Right. I'm not going to set the neighborhood on fire. And you won't get any complaints. I even invited that cranky Edna Howell. You might as well come, too. Your dad's going to be there."

"My father is spending Christmas Eve at Vernay House?"

"Said he was."

"Those must have been some terms you came to. Do my parents still own the marina? Am I still their first-born child?"

Huey dismissed the questions with a wave, and Reese leaned close to Abby. "Is it okay with you if I show up?"

"Sure. In fact, you shouldn't miss it."

"Well, okay then. I accept," he said to Huey.

"Your mom's not coming," Huey stated. "She's got some garden club event…if you believe that."

"We'll be there," Loretta said. "Closing down the Shack. Phil said he wouldn't miss it for the world. Huey has criticized his cooking all these years, so he wants the chance to pay him back."

Abby's curiosity got the best of her. "Wait a minute, Poppy."

He walked over to her, leaving Loretta on the sidewalk.

"You and Uncle Phil?"

Huey grinned. "He's showing some human traits." He leaned down so he could confide in her. "You remember that mysterious payment made on my property taxes, the one I thought was an error?"

She nodded. "Are you saying Uncle Phil…?"

"Shh…don't let on to your mother. She'll use that information against me for the next twenty years."

Abby smiled as Huey rejoined Loretta and they headed toward the Pirate Shack.

"You two watch the dog cart and Flake," Huey hollered from down the block. "Don't let him get into those candy canes. He's had too many already."

Reese patted the dog as he spoke to Abby. "I thought his breath smelled a lot like peppermint. You might want

to take him for a good long walk before he settles down for the night."

She grimaced. "Good advice." Running her hand over the smooth, shiny surface of a coach lantern, she said, "Do you feel like we've walked into an alternate universe?"

"Yep. Imagine me spending Christmas Eve at Huey Vernay's."

"An interesting picture." Abby was eager to get back to the house and have a long talk with her father, though she already suspected the reasons for his transformation. With his paintings, he'd found a purpose for his life. She took some of the credit for that discovery. And he'd found a darn good dog. That was purely fate.

"You don't have to stick around with me," she said to Reese. "I can keep an eye on things until Huey gets back."

"If you're sure. The stores are open late tonight, and I've still got my Christmas shopping to finish."

"Just like a man. Everything last minute." She smiled, planning to hit the stores again herself. She needed to add a couple of gifts to her list, something for Frank and maybe a bottle of cologne for Mrs. Howell.

She'd already done most of her shopping, including purchasing a Swiss fish filet knife set for Reese before she'd told him about Jamie. Afterward, she'd figured she'd take it back. Now she wouldn't. And she'd just thought of another gift for him—something risky, considering their relationship, but one she wanted him to have, since it would probably be his last reminder of her.

Reese squeezed her hand. "See you tomorrow night."

She watched him walk away and was grateful that the chill that had gripped them the last hour of their journey had melted with the holiday cheer of Duval Street.

She didn't like being angry with him. She wished the same spirit affecting their families would heal her and Reese's relationship.

He stopped and shook hands with a couple of officers on bicycles. They kidded around, smiling and laughing for a minute, and then Reese sauntered off into the crowd. He seemed as at home with strangers as he was with lifelong friends.

Abby leaned on the side of Armand's old dog cart and put her arm around Flake. She couldn't help feeling a bit jealous that Reese so easily fitted in here at Key West, the place she'd called home until a nearly impossible decision had forced her away. Could she come home again? Many people had managed it, but she'd always felt it would never work for her. The pain had been too deep, the secret too big.

Flake licked her cheek and Abby smiled up at him. "What am I going to do?" she asked. "I don't enjoy having these feelings about Reese anymore—all the guilt mixed with unrealistic yearning. What I want is for him not to resent me for the rest of my life. I want a free ticket to start over with him." She scratched Flake under his snout. "But what I *really* want—don't laugh—is for him to love me. And I'm afraid a wish of that magnitude will take a real-life Santa Claus to make it come true."

CHAPTER EIGHTEEN

BY ONE O'CLOCK Christmas Eve, Abby and Huey had made their home shine with glass cleaner and furniture polish. But since the old place still lacked sparkle, Abby now stood in a long line at Kmart, her cart crammed with Christmas decorations at twenty-five percent off. The woman in front of her turned away from the conveyor belt, where her basket was loaded with snacks, and said, "You realize that two days from now, those same items will be half off?"

Abby nodded. "I know, but I don't mind, really." She lifted the box with a seven-foot prelit tree onto the belt. She would have paid full price if that was what it took to fill her family home with holiday cheer, because this was the first Christmas in years that it mattered.

She and Huey were ready at seven o'clock when their first guests arrived—Loretta and Phil. Loretta hugged Abby and kissed Huey on his cheek. Phil presented him with a bottle of wine and a basket of conch fritters, which he swore were not prepared in week-old grease.

Reese and Frank arrived next, with an armload of baked goods from Martha's. Frank announced that Ellen sent her regrets, while Reese looked down at the floor, obviously uncomfortable with his father's lie.

Abby didn't mind Ellen's absence. This night wasn't

about her. This was about the members of the two families who'd decided to put aside bad feelings at the time of year when forgiveness was most possible. Maybe Reese would never be able to forgive her, just as she would never completely forgive herself, but for tonight they could pretend.

Mrs. Howell, in a flowing red satin dress, vintage 1960, and diamonds dripping from her ears, brought her "famous" fruitcake, to which she admitted having added two cups of bourbon before leaving the concoction to ferment in her pantry from June on. Abby decided that she would limit her alcohol intake to Phil's merlot. When Huey announced without chagrin that Flake would love it, Abby assigned Reese the job of keeping the dog far away from the cake.

Everyone commented on Abby's hasty decorating. Huey's pledge to keep the neighborhood safe from flaming turkey wildfires proved reliable. The meal was delicious. At eight-thirty, Huey got up from the table and told everyone it was showtime. He disappeared up the stairs and returned a few minutes later dressed as Armand. He and Flake stepped onto the porch just as Undertaker and his tourists strolled by for a special Christmas Eve ghost walk. Huey's guests sat on the veranda and pretended to be victims of Armand's unscrupulous salvaging activities.

When the show was over, Reese went to his truck, retrieved a colorful Christmas sack and approached Abby. "Walk with me, okay?"

They sat on the bench in the backyard beside the bougainvillea, which was sparkling with white lights. Music from Duval Street drifted over the fence. Abby recognized the rock beat. "Isn't that the Barenaked Ladies' holiday album?"

"I believe it's their 'Green Christmas' song," Reese said.

"Probably coming from the Bilge Bucket. They blasted that song last Christmas Eve about this same time. Apparently, they're making it a tradition." He laughed. "There's nothing quite like a Key West Christmas."

Abby smiled. He was so right. This was a Christmas she would never forget, for reasons that both cheered and saddened her. When she'd told Reese about Jamie, the awful weight of that guilty secret had been lifted from her shoulders, but new regrets had taken its place. She had to accept that she and Reese might never mend the past or be able to live with the decision she'd made.

"So what are we doing here?" she said. "Did you want to talk?"

"I thought we might, but mostly I wanted to give you my gifts."

"Oh! I have gifts for you, too." She ran into the house and returned with two packages. Handing them to him, she said quickly, "Go ahead. Open them. This might truly be the last time you ever speak to me."

He laughed, and the spontaneous sound warmed her inside and out. He was impressed with the set of knives, saying they were just what he needed. Whether or not it was true, Abby was pleased. When he began opening the second gift, she held her breath. She still had no idea how he would react. But if she knew Reese even half as well as she believed she did, he would appreciate her gesture.

He tossed the wrapping to the ground and held the portrait under the lights, to see their son's face smiling up at him. Jamie's expression had been captured in a moment of sublime joy, taken with Abby's zoom lens when she'd seen him perform in that school play two years ago.

Reese stared at the photo. "Abby, how…?"

"Before you say anything, read the back."

He turned the frame over and read aloud. "'Dearest Reese. No matter what else, we did create something amazing.'"

Tears gathered in his eyes, which he tried to hide by blinking hard. "When did you get this?" His voice hitched. "Where...?"

She explained the circumstances, adding that she'd brought the photo with her to Key West because she never went anywhere without it. She'd had it duplicated the night before. "Maybe this will help sustain you until that phone call," she said.

He smiled. "And he'll call. I know it."

"I believe that, too."

"Thank you, Abby. I'll always treasure this." Reese set the photo beside him on the bench and held her hand. "Will you go out with me New Year's Eve?"

She sat back and considered the unexpected invitation. December thirty-first was a week away. Did that mean he didn't want to see her until then? "Reese, I'm not sure. I'm leaving the next day, and..."

He released her hand and rubbed his jaw. "I wasn't just asking about this New Year's. I was sort of making a standing date for the next fifty years or so."

"What are you talking about?"

"If we get tired of the celebrations in Key West, we can go someplace else."

She grinned, what she figured was a giddy, lopsided expression that made her appear ridiculous. But she didn't care. For the first time in many years, she was enjoying riddles. "I don't have any definite New Year's plans for the next fifty years, so okay, sure. It's a date—or dates."

Seeming pleased with himself, he said, "Good. That's

settled." He reached behind him and removed two wrapped packages from the sack. "Here are your presents."

She took the first one he offered. It was shaped like a book. It felt like a book.

"It's a book," he said. "A little hard to disguise. I bought it last night."

She opened the wrapping and read the title: *The Magic of the Keys and Key West. Why We Keep Coming Back.* She flipped through the illustrated pages, and stopped at a photograph of Vernay House as it had looked years ago, before she and her mother had moved out and Huey had stopped caring about the property. "I'd forgotten how beautiful this house used to be," she said. She glanced up at the back porch rafters, their paint cracked and peeling. "It's in a sad state tonight."

Reese hid a smile behind his cupped hand. "It's Christmas, Abby. No time to be sad."

"I know, but…"

"Guess what I did today," he said, his smile mischievous.

"I can't imagine."

"I met with the head of the Community Improvement Board."

"You didn't! You said you were going to resign from that committee."

"I am, but first I wanted to suggest a plan."

She frowned at him, ready for bad news, but not really believing she was going to hear it.

"I did some investigating. Turns out that the CIB actually does some improving around here. They regularly repaint the sign at the Southernmost Point. They arranged for a new roof on the Wreckers Museum. They do some good."

"As well as some general hassling of citizens," she couldn't help pointing out.

"That, too. Anyway, I'll have to attend at least one meeting before I step down, the first one in January. That's when my proposal will go up for a vote. According to Harry Myers, the head of the committee, the proposal should pass."

Completely intrigued, she closed the book and laced her fingers together on top of it. "And what is your proposal?"

"I'm suggesting that Vernay House be given a new coat of paint and benefit from a few repairs to its exterior." He stood and appraised the roof. "Maybe fix some leaks up there, patch a few window moldings, shore up the carriage house. Things like that."

"Why would the committee do that?"

"Because I'm going to talk Huey into opening the place to visitors during a couple of the island's historic festivals each year, when we have an influx of tourists. This house can be part of the historic buildings tour, and the CIB can keep the profits from ticket sales."

Abby could barely contain the excitement building inside her. It was a wonderful idea, one that would preserve her home and restore her pride. Unfortunately, a gigantic obstacle to the plan was right now changing out of his Armand costume. Huey would never go for the public traipsing through his house. "It's a good idea, Reese. Maybe if I approach Poppy at the right time, I can convince him—"

"Nope. I don't want you to talk to him about this. You've had enough problems since you've been here, and you've done plenty to help him. I'm going to do it. Huey and I have some common ground to build on." Reese grinned down at her. "You being the most significant example. I can make him go along with it. Trust me."

She did. And then she hugged the book to her. "Maybe the next time I visit this house it will look a lot like it did in the picture. And I'll have you to thank for it."

He smiled. "Speaking of thank-yous, I'd like to bring up that idiotic one I gave you at the motel. My timing was terrible, but my intentions were the best. I can be dense sometimes, Abby. I didn't realize how those words might have sounded the other night."

"Don't worry about it. I hardly noticed."

He chuckled. "Right. The truth is I *was* thankful. You brought me in from the cold that night, and I'm not talking about the weather. Still, after what happened, for me to say 'Thank you' was the asinine statement of a thick-headed dunce."

He reached for the book, set it beside her and grasped her hand. "I wanted to stay with you. God, if you only knew how badly. You may not believe this, but some sort of twisted nobility made me leave. I didn't want you to think I'd come to you just for…well, for sex. Though it was pretty darn great."

He put his finger under her chin and raised her face. "That happened to us once before. It was just sex. Only I didn't know at the time that it would linger in my mind as something a whole lot more. If I ever get the chance to make love to you again, I want it to mean what it did two nights ago, when it meant everything."

Abby swallowed, prayed the words would find their way past the constriction in her throat. Prayed his answer would be the one she hoped for. "Reese, are you saying that you can forgive me?"

He rubbed the back of her hand with his thumb. "I'm saying that forgiveness works both ways. Can you forgive

me for not understanding what you went through? For not appreciating how hard it was for you to put the baby up for adoption?"

"There's nothing to forgive—"

"Yes, there is. You made the hardest decision a mother ever has to make. And you made it with good judgment and careful consideration. When Jamie comes to us, as he will, he'll arrive on our doorstep as a well-adjusted, confident, fulfilled individual. And while we didn't raise him, you're the one responsible for that."

She'd never thought of her decision in just that way. And for Reese to tell her meant so much now. She gazed down at his hand, strong and comforting on hers, and felt the first tears fall. She sniffed, trying to stop the flow, but they had to come because they were good tears. Healing ones.

"I was afraid you were going to do that," he said, giving her a handkerchief. "Abby, the forgiveness stuff—it's done. Okay?"

"Okay."

He handed her a second package, a small jewelry box. "But now, here's a little something extra I picked up for you."

Abby's hand shook as she unwrapped the paper and opened the box. On a bed of soft black velvet rested a gold conch shell charm hanging from a chain. "It's beautiful," she said, removing it from the box. The Christmas lights on the bougainvillea shone on a red stone glimmering in the center of the shell.

"It's a ruby," Reese said. "A small one, but it's appropriate, considering it's Christmas. And since this seems to be the year for personal messages, I had it engraved."

She turned the charm over. It felt like warm satin in her

palm. She could just make out the delicate scripted words: *To A.V. from R.B.—the 1st Christmas.* She looked up at him. "The first Christmas?"

"A bit presumptuous of me, I suppose."

"What do you mean?"

"Years from now I hope to present you with a necklace celebrating our tenth Christmas. And years after that, another one."

Abby's chest squeezed. Her throat burned and her eyes filled with tears again. She felt feverish and faint and dizzy. It was the happiest moment of her life.

"Aren't you going to say anything?" he asked.

She hooked the necklace around her throat and laid her hand over the shell. The warm tropical breeze that she suddenly longed to feel every day of her life washed over her. "Reese, if you're really saying what I hope you are, that we have a future after tonight, I need to hear the words."

"Abby, my darling, our future started thirteen years ago, and I don't see an end in sight. And who knows? This New Year's Eve could be special for us."

"It could?"

"I plan to ring in the New Year in bed with you, with hopes of doing exactly that for a long time. And if by some miracle you're pregnant next Christmas, I'm going to be right here holding your hand." He smiled, his whole face lighting up. "We're not getting any younger for this parenting job."

She laughed. "So you're suggesting we should try the baby thing again?"

He nodded. "Not a bad idea, if you approve. And this time we'll get it right. And when Jamie calls us, maybe we'll introduce him to a brother or sister or two."

She picked up the book and read part of the title aloud. *"Why We Keep Coming Back."* Blinking hard, she said, "And we do, don't we?"

"We do. Until we finally realize this is where we were meant to be."

This night had changed everything for her. Brought her full circle with Reese and brought her home. "I have to go back to Atlanta for a while," she said. "I have cases, young women who need me."

"I understand that, and I'll be patient. Those women are lucky to have you on their side. But you might consider that we have girls right here in Monroe County who could use your help, too."

A burst of heat spread through Amy's body. Reese loved her. He admired her.

With his hands cradling her face, he kissed her. "But you will hurry home, won't you?"

Home. Just a few weeks ago, Abby had told her father she'd never return to Key West. Now no place else on earth could feel as much like home as this island. "You bet."

Still holding her close, Reese said, "I'm glad this matter is settled, because I've got more shopping to do. I've opened an account at the jewelry store."

He kissed her again as the music of a Key West Christmas once more filled the air. This time Elvis crooned "I'll be Home for Christmas." And Abby knew exactly how he felt.

* * * * *

Mills & Boon® Special Moments™
brings you a sneak preview.

In Mistletoe and Miracles *child psychologist*
Trent Marlowe can't believe his eyes when Laurel
– the woman he'd loved and lost – comes to him for
help. Now a widow with a troubled son, Laurel needs
a miracle from Trent...and a brief detour under the
mistletoe wouldn't hurt either...

Turn the page for a peek at this fantastic new story
from Marie Ferrarella, available next month in
Mills & Boon® Special Moments™!

Don't forget you can still find all your favourite
Superromance and Special Edition stories
every month in Special Moments™!

Mistletoe and Miracles
by
Marie Ferrarella

For a moment, Trent Marlowe thought he was dreaming.

When he first looked up from the latest article on selective mutism and saw her standing in the doorway of his office, he was certain he had fallen asleep.

But even though the article was dry, the last time he'd actually nodded out while sitting at a desk had been during an eight-o'clock Pol-Sci 1 class, where the lackluster professor's monotone voice had been a first-class cure for insomnia.

He'd been a college freshman then.

And so had she.

Blinking, Trent glanced down at his appointment calendar and then up again at the sad-eyed, slender blonde. It was nine in the morning and he had a full day ahead of him, begin-

ning with a new patient, a Cody Greer. Cody was only six years old and was brought in by his mother, Laurel Greer.

When he'd seen it on his schedule, the first name had given him a fleeting moment's pause. It made him remember another Laurel. Someone who had been a very important part of his life. But that was years ago and if he thought of her every now and then, it was never in this setting. Never walking into his office. After all, like his stepmother, he had become a child psychologist, and Laurel Valentine was hardly a child. Even when she'd been one.

Laurel wasn't that unusual a name. It had never occurred to him that Laurel Greer and Laurel Valentine were one and the same person.

And yet, here she was, in his doorway. Just as achingly beautiful as ever.

Maybe more so.

Trent didn't remember rising from behind his desk. Didn't remember opening his mouth to speak. His voice sounded almost surreal to his ear as he said her name. "Laurel?"

And then she smiled.

It was a tense, hesitant smile, but still Laurel's smile, splashing sunshine through the entire room. That was when he knew he wasn't dreaming, wasn't revisiting a space in his mind reserved for things that should have been but weren't.

Laurel remained where she was, as if she had doubts about taking this last step into his world. "Hello, Trent. How are you?"

Her voice was soft, melodic. His was stilted. "Startled."

He'd said the first word that came to him. But this wasn't a word association test. Trent laughed dryly to shake off the bewildered mood that closed around him.

How long had it been? Over seven years now. And, at first glance, she hadn't changed. She still had a shyness that made him think of a fairy-tale princess in need of rescue.

Confusion wove its way through the moment. Had she come here looking for him? Or was it his professional services she needed? But he didn't treat adults.

"I'm a child psychologist," he heard himself telling her.

Her smile widened, so did the radiance. But that could have just been a trick of the sunshine streaming in the window behind him.

"I know," she said. "I have a child."

Something twisted inside of him, but he forced himself to ignore it. Trent tilted his head slightly as he looked behind her, but there didn't seem to be anyone with Laurel, at least not close by. Trent raised an inquiring eyebrow as his eyes shifted back to her.

"He's at home," she explained. "With my mother."

He looked at his watch even though three minutes ago he'd known what time it was. Right now he wasn't sure of anything. The ground had opened up beneath him and he'd fallen down the rabbit hole.

"Shouldn't he be in school?"

Laurel sighed before answering, as if some burden had made her incredibly tired. "These days, he doesn't want

to go anymore." Laurel pressed her lips together and looked at him hopefully. "Can I come in?"

Idiot, Trent berated himself. But the sight of his first, no, his *only* love after all these years had completely thrown him for a loop, incinerating his usual poise.

He forced himself to focus. To relax. With effort, he locked away the myriad questions popping up in his brain.

"Of course. Sorry. Seeing you just now really caught me off guard." He gestured toward the two chairs before his sleek, modern desk. "Please, take a seat."

She moved across the room like the model she had once confided she wanted to become, gliding gracefully into one of the chairs he'd indicated. Placing her purse on the floor beside her, she crossed her ankles and folded her hands in her lap.

She seemed uncomfortable and she'd never been ill at ease around him before. But there were seven years between then and now. A lot could have happened in that time.

"I wanted to talk to you about Cody before you started working with him, but I didn't want him to hear me."

Did she think the boy wouldn't understand? Or that Cody would understand all too well? "Why?"

"Cody's practically a statue as it is. I don't want him feeling that I'm talking about him as if he wasn't there. I mean…" She stopped abruptly, working her lower lip the way she used to when a topic was too hard for her to put into words. Some things didn't change. He wasn't sure if he found comfort in that or not.

When she looked up at him, he realized that she'd bitten

down on her lower lip to keep from crying. Tears shimmered in her eyes. "I don't know where to start."

"Anyplace that feels comfortable," he told her gently, a well of old feelings springing forth. He smiled at her encouragingly. "Most people start at the beginning."

No place feels comfortable, Laurel thought. She was hanging on by a thread and that thread was getting thinner and thinner. Any second now, she was going to fall into the abyss.

Clenching her hands together, she forced herself to rally. She couldn't fall apart, she couldn't. She had to save Cody. Or, more accurately, she had to get Trent to save Cody, because if anyone could help her son, it was Trent.

© Marie Rydzynski-Ferrarella 2008

 # SPECIAL MOMENTS™ 2-in-1

Coming next month

THE MILLIONAIRE'S CHRISTMAS WIFE by Susan Crosby

To seal a crucial deal, Gideon needed a wife. Denise Watson agreed to help – but what if their fake marriage could be for real?

A BABY IN THE BUNKHOUSE by Cathy Gillen Thacker

When Rafferty Evans offers a pregnant beauty shelter, the rancher doesn't expect to deliver her baby! Soon he finds himself opening his heart to love…and to an instant family.

THE HOLIDAY VISITOR by Tara Taylor Quinn

Craig McKellips stays at Marybeth's hotel every Christmas. But their slow-burning attraction is jeopardised when he reveals his identity…and his link to the past.

WORTH FIGHTING FOR by Molly O'Keefe

Jonah Closky has only come to the inn to meet his estranged family. He's distracted from his attempt to reconnect with them by gorgeous Daphne…a woman who he can believe in.

ALL SHE WANTS FOR CHRISTMAS by Stacy Connelly

She is determined to give Hopewell House's foster children the best holiday ever. And when a gorgeous businessman plays Santa, it might be Holly's happiest Christmas, too!

BE MY BABIES by Kathryn Shay

Lily Wakefield is pregnant – with twins! She should be off-limits to Simon, but the attraction is mutual. Then her past catches up and threatens to destroy everything…

On sale 20th November 2009

Available at WHSmith, Tesco, ASDA, Eason and all good bookshops.
For full Mills & Boon range including eBooks visit
www.millsandboon.co.uk

2 FREE BOOKS
AND A SURPRISE GIFT

We would like to take this opportunity to thank you for reading this Mills & Boon® book by offering you the chance to take TWO more specially selected books from the Special Moments™ series absolutely FREE! We're also making this offer to introduce you to the benefits of the Mills & Boon® Book Club™—

- **FREE home delivery**
- **FREE gifts and competitions**
- **FREE monthly Newsletter**
- **Exclusive Mills & Boon Book Club offers**
- **Books available before they're in the shops**

Accepting these FREE books and gift places you under no obligation to buy, you may cancel at any time, even after receiving your free books. Simply complete your details below and return the entire page to the address below. You don't even need a stamp!

YES Please send me 2 free Special Moments books and a surprise gift. I understand that unless you hear from me, I will receive 5 superb new stories every month, including a 2-in-1 book priced at £4.99 and three single books priced at £3.19 each, postage and packing free. I am under no obligation to purchase any books and may cancel my subscription at any time. The free books and gift will be mine to keep in any case.

Ms/Mrs/Miss/Mr _____ Initials _____

Surname _____

Address _____

_____ Postcode _____

Send this whole page to: Mills & Boon Book Club, Free Book Offer, FREEPOST NAT 10298, Richmond, TW9 1BR